The Hasselblad Manual

The Hasselblad Manual
Sixth Edition

Ernst Wildi

AMSTERDAM • BOSTON • HEIDELBERG
LONDON • NEW YORK • OXFORD
PARIS • SAN DIEGO • SAN FRANCISCO
SINGAPORE • SYDNEY • TOKYO
An Imprint of Elsevier

The main cover photo is a digital image produced by Sarah Silver with a motorized 503CW camera (model saskia) for T Management in New York and used first in *City Magazine*, March, April 2003. Hair: Kevin Woon at Jet Root. Make up: Walter Obal for Make up forever at Bradley Curry. Stylist Sarah Parlow at Mark Edwards.

 This book is printed on acid-free paper.

Library of Congress Cataloging-in-Publication Data
Wildi, Ernst.
 The Hasselblad manual / Ernst Wildi.—6th ed.
 p. cm.
 ISBN 0-240-80613-1 (alk.paper)
 1. Hasselblad camera—Handbooks, manuals, etc. 2. Photography—Handbooks, manuals, etc. I. Title.
TR263.H3W54 2003
771.3′1—dc22 2003058421

British Library Cataloguing-in-Publication Data
A catalogue record for this book is available from the British Library.

The publisher offers special discounts on bulk orders of this book.
For information, please contact:
Manager of Special Sales
Elsevier
200 Wheeler Road
Burlington, MA 01803
Tel: 781-313-4700
Fax: 781-313-4802

For information on all Focal Press publications available, contact our Web site at http://www.focalpress.com

10 9 8 7 6 5 4 3 2 1
Printed in the United States of America

Contents

6 OPERATING V SYSTEM CAMERAS 83

11 V SYSTEM VIEWFINDERS AND FOCUSING SCREENS 157

Preface

Since the first edition of *The Hasselblad Manual* was published more than 20 years ago, Hasselblad has taken giant steps forward into the sophisticated field of high-tech electronics. The company has produced updated and sophisticated cameras that include the automation, the operating conveniences, and the programming possibilities that let you customize the camera operations to your personal photographic approach so that you can produce images of the highest quality in a simpler, more precise, and more enjoyable fashion.

Hasselblad cameras have also become great tools for digital imaging. Although electronic imaging requires a new knowledge of computers, scanners, and imaging software, it is worthwhile keeping in mind that a successful digital image requires recording a great image in the camera as is the case with film. You must first learn everything about the camera and lens operation and the approaches that create great images of the highest quality in the camera. *The Hasselblad Manual* covers all these aspects and should therefore be helpful regardless of whether you create the images on film or digitally.

I have had the opportunity over many years to conduct lectures and workshops in the United States and in more than 50 other countries on five continents. The questions and comments that come up in these lectures always encourage me to find better and more effective ways of teaching the use of Hasselblad cameras for producing effective images of the highest quality in the simplest and most enjoyable fashion. These new ideas are included in the sixth edition of the *Manual* in addition to updated information on the use and operation of the latest Hasselblad cameras, lenses, and accessories. My main interest was to supply you with information that can help you in producing better and more effective images rather than duplicating the information in the instruction manual. Keep the instruction manuals for your equipment where they can be found easily. Because Hasselblad items are frequently changed or discontinued and new items are added, I also did not try to provide an updated catalog listing of the Hasselblad products. You can obtain the latest catalog from the Hasselblad agent or dealer.

The black and white and color pictures in the *Manual* were made on film, with the exception of those specifically indicated as having been pro-

duced digitally. Naturally, almost all images could have been produced either on film or digitally using the same camera techniques and approaches.

I would like to thank the many friends and experts at Victor Hasselblad AB in Goteborg, Sweden, for their wonderful help and cooperation in producing *The Hasselblad Manual*. Also, a special note of appreciation to Anders Engstrom, who produced the diagrams for the Hasselblad instruction books that are reproduced in the *Manual* with permission from Hasselblad.

Ernst Wildi

1

The Hasselblad Image Formats

Hasselblad cameras are great tools in every field of photography from critical studio work to handheld location photography. Except for the XPan model, Hasselblad cameras are made for the medium format, which combines many of the advantages of 35mm photography and large format photography. By simply switching the magazine on the camera, you can record images on black and white or color film, on instant recording film, or electronically.

Although all medium format cameras use the same basic roll film size (120 or 220), the image format recorded in different cameras on film can be of different sizes, or you can obtain different image formats by using different film magazines.

THE $2\frac{1}{4} \times 2\frac{1}{4}$-INCH SQUARE FORMAT

The $2\frac{1}{4} \times 2\frac{1}{4}$-in. ($6 \times 6$ cm) square format established the popularity of the medium format camera. The exact image size is 55×55 mm, with 12 images on one roll of 120 film, 24 on the 220 type. All Hasselblad cameras in the V system are basically built for the square.

Many good points can be made about photographing in the square format. You have a wide choice in composing the subject, and you need not decide the final image shape when you take the picture. Afterward you can change a square image beautifully into a vertical or a horizontal if desired, and you will not lose image sharpness if you leave the long image side in its original length of 55 mm. You also need not decide which way to turn the camera. The 12 square images from a 120 roll of film fit beautifully on a sheet of 8×10-in. paper, and all the images are right side up.

THE 6×4.5 CM FORMAT

The exact image size of the 6×4.5 cm format is 55×42 mm, which corresponds closely to the shape of standard enlarging papers. Enlargements can therefore be made with almost no cropping. Because the long side of the

image is the same as the 6 × 6 square, image quality is identical. The 6 × 4.5cm images are not smaller images, only images of a different shape. When you photograph in the 6 × 4.5 format, you must decide before you photograph whether the picture should be horizontal or vertical, and you must turn the camera for verticals. In return, you obtain more images on the film: 16 on 120 type, 32 on 220 roll film.

The H1 Hasselblad camera is made specifically for this rectangular 6 × 4.5 format. In the V system cameras, you can obtain images in the 6 × 4.5 format by attaching a special film magazine designated as A16, A32, E16, or E32 (which has been discontinued). On newer Hasselblad cameras in the 500 series, you can also obtain images in the 6 × 4.5cm horizontal or vertical format by placing a mask at the rear of the camera body. You obtain only the "normal" number of images (12 on magazine 120), but you need not turn the camera. Instead, you simply turn the mask.

THE SUPERSLIDE FORMAT

The exact image size of the Superslide format is 41 × 41 mm, small enough for transparencies to be projected in 35 mm projectors. Hasselblad used to offer a special magazine (A16S) for the Superslide size. It is no longer made, however, because newer 35mm slide projectors do not project Superslides without darkening in the corners. Consequently, the Superslide format no longer serves a purpose.

THE PANORAMIC FORMAT

Images are considered panoramic when the long image side is at least twice as long as the other side. The medium format image size is large enough so that you can produce panoramic images in any Hasselblad camera. Just use the center portion of the square or 6 × 4.5cm image by masking the transparency or by eliminating the rest when the print is made. Such "cut" panoramic images can then have a long side of 55 mm and a short side anywhere from 18 mm to 28 mm.

Hasselblad produces a panoramic mask that fits into the rear of the newer 500 series cameras to mask off the unused area of the film. If you advance the film normally, you do not increase the number of images on a roll of film, and therefore the benefits of using the mask are limited.

Panoramic images in the 24mm × 65mm size can be produced in the Hasselblad XPan dual format camera on standard 35mm film. This panoramic format is about $3\frac{1}{2}$ times as large as a panoramic image cropped from a standard 35 mm frame, or 5 times as large as the panoramic APS format. With the XPan camera, you can also produce images in the standard 35mm format of 24 × 36 mm, and such images can be produced on the same roll of film if

desired. Viewfinder framing and frame counter change automatically when you switch from one format to the other.

Although the XPan panoramic images are produced on 35mm film, they can be considered medium format because the long side of the image is longer than the 55mm long side of medium format images produced in other Hasselblad cameras. The XPan images also exhibit medium format image quality. The XPan camera offers photographers a new opportunity for creating panoramic images of the best quality in an inexpensive fashion.

THE 6 × 7 CM MEDIUM FORMAT

Some camera manufacturers other than Hasselblad make cameras for the 6 × 7 cm format, which is about 55 × 68 mm in size, or about 12mm (or 20%) longer in one dimension than those in the 6 × 6 or 6 × 4.5 format. The difference in image size and enlarging degree has proven to be insufficient for producing images of better quality. I therefore see no benefits or need for considering the 6 × 7 format for any type of medium format photography, especially because this format produces only 10 images on a roll of 120 film. It also requires that you work with a camera that does not have the convenience and mobility that make Hasselblads such great tools for critical studio work as well as for handheld location photography. With Hasselblad and today's high-resolution films you can obtain the ultimate image sharpness and definition possible in medium format photography on the slightly smaller but more practical $2\frac{1}{4}$-in. square or rectangular 6 × 4.5cm format.

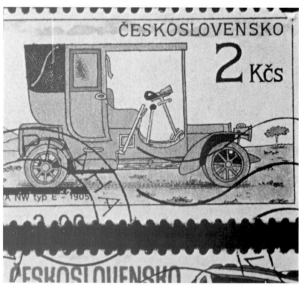

▲ The superb image quality of the medium format is conveyed by the 10× blow up of one of the postage stamps on the original transparency photographed with 120 mm Carl Zeiss Makro Planar. Ernst Wildi

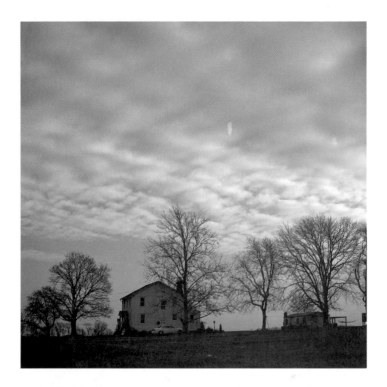

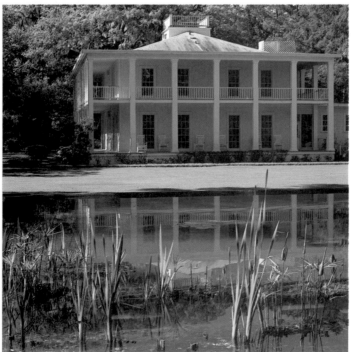

▲ Since the interesting cloud formations in the early
morning sky in New Jersey were the main attraction,
the image was composed with the horizon
approximately 1/3 from the bottom with 110mm
lens combined with 1.4× teleconverter.
In images with reflections, the dividing line composed
in the center emphasizes the repetition between the
actual subject and the reflections. Taken in Florida with
110mm lens. *Both images Ernst Wildi*

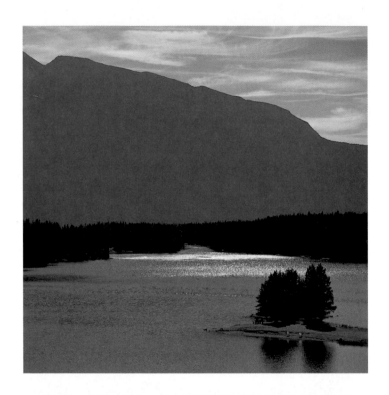

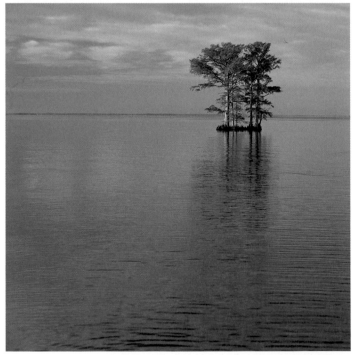

▲ The trees in the water in the Carolinas and the tress in the backlit scene in the Canadian Rocky Mountains composed approximately 1/3 from the right and 1/3 from top or bottom resulted in a pleasing composition. *Both taken by Ernst Wildi*

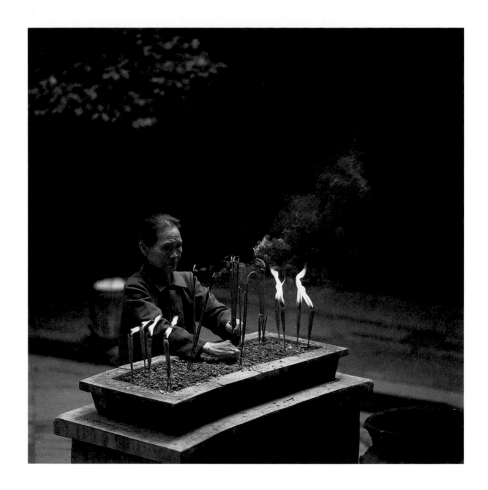

▲ The diagonal trail of smoke leading to the lady
enhanced the composition in the picture taken in
China by Ernst Wildi

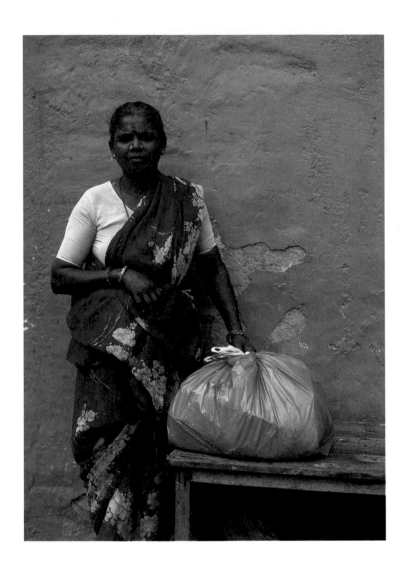

▲ The effectiveness of this candid portrait taken with
110mm lens in Singapore is created by the beautiful
contrast of colors with the red bag against the blue
background. *Ernst Wildi*

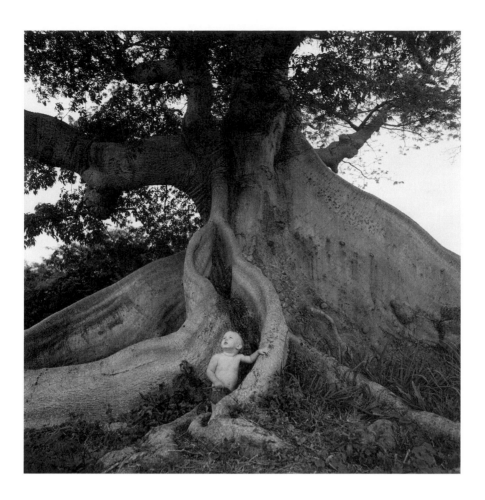

▲ A carefully selected outdoor location that produced a
dynamic image and composition of Emmet and tree by
Karen Kuehn

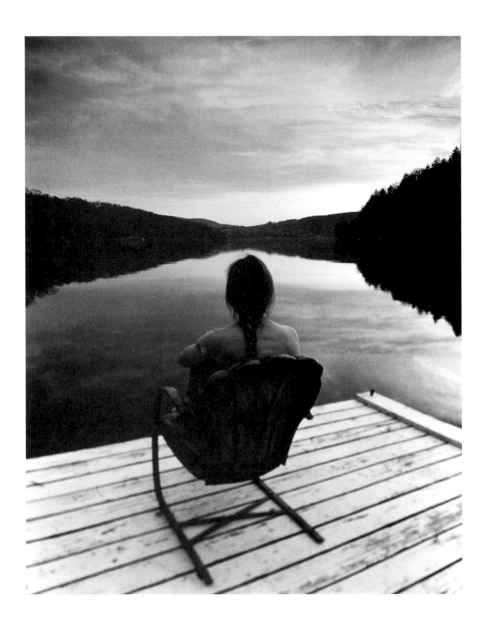

▲ Janne Hall sitting on dock beautifully composed within the bright area of the lake surface. Karen Kuehn

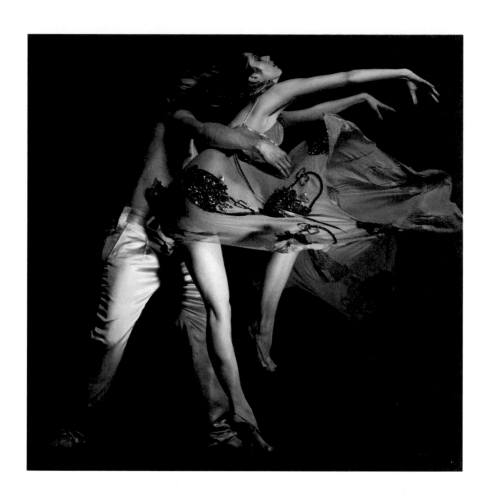

▲ A digital image of dancers from the NYC ballet company created by Sarah Silver for *Noise* magazine, Fall 2003. Produced with Sinarback attached to motorized 503 camera

2

Digital Imaging with Hasselblad

THE ADVANTAGES OF HASSELBLAD'S DIGITAL IMAGING SYSTEM

You can create digital images with Hasselblad medium-format cameras by simply replacing a film magazine with a magazine for electronic imaging, as shown in Figure 2-1. This design allows you to use the same camera and the same lenses and accessories for film photography as for electronic imaging. You need not invest in a completely new digital camera system and need not familiarize yourself with another camera. You need not learn anything new about creating the ultimate image quality, the use and operation of lenses and lens controls, exposure, composition, use of light, and so on.

Working with the same camera for film and digital photography is advantageous because recording either type of image is based on the same principles and requires the same camera and lens operation. The image is simply recorded on a different medium. The real differences between film and digital photography come after the image is recorded in the camera. That is when you must decide whether to change the image and how to present and store it. Even if you plan to record all your images digitally, you cannot limit your studies to electronic recording principles and the use of computers, scanners, or imaging software. As with film, producing a great digital image requires recording a good image in the camera. You must first learn everything about the camera and lens operation and about the approaches that create great images of the highest quality in your camera. *The Hasselblad Manual* covers all these aspects.

The comment is often heard that in this digital age photographers need no longer be overly concerned about creating perfect results in the camera because images can easily be changed and improved, and all the faults can be corrected afterward in the computer. It is certainly possible to retouch images and to improve their quality by making them brighter or darker or sharper or by changing colors. You can also add a soft touch, make an image more effective by changing the composition or the background, produce double exposures, combine different images, or make almost any other desired changes. But these manipulations done in the computer are very time-consuming if you want to do them yourself and very costly when done on the outside. The best approach is still to become a good photographer

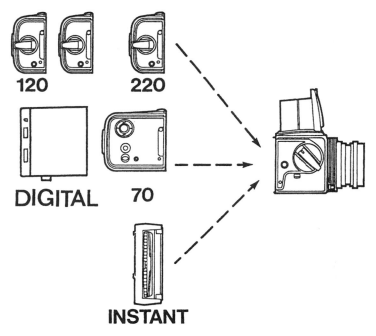

120 220

DIGITAL 70

INSTANT

Figure 2-1 *Magazines for electronic imaging* A digital imaging back can be attached to some Hasselblad cameras in the V system in place of a film magazine. The H camera can also be used with digital backs specifically made for this camera model.

and to try to record an image in the camera that is as perfect as possible so that it needs little or no after work on the computer.

If you decide now or in the future to make digital recording part of your photography, learn the principles of electronic imaging and the possibilities offered by this new recording medium from other photographers, in workshops, or with updated books on digital imaging.

DIGITAL BACKS FOR THE HASSELBLAD

The magazines for electronic imaging are not made by Hasselblad but by several other companies specifically for use on Hasselblad cameras. Most magazines must be used with specific Hasselblad camera models, so study the specifications supplied by Hasselblad or the manufacturer of the digital back. Most backs require motor-driven camera models, with the 555ELD being an ideal model for various digital backs. The 555ELD has Databus connections at the rear of the camera body, eliminating cable connections to digital backs that also have the electronic coupling. The 555ELD has a special release for electronic imaging in addition to the release for film photography.

The Hasselblad H camera system offers the most complete integration for electronic imaging, with digital Databus interface technology between the

camera and the electronic imaging backs. The camera's LCD display can show a histogram of a digital exposure. All the HC lenses are also designed for the ultimate image quality in electronic recording. The H camera can therefore be considered the most updated and most sophisticated medium-format camera for electronic imaging.

THE DIGITAL CAMERA BACKS

Because electronic imaging technology is changing rapidly and new and modified products are introduced constantly, I refrain from discussing specific products or recording techniques. Doing so would outdate this manual rapidly, perhaps even before it comes on the market. When you are ready for electronic imaging, study the specifications for the various digital backs. Meanwhile, a few basic points can be made here.

A single-shot back lets you record moving subjects and use flash, and therefore it is suitable for any type of photography. A multishot back can be used only for stationary subjects but produces better image quality. Some backs offer the option of both approaches.

Some backs must be used in combination with a computer (which can be a laptop) when the image is recorded and therefore are more suitable for studio work. Others can be used untethered, with the image being recorded on a media card as done with special digital cameras. This is probably the type you want to consider for location work.

SENSOR SIZE AND FOCAL LENGTH OF LENS

The sensor size varies greatly among cameras made specifically for digital recording, either the point-and-shoot or the professional approach. There are also variations in sensor size among digital backs, but at present most of them are either the 37×37mm square or the 24×36mm rectangular size. Because these sensors are considerably smaller than the 6×6cm or the 6×4.5cm film formats, the lenses on the camera cover smaller areas than they do with film magazines. In other words, a wide-angle lens for film photography becomes a standard lens for digital recording, and a standard focal length lens becomes a telephoto lens.

I feel it is most logical to determine the equivalent focal length or area coverage by the difference between the long side of the film format and the imaging sensors rather than the diagonal. The factor is approximately 0.7 for the 37mm square and the 24×36mm rectangular sensor and the 6×6 or 6×4.5 film format. This means that a 50mm lens covers the same area in digital recording as the 80mm lens does on film. The 80mm standard focal length becomes a telephoto, covering the same area as a 120mm lens on film. If you work with a monitor or if the back has one built in, you can see the covered area on the screen. If you want to see the composition on the focusing screen of the camera, you must mask it down. Some backs come with a focusing screen, with the digital area coverage clearly marked.

IMAGE QUALITY

The digital image is formed on the sensor in the camera by pixels that are light sensitive to either green, blue, or red. The number of pixels is indicated in a specification sheet, either by the number of pixels along either side of the sensor or by the total number of pixels on the entire surface (or both). The specifications may perhaps read 3120×2060 pixels, which adds up to 6.4 megapixels. The number of pixels is directly related to the image quality produced in the camera. The higher the number of pixels, the better the image quality (provided that everything else is equal, especially the performance of the lenses). Lenses of questionable quality limit the image sharpness in digital recording just as they do in film photography.

The number of pixels is only part of the quality story. The size of the pixel needs to be considered, and that is determined by the size of the sensor. In a 24×36 mm sensor that has 2048 pixels along the 24 mm side, the pixel size is 0.0117 mm, or 11.7 microns (μm). The pixel size on a smaller 15×23mm sensor with the same pixel count is only 7.4 microns.

A larger pixel collects more light, and its signal needs to be less amplified, thus creating less "noise," as it is called in electronic imaging. The result is a better dynamic range in the picture, with a wider range of shades from the deepest shaded areas to the brightest highlights. A file with all this information will also survive postprocessing much better. Whereas the sensors in most digital backs for Hasselblad are not larger than those in professional 35mm cameras, future digital backs for Hasselblad may very well have sensors that are considerably larger than the 24×36mm film size.

The present 37×37mm sensor is already considerably larger than those in 35mm cameras, and other digital backs with medium-format sensors seem to be on the way.

At this writing, two companies have announced digital backs with large 36×48mm sensors. These larger sensors can be used only in medium-format cameras. They cannot be built into cameras based on the 35mm camera design, equipped with lenses designed for covering the 24×36mm area only. With all these larger sensors, Hasselblad medium-format cameras will provide in digital imaging the same great benefit of a larger image with better image quality as they do now in film photography.

Some digital backs for medium-format cameras offer the multishot capability, which can also greatly improve image sharpness. In the normal one-shot mode, only 25% of the total pixels record red, only 25% record blue, and only 50% are used to record green. In the multishot mode, all of the pixels (100%) in the sensor record red, 100% of the pixels record blue, and 100% record the green image. A much larger number of pixels is used to record the image, thus producing better quality. Although multishot backs cannot be used for a moving subject, they offer the utmost digital image quality for still lifes, architectural work, product photography, and copying, where utmost image sharpness is a prime requirement.

LENSES FOR DIGITAL RECORDING

Some manufacturers of digital cameras emphasize that lenses for digital recording must have different quality requirements, must be designed to focus the light more directly to each pixel and that lenses designed for film recording do not provide the best or satisfactory quality especially on the edges of the image. While there is some truth to these facts, they apply only to specific sensor designs.

Practically all large camera sensors, 24 × 36 mm and larger, which includes the sensors in digital backs for Hasselblad cameras, are at present of the flat sensor type which show a slight loss of quality only with lights rays reach the sensor at an extreme angle of incidence. This is hardly the case on Hasselblad since the incident light angle is reduced due to the sensors not covering the entire 55 × 55 or 55 × 42 image area for which the lenses are designed. Even the 38mm Biogon has proven to produce excellent quality out to the corners on a 36 × 48mm sensor. All other Hasselblad wide angle lenses are of the retro focus design with an associated moderate incidence angle to the sensor corners. Keeping in mind that high resolution is the main requirement for digital lenses as it is for lenses for high quality film recording, we can state that all Hasselblad lenses in the V and H system are an excellent compromise for film and digital work.

EVALUATING THE TONAL RANGE AND EXPOSURE IN ELECTRONIC IMAGING

In electronic imaging with a digital back attached to Hasselblad cameras, you can evaluate exposure and the image in general on a computer monitor or the monitor on the digital back if the back is so equipped. You can do this at any time and so can make adjustments before you record the final image. This approach is somewhat similar to making a test exposure on instant film.

You can use a histogram to evaluate precisely and scientifically the distribution of the tonal values, in the image and in its exposure. This possibility exists when a digital back is attached to the H camera. To make the histogram appear on the LCD panel on the H camera grip, you program custom option 17, SHOW HISTOGRAM, into the camera, as described under Custom Options in Chapter 4. Programmed to YES (the default setting), the histogram appears on the LCD panel shortly after the exposure. It works with various digital backs, but the histogram may look slightly different depending on the back attached to the camera.

The Histogram

A histogram shows the distribution of the tonal values within an image. The values vary from the black shadow areas (shown at the far left) to the pure white highlight areas (shown at the far right), with the middle tones in

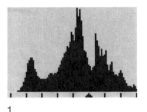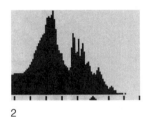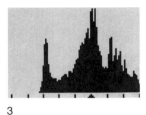

1 2 3

Figure 2-2 A histogram of a normal contrast scene with correct exposure (1), underexposure (2), and overexposure (3).

between. The horizontal spread covers the full potential dynamic range of the camera system. Photographers familiar with the zone system can think of a histogram as showing the tone values from zone 0 (black) on the left to zone 10 (white) on the right.

The vertical height of the curve indicates the number of pixels for each tonal value. A high curve indicates a large number of pixels for that particular tonal value. The histogram for a high-key image with few or any dark areas has curves mainly or completely toward the right, whereas most of the curves for a low-key image with few or any bright areas are mostly to the left. An image with an average tonal range from white to black has curves all the way from left to right.

Determining Exposure from the Histogram

The interpretation of the histogram is somewhat different for different digital backs, in part because different backs may report ISO values to the camera in different ways. In principle, however, regardless of the contrast range of the image, all the vertical curves must be within the left and right margin of the histogram—that is, within the maximum potential dynamic range (see Figure 2-2). They should never go beyond the left or right margin. If the curves go beyond the right margin, areas in the image will be totally white without any information, and the lens settings must be changed to make them fall within the left and right margin. If the curves go beyond the left margin, the black zone, parts of the image will be totally black, and you must change aperture or shutter speed (or both) accordingly.

The histogram does not show the exact amount of under- or overexposure, but the results of any corrections made in the aperture or shutter speed setting are clearly shown on the new histogram. Overexposure in digital recording must be avoided because details in the overexposed areas are completely lost. This should be remembered especially by photographers accustomed to working with negative films and leaning toward overexposure to obtain sufficient detail in the shaded areas.

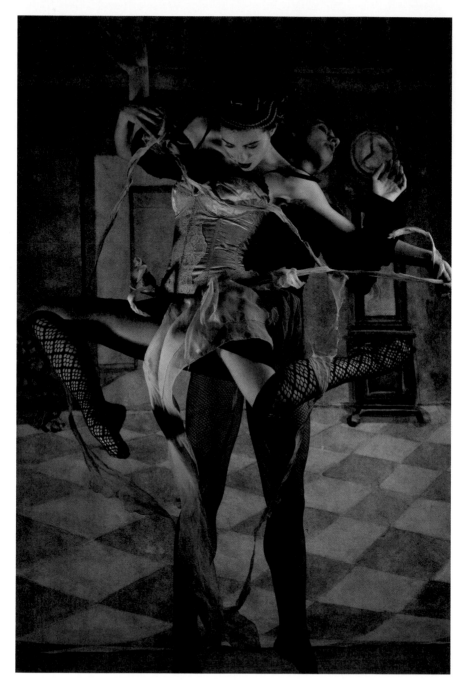

▲ A digital image of Todd Williams and Jimena Paz created
by Sarah Silver for Bellerophon Dance and published
first in the *New York Times*, May 2002. Stylist: Anne
Wlaysewski@R.J.BennettRepresents. Hair; Charles Ward.
Make-up: Aaron Bement

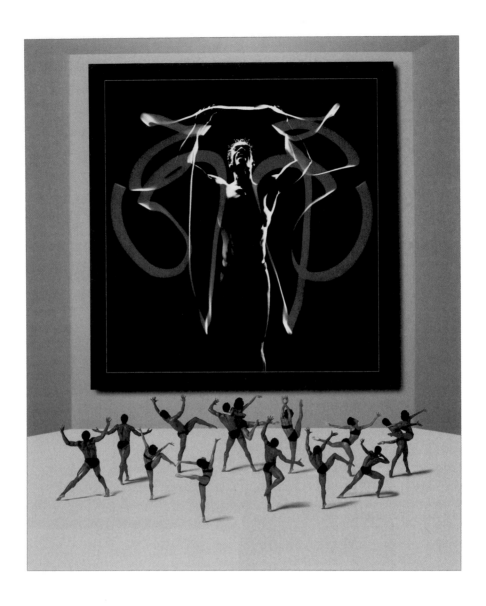

▲ Each dancer in the bottom part of the image was recorded individually and digitally with Hasselblad and was then combined with the top image also created with a digital back on a Hasselblad camera. Created for the Complexions Dance Company by Howard Schatz. Available as a Fine Art print. Schatz/Ornstein 2000 www.howardschatz.com

▲ A fashion illustration created digitally by Sarah Silver of model Anton Cobb and first published in *Reat This*, Oct 2002. Stylist Anton Cobb

▲ A digital image created for the Stephen Petronio Dance Company with a Sinarback attached to a Hasselblad 503 camera operated with wireless infrared remote release. Sarah Silver

3

The Hasselblad Camera Systems

HISTORY OF THE HASSELBLAD CAMERA

In 1948, the Hasselblad 1600F was unveiled as the world's first $2\frac{1}{4}$ single-lens reflex camera with interchangeable viewfinders, film magazines, and lenses. The 1600F had a focal plane shutter with speeds up to $\frac{1}{1600}$ second, and the lenses were Kodak Ektar.

In 1952, the 1600F model was superseded by the 1000F, which was identical in design but had shutter speeds only up to $\frac{1}{1000}$ second. The 1954 Photokina, held in Cologne, was used to introduce the Hasselblad Supreme Wide Angle camera, with a fixed 38mm $f/4.5$ Zeiss Biogon mounted in a Compur shutter. This camera was updated in 1959 and renamed the Superwide C, modified in 1980 to the SWCM, renamed the 903SWC in 1988, and renamed the 905SWC in 2001. The Superwide camera design is also available in a special version known as the MKWE for photogrammetric applications.

The next major step in the history of Hasselblad SLR cameras came in 1957, when the 500C model replaced the 1000F. The basic camera design and component interchangeability were kept, but in place of a focal plane shutter, a Compur shutter was built into each Carl Zeiss lens to allow electronic flash to be used at all shutter speeds up to $\frac{1}{500}$ second. The 500C was superseded by the 500CM in 1970, the 503CX in 1988, the 503CXi in 1994, and the current 503CW in 1997. A similar camera model appeared in 1989. Called Classic, this model became the 501C in 1994 and was changed to the current model 501CM in 1997.

The motor-driven camera model, the 500EL, appeared in 1965. The 500EL design formed the basis for the 500EL Data camera, specially produced for NASA. On July 20, 1969, the 500EL Data camera became the first still camera to take pictures on the surface of the moon. A camera based on the NASA data camera design is available as the MK70 model, used mainly for photogrammetric applications.

The 500EL became the 500ELM in 1970, the 500ELX in 1984, the 553ELX in 1988, and the current 555ELD in 1998.

In 1965, Hasselblad started the publication of the *Hasselblad Magazine*, known today as the *Forum*.

Hasselblad history continued with the introduction of major products as follows:

1977 Schneider Variogon C 140–280mm zoom lens (changed to CF type in 1988). The 2000FC focal plane shutter camera and four F lenses without shutters, including a 50mm Distagon with floating lens element design. The 2000FC model was superseded in 1982 by the 2000FC/M, in 1984 by the 2000FCW, and in 1988 by the 2003FCW.

1982 PCP 80 slide projector. C shutter lenses changed to CF types.

1985 First 2× teleconverter made by Zeiss. Changed to a Hasselblad 2XE converter in 1994 and complemented with a 1.4XE converter in 1996.

1990 PC Mutar with shift capability. Hasselblad ProFlash, replaced in 1996 by the D Flash 40.

1991 205TCC camera with TCC lenses and TCC film magazines. ("TCC" stands for "tone and contrast control.") The 205TCC was renamed the 205FCC, and TCC lenses were renamed FE in 1995.

1994 203FE camera and 201F focal plane shutter camera without metering system.

1995 FlexBody, complemented in 1997 by ArcBody with three special Rodenstock lenses.

1997 PME 90 meter prism finder. CB lenses and the 350mm CFE Tele-Superachromat, the first CFE lens type.

1998 202FA camera. XPan camera with 45mm and 90mm lenses. 30mm lens added in 1999. Hasselblad FE VarioSonnar 60–120 zoom lens and CFi lenses replacing the CF types.

1999 300mm *f*/2.8 lens and teleconverter.

2000 PME45 meter prism viewfinder.

2002 Hasselblad H1 camera system and three fixed focal length HC lenses of 35mm, 80mm, and 150mm focal length, a 50–110mm HC zoom lens, and 1.7× teleconverter

2003 Introduction of XPan II dual-format camera and three additional HC lenses of 50mm, 210mm, and 120mm focal length for the H camera.

Discontinued Items

This manual includes descriptions of items mentioned as "being discontinued" or "no longer made." Some of these recently discontinued cameras, lenses, or accessories may still be available new from some camera dealers and certainly can be located on the used camera market.

THE HASSELBLAD CAMERA SYSTEMS

In 2002, the Hasselblad camera system was reclassified, and the various camera models were grouped into three systems: the H system, the V system, and the X system.

The Hasselblad H Camera System

At Photokina 2002, Hasselblad introduced the H1 camera, a modern medium-format camera with a versatile built-in metering system, motor drive, incredibly fast and accurate automatic focusing, and lens shutters synchronized up to $\frac{1}{800}$ second for flash. The H1 also includes a full complement of sophisticated electronic and mechanical features that let you customize the camera operation to your personal approach to photography, whether you work with film or work digitally.

The designation H stands for Hasselblad and handheld. To produce a compact, medium-format camera with mechanical and electronic sophistication and at the same time allow medium-format photography with the speed and convenience of 35mm, Hasselblad created a completely new camera design rather than basing the camera on the existing system. To keep the new camera and lenses compact and convenient for handheld operation like a 35mm, the H1, along with future camera models in this line, is made for the 6 × 4.5cm rectangular image format.

The H1 is the first Hasselblad camera since 1957 that does not offer component interchangeability with the existing 500 and 200 series cameras. The tripod coupling can be used, but the new version is more practical and is recommended for use with the H camera. The new tripod coupling has two spirit levels, so you can level the camera whether it is set up for horizontal or vertical pictures. The new design also makes removing the film magazines easier. An adapter is available that allows using CF, CFi, CFE, and CB lenses on the H1. However, the aperture, shutter speed, and focus settings must then be made manually; and exposure readings must be made with the aperture manually closed down. This operation greatly reduces the benefits of the H1 operating features. However, the adapter can be helpful for using lenses such as the 30mm Distagon Fisheye or very long telephotos, which are not yet made for the H1 system.

Because the H1 camera is made in cooperation with the Fuji Photo Film Co., the H1 lenses are made by Fuji. The lenses are made to the same standards and precision as those produced by Carl Zeiss, and their quality is constantly controlled and verified by Hasselblad. The lenses of the H1 system therefore provide the photographer with the ultimate image quality in the 6 × 4.5cm image format as well as in digital recording.

The H system camera was not introduced to replace the cameras in the existing system but rather to give the photographer an even wider choice of Hasselblad camera models designed for either the square or the rectangular image format.

The Hasselblad V Camera System

The V system comprises all the Hasselblad camera models existing up to 2002 and having component interchangeability. The V stands for Victor and versa-

tility. The V system line of cameras includes all the 500 models, all the motor-driven EL models, the Superwide cameras, the FlexBody and ArcBody, all the 200 models with focal plane shutter, and the discontinued cameras from the 2000 series. New and modified models in the 500, the EL, and the 200 series may also appear in the future and will become part of the V system.

The V system cameras are completely mechanical and battery independent. Batteries are used in the 200 series for the metering system and in the EL models for the film transport. The V system offers the widest choice of lenses, viewfinders, and accessories; and they are still superb cameras, especially for controlled photography, for studio work, and for photography from a tripod. Furthermore, the 200 series cameras can be used with larger aperture lenses, feature a beautiful built-in metering system, and provide shutter speeds up to $\frac{1}{2000}$ second (but are flash synchronized only up to $\frac{1}{90}$ second, unless a shutter lens is used on the camera).

The V system cameras also let you record the images in the 6 × 6cm square or in the 6 × 4.5cm rectangular format by using special magazines or a mask in the camera.

The Hasselblad X Camera System

The Hasselblad X system includes the XPan cameras, lenses, and accessories. The Hasselblad XPan camera was developed in cooperation with Fuji Photo Film Co. and involves a camera concept completely different from that of any other Hasselblad camera. There is no component or lens interchangeability between the XPan and any of the other Hasselblad camera systems.

The XPan is shaped like a 35mm camera, and the pictures are made on standard 35mm film in standard cassettes with 36, 24, or 12 exposures. The uniqueness of this camera is in the dual-format camera concept, which can be considered a combination of 35mm and medium-format photography. The images on the 35mm film can be made in the standard 24mm × 36mm size or in a 24mm × 65mm panoramic format, which is longer than the side of a $2\frac{1}{4}$ square or 6 × 4.5 medium-format image. You obtain 21 panoramic images on a 36-exposure roll, 13 on the 24-exposure type, and 6 on a roll made for 12 exposures. You change the format using a simple turn of a knob, which automatically adjusts the viewfinder image and the frame counter in the camera. You can produce images of both formats on the same roll of film; the number of images per roll then depends on the ratio between regular and panoramic types.

SELECTING THE SHUTTER TYPE AND FILM ADVANCE

You can select a camera model based on the image or camera size, on the features of the camera (especially the type of shutter that produces the images on the film or electronic sensor), or on the way the film is advanced.

Cameras have either focal plane shutters in the camera or shutters in the lenses. Most Hasselblad 200 camera models give you the choice of using either one.

Focal Plane Shutters

All Hasselblad cameras in the 200 series, the discontinued 2000 and 2003 models, and the XPan have focal plane shutters, with the shutter speed controlled electronically. Although the actual movement of the shutter is mechanical, this type of shutter involves fewer mechanical components, especially those that need lubrication, than does a lens shutter. Focal plane shutters can provide short shutter speeds up to $\frac{1}{1000}$ second on the XPan and up to $\frac{1}{2000}$ second on the medium-format models.

A focal plane shutter scans the film area from side to side or top to bottom (see Figures 3-1, 3-2, and 3-3). As a result, different areas of the film are exposed to light at different times. The flash must fire when the shutter is open over the entire image area; otherwise, only part of the area is exposed. Flash pictures must be made at slower speeds. The top shutter speed for flash is $\frac{1}{125}$ second on the XPan and $\frac{1}{90}$ second on the other Hasselblad focal plane shutter models. These cameras have a built-in system to warn you or prevent you from inadvertently taking flash pictures at higher shutter speeds.

Figure 3-1 When the focal plane shutter is used, the film is exposed progressively by a slit that moves across the image area. **1.** The shutter curtains are closed. **2.** The first shutter curtain moves, creating a slit that begins the exposure. **3.** The second shutter curtain follows the first. **4.** The shutter is closed.

Figure 3-2 At longer shutter speeds, the second shutter curtain begins to move only after the first has reached the other side. Flash synchronization is possible at the moment when the entire image area is uncovered (3).

Figure 3-3 Focal plane shutters can distort images of moving subjects because the recording of the subject is progressive rather than instantaneous. A subject moving in the same direction as the shutter may appear elongated, whereas one moving in the opposite direction may appear shortened.

Figure 3-4 With a lens shutter, the entire film area is exposed from the moment the shutter opens until it closes.

Lens Shutters

The other type of shutter is in the lens, sometimes called a central shutter, giving the designation C to such lenses in the Hasselblad V system. Shutter blades open and close at the set speed, exposing the entire film area at the same time (see Figure 3-4). Flash pictures can be made at all shutter speeds.

A lens shutter must be positioned at a specific point within the optical design of the lens where it produces an image that is equally exposed (except for the common loss of light due to the optical design of the lens) from the center to the corners, even though the shutter blades open from the center and close again toward the center. With a lens shutter, exposures vary slightly depending on whether the images are made with the lens aperture wide open or closed. The variations are within acceptable limits for general photography. The H1 camera, however, can be programmed for "true exposures," producing images with perfectly even exposures regardless of the aperture setting.

Lens shutters, with the shutter blades moving around the optical center, provide the smoothest and quietest shutter operation with the minimum of camera motion or vibrations. The maximum shutter speed, however, is limited to $\frac{1}{800}$ second on the H1 and $\frac{1}{500}$ second on the other lenses. Shutter speeds can be controlled mechanically or electronically. Mechanically controlled

speeds are accurate but only if the shutters are in perfect condition and properly lubricated. The shutter slows down when lubricants are old or when you are working in cold temperatures. Shutter lenses should therefore be cleaned and lubricated at regular intervals depending on frequency of use.

Manual or Motor-Driven Film Advance

On the Hasselblad H1, the XPan camera, and all EL models, the film is advanced automatically via a built-in electric motor. The built-in motor and the necessary batteries add weight to the cameras, and that is the main difference between the EL cameras and the other models in the 500 series. The H1 and XPan cameras are so beautifully designed for handheld work that the additional weight is never considered objectionable.

On all the other models in the Hasselblad V line, the film is advanced, and the shutter is cocked manually by a single turn of a knob or crank. On the 503CXi and 503CW, on all the 200 models, and on some of the discontinued 2000 cameras, a motor winder can be attached in place of the winding crank, thus giving you the option of advancing the film manually or automatically.

The Advantages of Motorized Film Transport

Camera operation, which is now reduced to pressing the release, can be done with one hand. One-handed operation is useful when the other hand may have to be used for directing models or for holding the camera, a flash, or another accessory. Automatic electric film advance is smooth, with little danger that a tripod-mounted camera will move out of position between shots. It is especially helpful in copying, product, and close-up photography.

Sequence operation (shooting pictures continuously during a single press of the shutter release) is another advantage, especially in sport and action photography. Its application, however, depends on the speed capability (the speed at which pictures can be taken). The fastest speed with any motor-driven V system Hasselblad is about 12 pictures in 9 seconds, or a little faster than one picture per second, and 2 pictures per second on the H1 model. This may be somewhat limited in sports photography, but it is sufficient for sequence shots in most other fields and is almost ideal for fashion work.

For most photographers the benefits of a motor-driven camera are simply in the fact that you can make a second and subsequent pictures without ever removing your eye from the viewfinder. You maintain complete visual contact with your subject, a main reason motor drives are used in most fashion work and in child and animal photography. When you photograph people, especially children, the best expression often appears just after a picture is snapped. This expression lasts for a moment only, never long enough to capture it with manual film advance but long enough for a second push on the release of the motor-driven camera.

Motor-driven cameras also present the possibility of remote releasing. You no longer need to stand behind the camera. You can be close to the subject, watch expressions closely, play with a child, and snap the shutter when everything is right. Wireless remote releasing is possible on the H1, the 555ELD, and the 503 cameras equipped with motor winder. Other EL models can be released with remote release cords.

HOLDING AND SUPPORTING THE CAMERA

Before you take a picture with any Hasselblad camera, you must decide whether to work handheld or place the camera on a support. All Hasselblad camera models are ideally suited for both approaches. The V models perhaps have a slight edge for tripod use because they need not be turned and they provide a wide range of viewfinders, whereas the H1, being operated like a 35mm camera, is an exceptionally beautiful tool for handheld work.

Handheld Photography

All Hasselblad models can be used handheld and, I believe, can be held as steadily as 35mm cameras. Find your own best method for holding the camera (see Figure 3-5). No matter how you hold the camera, you need a firm foundation. Stand with your feet apart, and press your elbows into your body for additional bracing. Press the viewfinder eyepiece toward your eye and

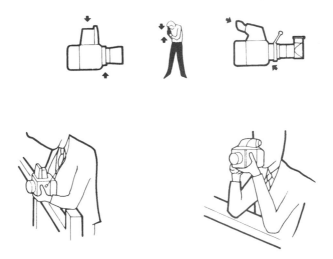

Figure 3-5 *Handheld photography* The best camera steadiness is obtained when two forces work against each other. With the standard finder and magnifying hood, the hands press the camera upward and the eye pushes it downward. With the 45-degree prism finder, the two forces work diagonally. Whenever possible, try to find natural supports for elbows, such as a fence or a wall.

forehead. This creates two opposing forces: the hands pressing the camera toward the eye, and the eye and forehead pressing in the opposite direction. This suggestion applies regardless of the viewfinder on your camera. With the standard or the magnifying hood, push the camera upward with your hands, and use your head to push it down. With the prism finders, do the same but in a diagonal or horizontal fashion.

To reduce the danger of camera motion blurring the picture, shutter speeds must be relatively short. How short depends on many factors, including the photographer's own steadiness, the weather (whether it is windy or calm), and the focal length of the lens on the camera. The longer the focal length, the shorter the recommended speed.

A common rule is that the shutter speed should not be longer than the inverse of the focal length: $\frac{1}{60}$ second for a 60mm lens, $\frac{1}{250}$ second for a 250mm lens. It is a good rule to follow in most situations. I can use somewhat longer speeds in many situations and have photographed at $\frac{1}{30}$ and even $\frac{1}{20}$ second with the 80mm lens on the H1 camera and have found the image sharpness completely up to my expectations.

The main limitation of handheld photography to me is in the limited choice of apertures. Because shutter speeds must be short, the existing light may not be sufficient to photograph at small apertures that provide the desired depth of field. This is the main reason I always carry a small tripod, even for outdoor photography in good light. It allows me to use any desired aperture and shutter speed combination.

Consider handheld camera use also for selecting the best camera angle, even if you plan to use a tripod for the final picture. Move around the subject with the handheld camera; view the scene or subject from every angle, from different distances, through different lenses; go down on the ground and view it from below; go as high as possible and look down. Set up the tripod, and place the camera on it only after you have exhausted all possibilities and have found the most effective camera position.

When shutter speeds become too long for steady handheld photography, some kind of support is necessary. Before rushing to select a mechanical camera support, investigate other methods, such as leaning the body, head, or camera against a wall, post, or tree, or resting the camera or your elbows on a table, car, fence, the ground, or any other suitable surface. Rather than place the camera directly on the surface, try a bean bag, which shapes itself to the contours of the camera, making it more difficult to move the camera. For low camera angles, lie on the ground and use your elbows as a support.

Camera Grips and Handles

Brackets or grips can be attached to some Hasselblad camera models. Whether you use a grip or bracket or put your hands directly on the camera body must be your personal decision. Try these accessories to form your own opinion. Grips or brackets do not ensure a steadier camera in handheld work,

but they make carrying the camera much more convenient. This is especially true if you work with a handheld camera for long periods, as in wedding photography.

A built-in or detachable motor winder can serve as a wonderful camera grip, especially in the H1 camera. The 503CW motor winder is also designed with a carrying strap for convenient carrying and handheld photography. The motor winder for the focal plane shutter cameras, however, is not designed for carrying the camera between shots.

SELECTING AND USING A TRIPOD

Reasons for Using a Tripod

Camera steadiness (see Figure 3-6) is not the only reason for using a tripod. With a mounted camera, you probably spend more time in evaluating the image and are more critical in composing the scene or subject in the camera. Furthermore, after the composition is made and the lens is focused, you no longer need to look on the focusing screen. You can look directly at the subject, something that is extremely valuable when you're photographing people. It allows you to communicate more directly with your subjects. A mounted camera also leaves one arm free for directing people or holding a flash, and it allows you to take several identical images.

Selecting a Tripod

The first thing to ascertain when you choose a tripod is how steadily it holds the camera. From this point of view you cannot go wrong in selecting and

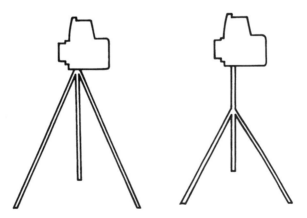

Figure 3-6 *Tripod use* A camera is steadiest when it rests directly on the three legs of the tripod. The center post should be extended only for minor adjustments in the camera height, not to extend the tripod height.

using the largest, heaviest studio model for all work. Do so if the tripod stays in your studio or home. Most tripods, however, are also taken into the field, so there must be a compromise between steadiness and portability.

In addition to being a solid stand, a tripod must be designed for fast, convenient operation so that it is a pleasure rather than a nuisance to work with. Camera operating convenience is determined mainly by the tripod head. I prefer ballheads. To turn the camera or tilt it sideways or up and down, you need to tighten or loosen only one knob.

Preventing camera shake during exposure is less a function of tripod size and design than of how you operate the camera. Hasselblad cameras have shutter and mirror motions that are exceptionally well dampened to reduce, if not eliminate, camera motion. It is nevertheless only logical to use the prerelease.

Operating the Tripod-Mounted Camera

There are two theories of working with a tripod. In the "free standing" theory, the photographer stands away from the tripod, avoiding any body contact with the tripod or camera. The shutter is released with a cable or remote release. Camera steadiness is completely dependent on the tripod. This approach must be used when exposure times are longer than $\frac{1}{2}$ or 1 second.

In the other method, either both hands are on the camera or one hand is on the camera and the other on the tripod, with both pressing the tripod and camera toward the ground. It is almost like handheld photography but with the tripod serving as an additional support. The shutter can be released with or without a cable release. If carefully done, direct releasing is just as good. The tripod/body combination works beautifully and can produce absolutely sharp results even with lightweight tripods.

Monopods

Monopods can be excellent for location work when exposure times do not exceed $\frac{1}{4}$ second. Properly used, the camera can be as steady as on a tripod. This is best accomplished when the monopod is arranged so that it becomes a third tilted tripod leg with your own legs being the other two (see Figure 3-7). Move the bottom of its leg about two to three feet forward, press your eye to the viewfinder, and use your hands to press the monopod toward the ground. Attach a ballhead to the top.

Tripod Coupling

I highly recommend using a tripod coupling on a tripod, monopod, or any other camera stand (see Figure 3-8). Not only does this make it fast and convenient to attach and remove the camera, but also it avoids possible damage

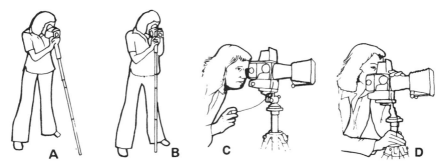

Figure 3-7 *Using monopods and tripods* **A.** The steadiest position for a monopod is when it forms the third leg of a tripod, with the photographer's spread legs being the other two. The face is firmly pushed against the camera. **B.** In this position, the camera can hardly move in any direction, which is not the case when the monopod is vertical. **C.** When exposure times exceed $\frac{1}{2}$ second, the body and hands should not be in contact with the camera. **D.** At shorter shutter speeds, you can prevent camera motion by pressing the camera and tripod firmly toward the ground with the hands and face.

Figure 3-8 *Tripod couplings and brackets* **1.** The Hasselblad flash gun brackets make carrying the V system cameras very convenient. A flash unit can be attached directly to the top of the grip or with accessories so that the flash head is above the camera lens. **2.** With a Hasselblad tripod quick coupling permanently attached to the tripod head, you can slide the camera onto the accessory and lock it into place by turning the lever. The latest tripod couplings also have built-in spirit levels.

to the camera. Some tripod screws are long, and they could possibly be forced into a camera body, causing extensive damage to the inside components.

The Hasselblad tripod coupling is attached to the tripod and left there as part of the tripod. The camera slides into the adapter plate, where it is held by a snap lock; in addition, it is locked with a locking lever. To remove the camera, you move the locking lever and press the snap lock lever. The camera slides right out.

Newer tripod couplings have built-in spirit levels for accurate leveling of a camera.

CAMERA CASES

Consider camera cases not only for carrying cameras, lenses, and accessories but also as an aid to producing better photographs quickly and conveniently. Select a case that lets you store each item in a specific place so that you can find the needed item instantly. Try to find a case that holds the items that you use most often. If you normally work with a prism viewfinder, for example, select a case that holds the camera with the attached finder, lens, and magazine. It is also advantageous to be able to leave a lens shade on the lens. Most modern cases give you this option via removable partitions.

There are two styles of carrying cases: the shoulder case type and the suitcase type. The latter is more awkward to open, but it can hold more items in a more orderly fashion. Suitcase types are ideal for transporting equipment in a car or plane.

In a shoulder case, the camera is lodged so that you can remove it while the case is hanging over your shoulder. The advantage is that you can hang the camera around your neck, ready to snap a picture, while the case with the rest of the equipment is hanging from your shoulder.

Backpack types have also become popular, especially with photographers who move around. Backpack cases make carrying equipment, especially heavy equipment, more practical and photography more enjoyable.

▲ A medium format Hasselblad allows a portrait or celebrity photographer to use the same camera for studio work as well as for location celebrity photography. Jonathan Exley

▲ Jonathan Exley used the Hasselblad with an 80mm lens
 for this striking location celebrity portrait

▲ A celebrity portrait by Jonathan Exley

▲ A handheld Hasselblad provides the speed and
convenience necessary to capture actions that may
happen on a market place in Mexico and may last for a
fraction of a second only. *Ernst Wildi*

4

The Hasselblad H Camera System

THE H CAMERA SYSTEM CONCEPT

You don't need to learn much about the Hasselblad H camera and its operation to take pictures with superb image quality and excellent exposures, with or without flash. Load the camera with a roll of film, and it winds automatically to frame 1. If the film is bar-coded, its ISO rating and its length (120 or 220) are automatically programmed into the camera. Set the camera for automatic focusing and the desired metering mode; center-weighted is my suggestion for general photography. Set the camera for Programmed Exposure mode, where the camera selects the aperture and shutter speed that are considered best for that particular picture. Compose the picture, and press the shutter release. The film winds automatically to the next frame and also automatically winds up the paper trailer at the end of the roll.

If, on the other hand, you want to control how each image is recorded in the camera, the H1 camera gives you complete control over every step in the process and does so in a simple, sophisticated fashion that will likely add enjoyment and fascination to your photographic hobby or profession. You can select your preferred metering and focusing modes that provide perfect exposures and maximum image sharpness for any subject and lighting situation. You can let the camera imprint important and valuable information on every image on the film.

You can also program into the camera an almost unlimited number of functions and operations that can simplify your photography, customize the camera operation for your photography, and memorize what you are trying to accomplish. With the H camera you need not match your photographic approach to what the camera can do. Instead, you program the H camera operations for the way you like to work and for the results you are trying to achieve. The images that come out of the H camera will satisfy you even more when you evaluate the sharpness and effectiveness that only the medium format can provide.

Rather than repeat all the operational details that are in the instruction manual, I will concentrate on explaining in detail how the H camera and its features should be used to produce the best possible pictures in the simplest

fashion. I suggest that you keep the instruction manual handy in case you have to refer to it while photographing.

The Hasselblad H camera system includes the H1 camera model, lenses, and accessories. Although there are no plans for other H camera models, the possibility certainly exists that such models with modified functions may appear in the future. Keeping this possibility in mind, I refer in this book to the H1 camera simply as the H camera model. Figure 4-1 shows the H1 camera and its controls.

REMOVING THE BOTTOM PLATE

The H cameras delivered from the factory have a plastic bottom plate with rounded, rubber-covered corners that makes for pleasant holding of the camera. The plate can be left on the camera if used exclusively for handheld photography. It needs to be removed for mounting the camera on a tripod or stand. To do so, lift the little rectangular portion in the center (with a screw driver or similar tool) and push the plate forward (toward the front of the camera). This requires a little effort. Tapping the rear of the plate with a little hammer may help.

BATTERY OPERATION

The H camera is powered by three CR-123 lithium (or equivalent) batteries, which are located in the camera grip. You insert or change the batteries by pressing the Battery Holder button on the battery holder and pulling the battery holder downward while swinging the battery holder retaining lever down. The battery cassette is released by pressing the red button. To slide the battery cassette back into the grip, align the two upper lugs with the slot in the grip.

Battery life depends on many factors, especially how long the camera is left in the active mode, and therefore cannot be predicted. A low-battery charge is indicated by a battery symbol on the LCD display on the grip and in the viewfinder. When the batteries are almost completely exhausted, a LOW BATTERY warning message appears on the screen, and the camera no longer functions. You need to change batteries. Because camera operation is completely dependent on batteries, you should always carry a backup set.

Removing or changing the battery does not erase any functions programmed and saved into the camera. The memory in the H camera does not need the power from the battery to store such data. Unsaved data, however, will be lost. Aperture and shutter speed are not saved and will revert to the default settings of $f/5.6$ and $\frac{1}{125}$ second when the battery is removed.

A battery pack for rechargeable cells, called Battery Grip Rechargeable 9.6V, is available as an accessory. It replaces the standard battery cassette.

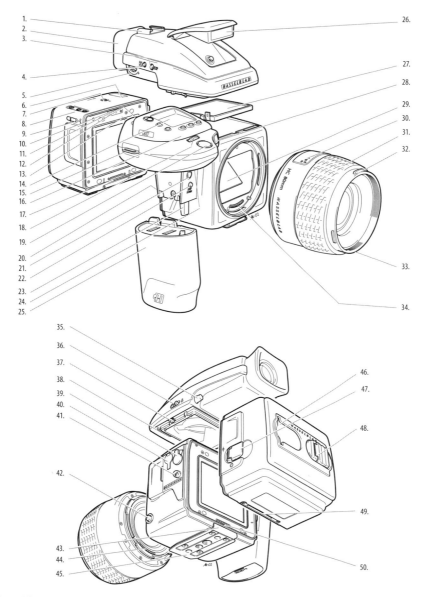

Figure 4-1 The H1 camera and camera controls. Note that controls 10, 11, and 12 are at the rear of the grip and are not visible in illustration.

1. Flash unit hot shoe
2. Rubber eyecup
3. Exposure Mode and Metering Mode selector button
4. Exposure Compensation button
5. Eyepiece adjustment dial
6. Magazine LCD
7. LCD illumination button
8. Magazine control buttons
9. Magazine settings lock
10. AE-L button
11. Film Wind-Off button
12. User button
13. Rear control wheel
14. Grip LCD
15. Support strap lug
16. Camera control buttons

17. Magazine Databus
18. Front control wheel
19. Shutter Release button
20. Battery Holder button
21. Release cord socket
22. Stop Down button
23. Battery holder retaining lever
24. Mirror Up button
25. Battery holder
26. Flash unit
27. Viewfinder screen
28. Focus assist light
29. Mirror
30. Distance and depth-of-field scales
31. Focusing ring
32. Lens shade bayonet
33. Filter screw thread

34. Databus connection
35. Viewfinder Release button
36. Flash unit catch
37. Viewfinder attachment hook
38. Viewfinder Databus connection
39. Magazine Release button
40. Flash PC socket
41. Camera strap lug
42. Lens Release button
43. Magazine support
44. Databus connection
45. Quick coupling tripod plate
46. Film tab holder
47. Magazine darkslide key
48. Film holder key
49. Magazine support groove
50. Databus connection

A rechargeable pack can perhaps be recommended for high-volume shooting.

ATTACHING AND REMOVING LENSES

To attach a lens to the camera body, align the red index on the rear lens mount with the red index on the camera body; then turn the lens approximately one-quarter turn until it clicks into position. To remove lenses, press the Lens Release button (item 42 in Figure 4-1) on the side of the camera, and turn the lens in the opposite direction. When removing or attaching lenses, always grip the lenses by the metal lens barrel, not by the rubber focusing ring. Because there is no mechanical connection between camera and lens, lenses can be removed or attached at any time.

The electronic Databus connections between camera body and lenses should never be touched with the fingers and must be kept clean. It is therefore recommended that you attach rear covers to detached lenses and place a front cover on the camera body if it is stored without a lens attached.

Chapter 14, Characteristics and Use of Lenses on All Camera Models, has a detailed discussion of lens design, lens characteristics, lens quality, and the proper selection, effective use, and operation of various HC focal length lenses for creating images of the highest quality. Close-up photography and the use of close-up accessories on the H camera are discussed in Chapter 18.

ATTACHING, REMOVING, AND ADJUSTING VIEWFINDERS

Because you must turn the H camera to take vertical pictures, you must view from behind the camera, especially when photographing handheld. The H camera therefore comes equipped with an eye-level viewfinder with a 2.7 × magnification shown in Figure 4-2. Other viewfinders that may be better suited for more controlled photography from a tripod are likely to become available.

The Acute Matte focusing screen, with the indicated spot meter and automatic focusing areas, shows 100% of the image recorded on the film. An accessory screen, with lines for precise alignment of vertical or horizontal subjects, is available.

Because the camera's metering system is in the viewfinder, the finders have electronic Databus connections at the bottom to transfer data from the camera to the finder and vice versa. The viewfinders have two Exposure Control buttons on the side of the camera grip for setting the light-metering mode and for setting exposure compensations.

You can attach or remove viewfinders from the camera without removing the film magazine or lenses. To remove a finder, press the Viewfinder

Figure 4-2 *Viewfinder controls* From left to right in top illustration: The diopter adjustment wheel, the Exposure Adjustment button, and the Exposure Mode/Light-Metering Mode button. The bottom illustration shows the button for the flash unit. The finder release lock is to the right.

Release button (item 35 in Figure 4-1), and lift the finder upward. To attach a finder, hold the finder at a slight angle and slide it forward and downward until it clicks into position.

The viewfinder is designed so that you can see the entire focusing screen with or without eyeglasses. The longer rubber eyecup is most practical for viewing without glasses. A shorter one is available for viewing with glasses. More details about viewing with or without glasses are found in Chapter 11, V System Viewfinders and Focusing Screens.

Adjusting the Eyepiece Diopter Correction

The viewfinder has a built-in eyepiece correction that can be adjusted over a wide diopter range from −4 to +2.5. This range should allow any photographer to see a sharp image of the focusing screen.

Before using the viewfinder, you should adjust the finder for your eyesight. To do so, it is best, but not necessary, to remove the lens from the camera, and then turn the eyepiece adjustment control (item 5 in Figure 4-1) on the side of the finder until you see the spot meter and focusing indications on the screen very sharply. Make this adjustment with or without glasses, depending on how you plan to do the viewing. If you make this

adjustment with a lens on the camera, make certain that you adjust the diopter correction for a sharp image of the screen markings, not of the image itself. After the first adjustment, move your eye away from the finder, look at something in the distance for a few seconds to relax your eye, and then view through the finder again to see whether the image is still sharp. If it is not, make a new adjustment and repeat the process.

FILM MAGAZINES AND FILM LOADING

The H Film Magazine

Only one type of rollfilm magazine, the HM16–32, is needed and available for the camera. Designing the camera specifically and only for the 6 × 4.5cm format eliminated the need for different format-type magazines. Furthermore, you can use one and the same magazine for 120 and 220 rollfilm without any need for a manual adjustment. When you use bar-coded films, the pressure plate in the magazine automatically adjusts for the different thickness of 120 film with paper and 220 film without. This automatic adjustment in the film transport ensures that you obtain images with the very best image sharpness

Figure 4-3 *The magazine controls* **1.** You illuminate the magazine LCD display on the left by pressing the illumination button (the one with the light bulb icon). The function selector is at the bottom right, with the up/down controls above it. **2.** The rear view of the magazine shows the film tab holder on the left and the film holder key on the right. The magazine settings lock is in the illustration on the right.

no matter which film you use. Images made in H film magazines still show the Hasselblad trademark—the two typical notches—on the border of every image.

With this automatic pressure plate adjustment, there is no need to match each insert to a specific magazine shell, as is the case in the V system. The H design also gives you the opportunity to buy either additional complete film magazines or additional film inserts. The latter approach is just as good if you use the same type of film for most or all of your photography and you find no need to change to a different type of film in the middle of a roll. If you frequently work with two different films, I suggest buying at least two magazines and the desired number of inserts. This approach allows you to switch film without making any adjustments. With two or more magazines, you can also change film with almost no delay.

In addition to the normal 120 and 220 films, there is a half-length 120 film for 8 exposures available in Japan. This film can also be used in the H camera.

Removing and Attaching the H Film Magazines

The H film magazines have a built-in darkslide curtain, which can be manually closed and opened by turning the magazine darkslide key (item 47 in Figure 4-1) (Figure 4-4). The darkslide curtain is closed, covering the film area, when the dot on the darkslide key points toward the closed mouth symbol and the darkslide indicator below the key shows red. The darkslide curtain is open when the dot on the key points toward the open mouth symbol and

Figure 4-4 1. The side view of the magazine shows the darkslide key with the darkslide indicator below. **2.** When removing the magazine, press the lower round part of the lever first toward the camera. Keeping it pressed, turn the upper part of the lever toward the magazine.

the signal is white. As with all Hasselblad cameras, the magazine can be removed only when the signal is red (curtain closed), and pictures can be taken only when the signal is white. A warning, THE DARKSLIDE IS CLOSED, appears on the grip display and in the viewfinder if you try to take pictures with the curtain closed.

The darkslide curtain cannot be opened if the magazine is detached from the camera because this would expose the film in the magazine to light. A pin on the camera body unlocks the curtain so that it can be opened when the magazine is attached to the camera body.

To remove the magazine from the camera body, turn the Magazine Release button (item 39 in Figure 4-1) on the camera body to the right, at the same time pressing the center of the circular button toward the camera body. Make certain that you press the central round part of the lever (not the top of the lever) toward the camera body.

You attach a magazine by simply placing the magazine support groove (item 49 in Figure 4-1) into the support and pressing the magazine toward the camera body. As with all Databus connections, do not touch it with your fingers. Keep it clean by placing the protective cover on the magazine and camera body when the two are detached. The rear of the H camera body has a curtain to protect the film in the magazine from being exposed to light before and after the exposure is made. It opens—moves sideways—when the release is pressed.

Magazine Settings

The film data programmed into the film magazine and shown on the display are transferred electronically into the camera system. The necessary power for setting and maintaining the magazine programming functions comes from the batteries in the camera when the magazine is attached to the camera. When the magazine is detached from the camera, the data are retained by the power from a small CR 2032 3V lithium battery located in the bottom plate of the magazine; you can see the battery cover after removing the film insert. To change the battery, insert a small coin into the battery cover and turn about 20 degrees counterclockwise.

A battery should last one to two years depending on use, especially to what extent the magazine is on and off the camera and the frequency in which the display illumination is used. Because the power to an attached magazine comes from the camera, the magazine works properly even if the magazine battery is dead. The data programmed into the magazine, however, are not retained when the magazine is removed from the camera. Figure 4-3 shows the magazine programming controls.

Programming the Magazine Settings

Bar-coded films are available only from Fuji and are clearly marked as Bar Code System, B, or EL (for Easy Loading). With these films, no settings need

to be made on the magazine. The bar code automatically tells the magazine whether it is 120 or 220 film and what sensitivity it has. The bar-code symbol also appears on the LCD display on the magazine. To use the bar code and automatic setting of film speed and length, the magazine must be set to Bar Code mode, which is indicated by a small B symbol on the magazine LCD (see Figure 4-5).

If you use films that do not have the bar code, you must program the type (120 or 220) and the film sensitivity into the magazine. Follow these steps:

1. Move the settings lock switch (item 9 in Figure 4-1) on the side of the magazine to the unlocked position—that is, toward the camera—covering up the white area.
2. Repeatedly press the Function Selector button, which displays the functions FILM SPEED, FILM LENGTH, DATA, and FRAME COUNTER. Press the button repeatedly until the desired menu (Film Speed ISO value, Film Length 120 or 220 film) shows on the magazine's LCD panel.
3. Set the correct values for each menu by pressing either the Up-Change button or Down-Change button until the desired values show on the magazine LCD panel.
4. After the settings are made, lock them by setting the lock control (item 9 in Figure 4-1) in the direction of the arrow, away from the camera body so that the white area is visible. The locking button is also marked with a key symbol and an arrow, which might help you to remember that you lock the settings by turning the key in the direction of the arrow, moving the lever in the same direction. To illuminate the panel, press the illumination button on the magazine. If the magazine is attached to the camera, the LCD is illuminated when the illumination button on the camera is pressed.

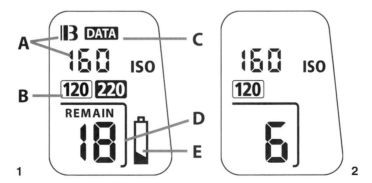

Figure 4-5 *Magazine LCD display* **1.** A. Film sensitivity and bar code. B. Film length. C. Data must be set to ON if imprinting is desired. D. Frame counter. If REMAIN is set to ON, the frame counter shows the remaining number of exposures. E. Low battery symbol. **2.** Example of display with film length and sensitivity set manually. Five frames have been exposed, and the battery is in good condition.

You can program the camera so that the ISO value shows or does not show on the grip display. This option is discussed under custom option 21 later in this chapter in the section titled The Custom Options. I prefer seeing the ISO value on the display, at least when working with non-bar-coded films, just to be certain that the settings have not changed accidentally for some reason.

Setting the Frame Counter

You can set the frame counter in the film magazine to show either the number of the next frame to be exposed or the number of unexposed frames remaining on the roll of film. Before loading the film, you may want to set the counter to the desired mode. With the setting lock control in the unlocked position, press the Function Selector button until REMAIN and ON or OFF appear. Press the Up or Down button to change between ON and OFF. ON indicates that the frame counter will count the remaining number of frames. Lock the setting by moving the setting lock in the direction of the arrow.

Because most cameras show the number of the next frame, your first thought is probably to do the same on the H camera. This approach works well if you always work with either 120 film or the 220 type. However, if you use the two film lengths interchangeably, it makes more sense to set the counter to REMAIN. If the counter shows 4, for instance, you know you have 4 images left, whether you have 120 or 220 film in the camera. When a counter set for "exposed images" shows 12, you may have to think whether you can take 5 more images (with 120 film) or you have 21 more exposures left (with 220 film).

Loading the Film

To load the film with the magazine on or off the camera, fold out the film holder key (item 48 in Figure 4-1) and turn it 90 degrees counterclockwise. This allows you to remove the film holder. Remove the paper band completely from the new roll of film, and place the spool on the bottom side of the film holder (which is clearly indicated by an arrow pointing away from the spool), with the film rolling in the direction of the arrow. Place the take-up spool on the other side (which is clearly indicated by an arrow pointing toward the spool), again with the film entering in the direction of the arrow.

Bar-coded film is likely to have a hole at the end of the paper tab that holds the film to the little finger on the take-up spool. With non-bar-coded films, or with a take-up spool that does not have the finger, slide the beginning of the paper leader into the slot in the spool as usual. To ascertain that the beginning of the film is firmly attached, I recommend that you manually wind the film one or two turns onto the spool before reinserting the holder into the magazine and locking it with a clockwise turn on the film holder

key (item 48 in Figure 4-1). Nothing more needs to be done except to open the darkslide curtain if necessary.

When the camera is turned on, the film winds automatically to frame 1, and the camera's motor drive automatically winds it to subsequent frames. It also automatically winds up the paper trailer at the end of the roll.

If you do not want the film to wind automatically to frame 1, but rather you want it to do so when the release is pressed the first time, you can do that by programming custom setting 15, as described later in this chapter in the section titled The Custom Options.

If you need to remove a partially exposed roll of film, press the Film Wind-Off button on the rear part of the camera grip using a ballpoint pen or similar pointed object. Before the film winds off, you will receive a message on the LCD panel that you must confirm (see Figure 4-6).

Changing Film

To change film you simply remove the film holder from a detached or mounted magazine and replace the exposed film with a new roll. Because the film holder can be removed at any time, it is possible that you might accidentally remove a film holder with a partially exposed film, exposing part of the film to light. To minimize the damage, quickly reinsert the holder. The film is then automatically advanced three frames to a portion of the film that probably has not been exposed to light.

Some Suggestions about Film Loading

If the film is not wound to frame 1, perhaps because you did not attach the beginning firmly to the take-up spool, an ERROR warning appears on the display and in the viewfinder, and the camera cannot be released. To ensure proper film operation, I can make four suggestions:

Figure 4-6 1. Proper film path from feed reel on the right to the take-up reel on the left. **2.** A partially exposed roll of film can be rewound and removed only after you confirm the message on the grip LCD panel.

- Always insert the film holder by pressing it in the center toward the magazine shell (not on the left or right side). This ensures that it is locked on both sides to the magazine shell.
- After you insert the loaded film holder and the camera is turned on, make certain that you hear the sound of the film wind for about two seconds.
- Always check that the display on the camera, in the viewfinder or on the magazine, shows the number 1 (or the last frame number when set to REMAIN).
- You can program the camera so that it operates only with film properly loaded. You do this as described under option 6 later in this chapter in the section titled The Custom Options.

Imprinting the Film

The H camera allows you to imprint the dark area along each image with all kinds of text and figures, information that can be extremely helpful when you evaluate the results. The imprint can show the date and time when the image was made, the aperture and shutter speed, the metering mode, and other helpful data. For many photographers, the most valuable imprint is probably the photographer's name and copyright symbol imprinted next to every picture.

To make certain that the imprint appears on the film, you must program the film magazine accordingly. Follow these steps:

1. Unlock the setting lock lever (item 9 in Figure 4-1).
2. Press the function selector repeatedly until DATA appears.
3. Press either the up or the down control until ON or OFF appears, and set to ON if you want to imprint data.
4. Place the locking lever into the locked position.

Deciding on the Imprint

You now specify the desired imprint by watching the LCD display on the camera grip (shown in the section on camera operation) and operating the controls around the display. You have six options for imprinting the film. Follow these steps (see Figures 4-7, 4-8, and 4-9):

1. Press the Menu button next to the display, and turn the front wheel until SETTINGS appears.
2. Press the Save (Drive) control, and turn the front wheel until IMPRINT (menu 4.2) appears.
3. Click Enter (Drive) control to show IMPRINT TYPE.
4. Click Save (Drive) control, and turn the front wheel to access six options of imprint combinations:
 - IMP. TYPE 1: prints all relevant exposure information
 - IMP. TYPE 2: prints basic exposure information
 - DATE & TIME: prints date and time
 - TEXT & DATE: prints the preset custom text and the date

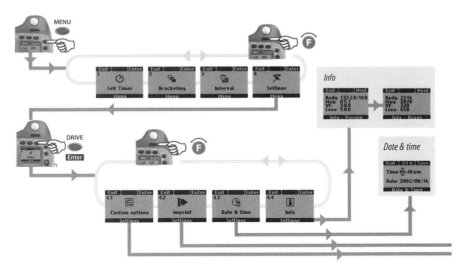

Figure 4-7 The operating procedure for imprinting.

- TEXT & INFO: Prints the preset custom text and basic exposure information
- TEXT: prints the preset custom text.

If you want to imprint only type 1 or type 2, select the type by turning either the front or the rear wheel, and then click the Save (Drive) button.

If you also want to imprint text, turn the front wheel to show TEXT (menu 4.2.2), and click the Save (Drive) button which brings up the text display. Turning the front wheel moves the cursor sideways, and turning the rear wheel moves it up and down. This allows you to choose the desired letters or symbols. The screen can show only three lines of characters at a time, but you can scroll up or down by turning the rear wheel. The selected letter or symbol is highlighted and is saved by clicking the Sel (Select) (AF) button. The text string appears on the bottom of the screen. Proceed in the same way with the additional desired letters or symbols. Click the Save (Drive) button when you are finished.

To erase a character, place the cursor into the X box on the left by turning the front and/or rear wheel. Clicking the AF button now erases the figure, number or the symbol highlighted on the Imprint line on the panel.

You can move the highlighted area in the Imprint line one character to the left or right by placing the cursor over either one of the arrow boxes on the left. Placing the cursor in the X box and clicking the AF button erases the highlighted character.

You can print a total of 37 characters in Text (including spaces) and a total of 32 characters in Text and Date or Text and Inf.

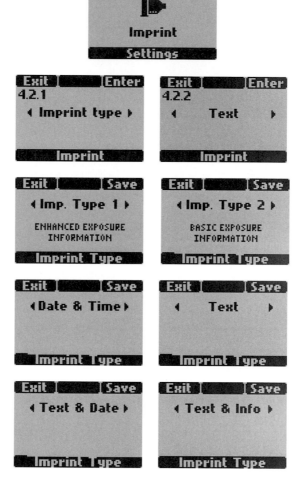

Figure 4-8 The various LCD displays for imprinting.

Imprinting Date and Time

To imprint the date and time, follow these steps:

1. Press Menu and select SETTINGS with the front wheel. Then press Enter (Drive). Turn front wheel to DATE & TIME (menu 4.3).
2. Press the Enter (Drive) button, and use the front wheel to move the cursor above the text to be changed. Make the change by turning the rear wheel.
3. Press the Save (Drive) button to save the change.

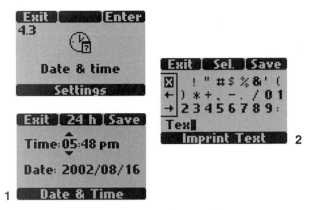

Figure 4-9 LCD display for (1) imprinting date and time and (2) imprinting text.

The Instant Film Magazine

The instant film magazine HMi100 for the H camera has the databus connections and a dial for programming the ISO value on the magazine. This magazine is basically attached and detached from the camera in the same way as other film magazines. It also has a darkslide, with a clearly marked handle in bright red, that must be removed to take a picture. The darkslide must be inserted when you remove the magazine from the camera.

Unlike the instant film magazines for the other Hasselblad cameras, the H magazine does not have, and does not need, a glass plate because the image plane is in the same position as the film plane in the film magazines.

CAMERA OPERATION

Activating the Camera

The controls for activating the camera are on top of the camera grip, with the information visible on the LCD display (see Figure 4-10). You activate the H camera by pressing the ON/OFF button next to the LCD display for ½ second. This puts the camera in the standby mode with the LCD display showing the H1 Logo. Clicking the On/Off button, or the Stop Down button, or depressing the release halfway always changes the camera from the Standby to the Power On (Active) mode with the Home screen with the standard information display showing on the LCD screen.

After 16 seconds, or whatever standby time is programmed into the camera, the camera changes automatically to Standby mode, which is again indicated by the H1 symbol on the display. Leaving the camera in Standby mode, instead of turning it off completely, is a great idea during a shoot because you can then reactivate the camera instantly, either by pressing the

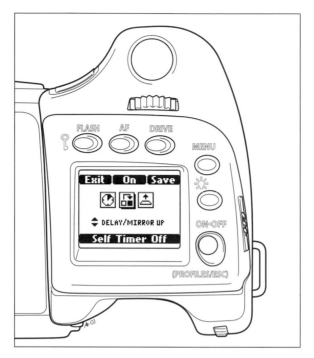

Figure 4-10 The operating controls around the grip LCD panel (clockwise from upper left): the Flash/Exit button, the AF/On button, the Save (Drive) button, the Menu button, the illumination button (with the light bulb symbol), the On/Off/Profiles/Esc button, and the rear control wheel (item 13 in Figure 4-1) at the rear of the grip. The Shutter Release button (item 19 in Figure 4-1) is on the top, with the front control wheel (item 18 in Figure 4-1) behind it.

Shutter Release button (item 19 in Figure 4-1) halfway down or by clicking the On/Off button or the Stop Down button control (item 22 in Figure 4-1). You can illuminate the LCD display on the grip by pressing the illumination button (the one with the light bulb symbol). The light goes off automatically when the camera goes into Standby mode or when the button is pressed again.

The length of the time the camera remains in the active (Standby) mode can be changed from 5 to 60 seconds as described later under custom setting 1. A longer standby cycle naturally uses more battery power. To save battery power even more when the camera is stored or not used for some time, turn it off by pressing the On/Off switch for $\frac{1}{2}$ second.

The Camera Operating Controls

All the major controls necessary for operating the camera and programming information into the camera are grouped around the LCD display on top of the camera grip, where they can be operated conveniently with one hand. The controls are as follows.

The Shutter Release button (item 19 in Figure 4-1), when pressed halfway, activates the focusing and metering systems. Fully pressed, it makes the exposure or turns on the self-timer or interval timer and moves the film to the next frame (unless the camera is set for multiple exposures). Pressing the release halfway always saves a change and returns directly to normal operation (the Home screen).

The Flash button brings the Flash menu on the screen (described in more detail in the section Flash Photography). The control is sometimes also indicated on the screen by the word EXIT because it is also used to exit a setting without saving the changes. If the button is pressed one second or longer, a beeper (if turned on) will be heard, indicating that all buttons and control wheels (except release) have been locked and cannot be changed. To unlock them, press the button again for one second or longer.

The AF button, in addition to other functions, allows you to select the focusing mode, as described in detail later in the section Focusing the H Camera.

The Drive button, also indicated on the screen with SAVE, serves various functions but is used mainly to save functions programmed into the camera.

The front control wheel (item 18 in Figure 4-1) lets you make changes in the aperture/shutter speed combination while maintaining the EV value, thus not changing the exposure in A, S, P, and Pv modes. The wheel also controls the commands in the upper part of the LCD screen indicated by sideways-pointing arrows.

The Menu button allows access to the menu settings.

Pressing the control with the light bulb symbol illuminates the display on the camera and magazine. It turns off when the button is pressed again, when the camera goes into Standby mode, and when it is turned off.

The On/Off button, also marked Profiles/Esc, activates the camera when pressed for $\frac{1}{2}$ second. To turn the camera completely off, you press the button again for at least $\frac{1}{2}$ second. Clicking the button in the Home screen allows access to the Profiles screen. If a function in the camera (such as a long exposure or self-timer) is active, this button escapes from the function and returns the LCD display directly back to the Home screen.

The rear control wheel (item 13 in Figure 4-1) controls the setting information on the lower part of the screen indicated by up- or down-pointing arrows. It also allows changes in the exposure settings for manual bracketing.

Preparing the Camera for Operation

Before you photograph with the H camera, you should set the desired drive mode, the focusing, the light metering, and the exposure mode to match your desired photographic approach for the subject being photographed.

Setting the Drive Mode The H camera can be set for single exposures (one exposure when the release is pressed, with the film wound to the next exposure),

continuous exposure (taking pictures as long as the release is pressed or as long as there is film in the camera), and multiple exposures (taking a picture without the film being advanced, as necessary for double and multiple exposures).

The three options (see Figure 4-11) are set as follows:

1. After activating the camera, click the Save (Drive) button, and turn the front wheel until you see SINGLE, CONTINUOUS, or MULTI EXP on the display.
2. Lock the chosen setting by pressing the Drive (Save) button.
3. In the MULTI EXP mode, you also need to decide how many images should be superimposed; then set the number by turning the rear wheel. If you want a double exposure with two images, turn the rear wheel until you see NUMBER 2. The camera will now make the first exposure without advancing the film but will advance the film after the second exposure or whatever number was programmed into the camera.
 If the programmed multiple-exposure drive mode is no longer desired, click the Esc (On/Off) button.
4. As indicated on the display, you can also terminate the present multiple-exposure sequence and wind film one frame by pressing the Drive button. The camera remains in multiple-exposure mode in this case.

Releasing the Camera

Before taking a picture, you also must decide whether the exposure should be made with the release on the camera, with the built-in self-timer, or in the Interval mode. Pressing the Release button halfway focuses the lens if the lens is set to Auto Focus. If it is set to AF-S mode, the focus will also be locked as long as you keep the release pressed halfway. Pressed halfway also saves any settings and returns the LCD display to the Home screen. When you press the release completely, the picture is taken, and the film is advanced to the next frame (unless the camera is set for multiple exposures).

Before you make the exposure, I suggest that you check, whenever possible, that the aperture and shutter speed shown in the viewfinder and on the display produce the desired results.

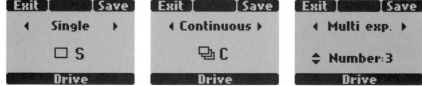

Figure 4-11 The grip LCD display for single exposures (left), for continuous operation (center), and for multiple exposures set for three exposures (right).

The camera can also be released using an accessory release cord, 0.5m (20 inches) long, attached to the release cord socket (item 21 in Figure 4-1).

Operating the Self-Timer

The self-timer built into the H camera can be programmed for the desired delay time from 2 to 60 seconds. It can also be programmed so that the mirror lifts up the moment the release is pressed or just before the exposure is made. It can also be programmed so that the mirror goes down or stays up after the exposure.

The programming procedure is as follows (see Figure 4-12):

1. Click the Menu button, and turn the front control wheel until SELF TIMER appears on the display. Click the Save (Drive) button, and use the front wheel to select the left icon. Then turn the rear wheel to the desired delay in seconds.
2. Turn the front wheel to select the middle icon, and you will see DELAY MIRROR UP or MIRROR UP DELAY. Turn the rear wheel to the desired mode, and press the Save (Drive) button to lock it. As the name indicates, in MIRROR UP DELAY, the mirror lifts up the moment the release is pressed, in which case the image on the focusing screen disappears. This setting, however, is the best assurance for eliminating any possibility of camera vibration. If you like to see the image as long as possible, set it to DELAY MIRROR UP so that the mirror lifts up after the delay and just before the exposure is made.
3. Turn the front wheel until you see MIRROR GOES DOWN or MIRROR REMAINS UP. Select the desired mode by turning the rear wheel, and lock it by clicking the Save (Drive) button. In MIRROR GOES DOWN the mirror returns to the viewing position after each exposure. When set to MIRROR REMAINS UP, it stays up for subsequent self-timer operation. Click the MUP (Mirror Up) button (item 24 in Figure 4-1) to bring the mirror down.
4. When the self-timer is programmed, press the AF (On) button to activate the self-timer function. When you press the release, the exposure is made with the self-timer at the set delay. Pressing the button again will deactivate the self-timer, which is indicated accordingly at the bottom of the screen. The self-timer can also be activated by double-clicking (within 1 second) the Mirror Up (MUP) button (item 24 in Figure 4-1) or by programming the User button (discussed later) to activate the self-timer. The self-timer is deactivated after use unless it is programmed to remain in the camera, as described under custom option 18. To stop a self-timer sequence that is in progress, click the Esc (On/Off) button.

Figure 4-12 shows a sample program for a self-timer operation, and Figure 4-13 shows the mirror controls.

Wireless Remote Operation

The H1 camera can be operated wirelessly from a distance up to about 33 feet (10 meters). To do this, attach the infrared release unit accessory

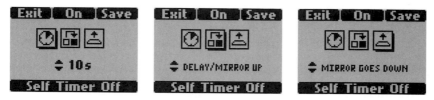

Figure 4-12 Self-timer operation on the LCD display set for a 10-second delay (left), for the mirror to lift after the delay and just before the exposure is made (center), and for the mirror to go down after the exposure (right).

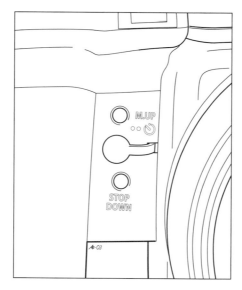

Figure 4-13 The controls at the front of the camera (from top to bottom): Mirror Up button, (24 in Figure 4-1), release cord socket (21), and Stop Down button. (22)

to the accessory connection on the left side of the camera body. You reach the connection after sliding the protective cover to the left. Wireless remote exposures are made with the included remote release, which is the same as used with the IR release unit for the 555ELD and the 503CW motor winder.

The release options are single, continuous, or delay. In the latter case, the exposure is made two seconds after the mirror lifts up.

Interval Exposures

The H camera also allows you to take up to 32 pictures (with 220 film) automatically at preset intervals from 1 second to 24 hours (time lapse still photography). Follow these steps (see Figure 4-14):

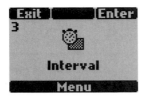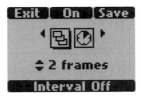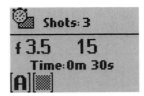

Figure 4-14 Grip LCD display for interval exposures (left) and programmed for two frames (center). The right illustration shows the display with three frames remaining in a sequence of one frame every 30 seconds made in the Automatic (A) mode with average metering.

1. With the camera set on a sturdy tripod, press the Menu button and turn the front control wheel to INTERVAL. Now press the Save (Drive) button, and turn the front wheel to the number of exposures indicated by a drop shadow over the square with three images. Set the desired number (from 2 to 32) by turning the rear wheel. You must use 220 film if you select more than 16 exposures.
2. Turn the front wheel to the interval duration, which is indicated by a drop shadow over the clock.
3. Turn the rear wheel to the desired interval from 1 second to 24 hours.
4. Click the Save (Drive) button.
5. Activate the setting by clicking the On (AF) button, and start the sequence by pressing the release. An interval setting can be stopped in midsequence by clicking the Esc (On/Off) button.

PHOTOGRAPHING WITH THE H CAMERA

Customizing Your Camera with Custom Options

Although the H camera is ready for photography without any further instructions, I recommend that you study the 21 custom options before you start working with the camera (see the section The Custom Options later in this chapter). You will undoubtedly want to use some of the options to make the camera operations ideal for the way you like to photograph specific subjects. Some custom options, such as Show ISO (option 21) or Show EV (option 20), allow you to put data on the display that might be helpful in your photography. Other options, such as Rear Wheel Quick Adjust (option 13), provide easy manual bracketing. The Spot Mode option (option 10) allows easy and instant locking of a spot meter reading so that you can recompose without a change in the exposure setting.

You will probably program some of these options, such as those that apply to the metering and focusing mode, into the camera and leave them there for all your photography. Others you may program for specific cases only.

FOCUSING THE H CAMERA

Focusing Options and Settings

The focusing area for the automatic focusing system in the H camera is clearly indicated by a small rectangular area within the spot meter circle in the center of the focusing screen. This design ensures that every lens is focused accurately on your selected subject area within the composition. In Auto Focus, you simply point this focusing area at the part of the composition on which the lens must be focused.

Automatic focusing with the H camera can be programmed for either Single or Continuous mode. In Single-shot mode (AF-S), the shutter release is blocked until the lens has time to focus on the center area. Because the automatic focusing in the H camera is extremely fast, this setting is not likely to cause an objectionable delay in any situation, and AF-S is therefore a good choice for most photography. In Continuous mode (AF-C), the shutter can be released instantly for instant pictures, which you may want to consider in action photography.

The desired focusing mode is set as follows with the camera in the active mode:

1. Press the AF button on top of the display.
2. Turn the front control wheel to either Manual (MF), Single-shot (AF-S), or Continuous (AF-C). Press the Save (Drive) button.
3. Precise focusing in dim light or with low-contrast subjects is best achieved with the AF assist light. As described under custom option 12, the red AF assist light can be programmed so that the red assist light in the camera is always used or so that the assist light in an external flash is used. The latter may be preferable because it is located farther away from the camera and is more powerful. It can also be turned off if it is objectionable to the people being photographed.

The LED Focus Aids

A correct focus setting, whether done manually or automatically, can be indicated in the viewfinder with two LEDs in the shape of arrowheads. This option can be changed as described in custom option 11. It gives you the option of programming the camera so that the LEDs are always visible, are visible only when the release is pressed halfway (the default setting), or are never visible. If a lens is not focused properly in the Manual mode, only one arrow is lit, indicating in which direction to turn the focusing ring. Proper focus is achieved when both LEDs are lit. Flickering of the LEDs indicates that proper focus is not possible, perhaps because the subject is beyond the minimum focusing distance of the lens. In the Automatic Focusing mode, both arrows are lit when the camera has locked focus, and both arrows are flashing when the camera cannot find focus.

Automatic Focusing

In the Automatic Focusing mode, the lens sets itself for the distance of the subject within the focusing area when the release is pressed halfway. The release is then pressed completely to make the exposure. Although this fully automatic operation can produce good results in many cases, you must keep in mind that the lens is always focused on the subject in the center area, which may not be the important part of the scene. Many compositions are made with the main subject placed toward one side or the top or bottom of the image, not in the center. In such compositions, you do not and cannot let the camera decide where to focus. Instead, you must make this decision.

The H camera lets you do this beautifully in two ways while maintaining the precision and speed of the Automatic Focusing mode.

Locking a Focus Setting with the Release In the first approach, you point the focusing area at the desired subject area anywhere within the composition. Press the release halfway, and keep it pressed while you move the camera for the final composition in the viewfinder; then press the release completely. The distance setting is maintained as long as the release is pressed halfway. If you remove the pressure on the release button purposely or accidentally and press the release again, the camera will focus on the new subject in the focusing area. After the picture is taken, the distance setting is no longer locked and adjusts to whatever subject area is in the center of the composition. If you want to maintain the focus setting for several pictures, keep the release in the halfway position between exposures.

If you want to maintain the focus setting for a number of exposures of the same subject or the same location—perhaps to bracket daylight or flash exposures or to end up with different poses of a model—you have another, better option: programming the User button to activate AF focus mode in custom option 3.

Setting the User Button to AF Drive Custom option 3, the User button function, offers a wonderful solution for locking and maintaining a focus setting as long as you want without the need for keeping the release pressed. Figure 4-15 shows the controls at the rear of the camera grip, including the User button.

You can set this option using the following shortcut:

1. Click the Menu button and then the User button on the rear part of the camera grip.
2. Turn the rear wheel to AF DRIVE.
3. Click the Save (Drive) button, or press the release halfway.
4. Click the AF button, and set the camera for manual focus (MF). Although the camera is set to manual focus, focusing is automatic when you press the User button.
5. To focus a lens, make certain that the camera is activated; then point the measuring area at the desired subject part and click the User button. The lens now

Figure 4-15 The controls at the rear of the camera grip (from top to bottom): the AE Lock (AE-L) button, the button for rewinding partially exposed film, and the User button.

focuses automatically on that part of the composition and locks the setting automatically. You can now move the camera to recompose the image and press the release to take the picture. The focus setting stays locked until you press the User button again to focus on something else. This option maintains the fast, precise, automatic focusing mode while giving you the opportunity to decide on the focusing area within the composition.

Focusing Override

There are undoubtedly cases when you may want to make a manual adjustment on the automatic focus setting—for example, to change the depth-of-field range toward the front or back of the focused distance. With a fence leading to a house some distance away, you undoubtedly want the house sharp but also want as much depth of field as possible in the front. To achieve this effect, you can let the camera focus automatically on the house but then adjust the focusing ring toward the closer distances. In this way, the house can be close to the end of the depth-of-field range, and a good part of the fence is acceptably sharp.

When working from a tripod with a composition where the main subject is not in the center area, you may find it more convenient to leave the camera as set up for the desired composition and focus on the main subject manually instead of turning and moving the mounted camera to bring the focusing area over the main subject.

Both of these problems can be solved with manual focusing. The H camera, however, offers a better solution: the Manual Override option, which eliminates the need for switching from the Manual to the Automatic Focusing mode and vice versa. With the camera left in Automatic Focus, you can manually override and adjust the distance setting on any lens.

In the first example, let the camera focus automatically on the building by pressing the release halfway; then, keeping the release pressed halfway, turn the focusing ring manually to the desired distance. Press the release completely to make the exposure. In the second example, with the camera set to Automatic Focus, press the release halfway, focus the lens manually for the main subject, and then press completely to make the exposure.

It is worth keeping in mind that in Manual Override, the camera is still set for automatic focusing (AF-S or AF-C), so you must keep the release pressed halfway while refocusing. If instead you let the release go and press it again halfway, a new focusing cycle starts.

Manual Focusing

All the H lenses can be focused automatically, in manual override, and manually. Because the Automatic Focusing system focuses more accurately and faster than most photographers can do manually, I see little reason for using the Manual focusing mode. This is especially the case if the User button is set to AF DRIVE, as described earlier. The H camera, however, offers the option of manual focusing, and the LED focusing aids make manual focusing extremely accurate, something that must be appreciated especially by photographers who have problems focusing a lens visually.

Depth of Field

In many cases, the focus setting and the lens aperture must be made based on the desired depth of field. All H lenses, except for the zoom, have depth-of-field scales. The use of these scales and the setting of the focusing ring are discussed in Chapter 13, Controls for Exposure and Creating Images. To set the lens for a specific depth-of-field range, focus, manually or automatically, on the closest subject to be sharp and then read the distance on the lens. Do the same for the subject at the longest distance. Then set the focusing ring accordingly, either manually or with the manual override.

METERING AND EXPOSURE CONTROLS

The H Camera's Metering Modes

The metering mode refers to the method of taking the meter reading of the subject or scene. The H camera gives you a choice of either average, center-weighted, or spot metering. The set mode is always indicated in the

viewfinder and on the grip LCD display and can also be imprinted on the film. The subject areas measured in each approach are shown in Figure 4-16. The spot metered area is also engraved on the camera's focusing screen.

Chapter 12, Achieving Perfect Exposures, discusses the advantages of each metering mode, the recommended choice, and the most successful use of each for providing perfect exposures with any subject under any lighting situations.

Setting the Metering Mode

To set or change the metering mode, proceed as follows:

1. Click the Exposure Mode button (item 3 on Figure 4-1) on the viewfinder.
2. Turn the rear wheel until the desired metering mode and symbol appear on the display.
3. Press the Drive (Save) button to lock the setting.

Exposure Modes

"Exposure mode" refers to the way the meter reading is transferred to the aperture and shutter speed settings. You can set the H camera for either manual exposure (M) or automatic exposure. The automatic exposure options are Aperture Priority (A), Shutter Speed Priority (S), Programmed (P), or Programmed Variable (Pv).

Setting the exposure Mode The desired exposure mode is set as follows:

1. Press the Exposure Mode button (item 3 on Figure 4-1).
2. Turn the front control wheel until the desired mode appears on the display.
3. Press the Save (Drive) button.

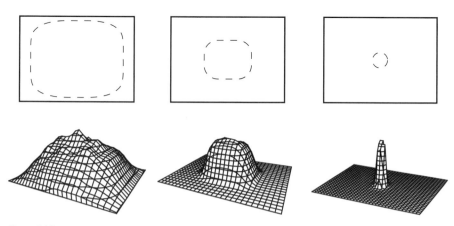

Figure 4-16 The metering areas in the different metering modes with average metering (45 × 37 mm) (top), center-weighted (23 × 20 mm) (center), and spot metering (7.5 mm) (bottom).

The selected aperture and shutter speed are shown in all modes in the viewfinder and on the grip LCD display. In all automatic exposure modes, you can change the selected aperture/shutter speed combination in an inter-locked fashion without changing the EV value and thus the exposure. This is done by turning the front wheel.

The Programmed (P) and Programmed Variable (Pv) Modes In both programmed modes, the camera selects both the aperture and the shutter speed that the camera's electronic brain considers best for that particular light situation. This point-and-shoot approach provides amazingly accurate results in many cases. It can certainly be considered for fast candid shooting when there is no time for a manual selection of aperture and shutter speed and when subjects are of more or less average brightness and without a mixture of large shaded and brightly lit areas.

The Pv mode is identical to P but selects aperture and shutter speed based not only on the subject brightness but also on the focal length of the lens on the camera. For example, it avoids longer shutter speeds for longer focal length lenses. This is the recommended setting for exposure automa-tion if you work with different focal length lenses. The P and Pv modes should be used only with the camera set for average or center-weighted metering.

Shutter Speed Priority (Shutter Pr) or (S) Mode The electronically controlled shutter speed range of the central shutter in the H camera lenses is from $\frac{1}{800}$ second to 18 hours, including B and T modes. Shutter speeds are indicated on the display and in the viewfinder with an "s" when the speeds are longer than one second (2s means two seconds); for fractions of a second there is no "s" (30 means $\frac{1}{30}$ second).

In the Shutter Priority mode, you select the desired shutter speed by turning the front control wheel. The camera selects the aperture that pro-vides the correct exposure for the metered area. Shutter Speed Priority is the recommended mode when you're photographing moving subjects, where the shutter speed determines whether the moving subjects are recorded sharply or with a blur. You may perhaps also want to consider Shutter Priority for handheld photography, giving you the opportunity to set a shutter speed that is short enough to reduce or eliminate blur caused by camera motion. Such shutter speeds can be relatively long because the H camera is beautifully designed for handheld work, providing good camera steadiness at relatively long shutter speeds. I have obtained pictures with beautiful sharpness at shutter speeds that I have not dared to use for years, such as $\frac{1}{30}$ second and even $\frac{1}{20}$ second with the standard 80mm lens.

Aperture Priority (Aperture Pr) or (A) mode Because the depth-of-field range must be considered in many images, Aperture Priority (A) mode is the most logical approach for most photography and for most photographers. The A mode allows you to preset the aperture to a value that produces the desired depth

of field. You set the desired lens aperture by turning the front control wheel. The camera then selects the appropriate shutter speed. Aperture Pr mode is also a good choice because the camera sets the shutter speeds much more accurately than the ½ or ⅓ increments possible in Manual mode.

With the function and operation of the automatic exposure modes so beautifully designed, I personally see no good reason for using the Manual mode. It does, however, exist in the camera.

Manual Exposure Mode (M) In the Manual mode, you set the aperture by turning the front control wheel, and you set the shutter speed by turning the rear control wheel. For correct exposure, you turn either the front or the rear wheel (or both) until the pointer over the exposure scale in the finder is positioned above the central index. The deviations to the left or right are indicated in ⅓ EV values on the scale. In the Manual mode, aperture and shutter speed settings are and remain locked.

Figure 4-17 illustrates various operating and exposure settings on the grip LCD panel, and Figure 4-18 shows the operating and exposure information on the viewfinder display.

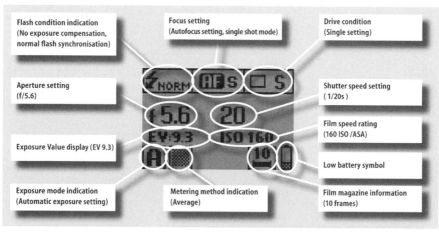

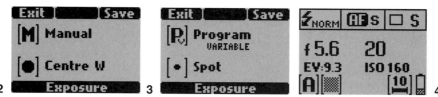

Figure 4-17 **1.** The complete operating and exposure information on the grip LCD panel. **2.** The camera is set for manual exposure in the center-weighted mode. **3.** The camera is set for programmed variable exposures in the spot metering mode. **4.** The camera is set for automatic focusing and automatic exposures in the average metering mode with either frame 10 coming up or 10 exposures left on the roll, depending on how the magazine is programmed.

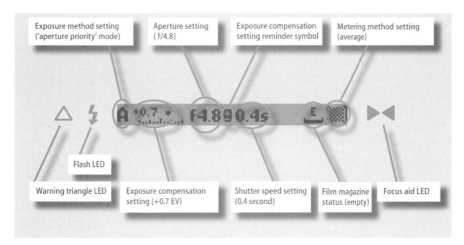

Figure 4-18 The operating and exposure information on the viewfinder display.

Metering Approaches

In all automatic exposure modes, the lens settings change as the camera's metering area is moved to darker or lighter subject areas. This is desirable in fast candid shooting or when you're following moving subjects. This change in the lens settings happens while you compose and before you take a picture and again after the picture is made.

In more critical work, whenever you have time for a more complete subject evaluation you probably want to determine what the exposure should be rather than let the camera make this decision for you. You probably want to base the meter reading on specific subject areas and not necessarily on what happens to be in the center of the composition. For example, with transparency film, you want to be certain that exposure is based on lighted areas, whereas with negative films you want to consider shaded areas.

A practical and fast metering approach in the center-weighted or spot metering mode is as follows:

1. Evaluate the subject or scene, and check whether there are areas of average brightness (18% reflectance and lighted for transparency film, in the shade for negative emulsions).
2. If you find such areas, point the metering area at that area of the subject or scene and take the meter reading. You can press the AE Lock button to lock the setting so you can recompose and take the picture.

If there are no areas of average brightness, measure a darker or lighter area and compensate. Complete details about exposure, metering, subject brightness, and working with negative and transparency films are found in Chapter 12.

Locking the Exposure

The approach just mentioned works beautifully in the center-weighted or spot metering mode. With the camera pointed at the desired area, you can lock the setting by pressing the AE Lock button at the rear of the camera grip. You unlock the setting by pressing the same button again. A locked setting is indicated in the finder and on the display by an L between the aperture and shutter speed indications. To change the locked aperture and shutter speed settings without changing the EV (exposure), turn the front control wheel.

Because the settings are unlocked after the exposure, requiring a new meter reading, this approach works fine when you're taking only one picture in a specific location. When you're taking many pictures in the same location and the same light, as is usually the case when you're photographing people or animals, I suggest using the Permanent Locking mode described under custom option 19. Set to this option with the LCD screen marked AE LOCK AND QUICK ADJUST, and then turn the rear wheel to SAVED. Make the meter reading as suggested by pointing the measuring area at the selected part in the composition, and then click the AE Lock. Recompose and take the picture. The locked exposure and any exposure adjustments that are made with the rear wheel are not reset when you release the camera. You can unlock the settings by pressing the AE Lock button again.

Locking Exposure Values in the Spot Metering Mode

In the spot metering mode, there is another way to lock lens settings without the need for relocking the exposure after each picture. This is done by programming custom option 10 into the camera. Follow these steps:

1. Set the camera to CUSTOM OPTIONS as discussed in the custom options section later in this chapter. Turn the front wheel until you come to SPOT MODE on top of the display.
2. Turn the rear wheel so the display shows ZONE (not NORMAL) at the bottom.
3. Lock the setting by pressing the Drive (Save) button.
4. You now take the meter reading by pointing the spot meter area at the part of the subject that you want to measure. Press the AE Lock, which sets and locks the setting and shows ZONE 5 on the display and viewfinder. Recompose and take the picture.
5. Proceed the same way for the next picture. If desired, you can place the reading into a different zone—for example, zone 7 for a reading of white snow—by turning the rear control wheel. You can also point the spot meter area with the locked setting at other subject areas. The display then shows the deviation in zone values so that you know the difference in subject brightness. For example, a zone 4 reading indicates that the new area is one EV value darker. If you want to use the spot meter without this locking approach, make certain that the custom option SPOT MODE is set to NORMAL (the default setting).

Exposure Compensations

To make all the exposures somewhat darker or lighter in manual or automatic exposure mode, you can program an exposure compensation from −5 to +5 EV values in $\frac{1}{3}$ *f* stop increments into the camera. Proceed as follows:

1. Press the Exposure Compensation button (item 4 in Figure 4-1) on the viewfinder.
2. Turn the front or rear control wheel until the desired adjustment value is visible on the display.
3. Press the Save (Drive) button. The adjusted value is visible in the viewfinder with a + or − indication between the aperture and shutter speed indications. This indication does not appear at all if there is no compensation made.
4. Click the Exposure Compensation button on the finder, and set the value to zero if you no longer want the compensation; or, as a shortcut to setting the value to zero, press the AF button.

 You can also input a temporary exposure adjustment in any of the automatic modes by turning the rear wheel with the amount of the adjustment shown on the scale in the viewfinder LCD display. It can be programmed as a fixed adjustment by setting custom option 19 to SAVED.

Manual Exposure Bracketing

In the Manual exposure (M) setting, you can bracket exposures as with all cameras by changing either the aperture or the shutter speed manually. The deviation from normal exposure is shown on the display and in the viewfinder with a + or − value adjustment.

In all automatic light measuring modes, you can bracket by using the rear control wheel but only if the wheel function is programmed appropriately. This is done with custom option 13, Rear Wheel Quick Adjust. Program this option into the camera as described under custom options. Turn the rear wheel to YES (the default setting). Save the setting by clicking the Save (Drive) button.

Turning the rear control wheel now adjusts the exposure by changing the aperture only in Shutter Priority mode (S) and changing the shutter speed only in the Aperture Priority (A) setting. Set to programmed (P) or (Pv), the camera decides which one to change. In all cases the adjustments are indicated on the display and in the viewfinder as + or − in $\frac{1}{3}$ increments.

Because the indications appear in the viewfinder, you can bracket without removing your eye from the finder.

Automatic Exposure Bracketing

Automatic exposure bracketing in $\frac{1}{3}$-, $\frac{1}{2}$-, and 1-stop exposure increments can also be programmed into the camera and made either over two, three, or five frames. With the camera set to the Continuous Drive mode, the two, three, or five exposures are made automatically while the release is kept pressed,

and the camera stops when the cycle is completed. In the Single-frame mode, the bracketing cycle is made by pressing the release two, three, or five times. If you no longer need or want automatic bracketing, click the Esc (On/Off) button. If you don't do so, exposure bracketing stays programmed in the camera. If you take only one picture in the Automatic bracketing mode (rather than the complete programmed sequence of two, three, or five), the next picture, or pictures, will be exposed at the programmed bracketing compensation, such as perhaps one *f* stop over or under. This is true even if the pictures are taken in a completely different location and after the camera has been deactivated.

Programming Automatic Bracketing

To program automatic bracketing, follow these steps shown in Figure 4-20.

1. Click the Menu button and turn the front wheel until BRACKETING appears.
2. Click the Save (Drive) button, which brings up the three bracketing symbols on top of the display. Select the leftmost icon, and turn the rear wheel to set the desired number of frames (2, 3, or 5). See Figure 4-19.
3. Select the middle icon with the front wheel and change the desired exposure sequence with the rear wheel. See Figure 4-19.
4. Select the rightmost icon with the front wheel, and change the desired amount of exposure adjustment.
5. Click the AF button. The status line at the bottom of the LCD will now show BRACKETING ON.
6. Click the Save (Drive) button to lock. The upper part of the screen now shows the actual settings for the bracketing mode. To go back to normal operation, click the Esc button.

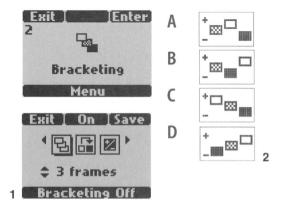

Figure 4-19 **1.** The grip display for automatic bracketing. **2.** The bracketing sequence options. **A.** Normal/over/under. **B.** Normal/under/over. **C.** Over/normal/under. **D.** Under/normal/over.

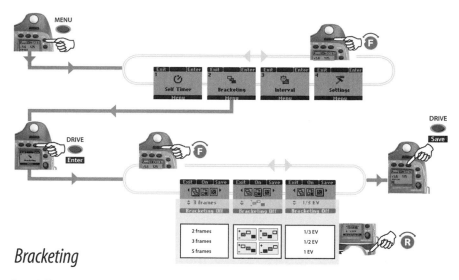

Bracketing

Figure 4-20 The operating sequence for automatic bracketing.

OTHER OPERATING AND IMAGE CREATING CONTROLS

Manual Diaphragm Stop Down Control

As with all SLR cameras, the lens diaphragm is normally wide open to produce the brightest image on the focusing screen. You also see the image as it would be recorded at maximum aperture. In many situations, you may want to evaluate the image as it will be recorded at a smaller aperture, perhaps to see the amount of blur in foreground and background areas.

You can do this by using the manual Stop Down button (item 22 in Figure 4-1) at the front of the camera. Pressing the button closes the aperture to the preset value. The aperture stays closed until you release the button. Chapter 13, Controls for Exposure and Creating Images, gives more details on how the Stop Down control can help you produce more effective images.

The Mirror Lock-Up Control

As with all SLR cameras, it is highly recommended that you lock the mirror up when you're making long exposures with a tripod-mounted camera. The mirror flips up when you press the button and goes back into the normal viewing position when you press the button again. In the locked up mirror position, the shutter in the lens is closed, the aperture is closed, and the rear auxiliary shutter is open. A locked up mirror is still locked up after an exposure and must be brought into the normal viewing position by clicking the Mirror Lock-Up button again.

With the mirror locked up, the H camera is almost noiseless because the camera release operation is reduced to the opening and closing of the lens shutter.

Because the image on the focusing screen is no longer visible when the mirror is locked up, this approach is normally not suggested for handheld work or when you're working from a monopod. You may want to consider this possibility, however, with the H camera. The extremely smooth lens shutter operation may allow sharp images at slow shutter speeds of $\frac{1}{8}$ second, perhaps even $\frac{1}{4}$ second, from a monopod or a very lightweight tripod.

More reasons for using the manual Stop Down control are found in Chapter 6, Operating V System Cameras.

THE CUSTOM OPTIONS

Setting and Using the Options

The H camera gives you the possibility of programming 21 custom options that allow you to personalize the camera to your specific needs. The custom options can simplify the photographic approach and help you in accomplishing specific results in many situations, giving you more time to concentrate on creating effective images on film or digitally instead of worrying about technicalities and camera operations.

The custom options can be accessed in two ways. Here is the first:

1. Press the Menu button.
2. Turn the front control wheel to SETTINGS.
3. Click the Save (Drive) button and turn the front wheel to CUSTOM OPTIONS.
4. Click the Save (Drive) button. Turning the front wheel now brings the 21 options to the screen.

You can accomplish the same thing in a somewhat faster way as follows:

1. Press the Menu button.
2. Press the User button, which brings up custom option 3, User Button Function.
3. Turning the front wheel now brings up all the other 21 custom options.

All custom options are shown on the screen, with the number and name of the option on top of the screen and the options at the bottom (see Figure 4-21).

You change or set the options at the bottom by turning the rear wheel. After programming any option, you must save it by clicking the Save (Drive) button. You can, however, change more than one option before you press Save. Each programmed option remains in the camera until it is changed. For example, if the camera is set to SPOT MODE—ZONE, it remains there until you reprogram custom option 10 to NORMAL or, in this case, when you change

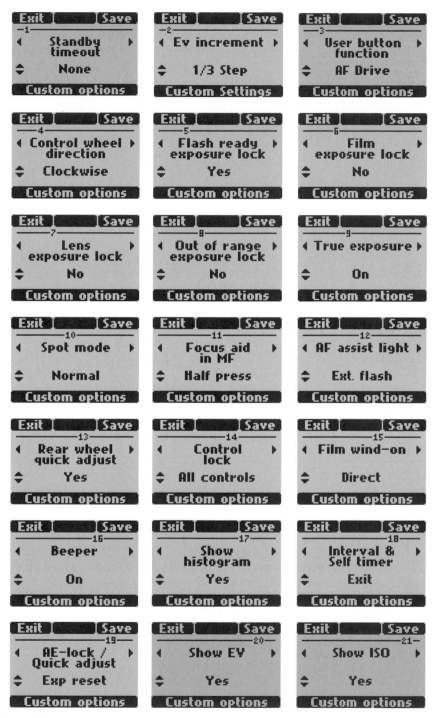

Figure 4-21 The custom options display. **1.** Standby Timeout. **2.** EV Increment. **3.** User Button Function. **4.** Control Wheel Direction. **5.** Flash Ready Exposure Lock. **6.** Film Exposure Lock. **7.** Lens Exposure Lock. **8.** Out of Range Exposure Lock. **9.** True Exposure. **10.** Spot Mode. **11.** Focus Aid in MF. **12.** AF Assist Light. **13.** Rear Wheel Quick Adjust. **14.** Control Lock. **15.** Film Wind-On. **16.** Beeper. **17.** Show Histogram. **18.** Interval and Self Timer. **19.** AE-Lock/Quick Adjust. **20.** Show EV. **21.** Show ISO.

from the spot to the average or center-weighted metering mode. Pressing the Esc button does not erase a function; it only cancels an ongoing operation.

Some of the custom options have already been described. Here is a complete list of the 21 options and their uses and applications.

1. Standby Timeout allows you to set from 5 to 60 seconds the length of time that the camera remains in the active state. Ten to 15 seconds is a good time for most photography. Do not set to NONE because it drains the battery excessively.

2. EV Increment gives you the choice of making aperture and shutter speed settings in intervals of either $\frac{1}{3}$, $\frac{1}{2}$, or 1 EV value.

3. User Button Function allows you to select and program into the camera one specific camera function that you use often in your photography—for example, automatic bracketing, mirror up, multiple exposures, and so on. You can then access this particular operation instantly by simply pressing the User button at the rear of the camera grip. You need not reprogram or change that function. For example, if the User button is programmed for automatic bracketing at a set value, you can bracket one picture sequence by simply pressing the User button. You can get out of the bracketing mode by pressing the User button again. The various User button options are listed later in the chapter.

4. Control Wheel Direction lets you set the direction to CLOCKWISE or ANTI-CLOCKWISE, which then determines how the various settings change when you turn the control wheels—for example, whether the aperture values go up or down when you turn the wheel clockwise.

5. Flash Ready Exposure Lock, when set to YES, locks the shutter so that it does not release until a flash unit, used in a dedicated fashion, is fully charged. This works only with the built-in flash and dedicated flash units attached to the hot shoe, not to the PC connection.

6. Film Exposure Lock, when set to YES, prevents the shutter from being released if there is no film in the magazine. This option also shows the signal NO FILM on the display.

7. Lens Exposure Lock, when set to YES, prevents the camera from being released without a lens on the camera, an action that would expose and ruin one image on the film. The LCD display also shows NO LENS.

8. Out of Range Exposure Lock, when set to YES, prevents you from taking pictures when the parameters (aperture and shutter speed) are outside the possible range—for example, with the light being too bright for the selected aperture in A mode or for the selected shutter speed in S mode.

9. True Exposure. The actual amount of light that falls on the image plane by the opening and closing of a central shutter depends slightly on the size of the lens aperture opening. Variations occur because the generated shutter speed will be slightly dependent on the selected aperture. This is normal in any lens shutter. The new design of the shutter in the HC lenses enables the camera to compensate for any such dependency. The True Exposure ON setting therefore provides the most precise exposures at any aperture and shutter speed combination and is recommended for critical work.

10. Spot Mode, when set to ZONE, allows convenient locking of a spot meter reading, as discussed earlier. If you do not plan to use this option, set it to NORMAL.

11. Focus Aid in MF allows you to set the arrowhead focus aids discussed in the section Manual Focusing so that they are always visible in the finder (ALWAYS) or visible only when the release is pressed halfway (HALF PRESS) or never visible (OFF).

12. AF Assist Light. The AF assist light in the H camera grip is actuated when the custom option is set to CAMERA. The EXTERNAL FLASH setting actuates an AF assist light in an external flash unit if so equipped.

13. Rear Wheel Quick Adjust, when set to YES, causes the rear control wheel to be used to input a temporary exposure adjustment in all exposure modes except Manual. It changes either the aperture or the shutter speed for manually bracketing exposures, as discussed earlier in this chapter. When this option is set to NO, the rear wheel changes the EV (aperture and shutter speed simultaneously) to maintain the same exposure as turning the front wheel does.

14. Control Lock, when set to ALL CONTROLS, locks all controls and buttons except the release. Set to WHEELS, it locks only the control wheels. The beeper sounds (if set) when the Flash button is pressed for one second with the controls locked.

15. Film Wind-On, when set to INSTANT, winds the film immediately to frame 1 when the film magazine is attached to the camera in active or standby mode or when the film holder is inserted into a magazine attached to the camera. Set to HALF PRESS, this option winds the film to frame 1 when the release is pressed halfway for the first picture, as discussed under film loading.

16. Beeper, when set to ON, enables the sound signal to be used in different situations.

17. Show Histogram. When you are using a digital back, the YES setting displays a histogram of a digital exposure after a picture is taken.

18. Interval and Self Timer leaves the Self-timer or Interval mode active after the exposure when programmed to STAY. It goes back to the standard setting in EXIT.

19. AE Lock and Quick Adjust. As explained in Locking the Exposure, the SAVED setting retains an AE Lock setting and an exposure adjustment made with the rear wheel. When this option is set to EXP RESET, both the AE lock and the quick adjust are reset.

20. Show EV displays EV values on the grip LCD display when set to YES.

21. Show ISO shows the ISO film rating on the grip LCD display, if set to YES, which is my recommended setting.

The User Button Functions

You can use the User button function for the following operations (most of them are obvious and need no further explanation): None, if not desired (the default setting); Standby; Stop Down (lens aperture); Flash Measure; Interval Timer; Multi Exposure; Self Timer; Bracketing; AF Drive (drive lens in MF or

AF) Mirror Up; B mode; T mode; Show Histogram (recall last histogram); Grey Balance Exposure; and Delete Last Image (the last three for digital work with digital backs that are equipped accordingly); Dig. Foc Check, which enlarges the image on a digital back with built-in monitor and designed for this application; and Cycle LM mode, which allows you to switch instantly from spot to center-weighted to average metering by simply pressing the User button repeatedly.

Keep in mind that only one of these functions can be programmed for the User button. The functions Show Histogram, Delete Last Image, Dig. Foc Check, and Grey Balance Exposure work only with digital backs that are equipped accordingly.

Keep in mind the shortcut for programming the User button: Click the Menu button, and then click the User button.

FLASH PHOTOGRAPHY

Flash Units

The eye-level viewfinder of the H camera is equipped with a built-in flash unit (item 26 in Figure 4-1) with a guide number of 12 (for meters) or 40 (when distances are measured in feet). The flash illuminates an area within a 56-degree angle horizontally and 44 degrees vertically, producing even illumination with lenses 80mm and longer. It should not be used with the 35mm, the 50mm, and the 50–110 zoom lenses set to focal lengths below 80mm.

You bring the flash into operational position by sliding the flash unit catch lever (item 36 in Figure 4-1) on the side of the finder in the direction of the flash symbol. Pressing the flash unit back down deactivates it and locks it back into the finder. The unit works in dedicated fashion, with the light measured from a 40mm center area on the film plane.

This built-in flash unit is sufficiently powerful when used as a fill light outdoors, where the flash brightness is usually reduced drastically and is completely satisfactory for family pictures or for any indoor photography at shorter distances. Other shoe mount units can also be mounted on the flash shoe. To work in dedicated fashion, however, they must be specially designed for the H camera. Currently, only flash units compatible with the SCA3002 system from Metz can be used. They must be used in combination with the Hasselblad SCA3902 adapter, which is made specifically for the H camera. The adapter made for the V camera system cannot be used. There may be other flash units specifically made for the H camera available in the future. When using handle mount flash units in the SCA3002 system, you attach the control unit from the flash to the Hasselblad SCA3902 adapter, which is mounted to the viewfinder hot shoe. As usual, flash units used in dedicated fashion are set to TTL.

Flash units dedicated to other camera makes cannot be used because damage will occur either to the camera or to the flash. You can identify a dedicated flash by its having more than one contact pin at the bottom of the flash shoe.

Nondedicated flash units, having only one central contact pin, can be mounted on the flash shoe or attached to the Flash PC socket (item 40 in Figure 4-1) via cable.

When you use an automatic flash (3902 compatible) with digital backs, I recommend using the flash in the A mode (using the metering system in the flash unit). This is recommended because the dark, shiny surface of the digital sensor reflects light in a different fashion than film does. TTL metering should therefore not be considered. When you use the A mode, the camera handling is the same as in TTL, with aperture, film speed, and flash exposure adjustments still controlled from the camera.

Shutter Speeds, Flash Sync, and Metering Modes

You can do flash photography with all lenses at all shutter speeds up to $\frac{1}{800}$ second. In many situations you can also use all measuring modes (certainly M, P, Pv, and S) with a properly selected shutter speed. The A and S modes are not recommended for indoor flash work in normally lit rooms. The fairly dark room light may set a long shutter speed that is not suitable for hand-held work. The P and Pv modes are usable because they set the shutter speed at $\frac{1}{60}$ second or shorter.

You can program the H camera so that it can be released only when a dedicated flash is fully charged (see custom option 5). You also have the option of programming the camera so that the flash exposures are made at the moment the shutter is fully open, as normally done (normal sync), or just before the shutter closes (rear sync). This sophisticated option offers interesting possibilities with moving subjects.

You can also program into the camera a flash compensation over an extended range from +3 to −3 EV values so that you can create any desired lighting ratio between the existing light and the flash. This possibility is extremely valuable when you're photographing people on location, where you usually want to reduce the flash exposure two to three EV values. Chapter 17, Flash Photography with Hasselblad Cameras, describes in detail the entire, simple approach for creating beautiful outdoor pictures with flash fill light.

Flash Photography with the H Camera

Setting the Flash Exposure For dedicated flash photography with the built-in or another flash unit with the SCA3902 adapter, follow these steps:

1. Activate the camera and then press the Flash button. This brings up the Flash Option screen.

2. Turn the front control wheel to set the desired compensation from −3 to +3 in ⅓ increments.
3. Turn the rear control wheel either for normal or rear sync.
4. Lock the setting by pressing the Save (Drive) button.

In flash photography with nondedicated flash units, you change the flash exposure by setting the ISO on the flash unit to a higher or lower value—for example, to ISO 400 if it is to be reduced two EV values with ISO 100 film.

In dedicated flash photography, insufficient flash illumination is indicated on the display and in the viewfinder by LOW FLASH. A flash illumination that is excessive for the set aperture, something that seldom occurs and only in close-up photography, is not indicated. You may want to make an exposure test if you visualize this possibility. An unusable setting is indicated by a red warning triangle and the message LOW FLASH on the viewfinder LCD display (see Figure 4-22).

Flash Measuring

The center area of the H camera's auxiliary shutter has a reflective center area that can be used for obtaining exposure readings for other flash units—for example, studio flash—and then serves as a flash exposure meter. This is done as follows:

1. Set the flash unit to Manual.
2. Press the Flash button.
3. Turn the rear wheel until FLASH MEASURE appears.
4. Click the Save (Drive) button to see the flash measure screen.
5. Set the aperture to a value based on your first guess.
6. Aim the camera at your subject, and click the AE-L button at the rear of the grip. This fires the flash with the aperture closed down and the mirror locked up so that the light of the flash can reach the measuring area on the auxiliary shutter to be measured by the sensor in the camera. If the set aperture was incorrect by more than two EV values, the screen shows DIFF EV LOW or DIFF

Figure 4-22 The viewfinder and grip LCD information in flash photography. The viewfinder display **1.** shows that the flash mode was set for rear flash and that the flash exposure is reduced by one EV value. If flash illumination is insufficient, a red triangle appears in the viewfinder together with a flashing green flash symbol **2.** and LOW FLASH appears on the grip LCD display **3.** The green flash symbol also flashes when a flash unit is not fully charged. In flash metering, an incorrect aperture is indicated by LOW or HIGH EV value on the display **4.** The display also reminds you to use the AE lock.

EV HIGH. Open or close the aperture, and make another test until the screen shows a value between −2 and +2 EV. Now use the aperture (the front wheel) to set the value to zero or to any desired deviation from zero. The aperture is now set to produce the desired exposure.

THE USE AND OPERATION OF PROFILES

The H camera profiles allow rapid access to stored combinations of camera settings and functions that provide the best approach for specific applications, eliminating the need to program each function separately each time it is needed. Profiles also allow you to switch from one to the other instantly. For example, for outdoor people pictures, you may want to program the camera for spot metering, in the Zone mode, for A exposure mode, fill flash, and Auto Focus. For landscapes of moving elements, such as water, reflections, wind-blown trees, and flowers, you may select center metering, S exposure mode, and Auto Focus. With the profiles in your camera changed to your way of working, you simply load the desired profile to set the camera accordingly. The profiles provide a fast and safe way to set the camera operations in the most stressful situations.

Four profiles are factory-programmed into the camera. They become visible by clicking the Profiles/Esc button.

- STANDARD: normal flash, auto focus single, single drive, aperture priority, (auto) exposure, and average metering
- FULL AUTO: normal flash, auto focus single, single drive, P exposure, center-weighted metering
- STUDIO: normal flash, manual focus, single drive, M exposure, spot metering
- FILL FLASH: flash exposure set to −1.7 EV, auto focus single, single drive, auto exposure, average metering

If any of these four profiles and their names are satisfactory as they are for your work, turn either the front or the rear wheel to the desired profile, press the Load (AF) button, and the camera is instantly set to the content of that profile.

Making Your Own Profile

You cannot change the camera settings stored in STANDARD, as this provides a fast and convenient way to return the camera to factory default settings. You can change the functions in the other three—FULL AUTO, STUDIO, and FILL FLASH—and make each one your very own Profiles matched to your photographic approaches. To make your own Profile or Profiles, proceed as follows: Program each desired function, for example the ones mentioned for "Outdoor people pictures" as normally done and described earlier. Save each function by clicking the Save (Drive) button. With the camera in the active

mode and the LCD screen showing aperture and shutter speed, click the Profiles/Esc. button. Turn either the front or rear wheel to highlight the one of the three profiles that you want to change. Click the Save (Drive) button which bring up the Profile name screen with the Profile name at the bottom. If you want to keep the Profile name, click the Save (Drive) button again.

If you want to change the name, for example, to change FULL AUTO to OUTDOOR, erase the existing name (FULL AUTO) on the Profile name screen by turning the front wheel to highlight the X character in the boxed area and then depressing the AF (Sel) button repeatedly. This erases one letter at a time Now print the new name OUTDOOR as described in Imprinting Click the Save (Drive) button. Proceed the same way to change any of the other factory programmed Profiles.

To access any one of the existing or the changed Profiles when needed or desired, do as follows: With the camera in the active mode, click the Profile (Esc) button which brings up the Profiles names. Scroll to the desired Profile-OUTDOOR or whatever else it might be with the front or rear wheel. Depress the AF (Load) button.

MOMIX
Dance Company

▲ An image created completely digitally with each of the
30 images made individually with a digital back
attached to Hasselblad and then combined afterwards
in an effective fashion. Made for the Momix dance
company by Howard Schatz Schatz/Orenstein 2001.
Available as a fine art print. www.howardschatz.com

▲ The automatic focusing system with the AF assist light of the H camera set the distance accurately even in the low light levels in Cologne, Germany. The convenient holding and smooth operation of the H camera produced sharp images with a handheld camera and an 80mm lens at the slow 1/30 second shutter speed. Ernst Wildi

▲ Anna Hedstrom, a fashion photographer in Gothenburg,
Sweden used her free flowing style of photography for
producing this image with the Hasselblad H 1 camera

▲ The automatic focusing and the built in metering system makes it easy to produce such well composed images handheld with the H 1 camera, Made with 80mm lens by Jim Morton in Zion National Park

▲ The early morning light was captured handheld with
an 80mm lens on the H 1 camera in Cologne, Germany
by Ernst Wildi and in Monument Valley by Jim Morton

 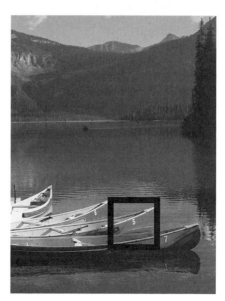

▲ In all four images, the automatic focusing area of the H 1 camera was pointed at the indicated subject area within the scene and locked before making the final composition. Ernst Wildi

▲ A dynamically composed candid wedding photograph
made by Bambi Cantrell with 80mm lens on Hasselblad
H 1 camera

▲ Bambi Cantrell used the 80 mm lens and the automatic features of the H 1 camera to produce this photojournalistic handheld wedding photograph while the H 1 camera was used in the completely automatic "point and shoot" approach by Ernst Wildi to photograph the artist working on the Dom Plaza in Cologne, Germany

5

The Hasselblad V System Cameras and Components

THE HASSELBLAD 500 SERIES CAMERAS

All Hasselblad cameras in the 500 series are identical in the interchangeability of their components and in the use and operation of lenses and magazines (see Figure 5-1). All are completely mechanical, battery-independent, single-lens reflex cameras in which the mirror returns to the viewing position when the film is advanced. The cameras do not have shutters. A rear curtain protects the film from light before and after an exposure is made.

The 500C and 500EL cameras made prior to 1970 are identical to the 500CM and 500ELM models but do not have interchangeable focusing screens. To verify whether your 500 camera has interchangeable focusing screens, remove the viewfinder and check whether the camera has the two focusing screen retaining clips.

Hasselblad Classic

The Classic is basically a 500CM but without a removable winding crank. The Classic camera was sold with an 80mm Planar lens engraved with the letter C. The optical and mechanical design of this lens, however, is identical to that of the CF type except that the Classic does not have the F setting and the interlock between the aperture and the shutter speed ring. The lens can be used on focal plane shutter cameras (except model 202FA), making the exposure with the shutter in the lens.

Hasselblad 501C

This camera model has the 500 Classic design but is equipped with the Acute Matte focusing screen.

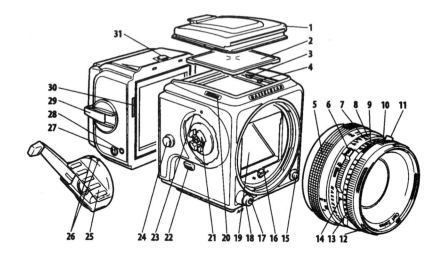

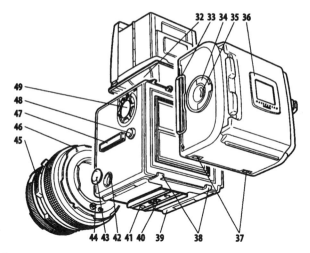

Figure 5-1 500/501/503 components.

1. Focusing hood
2. Focusing screen
3. Screen retaining clip
4. Flash ready signal*
5. Focusing ring and scale
6. Shutter speed and aperture interlock button
7. Central lens index
8. Depth-of-field scale
9. Aperture ring and scale
10. Shutter speed selector ring
11. PC flash terminal
12. Lens accessory mount
13. Exposure value scale
14. Exposure value index
15. Lens lock and release button
16. Drive shaft

17. Cable release socket
18. Shutter release button
19. Mirror
20. Nameplate
21. Winding crank bayonet*
22. Prerelease button
23. Winder bayonet mount*
24. Strap lug
25. Winding crank
26. Winding crank index*
27. Frame counter
28. Magazine status indicator
29. Film winding crank
30. Magazine driving gear
31. Magazine catch
32. Focusing hood magnifier
33. Magazine slide

34. Film insert key
35. Film consumption indicator
36. Film tab holder
37. Magazine support slots
38. Magazine supports
39. Camera support
40. Tripod socket
41. Quick coupling plate
42. Dedicated flash connection*
43. Connection cover*
44. Lens coupling shaft
45. Manual stop down control
46. Lens location index
47. Accessory rail
48. Strap lug
49. Film speed selector*

*Not on 500/501 models

Hasselblad 501CM

The current 501CM is the 501C but with an Acute Matte focusing screen with microprism and split-image rangefinder. The 501CM also has the gliding mirror system (GMS), which shows the entire image on the focusing screen with all lenses and all accessories. The 500 and 501 models do not have a dedicated flash system.

Hasselblad 503CX

The 503CX camera comes with the Acute Matte focusing screen and is equipped with the automatic dedicated flash system.

Hasselblad 503CXi and 503CW

The 503CXi and the current 503CW cameras have a new winding crank design. This lets you attach an accessory motor winder, which is also designed for convenient carrying and handheld camera operation. The winder has two infrared sensors for wireless camera operation and includes a remote release that works up to 33 feet (10 meters). Both cameras have the dedicated flash system, and the 503CW model also has the gliding mirror system.

Camera Finishes

The 501CM and 503CW cameras are available in the ruby red, cobalt blue, forest green, and sun yellow finishes. The use and operation of these models are identical to those in the chrome or black finish.

THE MOTOR-DRIVEN EL CAMERA MODELS

Hasselblad 500ELX

The 500ELX has the automatic dedicated flash system and a gliding mirror arrangement that shows the full viewfinder image with all lenses and accessories. Like those of the earlier EL and ELM models, the 500ELX motor is powered by rechargeable NiCad batteries.

Hasselblad 553ELX

The 553ELX motor, like the motor in all future models, is powered by five standard AA batteries instead of the NiCads. The camera is supplied with the Acute Matte focusing screen.

Hasselblad 555ELD

The current 555ELD has a new heavy-duty motor powered by five AA batteries and a gliding mirror system with a mirror suspension similar to that in the Hasselblad space cameras. The 555ELD camera also has the release mechanism that was part of the space cameras for years.

This camera is ideal for photography with film or for electronic recording via a digital camera back. The rear of the 555ELD has integrated connectors to interface with some digital backs, eliminating cable connections between camera and magazine. The camera also has separate release ports in the front for film photography and digital work. An accessory IR release unit can be attached to the front of the camera for wireless remote operation up to 33 feet (10 meters). It is powered by the camera batteries. The remote control works only on the 555ELD. It cannot be used on earlier EL models.

THE HASSELBLAD 200 SERIES CAMERA MODELS

All camera models in the 200 series have electronically controlled focal plane shutters, the gliding mirror system with an instant return mirror, the Acute Matte focusing screen, the dedicated flash system, and a built-in self-timer. Flash sync with the focal plane shutter is up to $\frac{1}{90}$ second. You can make double or multiple exposures without removing the film magazine.

The winding crank is removable for operation with a motor winder specifically made for these camera models. The cameras can be used with all non-shutter lenses (FE, TCC, and F) as well as the CF, CFi, and CFE types with shutter. With the latter, exposures can be made with the shutter in the lens or the focal plane shutter (except the 202FA, where the focal plane shutter must be used). Using the lens shutter, you can make flash pictures at shutter speeds up to $\frac{1}{500}$ second.

The camera models with built-in metering systems have the electronic Databus connection in the bayonet lens mount to transfer the data from FE, CFE, and TCC lenses into the camera. If you're using lenses that do not have the electronic coupling, you must manually stop down the lens aperture for the meter reading. The cameras with built-in metering systems also have the same electronic connection at the rear of the camera body to transfer the data from E, ECC, or TCC film magazines into the camera's metering system. You can use A-type film magazines. The film sensitivity is then programmed manually into the camera body's metering system.

All cameras need a 6V battery for timing the focal plane shutter speed and for operating the metering system. The rest of the camera operation is mechanical. All cameras (except the 202FA) can be operated without a battery if the shutter in CF, CFE, or CFi lenses is used to make the exposure.

Hasselblad 205

The original model was the 205TCC, with TCC film magazines that have an adjustment that automatically changes the exposure for shorter or longer film developing times. The purpose was to change the contrast on the negative, based on Ansel Adams's principles.

The camera designation was changed to 205FCC, with a change in the dedicated flash operation. The letter F designates that the camera has a focal plane shutter. All 205 cameras have a built-in spot meter with automatic bracketing that can be programmed in $\frac{1}{4}f$ stop values. The shutter speed ranges from 90 seconds to $\frac{1}{2000}$ second (from 34 minutes to $\frac{1}{2000}$ second in Manual mode). The shutter speeds are set electronically to an accuracy of $\frac{1}{12}$ f stop increment but can also be set manually to $\frac{1}{2}f$ stop values. The built-in self-timer can be programmed for delays from 2 to 60 seconds.

Hasselblad 203FE

The 203FE camera is identical to the 205FCC but has a center metering system (not a spot meter) and automatic bracketing in $\frac{1}{3}f$ stop increments.

Hasselblad 202FA

The 202FA model (discontinued) has the features of the 203FE but no automatic bracketing and a shutter speed range up to $\frac{1}{1000}$ second only. There is no manual shutter speed setting. With CF, CFi, and CFE shutter lenses, the exposure must be made with the focal plane shutter, limiting flash exposures to $\frac{1}{90}$ second or slower. CB lenses cannot be used.

Hasselblad 201F

Like the other 200 models, the 201F (discontinued) has the same camera and shutter design, with speeds up to $\frac{1}{1000}$ second adjustable in $\frac{1}{2}f$ stop increments but no metering system. The self-timer can be programmed for either a 2-second or a 10-second delay.

THE HASSELBLAD 2000/2003 CAMERA MODELS

The original Hasselblad focal plane shutter models (discontinued) offer electronically controlled shutter speeds from 1 second to $\frac{1}{2000}$ second, with a focal plane curtain made from very thin titanium, which can easily become damaged when the magazine is off the camera. Extreme care is necessary.

To prevent accidental damage to the shutter, the later 2000 FCM/FCW and 2003 models include a safeguard device that retracts the shutter curtain when the film magazine is removed. On the 2000FCW and the 2003 models,

a motor winder, specifically made for these cameras, can be attached. These two models can also be used without a battery if the shutter in a lens is used to make the exposure. Double or multiple exposures can be made on all models without removing the magazine. The mirror can be made to return instantly after the exposure when the film is advanced, or it can be locked up permanently.

THE HASSELBLAD SUPERWIDE CAMERAS

The Biogon 38mm f 4.5 lens with a 90-degree diagonal angle of view when used for the 2¼ square is the heart of all Superwides, from the earliest models to the latest 905SWC. The lens has shutter speeds and flash synchronization up to $\frac{1}{500}$ second.

The Biogon, permanently mounted on a short camera body without reflex viewing, is an optically true wide-angle design, which provides a distortion-free image with superb corner quality at close and far distances even with the lens aperture wide open. The Biogon focuses down to 12 inches (0.3 meters), making the Superwide an excellent camera for copying or other critical close-up work where a distortion-free image of the highest quality is desired or necessary. The rear of the camera is identical to those of the other Hasselblad models, so the same film magazines can be used. Older camera models, however, do not accept the Polaroid film magazine.

An optical viewfinder attaches to the top of the camera. Because the lens has great depth of field—for example, from 26 inches (66 cm) to infinity at f/22—you can usually achieve sufficiently accurate focusing by visually estimating the distance. However, you can view and focus the image on a focusing screen by removing the film magazine and attaching in its place the focusing screen adapter. This accessory is now equipped with the Acute Matte focusing screen. With this accessory attached, the Superwide is like a large-format, wide-angle camera from a viewing and focusing point of view.

Hasselblad Supreme Wide Angle

The original camera came equipped with a Biogon lens that operated like lenses on large-format cameras, with film advance and shutter cocking being two separate operations.

Hasselblad Superwide C

The next version of this camera model was equipped with a Biogon lens of the typical C lens design. Film advance and shutter cocking became one operation. A spirit level was built into the top of the camera body, with a prism attached to the viewfinder. This arrangement makes it possible to see the level setting from the viewing position.

Hasselblad Superwide SWC/M

The position of the viewfinder and the tripod coupling are changed slightly to allow the use of the Hasselblad instant film magazine. Newer SWC/M camera models also have a Biogon with the CF lens barrel design and are supplied with the new 903 model viewfinder.

Hasselblad 903SWC

The spirit level is no longer on the camera body but instead is on the top of the removable viewfinder and is visible in the viewfinder, together with the image area covered on the film. You can therefore see the position of the spirit level while you compose the image, and this allows you to do critical work, handheld if desired. The viewfinder also has a magnifier at the bottom that allows you to see the distance setting on the lens in the viewfinder. This new viewfinder can be attached to older camera models, but the distance setting is visible in the finder only with cameras that have the CF lens design.

Hasselblad 905SWC

The current 905 model is like the 903SWC but has a newly designed Biogon lens with reduced improvime. This can produce images with better color saturation, especially when you are photographing against bright background areas.

THE HASSELBLAD FLEXBODY AND ARCBODY CAMERAS

The Hasselblad V system also includes the FlexBody and the ArcBody models. In spite of their value in making the Hasselblad system even more versatile by providing swing and tilt control, the two cameras are no longer manufactured.

COMPONENT INTERCHANGEABILITY IN THE V SYSTEM

Many features and operations are identical on all Hasselblad V system cameras. The rear of the camera body is designed so that film magazines can be switched from one camera to another at the end or the middle of a roll of film. All the models, except the Superwide models made before 1980, also can be combined with the Hasselblad instant film (Polaroid) magazine. The magazine interchangeability is also included in the FlexBody and ArcBody and even in the original 1000F and 1600F models. The very early magazines with serial numbers below 20000, however, are usable only on 1000F and 1600F cameras.

All cameras can be used with the tripod coupling, but older camera models require that you add the Hasselblad quick coupling plate to the camera for use with the latest tripod coupling.

The lens mount was changed in 1957, so lenses from the original 1000F/1600F focal plane shutter models cannot be used on newer cameras and vice versa. However, all V system cameras made since 1957, except the ArcBody, have the same lens mount. All V system lenses fit on all cameras (except the ArcBody), but there are some restrictions regarding the use of shutter lenses on focal plane shutter cameras.

HASSELBLAD SHUTTER LENSES

Hasselblad lenses with shutters are indicated with a C (C, CF, CB, CFi, and CFE). The letter F in the designation indicates that those lenses, which also have an F setting on the shutter speed ring, can be used on focal plane shutter cameras as well.

C Lenses

The original Carl Zeiss C lenses were distinguished by their unique lens barrel design, with interlocked aperture and shutter speed rings, automatic depth-of-field scales, M and X flash synchronization (sync), and the built-in self-timer (see Figure 5-2). They should not be used on focal plane shutter cameras. The C lenses were discontinued in 1981. Although such lenses can still be cleaned and lubricated, many spare parts are no longer available, and more extensive service is therefore no longer possible.

CF Lenses

In 1982, all C lenses (including the 38mm Biogon on the Superwide) were replaced by the CF line. These models have a completely redesigned lens barrel and a new shutter, as well as new features to improve their operation. Some seldom-used features were omitted, including the self-timer.

Aperture and shutter speed rings are no longer interlocked but can be locked together easily when desired. The manual stop down control is more convenient, and the M sync setting has been eliminated. Figure 5-2 shows how to distinguish between C lenses and the CF and similar types.

CFi Lenses

The CFi lenses are optically identical to the CF types. The changes are in the lens mount. The front bayonet mount is made from a solid black acrylic material that is almost indestructible, and the rear bayonet ring is made from a single piece of specially treated metal. Focusing is extremely smooth, and the

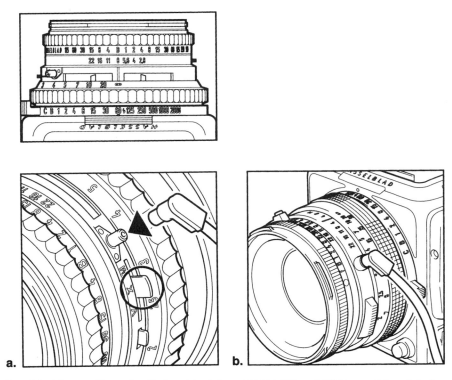

Figure 5-2 C lenses (a) can be distinguished from CF, CFi, CB, and CFE types (b) mainly by the VXM lever on the left side. This control is only on C types.

flash connector is equipped with a cable locking device. The CFi lenses also have a newly designed mainspring made from Nivarox, which is expected to perform reliably three times longer than the other types. The interior behind the lens elements has been opened up to reduce possible light reflections on the interior surface.

CFE Lenses

Lenses designated CFE are identical to CFi types but also have the electronic connections for the light-metering system in the 200 camera models.

CB Lenses

In the limited line of CB lenses, now discontinued, Carl Zeiss eliminated some features and functions that many photographers do not need, such as the F setting on the shutter speed ring. CB lenses can be used on focal plane shutter cameras (except the 202FA), but the exposure must be made with the shutter in the lens. Some lens designs (the 60mm, for example) are

identical to that of the CFi type. Others are new and different but produce an image sharpness that is completely up to Hasselblad standards.

LENSES WITHOUT SHUTTERS

Hasselblad decided to produce focal plane shutter cameras in 1977, mainly to allow the use of larger-aperture lenses. Adding a shutter to a lens made it difficult, if not impossible, to increase the maximum lens aperture, at least at that time. The Carl Zeiss F lenses were originally designed for the 2000 camera models, which did not have a built-in metering system; the lenses therefore did not include an electronic coupling to the camera body. The F lenses became TCC types with electronic Databus connections when the 205TCC camera was introduced. The lenses changed later, in name only, to the FE types. CFE lenses are shutter lenses with electronic Databus connections. They can be used on all V system cameras (except the Superwides).

THE V SYSTEM COMPONENTS

Removing and Attaching Lenses

Removing the Lens All cameras in the V system since 1957 have identical bayonet lens mounts. To take the lens off, press the lens lock lever, turn the lens about 35 degrees counterclockwise (preferably by holding the lens on a nonmovable part), and lift it out (see Figure 5-3). Lenses with or without shutters can be removed and attached only when the shutter is cocked and the camera is ready to be released but is not prereleased.

If the shutter in the lens is not cocked, turning the winding crank or knob on all models with manual film advance solves the problem but also advances the film. You can avoid this by removing the magazine before turning the crank. Use the same procedure with a camera in the prereleased mode, but press the camera release after the magazine is removed and turn

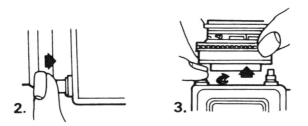

Figure 5-3 Before removing a lens, first check that the winding crank has been turned. **2.** Press the lens lock button. **3.** Turn the lens counterclockwise as seen from the front.

the crank or knob before reattaching the magazine. On 200 and 2000 series cameras, simply turn the winding crank while pressing the center chrome button, as for double exposures.

When EL models are prereleased, the operating control is probably set to SR or AS; if it is, remove the magazine, set the operating lever to 0, and press the release to bring the camera into the normal position.

Attaching the Lens To attach a lens to any camera body, it is not necessary, nor is it recommended, to press the lens lock lever. Instead, simply place the lens into the mount and turn it clockwise until you hear a definite click, which indicates a complete and secure combination of body and lens (see Figures 5-4 and 5-5). Lenses can be attached only if the shutter in the lens is cocked and the ridge on the camera's connecting shaft points to the dot. If neither is the case, reset the camera or the lens as if removing the lens.

The Hasselblad shutter lenses are designed to be stored with the shutter in the cocked position. They are designed for this type of operation. There are no parts in the lens that wear out because of the shutter being left in the cocked position.

The suggestions for attaching and removing lenses apply to all camera models and all lenses, including the types with the electronic coupling. These

Figure 5-4 **4.** To attach a lens, insert the lens in the bayonet mount so that the marking on the lens mount is aligned with the mark on the camera. **5.** Rotate the lens clockwise until it clicks into place.

Figure 5-5 **6.** Lenses can be attached only if the slot or ridge on the coupling shaft (A) is lined up with the dots (B) on the camera body and lens. If the camera slot is not lined up, turn the winding knob, or, on the EL models, change from the prereleased to the normal position. **7.** If the slot in the lens is not lined up, insert a coin in the slot and make one full turn clockwise.

suggestions for mounting and removing lenses also apply to bellows, tele-converters, and extension tubes with or without electronic coupling.

In addition, you must remember to remove the components from the camera in the proper sequence. Always remove the lens first from the con-verter, tube, or bellows; then remove the accessory from the camera body. You can remove lens and accessory together from the camera, but never remove a lens from the accessory without the components being attached to the camera. There is nothing to prevent the shaft from turning and uncock-ing the shutter during the process, and that might jam the lens and acces-sory together.

Removing and Attaching Film Magazines

The instructions for attaching and removing film magazines apply to all Has-selblad rollfilm and 70mm magazines with or without electronic contacts.

Removing the Film Magazine Hasselblad film magazines can be removed from all camera bodies, whether they are loaded with film and whether the film has been advanced. They can be removed, however, only when the darkslide is inserted completely. The purpose of the darkslide is to keep the film maga-zine completely light ight when it is removed from the camera. A darkslide in the magazine also prevents accidental releasing of the camera. As long as a darkslide is in the magazine, the camera release cannot be pressed. To remove a magazine, push the magazine lock on top of the magazine to the right (see Figure 5-6).

Attaching the Film Magazine Before a magazine is attached to the camera, determine whether the camera is in the ready position. If it is, attach the magazine by hooking the two lower support catches onto the camera body and pivoting the upper part of the magazine toward the camera body until it locks into position; remove the darkslide, and the camera is ready for the next shot.

Magazines with or without film can be attached to a camera whether or not the film has been advanced. You can check the latter by looking at the round window on the frame counter side. If it is white, the film has been advanced; if it is red, the film has not been advanced. You can check whether there is film in the magazine by looking at the film consumption window on the other side of the magazine. If it is all or partially red, it contains film. If it is all chrome, it is empty.

If you attach a magazine with film advanced (the signal is white) to a body that is not in the ready position, you will waste a frame, because the necessary shutter cocking will advance the film again. To avoid wasting a frame, lift the magazine off again and then turn the winding crank; or, on the focal plane shutter models, turn the winding crank while pressing the slotted disc.

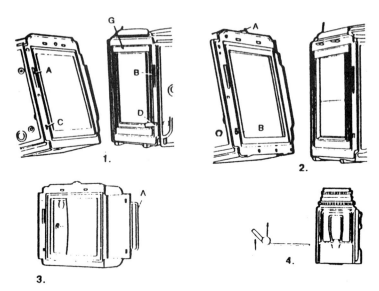

Figure 5-6 *The camera/magazine connection* **1.** A gear (A) on the magazine connects to the winding mechanism (B) of the camera. The opening (C) is for the pin (D) that comes out of the camera when the darkslide is out and the release is pressed. The 2000FCM and 2003 models also have a shutter retraction control (G). **2.** When the darkslide is inserted, a piece of white metal (B) covers half the opening so that the pin cannot penetrate and the release cannot be pressed. The magazine lock button (A) can be pressed only when the darkslide is fully inserted. **3.** The handle of the magazine slide (A) is moved to one side to clear the film insert. **4.** It is best to insert the magazine slide with the handle toward the camera front. E, ECC, and TCC magazines and camera models with a built-in metering system also have the four electronic connectors.

If the film has not been advanced (the signal in the magazine is red), attach the magazine to a camera body that also has not been cocked. Turn the winding crank, and then remove the darkslide; the camera is ready for the next shot.

There is one exception to this case. When you are making double exposures, the second exposure is made without the film having been advanced (that is, the magazine with a red signal is attached to a camera body) with a shutter cocked.

Figure 5-7 shows how to remove a magazine and attach a new one.

Operating the Instant Film Magazine

With instant film (Polaroid) magazines, you can turn the camera's winding crank without affecting the film. The current instant film magazine can be used on all newer camera models; the older, discontinued type 80 can be used only on 500Cs and 500ELs. Neither type can be used on Superwide cameras made before 1980.

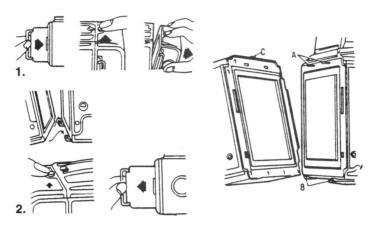

Figure 5-7 **1.** To remove a magazine, insert the darkslide. Press the magazine lock (C) on top of the magazine to the right, move the top of the magazine away from the camera, and lift the magazine off the two lower support catches. **2.** When attaching a magazine with the darkslide inserted, hook the bottom of the magazine onto the lower two support catches of the camera body (B). Pivot the top of the magazine toward the camera latches (A) while pressing the magazine lock (C) to the right. Remove the darkslide.

Attaching and Removing Viewfinders

Until the introduction of the 205TCC in 1991, all viewfinders were inter-changeable among all SLR models, including the 1000F and 1600F. On the 205 cameras and subsequent models with built-in metering systems, the viewfinder display panel prevents a "regular" viewfinder from being pushed forward completely.

The 205TCC was introduced with viewfinders that have the necessary cut-out for the display panel in the front. These new viewfinders can be used equally well on all the other camera models. This means that all the viewfinder types made since 1990 have the front cut-out and are usable on all camera models in the V system as well as on the focusing screen adapters made for the Superwides, the FlexBody, and the ArcBody. If you have older types, you must switch to the newer type when adding or switching to a camera model with a built-in metering system. The older types cannot be modified.

All viewfinders, old or new, are mounted and removed from a camera in the same fashion. After detaching the film magazine, slide the viewfinder toward the rear (see Figure 5-8). Slide in the new viewfinder from the rear, and replace the magazine.

Changing Focusing Screens

On all Hasselblad V system camera models made since 1970, you can remove the focusing screen after removing the film magazine and the viewfinder. To remove a screen, push the two retaining clips in the camera body toward the

Figure 5-8 *Changing a viewfinder* Viewfinders can be removed only with the film magazine detached. **8.** Slide the finder toward the rear and off the camera. **9.** Slide in the new viewfinder from the rear, making certain that it is properly placed in the guiding grooves.

Figure 5-9 *Changing a focusing screen* **1.** After removing the film magazine and viewfinder, push both screen retainers (A) into the camera body, and turn the camera upside down. The screen will drop out easily (if it does not, push gently from inside the camera body). **2.** Drop the new screen into the square opening, with the finished side up. **3.** Make certain that the screen rests on all four supports (A). The screen retaining clips will close automatically when the viewfinder is attached to the camera.

sides (see Figure 5-9). The clips are pushed back automatically when the viewfinder is inserted. To avoid finger marks, hold the screens by the edges.

Because the focusing screens and the opening in the camera are square, the screens can be inserted vertically or horizontally. A screen with a split-image rangefinder can be placed so that the dividing line is either horizontal or vertical. The screen must, however, be inserted the right way up. The finished side, which has a metal frame over the screen, must face up.

Changing the Winding Cranks or Knobs

On all camera models with removable winding cranks, the crank (or knob) is best removed and attached with the camera in the cocked position when the winding mechanism does not rotate (see Figures 5-10 and 5-11).

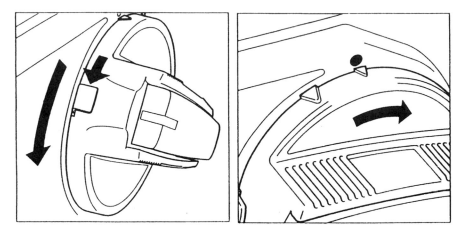

Figure 5-10 *Changing winding cranks on newer models* To remove the winding crank, push the locking lever downward while turning the crank counterclockwise (left). To attach the crank or motor winder, place the winder or motor with the small black triangle opposite the dot on the camera, and turn it clockwise until it locks into position (right).

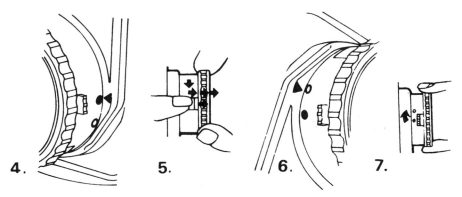

Figure 5-11 *Changing the winding crank or knob on older cameras* **4.** The dot (or the large triangular mark) on the crank or knob is usually opposite the red triangle on the camera body. **5.** To change the knob or crank, put the camera in the ready position and push the locking device on the knob or crank away from the camera body. On the newer cranks, press the center button while turning the knob or crank counterclockwise. **6.** Attach the knob or crank by pressing it against the camera body, with its engraved circle (or the small triangular mark) opposite the triangular index on the camera body. **7.** Turn it clockwise, and it will lock into position as soon as the red dot and the triangle match.

The Auxiliary Shutter

The purpose of the auxiliary shutter at the rear of lens shutter SLR cameras is to protect the film from light before and after an exposure is made. When the release is pressed, the top baffle plate flips up and the bottom plate flips down; they stay in this position until the pressure is taken off the release. Although the baffle plates cannot be damaged easily, care is nevertheless rec-

ommended. Check their proper operation occasionally by making certain that they open and close completely, as described in the section Checking the Camera Functions later in this chapter.

The Focal Plane Shutter

In the focal plane shutter cameras, the shutter curtain controls the exposure time and protects the film from light before and after the exposure. When the shutter in a lens is used to make the exposure (with the focal plane shutter set to C), the focal plane curtain works like the auxiliary shutter. It opens when you press the release, and it closes when you remove your finger from the release.

CHECKING THE CAMERA FUNCTIONS

Because all Hasselblad cameras can be operated without the film magazine attached to the camera body, you can easily check the camera and lens functions. With the magazine removed and the camera pointing toward a bright area, look through the camera body/lens combination from the rear to see what is happening when the release is pressed.

Make certain that the two rear baffle plates are completely out of the light path when the release is pressed and that they close completely and tightly when the button is released. Set the aperture ring at a small aperture, and check whether the diaphragm closes down to the preset aperture and whether the diaphragm has the familiar shape indicating that all blades are opening properly. With focal plane shutter cameras set to C, make certain that the curtain fully opens when you press the release and that it closes when you remove your finger from the release. You can also check whether the long shutter speeds (1 second, $\frac{1}{2}$ second, $\frac{1}{4}$ second) in the lens or focal plane shutter are approximately correct.

You can check the proper timing of the auxiliary or the focal plane shutter in relation to the shutter in the lens. The rear curtains or the focal plane shutter must be fully open when the lens shutter opens and closes. After attaching a flash unit to the camera or lens, you can also check the flash synchronization. You must see the flash firing while the lens or focal plane shutter is fully open.

If anything does not function as it should, it is usually an indication that the camera and/or lens should be cleaned and lubricated.

Bottom Plate and Tripod Socket

Although the newer camera models have a more solid and more professional-looking bottom plate, the tripod coupling plate design has been maintained, and all camera models can therefore be used with the tripod coupling. Older

models, however, may need the quick coupling plate for mounting the camera on the latest tripod coupling models.

Tripod couplings have been modified and improved over the years; the later models come with a built-in spirit level. The tripod coupling introduced in 2002 has two spirit levels that are helpful for perfect vertical or horizontal alignment of the camera and has the locking controls in a somewhat different position for most convenient mounting and detaching of H1 camera models. This latest type should be used with these new cameras.

Over the years the size of the tripod screw also has been changed and in some cases may have to be changed before you can attach a camera or accessory. Check with the Hasselblad agent or service department.

▲ Two wide-angle approaches. Photograph in Arizona made at the 60mm focal length setting of the 60–120mm Hasselblad zoom lens and Lake Louise photographed with a 50mm wide angel which allowed the inclusion of a sharp foreground area to enhance the feeling for depth. Both pictures Ernst Wildi

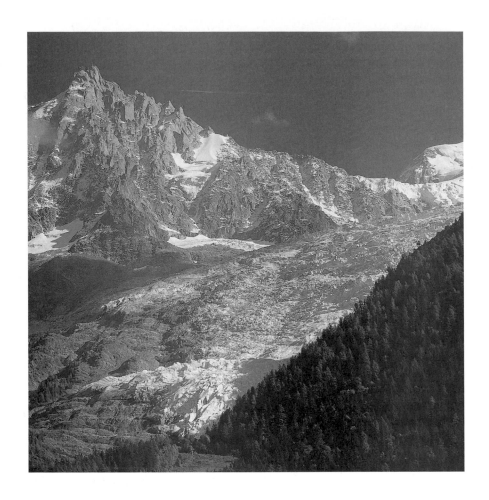

▲ Example of the superb image sharpness of the Carl
Zeiss Sonnar 180mm lens Mountains in Chamonix,
France, taken with polarizing filter by Ernst Wildi.

▲ Image of a Chapel in France demonstrates the quality
of the apochromatic 250mm Carl Zeiss Sonnar
Superachromat. Ernst Wildi

▲ The Biogon 38 mm, used for this picture in Hawaii is
recognized as a top performing wide angle lens for film
or digital photography. The Biogon has no trace of
visible distortion and is, therefore, a great lens for
critical architectural work. Ernst Wildi

6

Operating V System Cameras

THE BASIC CAMERA OPERATION

On all Hasselblad V system cameras without a built-in motor or a motor drive accessory, the film is advanced and the shutter recocked by a full turn of the winding crank or knob. On the motor-driven EL models set to the normal 0 operating position, or on any of the other 500, 200, and 2000 camera models equipped with a motor winder, the film is advanced and the shutter recocked automatically after the picture has been taken.

The Operating Signals

Hasselblad camera bodies interlock with the lenses and magazines so that they can be released only when all the settings are correct. The bodies or magazines have signals that show whether there is film in the camera, how many frames have been exposed, and whether the film has been advanced (see Figure 6-1). The frame counter is coupled to the transport mechanism in the magazine and works with or without film. It therefore cannot be used to determine whether the magazine is loaded with film.

SETTING APERTURE AND SHUTTER SPEEDS

CFi and CFE Lenses

On CF, CFi, and CFE shutter lenses, the aperture and the shutter speed ring rotate separately. You set and change the aperture, the shutter speed, or the EV value by turning either ring. To interlock the two rings, you press the cross coupling button on the aperture ring.

The shutter speed ring stops at B and does not automatically move into the F position, which is used when the focal plane shutter is used to make the exposure. To move the ring to F or out of F, you must press the locking button, which is green on CF lenses and orange on the CFi and CFE types. The aperture can be set at the engraved figures or between for $\frac{1}{2}$ stop settings. The shutter speed ring must be set at the engraved figures.

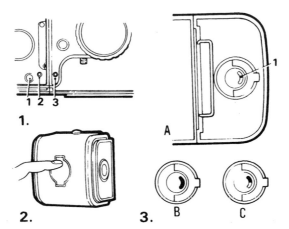

Figure 6-1 *The operating signals* **1.** The film counter in the magazine (1) shows how far the film has been advanced. The operating signal in the magazine (2) is white when the film has been advanced, red when the film has not been advanced. Older cameras also had a signal in the camera body (3), which showed white when the shutter was cocked, red when uncocked. **2.** In the old nonautomatic magazine, you see the paper backing of the film when the film indicator window is opened. **3.** When an automatic magazine (A) is newly loaded, the film consumption indicator is all chrome (1); when there is no film in the magazine or the roll of film is at the end, the indicator is all red (B). A partially exposed film is indicated by an intermediate red/chrome position (C).

CB Lenses

The operation of the CB lenses is identical to the CFi types except that the CB lenses do not have the F setting. They can be used on focal plane shutter cameras (except the 202FA) if the shutter in the lens is used for the exposure.

Figure 6-2 shows the lens controls on the CFi, CFE, and CB lenses.

CF Lenses

Some of the operating controls, such as the manual stop down, the interlock, and the F position lock, are slightly different on the CF lenses but are operated in exactly the same fashion. CF lenses do not have the locking arrangements on the flash socket, which is one of the distinguishing marks between CF lenses and CFI, CB, and CFE types. Figure 6-3 shows the operation of CB and CF type lenses.

FE, TCC, and F Non-shutter Lenses

FE and TCC lenses have the electronic coupling for the metering system; the F lenses do not. Operating aperture and shutter speed controls are identical. The shutter speed ring, which is part of the camera body, can be set at any

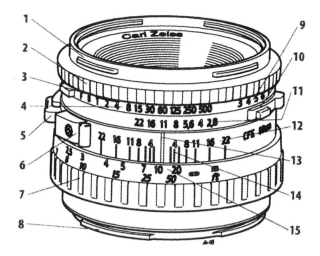

Figure 6-2 CFi, CFE, and CB lens controls.

1. External and internal bayonet mount
2. Shutter speed ring
3. Warning mark
4. Shutter speed scale
5. Manual stop down control
6. Flash terminal with lock
7. Focusing ring
8. Lens bayonet plate
9. EV scale
10. Aperture/shutter speed interlock
11. Aperture ring and scale
12. Depth-of-field scale
13. Index
14. Infrared focusing index
15. Distance scale

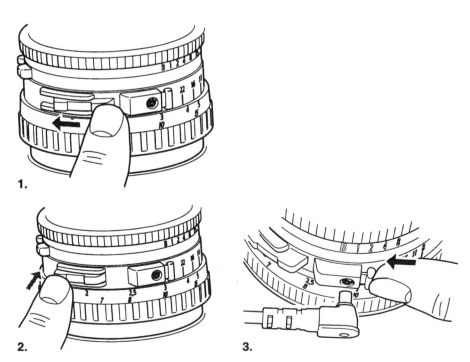

Figure 6-3 *Operating CF/CB lens controls* **1.** To close the aperture down manually, slide the knob in the direction of the arrow until it clicks into position. **2.** To return the aperture to the fully open position, press the lower part of the control. **3.** To attach a flash cord, press the locking button. When the button is released, the cord will be locked in the flash socket. To remove the cord, press the lock button again.

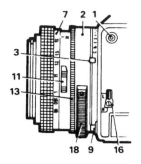
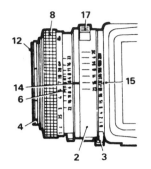
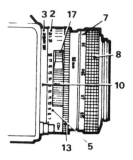

Figure 6-4 FE, TCC, and F lens controls.

1. Flash outlet in camera body for focal plane shutter
2. Aperture scale
3. Shutter speed ring and scale on camera (not on 202FA)
4. Bayonet mount for lens shade
5. EV scale
6. Depth-of-field indicator
7. Distance scale
8. Focusing ring
9. Lock for bayonet lens mount
10. Index for EV scale
11. Manual stop down control
12. Inside bayonet mount for filters
13. Grip ring for attaching and removing lenses
14. Index for aperture
15. Index for shutter speed
16. Shutter speed lock (only on 2000/2003 cameras)
17. Button for cross coupling of aperture and shutter speed (does not work on 200 series cameras)
18. Grip for aperture and EV setting

of the engraved shutter speeds or halfway between them. For example, between 500 and 1000, the shutter speed is $\frac{1}{750}$ second. The shortest flash sync speed of $\frac{1}{90}$ second is indicated by X. You set the aperture by turning the ring at the rear of the lens at the engraved figures or between for $\frac{1}{2}$ stop settings. On discontinued 2000/2003 cameras, you can couple the aperture and the shutter speed ring by pressing the cross coupling button on the aperture ring. Figure 6-4 shows operating controls on nonshutter lenses.

Operating C Lenses

On old C-type shutter lenses shown in Figure 6-5, the aperture and shutter speed rings are interlocked. Rotating the knurled ring in front of the shutter speed engravings changes shutter speed and aperture. You can set the aperture and shutter speed rings separately after pressing the cross coupling lever toward the camera body with your right hand. C lenses can be set at the engraved apertures or halfway between. Shutter speeds can be set only at the engraved figures.

The Self-Timer in C lenses

With the self-timer in C lenses, the exposure is made approximately eight seconds after the release is pressed. You make self-timer exposures by setting the flash synchronization lever to V. You cannot move the lever without releasing its lock, something that requires two hands. This difficulty is deliberate.

The rear curtain of the SLR models must be open eight seconds after the release is pressed, so the release lock on the camera or cable release must be

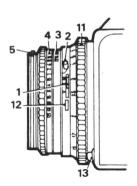
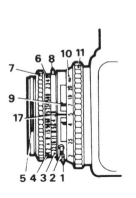
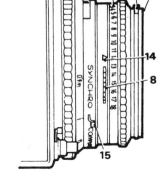

Figure 6-5 C lens controls.

1. Synchronizing lever
2. Flash outlet
3. Aperture scale
4. Shutter speed scale
5. Bayonet mount for lens shade
6. EV scale
7. Shutter speed ring
8. Aperture and shutter speed interlock

9. Depth-of-field indicator
10. Distance scale
11. Focusing mount
12. Lock for sync lever
13. Lock on camera for bayonet lens mount

14. Index for EV scale
15. Manual stop down control
16. Inside bayonet mount for filters
17. Index for aperture and shutter speed

used. The flash synchronization lever automatically jumps back to X after each exposure, so it must be reset to V if another self-timer exposure is made. The self-timer position V is synchronized for electronic flash.

Using Long Shutter Speeds

When shutter lenses are set to shutter speeds 1, 2, and 4 (corresponding to 1-second, $\frac{1}{2}$-second, and $\frac{1}{4}$-second shutter speeds), you must keep the camera release pressed until you hear the sound of the shutter closing; otherwise, the rear curtain closes when you remove your finger from the release and before the exposure cycle is finished. You need to take the same precaution on the focal plane shutter camera models when the exposure is made with the shutter in the lens.

Time Exposures

On 200 series cameras, electronically controlled long exposures up to 90 seconds can be made with the focal plane shutter in any exposure mode. For even longer exposures—up to 34 minutes—you can use the focal plane shutter in the Manual Exposure mode.

The longest adjustable speed in all V system shutter lenses is 1 second. For longer speeds, you set the shutter in the lens to B, where it stays open as long as the release on the camera or the cable release is pressed. Cameras or lenses set at B are still flash synchronized.

The old C lenses have green figures (4 to 125) on the left side of B, simply indicating how long the exposure time must be at the engraved aperture setting. To obtain shutter speeds longer than 1 second, you set the shutter speed ring at B and the desired aperture opposite B and the index. Press the release for the indicated number of seconds.

DISTANCE SETTING

You can make the distance setting on any lens by focusing on the main subject, or you can base it on the desired depth of field. All lenses in the V system (except the old C types) have large rubberized focusing rings that are far away from the camera body, so they can easily be reached and operated. On the latest CFi, CFE, and CB lenses, focusing is also exceptionally smooth even in cold weather.

Quick Focusing Handles

The focusing ring on some older C lenses was close to the camera body and not exceptionally easy to turn. To simplify the process, Hasselblad made quick focusing handles that attached over the focusing ring. Because the large, rubberized focusing rings on the new lenses allow easy, fast, and convenient focusing, such focusing handles are no longer made.

Focusing Apochromatic Lenses

The focusing ring on apochromatic lenses does not stop at the infinity mark but can be turned a few millimeters beyond this point. This is because the fluorite elements in these lenses are more sensitive to changes in temperature than glass elements, and distance settings may vary depending on the temperature. You should always focus on the image shown on the focusing screen; don't guess the distance or simply set the scale at infinity for anything that is far away.

RELEASING THE CAMERA

Hasselblad V system cameras can be released when the shutter is cocked, the darkslide is removed, and the frame counter in the magazine shows a number (not a black area). The release cycle in V system SLR cameras is shown in Figure 6-6.

Camera steadiness is determined by the way you operate the release. Push it slowly and gradually, so that you hardly know when it goes off. The releases have some free play to avoid accidental exposure at the slightest touch of the release. For smoothest operation, move the release to the

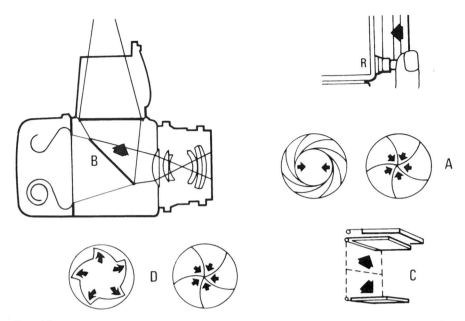

Figure 6-6 *The release cycle on all V system SLR camera models when the shutter in the lens is used* When the camera release is pressed, the lens shutter closes and the diaphragm stops down to the preset aperture (A), the mirror moves up (B), and the auxiliary shutter or focal plane shutter opens (C). The lens shutter opens and closes at the set shutter speed, or, in the B setting, the shutter closes when the finger is removed from the release (D). Depending on the camera model or the set operating mode on some models, the mirror returns either instantly after the exposure or when the film is advanced.

halfway position so that only a slight additional pressure makes the shutter click. On the 200 series cameras with built-in metering systems, pressing the release halfway also turns on the metering system.

Release Lock in Older 500 Cameras

The 500 series camera models used to have a small lever around the release button shown in Figure 6-7; it could be set to either 0 or T. When set to T, the release button stayed in even when you removed your finger. The release lock had to be used in combination with the self-timer in C lenses. It could also be used for time exposures, but that was not a recommended procedure because it was likely to produce camera motion. For time exposures, it is necessary to prerelease the camera and use a cable release. The release lock had no effect when you used a cable release. The film winding crank could not be turned when the release lock was set to T. Because the lock serves no practical purpose with today's lenses, it has been eliminated, except on the Superwide cameras.

1. **2.** **3.**

Figure 6-7 *The release lock* **1.** Set to T; the release lock in earlier 500 models keeps the auxiliary shutter open until the lever is moved back to 0. **2.** EL models have a release lock on the side of the battery compartment with the operating position 0 in the center, a release lock L to prevent accidental releasing at the top, and a lock T for time exposures at the bottom. **3.** Superwide cameras still have the release lock next to the release.

The Release on EL Camera Models

The release button is a separate item that is inserted in either one of the two openings at the front of EL cameras. On the 555ELD, the release button must be inserted in the lower opening for photography with film, or in the upper opening for digital recording. On the other EL models, it makes no difference which opening is used. You can use one opening for the small release button and the second for any of the accessory FK release cords. Some EL models come equipped with the large square release button that the astronauts use. It is removable, and when it is removed, the camera has the same two release openings.

The EL is released by electrical contact, not by mechanical means, even though the camera operation is mechanical. All EL models can also be released through the side socket at the rear of the camera using an SK release cord. EL cameras have a release lock in the form of a lever on the battery compartment, shown in Figure 6-7. Set to L, the camera cannot be released, an arrangement that prevents accidental exposures. A zero (0) in the center is the operating position. T can be used for time exposures. With the lens set to B, the shutter opens when the lever is moved to the lower T position and closes when moved back to 0. This procedure, however, is likely to create camera motion and therefore is not recommended. Use the release cables for this purpose after prereleasing the camera.

The Release Cycle on Focal Plane Shutter Cameras

When the lens shutter is used, the release cycle is identical to that of the other cameras except that the focal plane shutter (instead of the auxiliary shutter) opens and closes. On all the 200 series cameras, the mirror returns

instantly after the exposure is made. When the focal plane shutter is used, the release cycle is as follows:

1. The diaphragm stops down.
2. The mirror moves up.
3. The focal plane shutter opens and closes to make the exposure.
4. The lens diaphragm opens, and the mirror moves down.

Operating the 201F Camera

The 201F focal plane shutter camera without metering system shown in Figure 6-8 has a shutter speed range from 1 second to $\frac{1}{1000}$ second. You can lock the shutter speed setting by pushing forward the locking knob above the battery compartment. This is recommended when the focal plane shutter is set to C for use of the shutter in the lens.

The built-in self-timer can be programmed for a 2-second or a 10-second delay. For a 10-second delay, push the Mirror Lock-Up control once (after the mirror is locked up); for a 2-second delay, press twice. The 201F also has the ASA dial on the side for use with dedicated flash. It is set and used like the control on the 500 models.

To check the condition of the battery, turn the shutter speed ring to bring the battery symbol opposite the index as shown in Figure 6-9. If the battery is in good condition, the ready light of the dedicated flash system in the viewfinder lights up. If the ready light is already lit, the light intensity increases if the battery is in good condition.

Figure 6-8 The discontinued 201 camera is distinguished mainly by the ASA dial for dedicated flash. Above the battery compartment is the lock for the shutter speed ring.

Figure 6-9 *201 Battery check* The condition of the 201 battery is checked by placing the battery symbol on the shutter speed ring opposite the index.

Special Operating Controls on 2000/2003 Camera Models

The 2000/2003 cameras basically operate like the newer focal plane shutter models but have a few unique operating controls. The mirror motion is adjustable so that the mirror returns instantly or returns when the film is advanced or remains locked in the upper position (a permanent mirror lock up) (see Figure 6-10). On the 2000FCW and 2003FCW models, you must remove the winding crank or motor to change the mirror program disc.

You can lock the shutter speed setting by moving the lever above the battery compartment from O to L, a recommended procedure when the shutter is used in the C setting (see Figure 6-11). A shutter speed multiplier accessory, used in place of the battery compartment, was available and multiplied the set shutter speed by 60 (a 1-second setting becomes 60 seconds).

On the 2000FCM and the 2000FCW and 2003FCW models, the focal plane shutter automatically retracts when a film magazine is removed. When you reattach the magazine to such a camera and remove the darkslide, you will expose the film because the shutter is open. The proper procedure is as follows: Either recock the shutter before you attach the magazine, or attach the magazine; but before removing the darkslide, turn the winding crank with the center disc pressed as for double exposures. Now remove the darkslide. With a motor winder shown in Figure 6-12 on the camera, the shutter is automatically recocked when the film magazine is reattached. You can disconnect the shutter safeguard feature by pushing the lever on the rear of the camera body to the side.

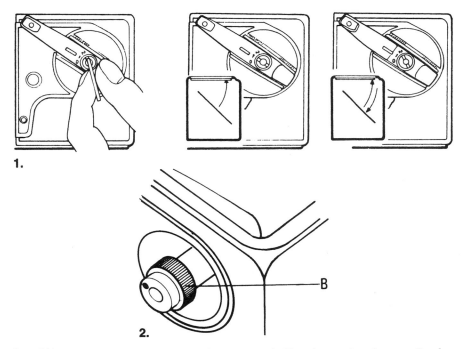

1.

2.

Figure 6-10 *Mirror motion on 2000/2003 cameras* **1.** You change the mirror motion by turning the slotted disc with a coin. Turn the disc to 1 if the mirror is to return when the shutter is recocked, to 2 for instant return operation, or to 0 if the mirror is to be permanently locked up. **2.** To change the mirror motion on 2003FCW models, remove the crank or motor, pull out the ring (B), and turn the shaft to 1, 2, or 3.

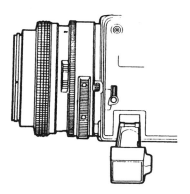

Figure 6-11 *Shutter speed lock on 2000/2003 models* You lock the shutter speed ring by pushing the locking lever above the battery compartment downward so that the indicator points toward L. The battery compartment on all focal plane shutter cameras is identical and can be removed easily using the fingernails. Remove and insert the battery compartment only with the camera in the ready position, with the shutter cocked and the mirror down.

PRERELEASING THE CAMERA

Before you can make an exposure on any V system SLR model using the shutter in the lens, the lens shutter must close completely, the aperture must close to the preset opening, the mirror must move out of the way, and the auxiliary or focal plane shutter must open. The required operations cause a

Figure 6-12 *Motor winder for 2000/2003 cameras* To attach the motor winder, align the triangular mark on the winder with the index on the camera. Turn clockwise until it stops. To detach the motor winder, pull the tab (A) away from the camera, and turn the winder counterclockwise. The winder can be attached only if the dots (B) on the winder and shaft are aligned. Turn the shaft, if necessary.

slight delay so that the picture is taken approximately $\frac{1}{25}$ second after the release is pressed. If you want to avoid this delay in sports or action photography, you can set the camera in a prerelease mode (see Figure 6-13). The shutter now opens and closes instantly, and the picture is taken without any delay, just as on a rangefinder or twin lens reflex camera.

Prereleasing can also reduce the danger of camera-created vibrations when the camera is mounted on a tripod or stand. Any moving element inside a camera, such as a mirror or shutter, can cause camera vibration. Such camera motion is not eliminated with a cable release but can be lessened by reducing the number of moving elements within the camera at the moment the exposure is made. This is exactly what prereleasing the camera does, eliminating the mirror motion and reducing the camera functions to the shutter operation.

Because Hasselblad cameras can be prereleased easily, my recommendation is to prerelease whenever you work with a mounted camera. Camera-produced motions need be considered only with a mounted camera. In handheld work, the body seems to absorb such motion.

Figure 6-13 *Prereleasing cameras* The 500 series cameras (1) and all focal-plane shutter models (2) are prereleased by pressing the lever below the winding crank or knob upward (on 500 models) or toward the rear (on 200 models). You prerelease EL cameras by setting the selector dial to S (3) or to SR (4). When set to S, the camera returns to its normal viewing position after the exposure. When set to SR, the camera remains in the prereleased mode.

Because prereleasing does not reduce the danger of vibration from the shutter operation, it is worthwhile mentioning that a lens shutter is extremely smooth because the shutter blades move in all directions around the optical axis. With a focal plane curtain moving sideways (or up and down), the danger for vibrations is somewhat greater. If you have a choice, use the lens shutter, especially with longer shutter speeds and longer lenses.

Prereleasing the 500 Series Cameras

The prerelease control is below the winding knob and is pushed upward (see Figure 6-13). As the mirror lifts up, the image on the focusing screen disappears. If, for some reason, you need to see the image before making the exposure, turn the winding knob or crank with the magazine removed from the camera. In this way, the film is not advanced. The prerelease cycle is shown in Figure 6-14.

Prereleasing the Focal Plane Shutter Models

The prerelease button is below the winding crank (see Figures 6-13 and 6-16), but you prerelease the camera by pushing the control toward the rear of the camera instead of upward. When the lens shutter is used for the exposure, prereleasing performs the same function as it does on 500 camera

Figure 6-14 *Prereleasing the 500 series and EL models* Prereleasing (A) causes the lens shutter to close (B), the lens diaphragm to stop down to the present aperture (C), the mirror to lift up (D), and the auxiliary shutter to open (E). When the release is pressed (F), only the lens shutter opens and closes (G) to make the exposure.

Figure 6-15 *Prereleasing the 200 and 2000 focal plane shutter cameras* When the lens shutter is used, the prerelease cycle is identical to that of the 500 and EL models, except that the focal plane shutter replaces the auxiliary shutter. When the focal plane shutter is used with non-shutter lenses, prereleasing lifts only the mirror and closes the diaphragm to the preset aperture (A). When the camera release is pressed (B), the focal plane shutter opens and closes to make the exposure (C), the mirror then flips down, and the diaphragm opens fully (E). An image at full brightness is therefore visible on the focusing screen immediately after the exposure has been made (on 2000/2003 cameras only with the mirror set at 2). You advance the film and cock the shutter by turning the crank (F).

models. When the exposure is made with the focal plane shutter, prereleasing lifts up only the mirror and closes the lens aperture to the preset opening. If you want to see the image on the focusing screen again after the camera is prereleased, simply turn the crank with the center button pressed, as for a double exposure. The prerelease cycle is shown in Figure 6-15.

Prereleasing the EL Models

You prerelease EL cameras (Figure 6-13) by setting the operating knob to S, at which point the lens shutter closes, the aperture presets itself, the mirror rises, and the rear curtains open. The exposure is made when the release is pressed. After the exposure, the control moves back to 0, with the camera

1. **2.**

Figure 6-16 *Prerelease function* **1.** On 200 series cameras, pressing the prerelease one time prereleases the camera, and pressing it a second time starts the self-timer (except on 201 models), with the self-timer delay time programmed into the camera. You can stop the self-timer by pressing the prerelease a third time. **2.** Self-timer operation is indicated by a red light at the front of the camera. On 201 models, pressing the prerelease control a second time starts the self-timer for a 10-second delay, and pressing it twice, for a 2-second delay.

returning to the normal position—the lens open and the mirror down for viewing.

When the camera is set to SR, the knob remains at SR, leaving the camera in the prereleased mode. Use the SR position when all the images are to be made in the prereleased mode and you don't need to see the image between exposures. The SR position also provides the fastest sequence operation: about 12 pictures in 9 seconds.

PRODUCING DOUBLE OR MULTIPLE EXPOSURES

All Hasselblad V system cameras are ideal for producing double or multiple exposures. With the magazine interchangeability, the two images need not be made right after each other. You can remove the magazine after the first exposure, work with another magazine, and then later reattach the first one to superimpose the second image. The second exposure need not even be made in the same camera. The magazine with the first exposure can be attached to any other Hasselblad V system camera model.

To produce a double exposure on Superwide and 500 model cameras, you must remove the film magazine after the first exposure so that the film is not advanced when you recock the shutter with the winding crank. After turning the crank, reattach the magazine and make the second exposure. See Figure 6-18.

Removing the magazine is not necessary on 200 and 2000 camera models. After the first exposure, turn the winding crank with the center disc pressed, thereby cocking the shutter without advancing the film. See Figure 6-17.

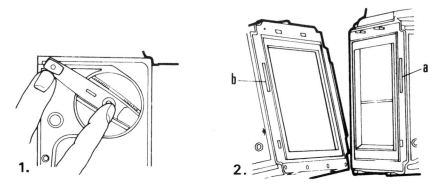

Figure 6-17 *Producing double exposures on 200 and 2000 camera models* Make the first exposure as usual. Press the mirror program disc with your index finger (1) while you start turning the winding crank. This operation ensures that the gear (2a) that connects to the film transport in the magazine (2b) will not turn and therefore will not advance the film.

Figure 6-18 *Producing double exposures in Superwide and 500 camera models* Make the first exposure as usual (3); the operating signal in the magazine will then be red (4). Insert the darkslide (5), and lift the magazine away from the camera (6). You need only tilt it away from the camera body to disconnect the gear. Turn the camera winding crank (7). Reattach the magazine (8). Remove the darkslide (9), and make the second exposure (10). Set the 503 motor winder to M for multiple exposures.

Most double exposures have two images recorded on the same film area, which results in one overexposed image. Exposure for each image must be reduced, the amount depending somewhat on the type of image. A good suggestion is to reduce the exposure for each by $1\frac{1}{2}$ EV values. Or, if you want to have one of the two images more dominant, reduce the exposure by 1 EV value for one and 2 EV values for the other. Test exposures are advised. In some double exposures, the second image may be recorded in a dark, unexposed area of the first, in which case an exposure reduction may not be necessary.

Figure 6-19 *Producing a double exposure on EL models* Release the camera for the first exposure, but keep your finger on the release so that the film does not advance. With the release pressed, move the time lever to the L position (11), which locks the mechanism. Insert the darkslide, and remove the magazine (12) from the camera. Move the time lever back to 0 (13); this starts the transport cycle and recocks the shutter. Replace the magazine and make the second exposure.

Figure 6-20 The CW motor winder.

1. Mode selector dial	7. Bayonet mount	13. Winder catch
2. Release button	8. Winder retaining slot	14. Remote cord connector
3. Mode selector	9. Camera interface plate	15. Strap mounting screws
4. Front IR sensor	10. Battery holder	16. Rear IR sensor
5. Camera release lever	11. Battery holder catch	17. Lower strap lug
6. Winder coupling	12. Upper strap lug	

OPERATION OF THE 503CW WINDER

The CW motor winder (see Figure 6-20) is held to the camera not only by the winding shaft but also by the carrying strap lug and can be used as a grip for convenient handheld photography. The camera/winder combination handles like a motor-driven 35mm camera. The winder transports the film at about 1.3 frames per second. The motor is powered by six 1.5V AA Alkaline

or rechargeable NiCad battery types. Alkaline batteries should provide at least 3000 exposures in normal conditions.

Attaching the 503 Winders

After removing the winding crank, lens, and carrying strap, place the winder over the winding mechanism with the strap lug in the winder's mounting plate. Rotate it clockwise until it clicks into position (see Figure 6-21). After the motor is attached, you may hear a faint sound indicating that the motor senses the camera status. It will also wind an uncocked camera automatically. With film in the camera, you will lose a frame. To avoid this, make certain that the shutter is cocked before you attach the motor winder.

Removing the Motor Winder

Remove the lens. Holding the winder firmly, press the detaching lever and keep it pressed while turning the winder counterclockwise. Keep in mind that the lens must be removed for attaching and detaching the winder.

Motor Operation

The motor winder can be used for single exposures (S) at any shutter speed. At shutter speeds of $\frac{1}{8}$ second and longer, you must keep the release button pressed until you hear the lens shutter closing. In sequence photography (C), the shutter speed must be $\frac{1}{8}$ second or shorter ($\frac{1}{15}$ second or shorter in cold temperatures).

You can make multiple exposures without removing the motor winder from the camera. Set the mode selector to M. The motor makes the exposure but does not advance the film. Insert the darkslide, remove the magazine, and switch the mode selector from M to S (or C), an action that recocks the shutter. Then reattach the film magazine and remove the darkslide. To prevent accidental exposures, set the mode selector to L (lock) when not in use. See Figure 6-22.

If the motor does not operate the camera, check whether a darkslide might be inserted and whether the frame counter in the film magazine may indicate that you are at the end of the film. Also check that the mode selector is not set to L or RC, and, of course, check the condition of the batteries and be sure that they have been inserted properly.

Remote Operation

A camera equipped with a motor winder can be remote-released by using a 10-foot (3m) accessory release cable or by using the supplied wireless infrared remote control. The remote release is connected to the socket in the motor winder. The winder can be operated in the S, C, or M mode.

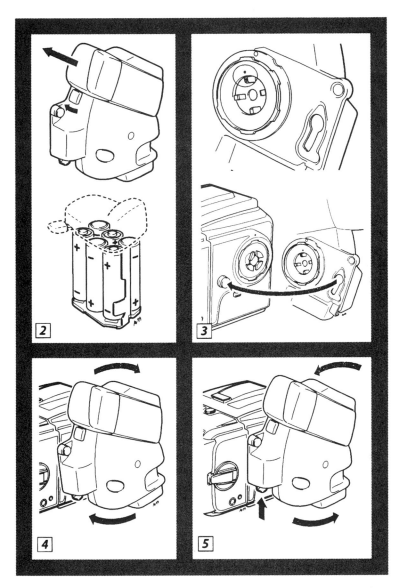

Figure 6-21 *503CW motor operation* **2.** After opening the battery compartment by moving the lever clockwise, insert the six batteries as shown in the battery holder. **3.** After removing the lens, attach the motor over the winding mechanism, with the strap lug in the motor's mounting plate. **4.** Turn the motor clockwise. **5.** To remove the motor, press the detaching lever and turn the winder counterclockwise.

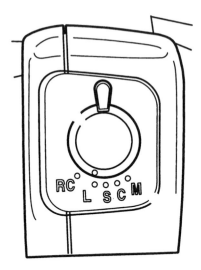

Figure 6-22 *The winder operating controls* The release and mode selector have these settings: RC (remote), L (lock), S (single pictures), C (sequences), and M (multiple exposures).

Figure 6-23 The IR remote release.
1. Release button 2. IR windows 3. Mode selector 4. Battery compartment

With the mode selector set to RC, the compact IR remote release (see Figure 6-23) can operate the camera from up to 33 feet (10 meters) from almost anywhere because the motor winder has IR sensors at the front and rear.

The remote control uses one CR2 battery. The mode selector should be set back to L or to S, C, or M as soon as the remote release is no longer used. This saves battery power.

Before using the IR remote, you must code it to the specific motor winder on the camera. Set the mode selector to RC, aiming the IR windows in the remote control at one of the IR sensors in the motor and pressing for three or four seconds both the release in the remote control and the release in the motor at the same time. If you want to operate more than one camera from one release, code each motor with the remote release in the same fashion.

7

Operating the EL Cameras

The basic camera operations that are identical or similar on all V system cameras are discussed in Chapter 6. The text here is limited to the operations that apply to EL models only. Most of those operations are identical on the various EL models. The 500ELX, 553ELX, and 555ELD models, which have a dedicated flash system, are most easily recognized by the film sensitivity dial above the accessory rail (see Figure 7-1). Dedicated flash photography with these cameras is discussed in Chapter 17.

THE MOTOR DRIVE

At the rear of the battery compartment is the motor drive. There are also small openings: The one above the motor drive is probably filled with a fuse, and the others can be used to store a spare fuse. The fuse is a 1.6V medium slow blow fuse, 5 × 20 mm in size. Only this type is to be used. Whatever else you find inside the compartment depends on the camera model.

BATTERIES IN NEWER MODELS

Starting with the ELX in 1988, EL cameras are made for the use of five standard 1.5V AA alkaline or lithium batteries. One set of alkaline batteries can provide up to 4000 exposures. Although alkaline batteries work well and are a good choice for most photographers, the lithium type is recommended for photographic applications where cameras are used extensively or used in cold temperatures. The lithium types have a higher capacity and are more reliable in cold weather. You can also use rechargeable 1.2 AA NiCads. The rechargeable types should give about 1000 exposures before recharging is necessary. To recharge the batteries, remove them from the camera and use a standard AA-type charging unit.

Insert the batteries into the camera's battery compartment in accordance with the symbols molded into the receptacles (see Figures 7-2 and 7-3). The positive (+) ends of the two upper batteries and the negative (−) ends of the

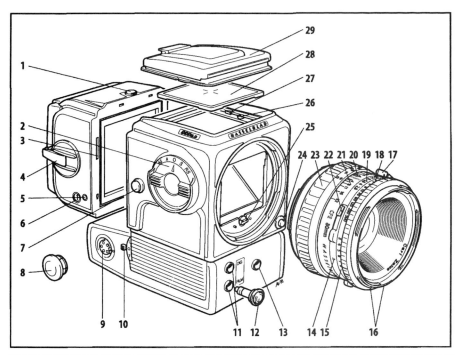

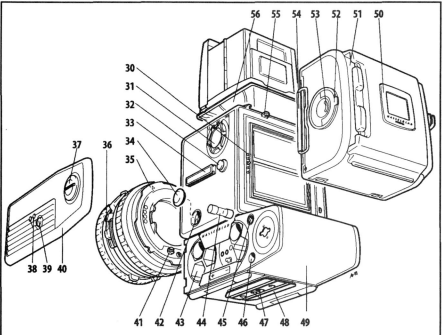

Figure 7-1 The important operating controls on the 555ELD.

2. Mode selector	26. Flash function indicator	39. Battery check button
8. Remote socket cover	27. Screen retaining clip	40. Battery compartment cover
9. Remote release socket	28. Focusing screen	41. Lens drive coupling
10. Time exposure and locking lever	29. Focusing hood	42. Dedicated flash connector
11. Release socket (digital and film on 555ELD)	30. Electronic connection (on 555ELD only)	43. Battery compartment
12. Release button	31. ISO setting for dedicated flash	44. Fuse
13. IR release unit mount (on 555ELD only)	32. Strap lug	45. Fuse holder
24. Lens release button	33. Accessory rail	46. Spare fuse holder
25. Drive shaft	34. Flash connector cover	47. Tripod socket
	37. Cover lock	48. Quick coupling plate
	38. Battery check lights	49. Motor housing

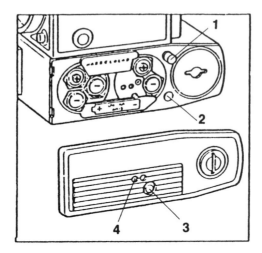

Figure 7-2 *The battery compartment* After removing the cover, you will find compartments for five AA batteries, a compartment for the fuse above the motor drive (1), and an empty compartment to store a spare fuse (2). You can check the condition of the alkaline or lithium batteries by pressing the battery check button (3) on the compartment cover. When both lights (4) come on, more than 40% of the power remains. One light indicates that about 20% is left. If neither light comes on, the batteries need to be changed.

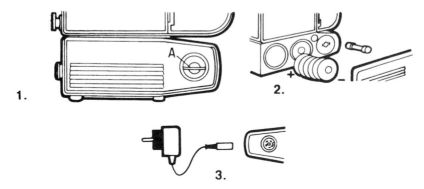

Figure 7-3 *The battery compartment in older cameras* You open the battery compartment on all EL models by a full clockwise turn of a coin inserted into the cover lock (1A). Inside the older cameras (2) are two battery and four smaller compartments. The smaller compartment above the motor carries the operating fuse. You charge the batteries in the camera by connecting a charger to the outlet at the side of the battery compartment (3). On newer cameras with a black locking lever, the camera can be charged with the lever at 0 or L. On older cameras with a chrome locking lever, the lever must be at L for charging, and the camera must have completed its cycle.

other three should be visible. Fit the fuse into its receptacle at the upper-right side of the battery compartment. It is advisable to have a spare fuse, which can conveniently be carried in the hole directly below the fuse receptacle.

Alkaline or lithium batteries do not need any special care or attention. You can check the charging condition by pressing the battery check button on the compartment cover. Rechargeable batteries have different discharge characteristics and cannot be checked; that is a good reason for using the standard AA types.

THE NICAD BATTERIES IN EARLIER MODELS

Earlier EL models are powered by rechargeable nickel cadmium batteries. Only one battery is necessary to drive the camera, and it can be inserted in either opening in the battery compartment. A fully charged battery should last for about 1000 exposures at normal temperature.

It is also possible to insert two batteries. The camera works in exactly the same fashion, at the same speed. You simply get twice as many exposures. If two batteries are used, both of them discharge simultaneously, not sequentially. Insert the battery or batteries properly, with the + end in first. If you insert them improperly, you cannot lock the compartment cover. Nicad batteries are still available. Consult a Hasselblad agent.

Recommended NiCad Battery Use

NiCad batteries can work properly over a long period of time but only if used and charged properly. They should never be overcharged, and they should always be used to the end of their capacity. If you use them only partially, they will create a memory and will no longer provide the 1000-exposure capacity. Because the condition of these batteries cannot be checked, the following is the simplest and most reliable operating mode. It also eliminates the need to keep a record of the number of exposures.

1. Insert only one battery into the motor compartment, and keep a second, fully charged battery readily available.
2. Operate the camera until the mechanism slows down (indicating that the battery is close to being discharged).
3. Change to a fully charged spare battery, and use this battery as in step 2.
4. Recharge the first battery whenever practical for 14 hours, and keep it as a spare.

In this way, you know that recharging always requires 14 hours, thus reducing the danger of overcharging.

After 14 hours, unplug the charging unit. It is a good idea to use a timer or alarm.

Some Discontinued Items

EL cameras for NiCad batteries have not been made for more than 10 years, so some of the older EL accessories have been discontinued. The list includes a battery compartment for charging the batteries outside the camera; a charging unit with a built-in timer; an AC power supply unit to allow operating the camera from AC; and an intervalometer for multiple camera operation.

CONVERTING CAMERAS

The Hasselblad service center can modify EL cameras made for NiCad batteries to the newer type for use with AA batteries. Before having it done, however, you should give some serious thought to trading the camera for a newer model. The cameras have been improved in many ways over the years and include new features such as the gliding mirror and the dedicated flash system.

Upgrading to the 555 model is especially recommended. This workhorse has a heavy-duty motor, improved internal stray light protection, and a new motor release and mirror suspension system—the type that has proven itself for a number of years in the space cameras. The 555ELD camera can also be equipped with an accessory infrared remote control for wireless remote releasing.

RELEASING THE CAMERA

In the FILM setting, the front release on the 555ELD operates the camera in the same fashion as the front release on other EL models (see Figure 7-4). For longer exposures, you must keep your finger on the release until the lens shutter closes. In the DIG position, in addition to operating the camera cycle, a signal goes to the digital back via the pins at the rear of the camera telling the digital back when the exposure starts and ends. This signal works only with digital backs designed for this operation, and, with such a back attached, the FILM release does not work. The regular FILM release is used with other digital backs. Obtain up-to-date details from the manufacturer of the digital back or from Hasselblad.

The Operating Selector Dial

When the camera is operated with the selector dial set to SR or AS, the camera stops in the prereleased mode. To put a camera in the normal viewing position, move the operating dial to 0, and press the release to take a picture (see Figure 7-5). If you do not want to waste a frame of film, remove the magazine before pressing the release. It is worth checking the operating dial position before releasing the camera.

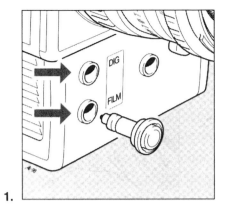

1. **2.**

Figure 7-4 *Releasing the camera* **1.** All EL models have two release openings at the front. On the 555ELD the top opening is for digital work, the bottom for film. On the other models, the two are identical, and either one can be used for releasing the camera. On some camera models, the two may be covered up by the large release plate used on the space cameras. **2.** The time exposure and locking lever can be set to L to lock the release, 0 for normal operation, or T for time exposures. Moving the lever from 0 to T is like releasing the camera and making an exposure.

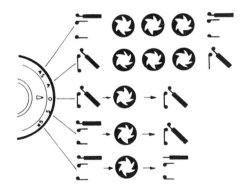

Figure 7-5 *The operating selector dial* At the normal (0) setting, one picture is taken, and the camera stops in the normal position with the mirror down. At S, the camera is prereleased but returns to the normal position after the picture is made. At SR, the camera is also in the prereleased position, but it returns to the prereleased mode with the mirror up. A is the automatic mode, where the camera takes pictures at the rate of one frame per second as long as the release is pressed or as long as film is in the camera; the camera returns to the normal mode. The AS setting is for automatic operation, starting and ending in the prereleased mode; the camera operates somewhat faster than in the A position: about 12 pictures in 9 seconds.

EL Camera Operation

If nothing happens when the release is pressed, check first that the locking lever on the side of the battery compartment is at 0 (not in the locked L position). Then check that the magazine slide has been removed and that the exposure counter in the magazine has not reached the end of the roll. If none

of these checks makes the camera work, check the batteries. If the batteries are still good, check the fuse. A blown fuse usually indicates that something is wrong in the electrical circuit, and changing the fuse may not solve the problem.

Releasing with Cables

All EL models can be released with an FK cable (F stands for "front") attached to one of the release sockets at the front of the camera. The open L connector must be used when the PC Mutar is attached to the camera.

Releasing through the Side Socket

You can also release all EL cameras through the side socket at the rear of the motor compartment by using the SK cable (S stands for "side") or the longer, discontinued LK types (see Figure 7-6). Wireless operation with the 555ELD is the modern approach for remote operation. Whether released through the side socket or the front, the EL cameras operate in the same way. The release must be kept pressed until the shutter closes. It is important to remember this when you use shutter speeds from $\frac{1}{4}$ second to 1 second.

Wireless Remote Releasing of the 555ELD

An accessory remote control for wireless remote camera operation up to 33 feet (10 meters) for film or digital photography can be attached to the front

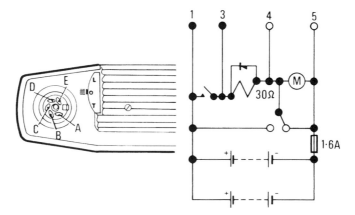

Figure 7-6 *Releasing from the side socket* Pins A and C on the side socket, corresponding to pins 1 and 3 on the circuit, are used for triggering the camera. Whenever the electrical circuits between 1 and 3 are closed, the camera is released. The circuit can be closed manually or automatically by an impulse from an instrument, a photocell when its light beam is cut, from a sound signal, and so on. The external resistance used for triggering through pins 1 and 3 should not exceed 6 ohms. The exposure current is O.2A, and the circuit voltage 6V.

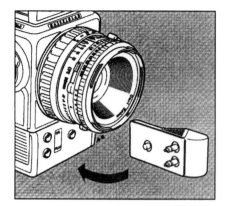

Figure 7-7 *Attaching the wireless IR release accessory* After removing the release button, match the respective release sockets, push the release unit to the front of the camera, and attach. The On/Off switch operates the unit. Set the Pr control for digital or film.

of 555ELD cameras (see Figure 7-7). The power for the camera unit comes from the batteries in the camera, but the remote release needs a CR2 battery. The release unit is the same as that available for the H1 camera and as supplied with the 503CW motor winder, it is described in Chapter 6. Multiple camera operation is possible. The IR release unit cannot be used on other EL camera models.

Working with the Wireless Remote Control Unit

Before you use the IR release, you must program it to the remote control unit on the camera. Switch the mode button to the PR setting. Point the IR release at the camera, and press the activating button for three or four seconds. After the release is programmed, you can use it for digital work or for photography with film. Set the desired mode on the unit.

The IR remote release has a switch with three settings: SINGLE, CONTINUOUS, and MULTI. These are for use with the 503CW and serve no purpose with the 555ELD. You can use the unit at either setting. When working at longer shutter speeds, keep the button on the remote release pressed long enough for the camera to complete its cycle.

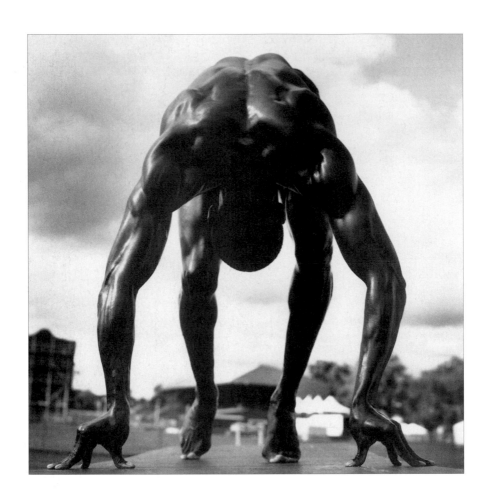

▲ Sprinter Shawn Crawford photographed on film by
Howard Schatz. From *ATHLETE* by Howard Schatz.
(Harper Collins) Available as a fine art print.
Schatz/Orenstein 2002. *www.howard.comschatz*

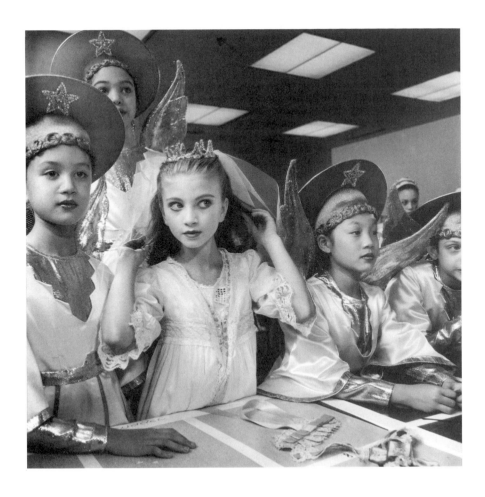

▲ Hasselblad camera used as a photojournalistic tool for photographing the Nutcracker ballet for *The New Yorker* magazine by Mary Ellan Mark

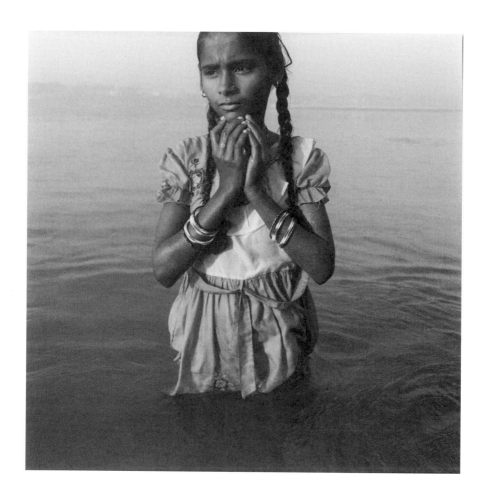

▲ The frame line cutting into the head makes a strong compositional element by attracting the viewer's eyes to the face and hands of the girl in India. *Mary Ellen Mark*

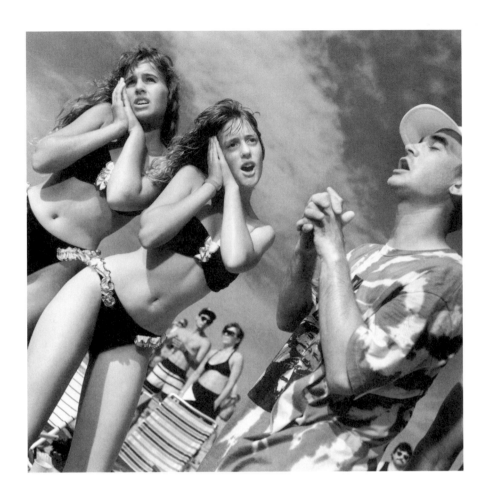

▲ A dynamic composition by Mare Ellen Mark for *Rolling Stone* magazine.

8

Operating the Superwide Cameras

Basic camera operations that apply to all V system cameras are discussed in Chapter 6. The information here is limited to the features and operations that apply specifically to Superwide models.

BASIC CAMERA OPERATION

The latest 905SWC model has a Biogon lens with a slightly different lens and barrel design to reduce the possibility of flare to the highest degree, but otherwise it is identical to the 903SWC (see Figure 8-1).

The basic operation of all Superwide cameras is identical except that on cameras made since 1980 the film can be advanced either with a ratchet-type motion (which is necessary when the instant film magazine is attached) or with a full turn on the crank. On earlier models, the crank needed to be turned. A Hasselblad service center can modify the earlier models. The earlier, discontinued Polaroid 80 magazine cannot be used on any original or modified Superwide cameras.

Because the Superwides are not SLR cameras, they have no mirror and no rear curtain and therefore do not have a prerelease mode. When you press the release, the shutter in the lens simply opens and closes for the set exposure time. It is not necessary to keep the release pressed when you use the longer shutter speeds. You must do so, however, for time exposures, and you do so by setting the release lock lever next to the release to position T. The release now stays pressed until you turn the lever to 0. Use a cable release to make the exposure.

The T position is especially helpful when you use the focusing screen adapter for evaluating the image. You need not keep your finger on the release, and you can evaluate the image at different apertures if desired.

Holding the Camera

Photographers hold the Superwide in one of two ways (see Figure 8-2). You can hold it between your two hands with your index finger on the release,

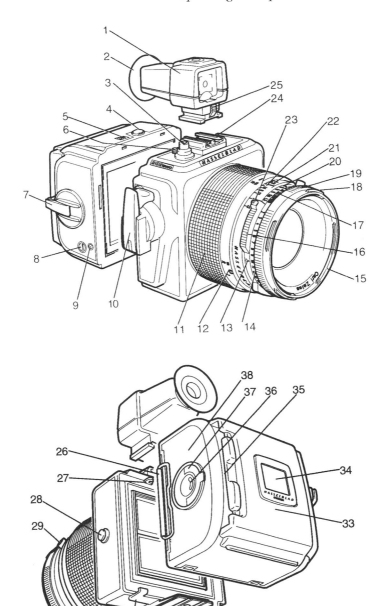

Figure 8-1 The important operating controls on the 903SWC camera.

1. Viewfinder with built-in spirit level
2. Rubber eyecup
3. Camera release
4. Magazine lock button
6. Time exposure lock
10. Winding crank
24. Accessory/viewfinder mount
25. Viewfinder release catch
27. Magazine hooks
28. Strap lug
30. Magazine supports
31. Tripod sockets
32. Quick coupling plate

Figure 8-2 *Holding the Superwide* You can rest the camera in your left hand and release it with the index finger of your right hand (left). Because the camera is small, you can also place both hands around the camera body, with your middle finger on the release (right).

Figure 8-3 *Attaching the Superwide viewfinder* The Superwide viewfinder slides from the rear into the shoe mount on top of the camera.

or you can hold it with your left hand placed underneath the camera and lens, and your right hand placed flat against the right side of the camera, with your index finger on the release. In both methods, press your elbows into your body and press the Superwide hard against your cheek for best camera steadiness.

Viewing with the Superwide

The optical viewfinder of the Superwide is a separate, removable component that slides from the rear into the shoe mount on top of the camera. Slide it forward until it rests against the pin (see Figures 8-3, 8-4, and 8-5).

The Superwide viewfinders have the same angle of view as the 38mm Biogon lens: 91 degrees diagonally and 75 degrees horizontally or vertically when used for the $2\frac{1}{4}$-in. (6 × 6cm) square format. The finder, however, shows a slightly larger area than is covered on the film. Because of the wide angle of view of the lens and therefore the very large area of coverage, the difference is never a problem at longer distances.

You may perhaps find it disturbing that the lens cuts into the field of view and cuts off a portion of the view at the bottom. Although this may be objectionable, it really does not interfere with precise camera alignment

Figure 8-4 *The Superwide viewfinder* **1.** The finder has a built-in spirit level on top. The spirit level is also visible in the viewfinder. **2.** You can see the leveling of the camera without removing your eye from the finder. A magnifying lens at the bottom lets you read the focusing distance, the depth of field, and the set shutter speed while also viewing through the finder. The four lines inside the finder show the area coverage vertically and horizontally for the 6 × 4.5 format.

Figure 8-5 *The old Superwide viewfinder* On earlier Superwide models, the spirit level is on top of the camera body and is reflected in the viewfinder prism, so it can be seen from the normal viewing position behind the camera. Masks for the 6 × 4.5 format are available.

because the bottom edge of the field can be seen on both sides of the lens even with the professional lens shade on the Biogon.

The barrel distortion seen in the finder may also be disturbing at first. The distortion is only in the finder, not in the image on the film. The Biogon is almost distortion free. To frame the desired area horizontally, make certain you see the area across the center of the viewfinder field, at the widest point of the curves. Align the top at the highest point, if necessary, allowing for the parallax difference at closer distances.

LEVELING THE CAMERA

When vertical lines of a building or a product for example must be recorded parallel to each other so that the subject seems to be standing straight up, the camera must be level. Any tilting of the camera records the verticals as

slanted lines. An extreme wide-angle lens like the Biogon enhances the slanting to a point where even the slightest tilt is recognizable. Check the spirit level carefully when doing this type of photography. The spirit level allows precise leveling thus making the Superwide an ideal professional tool or architectural work.

FOCUSING THE SUPERWIDE CAMERAS

At longer distances, you focus the Biogon lens by estimating the distance between the camera and the subject. This is sufficiently accurate because the short 38mm focal length provides considerable depth of field. At the maximum aperture of $f/4.5$, depth of field extends from 3 meters (10 feet) to infinity. With the aperture closed down to $f/22$, the depth-of-field range is from 26 inches (0.6 meters) to infinity.

The Biogon lens focuses down to 12 inches (0.3 meters), with the superb corner-to-corner image sharpness maintained down to this minimum focusing distance. This makes the Superwide an excellent tool for distortion-free close-up work, such as copying. In close-up work, estimating the distance is not good enough. At the minimum distance, the depth of field is less than one inch; with the aperture wide open, it is increased to about two inches at $f/22$. You can measure the distance from the subject to the film plane mark on the magazine or, better, focus the image visually by using the focusing screen adapter accessory made specifically for the Superwide cameras. This accessory allows precise focusing and also lets you see the area coverage as precisely as on a large-format camera.

Focusing with the Focusing Screen Adapter

The latest focusing screen adapters (see Figure 8-6) have the Acute Matte focusing screen, providing a beautiful, bright image over the entire area. Attach the focusing screen adapter after removing the film magazine. To see an image on the screen, set the shutter at B, and keep it open by placing the release lock to T. For the most accurate focusing, open the lens aperture fully. You can close down the diaphragm to evaluate the image at different apertures.

The image on the focusing screen can be viewed through any of the Hasselblad viewfinders, including the prism viewfinders, with or without a built-in meter.

The RMfx finder, with its 3.3× magnification, is especially recommended because it shows the image right side up. The finders slide into the grooves on the adapter and are held in place by a pin on the upper left. To remove the finder, push the pin to the left and slide out the finder. All finders provide a magnified view of the entire image and at the same time shield the focusing screen from all extraneous light.

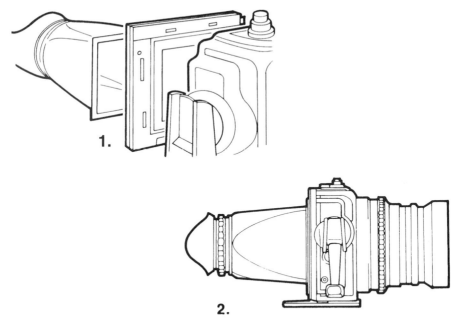

Figure 8-6 *The focusing screen adapter* Accurate framing and visual focusing are possible with the focusing screen adapter (1) attached to the rear of the Superwide after the film magazine has been removed. The focusing screen image can be magnified and shielded from extraneous light with any of the Hasselblad viewfinders (2). The finders slide into the focusing screen adapter from the top.

The focusing screen adapter can also be attached to the Hasselblad SLR cameras in the V system. Because these camera models already have a focusing screen, this accessory serves no practical purpose, except perhaps to let you check whether the focusing and framing correspond to those obtained on the camera's built-in screen.

The focusing screen adapter made for the Superwide is not interchangeable with the one made for the FlexBody and ArcBody. The different position of the exit pupil of the 38mm Biogon requires a different Fresnel lens for even illumination.

Determining Exposure

The aperture and shutter speed settings that provide correct exposure can be determined by using a regular handheld exposure meter or by attaching a Hasselblad meter prism finder over the focusing screen adapter, setting and using it in the same fashion. I suggest, however, that you make your own exposure test on your Superwide camera. Photograph an area with equal

illumination and equal brightness (preferably 18% reflectance) at the metered aperture and at lower and higher values in $\frac{1}{2}$ stop increments. Evaluate the film to see which one matches the subject. If adjustments are needed, they can be made in the future by changing the aperture, the shutter speed, or the ISO setting. To keep the test area small, you can make the test at closer distances—five to six feet. The focusing distance does not affect the exposure to any noticeable degree on this lens.

Naturally, you can also determine exposure with an instant film magazine.

9

Operating the 200 Cameras

The features, the component interchangeability, and the basic operations of the Hasselblad 200 camera models are described in Chapters 5 and 6. The text here concentrates on the operation of the special features, especially the built-in exposure and flash metering system (see Figure 9-1).

SHUTTER OPERATION

All camera models in the 200 series have electronically controlled focal plane shutters, with the shutter curtain made from a robust, rubberized silk textile material that is not easily damaged except with a sharp object or the corner of a film magazine. Care is recommended when you attach magazines. Protect the curtain when the camera is stored without a magazine attached.

Batteries

The basic camera operations are mechanical, but the shutter speeds are controlled electronically via the power from a 6V PX28 battery stored in a battery compartment on the left side (as seen from the rear) of the camera. Lithium types are highly recommended.

In the 202, 203, and 205 models, the battery also powers the metering system, so its life span depends mainly on the use of the meter and the display light. At normal temperatures, a battery should last for more than 4000 metering cycles of 15 seconds each. This is reduced to about 1000 cycles at very low temperatures. To save the battery power, the electronic circuit turns off automatically after about 15 seconds. A battery symbol appears on the viewfinder display when the battery needs to be replaced.

To insert or change a battery, pull out the battery compartment. Insert the battery with the minus (−) and plus (+) ends positioned as engraved on the compartment. Push the compartment completely into the camera body.

It is advisable to remove and insert the battery compartment when the camera is in the ready state, with the shutter cocked and the mirror down. To be certain that this is the case, before inserting a battery turn the winding

**Series 200
Camera Models**

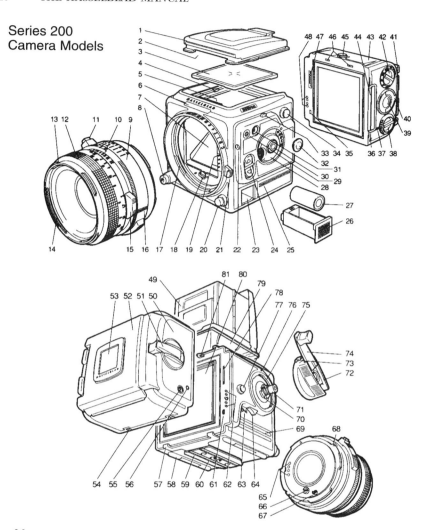

Figure 9-1 Main components and operating controls of cameras with a built-in metering system.

1. Focusing hood cover
2. Cut-out in viewfinder for finder display
3. Focusing screen
4. Focusing screen catch
5. Liquid crystal display
6. Illumination window
7. Mirror
8. Shutter release
16. System mark
17. Lens mount
18. Drive shaft
19. Electronic connections
20. Lens lock
21. Shutter speed ring (not on 202 model)
22. Self-timer indicator

23. Battery compartment
24. Adjustment controls
25. Grip cushion
26. Battery case
27. Battery
28. Mode selector dial
29. PC socket
30. AE lock
31. Dedicated flash connection
32. Flash socket cover
33. Display illumination button
34. Strap lug
58. Camera support
59. Quick coupling slide
60. Tripod thread
61. Magazine indicator trigger
62. Electronic connections

63. Self-timer symbol
64. Prerelease/self-timer control
65. Electronic connections
66. Drive shaft
67. Drive shaft catch
68. Lens bayonet
69. Grip cushion
70. Winder coupling
71. Double-exposure control
72. Winding crank hub
73. Crank catch
74. Winding crank
75. Winder bayonet mount
76. Winding crank index
77. Strap lug
78. Magazine driving gear
80. Shutter curtain

crank with the center disc pressed. Whenever you remove the battery compartment, all values programmed into the electronic circuit change to the standard values mentioned under Programming later in this chapter. When the shutter speed ring in 203 or 205 cameras is set to C, you can make an exposure without a battery in the camera if you use the shutter in the lens to make the exposure.

PRERELEASING AND USE OF THE SELF-TIMER

You lock the mirror up by pressing the release under the winding crank one time toward the rear (see Figures 9-2 and 6–16). Pressing the prerelease a second time starts the self-timer, with the self-timer exposures made with the mirror locked up.

The desired self-timer delay (from 2 to 60 seconds) is programmed into the camera. When the self-timer is in operation, the self-timer symbol appears on the display, and a red light flashes at the front of the camera, where it is visible to the people being photographed.

At the beginning, the light flashes twice per second. But when only 3 seconds of the delay time remains, it increases to four times per second and changes to a continuous light during the last $\frac{1}{2}$ second. In this way, you know precisely when the camera will go off. You can interrupt the self-timer function at any time by pressing the prerelease lever again or by turning the crank with the center disc pressed, as for a double exposure. The self-timer function is inoperative when the shutter speed ring is set in position B or C.

As with all V camera models, the mirror moves up when the camera is prereleased, and the image disappears from the focusing screen. If you want to see the image again before making the exposure, simply turn the crank with the center disc pressed, as for a multiple exposure.

MANUAL FILM ADVANCE

You recock the shutter and advance the film by turning the winding crank with the handle folded out or in. You can also recock the shutter without

Figure 9-2 *The prerelease control* The lever underneath the winding crank prereleases the camera when pushed once toward the rear. It starts the self-timer when pushed a second time. The self-timer exposure can be stopped with a third push on the lever. On the 201 camera, the self-timer delay is set for a 10-second delay with a second push and with an additional push, a 2-second delay.

advancing the film by pressing the program disc in the center of the crank when you start turning the crank. The magazine signal remains red. This is the procedure for making double and multiple exposures.

The easiest way to operate the crank without advancing the film is to press the program disc with your right index finger. Then start turning the crank with your right thumb. The disc needs to be pressed only when you start turning the crank, not for the complete turn.

MOTOR OPERATION

All 200 series camera models can be operated with a motor winder specifically made for these cameras. If only one picture is desired, you press the release for only a moment. When you keep the release pressed, sequences of images are recorded at the rate of 1.3 images per second until you remove your finger from the release or the roll of film is finished.

The motor is powered by five AA cells—alkaline or rechargeable. A set of fully charged batteries should provide about 3000 exposures at normal temperatures, or 1000 exposures with the rechargeable type.

The motor is held to the camera by means of a solid stainless steel coupling. It is shaped to serve as a second support for handheld photography, but you should never use the motor winder for carrying the camera. The motor winder is not designed for remote camera operation, and you must remove it from the camera to produce double exposures.

The electrical contacts on the camera and motor must be kept clean. A soft cloth can be used for cleaning. Do not use abrasives.

OPERATION OF FILM MAGAZINES

All cameras in the 200 series can be used with all Hasselblad film magazines. With E, ECC, and TCC magazines, the ISO film sensitivity set on the magazine is electronically transferred to the camera body. When you switch from one magazine to another having a different ISO setting, the change is made automatically when you change the magazine.

With A-type magazines or the instant film magazine, you manually program the ISO film sensitivity into the camera's electronic circuit by using the camera's Programming (Pr) mode. When you change from one A magazine to another A type having a different film sensitivity, you must manually program the new ISO value into the camera. This is not the case when you change from an E, ECC, or TCC magazine to an A type or vice versa. With the E, ECC, or TCC magazine on the camera, the electronic circuit is automatically set for the ISO set on the magazine, overriding any ISO value programmed into the camera. When you change to the A or instant film magazine, the electronic circuit automatically changes to the ISO value pro-

grammed into the camera. This design eliminates mistakes and simplifies the use of the camera, something that is especially helpful when you work with an instant film magazine. When the instant film or A-type film magazine is on the camera, a magazine symbol appears in the viewfinder, reminding you to program the film sensitivity into the camera.

SETTING THE SHUTTER SPEED

The 202, 203, and 205 cameras have a shutter speed ring that can be set manually to shutter speeds from 1 second to $\frac{1}{2000}$ second ($\frac{1}{1000}$ second on discontinued 201 and 202 models), either at the engraved speeds or between them for $\frac{1}{2}$ stops. The C setting beyond the 1-second engraving is used when exposures are made with the shutter in a lens. When you do so, you must keep the release pressed until the shutter in the lens closes, something you need to remember when using the longer speeds from $\frac{1}{8}$ second to 1 second. The B setting is for longer time exposures. These cameras, however, offer better ways for doing this electronically, as discussed later in the chapter.

You can turn the shutter speed ring to C and B only after pressing the lens lock button. You must also press the lens lock button to move the shutter speed ring back to the normal speed range.

Setting the Speed Electronically

Although the shutter speeds can be set manually, that is not likely the approach for photography with 200 cameras, except for the discontinued 201. Instead, you should let the camera set the shutter speed electronically. This not only eliminates a time-consuming manual operation but also sets the shutter speed to a more precise accuracy of $\frac{1}{12} f$ stop increment.

Long Exposure Times

The electronic shutter speed range is up to 90 seconds (see Figure 9-3). This is the recommended approach for long exposures because it does not require that you keep the release pressed manually.

Figure 9-3 *The long exposure mode* The long exposure mode is indicated on the viewfinder display by L.E. Exposure time here is 1 minute 30 seconds, or 90 seconds. The shutter speed ring was set at $\frac{1}{90}$ second.

On the 203 and 205 cameras, you can have electronically controlled exposure times up to 34 minutes, but only in the manual (M) exposure mode. Set the mode selector to M, and press both the + and the − adjustment buttons simultaneously (see Figure 9-4). The electronic circuit changes into the long exposure mode (LE), which is indicated on the viewfinder display. In the LE mode, every manually set shutter speed is reversed; $\frac{1}{2}$ second becomes 2 seconds, $\frac{1}{30}$ second will be 30 seconds, and $\frac{1}{2000}$ second will be 2000 seconds, which is almost 34 minutes. To go back to the normal shutter speed range, press both adjustment buttons again simultaneously.

Figure 9-4 *The exposure mode selector* The 202, 203, and 205 cameras can be distinguished by the mode selector: 203 model (1), 202 model (2), 205 model (3). The original 205TCC had A instead of Ab (no automatic bracketing), and the Pr and A settings were reversed, with A on top. The engravings mean the following: Pr = Programming, A = Automatic mode, Ab = Automatic mode with automatic bracketing, D = Differential mode, Z = Zone mode, M = Manual mode, and ML = Manual mode with locked shutter speed. The AE lock is in the center of the mode selector on all cameras.

OPERATION OF FE, CFE, AND TCC LENSES

The FE, CFE, and earlier TCC lenses without a shutter can be identified by the set of four Databus contact pins in the bayonet plate at the rear of the lens; these contact pins are used for electronic data transmission between the lens and the camera body. The contact surfaces of these pins are sensitive to contamination and should not be touched with your fingers. Attach the protective cover on the lens after removing the lens from the camera, and never set the lens on the unprotected bayonet plate.

Before you take a meter reading, decide on the lens aperture that you want to use, and set the lens manually to the desired value, either at one of the engraved figures or between two figures for $\frac{1}{2}$ stops. The set value is now transferred into the camera body. You can take the meter reading either with the lens aperture fully open (for maximum screen brightness) or with the aperture manually closed down (as you might do for evaluating the image at the set aperture). The shutter speed, which sets itself automatically in all modes except M (Manual), adjusts automatically when you change the lens aperture setting.

Operation of CFE Shutter Lenses

CFE shutter lenses are used on all 200 cameras, with the lens shutter set to F if the focal plane shutter is used for the exposure. On all models except the 202, the exposure can also be made with the shutter in the lens, in which case the shutter is operated like a CF type. The aperture need not be closed down manually for the meter reading in either case. The shutter speed ring on the camera is set to C. In 202 model cameras, shutter lenses must be used with the focal plane shutter.

Operation of Other Shutter Lenses

All shutter lenses except CB types are set to F when the exposure is made with the focal plane shutter. The lens shutter is inoperative, and the viewfinder image returns instantly after the exposure. When the shutter in the lens is used with the focal plane shutter set to C, the finder image does not return until the film is advanced manually or by the motor winder. CB lenses cannot be used on the 202FA. On other 200 models the exposure with CB lenses must be made with the lens shutter.

When the focal plane shutter is used for the exposure, the shutter speeds are automatically set and are indicated in the viewfinder no matter what type of lens is used. When the shutter in the lens is used for the exposure, the shutter speed that provides correct exposure at the set aperture is also indicated on the display, together with the letters SET, reminding you that you must set this shutter speed manually on the lens.

C lenses should not be considered for use on any focal plane shutter camera.

Manually Closing Down the Aperture

With shutter lenses (except the CFE type), you must manually close down the lens aperture when you are taking the exposure meter reading, whether you use the lens or the camera shutter for the exposure. To eliminate having to close the aperture for every picture, you can simply leave the lens in the closed down position if the darker focusing image is not objectionable. The need to close down the aperture manually must nevertheless be considered the main disadvantage of using such lenses on 200 cameras.

You must also manually close down the aperture when you use accessories without the electronic connection, such as the old extension tubes or old teleconverters, with any lens—even the FE, CFE, and TCC types.

Setting the Shutter Speed on the 202FA Camera

The 202FA camera does not have the manual shutter speed ring at the front of the camera. The electronic circuit in the camera always sets the shutter speed even in the Manual mode.

Selecting the Shutter Type

In addition to the need to close down the lens aperture with some shutter lenses, your choice of shutter is likely decided by the type of photography you are doing. For flash photography, especially outdoors, the lens shutter gives you the possibility of shooting flash at all shutter speeds up to $\frac{1}{500}$ second, an option that is extremely helpful on sunny days. You may also want to consider using the smooth-operating lens shutter when camera vibration is a possibility—for example, when you are using a lightweight tripod or working with long shutter speeds or long telephoto lenses.

THE METERING SYSTEM

The 202 and 203 camera models have a center area metering system, with the exposure based on the light reflected from a large center area. The 205 models have a spot meter, in which 100% of the meter reading is based on a center area that is approximately 1% of the total image area (Figure 9-5).

The light is always measured through the lens. The measuring angle therefore depends on the focal length of the lens on the camera and is about $4\frac{1}{2}$ degrees with the spot meter and the standard 80mm lens. It becomes a 1-degree spot meter when the reading is made through a 350mm focal length

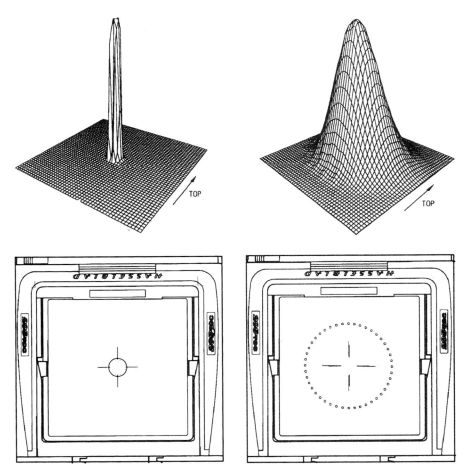

Figure 9-5 *The metering area* The 205 (left) has a precise spot meter that measures only a small center area. In the 202 and 203 models (right), approximately 75% of the light is measured within a 28mm center area and is also indicated on the screen. The measured areas are indicated on the focusing screens (bottom).

lens. Regardless of the lens, all cameras show the metered area on the Acute Matte focusing screen.

The entire metering system is within the camera body on all cameras (Figure 9-6). This design eliminates electronic contacts between camera and finder and allows you to use all the newer viewfinders that have display cut-outs and are used on the other cameras in the V system. Chapter 12 Achieving Perfect Exposures, discusses the suggested selection and use of various metering systems.

Turning On the Metering System

You can turn on the camera's metering system by pressing the AE lock on the side of the camera (Figure 9-7), by pressing the front release halfway, or

Figure 9-6 *The metering system* The metering cell is at the bottom of the camera and is completely protected from extraneous light.

by pressing the prerelease control, but you can do so only if the darkslide is removed.

The system and the display will turn on only when the shutter is cocked. Therefore, if the display does not come on, turn the winding crank. To save the battery, the metering system turns off automatically after about 15 seconds.

Using the AE Lock to Turn On the System

If you use the AE lock to turn on the system, any light value stored in the camera from the preceding shot is erased, and metering starts from scratch. This is the logical approach when you start taking pictures in new surroundings with a different light situation. Starting with the AE lock is also recommended when you are using shutter lenses in either mode because it eliminates possible mistakes if the lens settings should have been changed for some reason.

Using the Front Release or Prerelease to Turn On the System

When you turn on the system using the front release or the prerelease and with the mode selector set to D or Z, the light value from the preceding reading is maintained. The camera is still set to provide the same exposure as for the preceding shot. This is the ideal approach when you are continuing to take pictures in the same lighting situation. It eliminates the need to take a new reading for every shot.

With lenses having the electronic connection, you can change the aperture for the new picture, and the shutter speed automatically adjusts itself. With electronically coupled lenses, you can also change lenses and use the

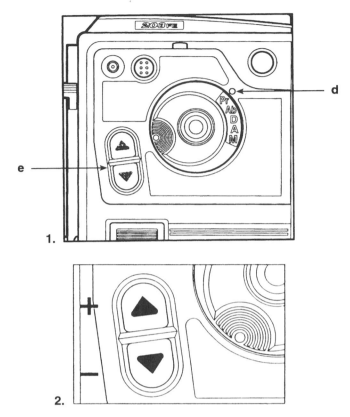

Figure 9-7 *The operating controls* The 200 cameras have a mode selector with engravings that differ according to model. **1.** The desired mode is set opposite the index (d). In the center of the selector is the AE lock button, which is used to activate the metering system or to lock the shutter speed or light value. **2.** The two adjustment buttons (e) are used to increase values (top button) or decrease them (bottom button).

new lens at any aperture without the need to take a new meter reading. You can use this approach with shutter lenses if the lens settings have not been changed manually. Keep in mind that this applies only in the D and Z settings, a good reason to consider either one of these modes for your photography.

In the A or Ab setting, the system always starts from scratch, even when turned on with the front release, unless a light value in the preceding reading was locked with the AE control. If the AE lock has been kept depressed for more than 16 seconds, the camera can be activated only by means of the release button or the prerelease lever.

Prereleasing the camera in any of the operating modes always locks and stores the exposure value that is present at the moment that the mirror was lifted, but the adjustment buttons can still be used to adjust that value.

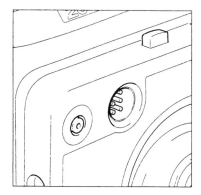

Figure 9-8 *Illuminating the display* The view-finder display is illuminated by daylight coming through the window below the Hasselblad engraving at the front of the camera. In dim light, you can illuminate the display by pressing the button above the flash connectors. It turns off automatically after about 15 seconds.

THE VIEWFINDER DISPLAY

The viewfinder display comes on only when the shutter is cocked. With the darkslide inserted, it comes on when you press the AE lock. The exposure indications depend on the camera model, the lens type, and the setting of the mode selector. Figure 9-9 shows the viewfinder display information.

The shutter speed is always visible on the right side. If a small "s" appears following the figures, the shutter speed is in seconds. For example, 4s means 4 seconds. If there is no s, it means a fraction, such as $\frac{1}{4}$ second. With the shutter set to C, the letters SET also appear, indicating that you must set the indicated shutter speed on the lens. This was not the case with the original TCC model. With FE, CFE, or TCC lenses on the camera, you can see the preset lens aperture on the left by pressing the release halfway.

The setting of the mode selector dial is always shown with the same letters as on the selector dial, with the exception of Ab, which is indicated only as A. When you are using the 202, 203, and 205FCC models in the A or Ab mode, the letter L comes on when the AE lock or the front release is pressed, the finder display can be illuminated (see Figure 9-8).

Warning Signals

An incorrect camera setting that you should be aware of appears on the display as some kind of warning. The most important ones are illustrated in Figure 9-10.

A few other points are worth mentioning. You know when the shutter speed ring is set at B because the display does not come on nor does it stay on. You know when the ring is set to C as the display on newer cameras will say SET, indicating that the shutter speeds need to be set manually. The exposure in all newer 200 cameras is made at the speed determined by the metering system regardless of the setting of the shutter speed ring. On the original

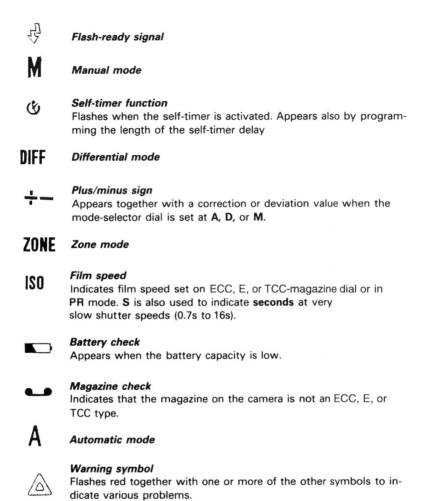

Flash-ready signal

M *Manual mode*

(⏲) *Self-timer function*
Flashes when the self-timer is activated. Appears also by programming the length of the self-timer delay

DIFF *Differential mode*

÷— *Plus/minus sign*
Appears together with a correction or deviation value when the mode-selector dial is set at **A, D,** or **M.**

ZONE *Zone mode*

ISO *Film speed*
Indicates film speed set on ECC, E, or TCC-magazine dial or in PR mode. **S** is also used to indicate **seconds** at very slow shutter speeds (0.7s to 16s).

Battery check
Appears when the battery capacity is low.

Magazine check
Indicates that the magazine on the camera is not an ECC, E, or TCC type.

A *Automatic mode*

Warning symbol
Flashes red together with one or more of the other symbols to indicate various problems.

Figure 9-9 *Viewfinder display information* Various kinds of information appear on the viewfinder display.

205TCC cameras, the shutter speed flickers if the calculated value is longer than the value set on the shutter speed ring. To avoid this, leave the shutter speed ring at 1 second.

PROGRAMMING

The Pr setting on the mode selector is not a metering function but rather is used to program certain values into the electronic circuit of the camera. Three values can be programmed into any 200 camera model (see Figure 9-12):

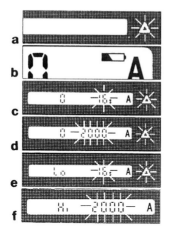

Figure 9-10 *Warning signals in finder display* The major warning signals that appear on the display are as follows:

 a. Flashing red triangle indicates an improper camera setting.
 b. Low battery power.
 c. Shutter speed should be longer than is possible on camera.
 d. Shutter speed should be shorter than is possible on camera.
 e. Light value is below meter range.
 f. Light value is above meter range.
 g. Flash was too bright for correct exposure (displayed in dedicated flash mode only).
 h. Flash was too low for correct exposure (displayed in dedicated flash mode only).
 i. Measured area falls below zone 0.
 j. Measured subject area falls above zone 10.
 k. Measured area is beyond set contrast range.

 • The ISO film sensitivity (works only with film magazines that do not have the electronic coupling)
 • The self-timer delay
 • A reduction (or increase) in the flash exposure of the dedicated flash system

On camera models that have automatic bracketing, you can program the Ab value, meaning the difference in exposure between the first and subsequent pictures. On the 205 models, you can also program a desired contrast range, and on the 203, a desired reference value.

Programming the Functions

To program any value into any camera model, you set the mode selector to PR and then repeatedly press the AE lock until the function that you want to program appears on the display. You set or change the programming values by pressing the plus or minus adjusting buttons. For example, pressing the + button changes the self-timer's delay from 10 to 12 to 14 seconds. Depressing the—adjustment control reduces the flash value from 0 to $-\frac{1}{3}, -\frac{2}{3}$, or -1 stop. Flash and automatic bracketing values are shown as fractions (Figure 9-11).

Figure 9-11 *Fractional indications on viewfinder display* **1.** On the 202 and 203 models, fractional indications on the display are in $\frac{1}{3}$ stop increments: $\frac{1}{3}$ (a), $\frac{2}{3}$ (b). **2.** On the 205 camera, the indications are in $\frac{1}{4}$ stop increments: $\frac{2}{4}$ or $\frac{1}{2}$ (a), $\frac{3}{4}$ (b).

Figure 9-12 *The programming display* The major programmed values as they appear on the display are the film sensitivity (a), the self-timer delay (b), the flash adjustment (c), and the bracketing value (d).

After programming the desired values, set the mode selector to the exposure mode that you want to use. Should you forget to do so, the picture will be made in the automatic mode and will probably still be usable.

The programmed values can be changed at any time. All programmed values remain stored in the camera as long as the camera's battery is in good condition. When you remove the battery, all programmed functions return to the normal (default) values: 10 seconds for the self-timer; 100 ISO for the film sensitivity; 0 for the flash, the bracketing, and the reference values; and −9 to +9 for the contrast range.

THE METERING OPERATION

Before using the built-in metering system, you must decide and set the desired metering mode and set the desired lens aperture, no matter what type of lens or which shutter you use. With lenses that do not have the electronic connection, you must also manually close the aperture to the preset value for the meter reading.

Exposure Modes

Different exposure modes (Figure 9-4) do not change the metering area but give you different choices for evaluating and measuring the subject and for setting the lens for the correct exposure based on your desired approach. The selected exposure mode is set opposite the index and the change is shown on the display (Figure 9-14). The dial is designed to stay in a set position.

Automatic Exposure Mode

In the A or Ab mode, you take one picture, with the shutter speed determined automatically. With a motor winder attached, the camera keeps taking pictures until you take your finger off the release or until you run out of film. This is the procedure for sequence photography and for automatic bracketing with the control set to Ab, where the camera takes pictures at different exposures as programmed into the camera.

When you set the camera in the A or Ab mode, the meter always starts with a new reading of the new subject unless you locked the previous setting using the AE lock.

When the camera is moved to brighter or darker subject areas in the A or Ab mode, the shutter speed adjusts itself automatically and continuously, giving you the point-and-shoot approach when there is no time to take more careful meter readings. It works well with cameras, such as the 203, that have center area metering. I do not suggest using the automatic mode on the 205 camera because the small spot metering area may point at a subject area that provides completely wrong readings.

Although the shutter speed is set automatically, I suggest having a quick look at the shutter speed indicated in the viewfinder just so that you know what it is. This is especially recommended in handheld work, where you need to make certain that the shutter speed is short enough to eliminate or reduce problems of camera motion.

If you do not want the shutter speed to adjust itself to a new subject area, you can lock it by pressing the AE lock. This is automatically done in the D and Z modes.

Automatic Bracketing Mode

With the motor winder attached and the 203 or 205FCC camera set to PR, program the desired bracketing value—the difference in exposure between images—into the camera by using the adjustment buttons (see Figure 9-13). The numeral 0 changes to horizontal fraction lines, showing $\frac{1}{3}f$ stops on the 203 and $\frac{1}{4}f$ stops on the 205. The maximum value is 1 stop. Set the mode control to AB.

If you want only three images, remove your finger from the release after the third take.

Differential and Zone Modes

The D mode and the Z mode work the same way. The difference is only in the viewfinder display. With the lens aperture preset, you point the metering area at a desired part of the subject and turn on the metering system using the AE lock. The shutter speed sets itself and also locks itself instantly. Figure 9-15 shows the finder display in the D mode; Figure 9-16 does the same for the Z setting.

This automatic locking is the real benefit and beauty of working in the Z or D mode. In both modes; the display shows the set shutter speed on the right. The display shows a 0 on the right in D, and zone 5 in Z, indicating in either case that the set shutter speed is correct for the measured area.

I recommend either of these two modes for most subjects and applications, except perhaps flash. They offer a wonderful, logical, fast, and convenient method of taking accurate meter readings no matter what the subject or the lighting might be. You know what subject area you are measuring, and the instant automatic locking of the shutter speed provides speed and convenience.

A good metering approach is to point the metering area at a part of the subject that has the average brightness (18% reflectance), use the AE lock to turn on the meter and set the shutter speed, and then recompose the image and take the picture. You can change the aperture if you like, and the shutter speed will adjust automatically. If you want to bracket exposures, do so by using the adjustment controls. If you want to take additional pictures in the

same location without a change in exposure, use the front release to turn on the metering system.

If you move the camera in the D or Z mode into brighter or darker subject areas, the shutter speed does not change (because it is locked), but the 0 on the left then shows the difference in brightness between the first and second area; for example, +1 means that the new area is 1 stop brighter. In the Z

Figure 9-13 *Programming the Ab value* In the automatic bracketing (Ab) mode (1), the Ab values are shown as $\frac{1}{3}$ (a), $\frac{2}{3}$ (b), and 1 f stop (c) on the 203 camera (2). They are programmed into the camera by pressing the + adjustment control with the mode selector set to PR (3). The values are $\frac{1}{4}$ stops on the 205.

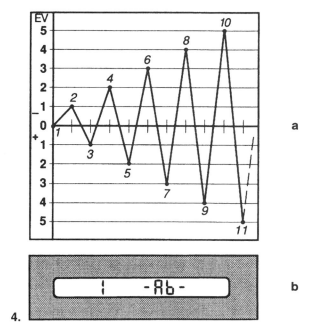

4.

Figure 9-13 *Programming the AB value (continued)* With the automatic bracketing function programmed for 1 stop (4b) the first exposure is now made at the set exposure value, the second image is made at 1 EV lower (1 stop brighter), the third at 1 EV higher (1 stop darker), the fourth 2 stops brighter, the fifth 2 stops darker, and so on (4a).

mode, zone 5 changes to a higher or lower zone number. These differences are indicated in $^1/_3 f$ stop values on the 202 and 203, and in $^1/_4$ values on the 205.

Manual Exposure Mode

Although the M mode works beautifully, I see little advantage in using this setting because the D or Z setting works the same way but without having to adjust the shutter speed manually. The main advantage of the M mode is in letting you preselect the shutter speed, an option that can be desirable in flash work.

In the M mode, you can preset the aperture and then turn the shutter speed ring until the display shows 0. You can also preset the shutter speed and then change the aperture until you see 0 on the display.

The ML Exposure Mode on the 202 Camera

The mode selector on the 202 camera has an ML setting, which is the Manual mode just described but with the possibility of locking the shutter speed.

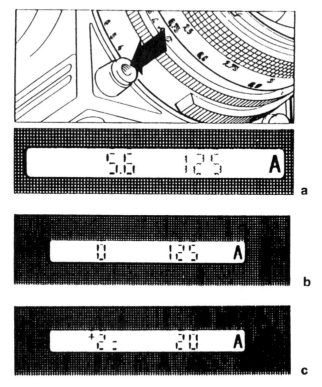

Figure 9-14 *Display of shutter speed and aperture* In the A, D, and Z modes, the display shows the selected mode, the shutter speed, and a 0 (zero) indicating the correct exposure for that area (b). The aperture is visible when you press the release halfway (a). You can change shutter speed by pressing an adjustment button. The display then shows the new shutter speed and the deviation (c), or the new zone.

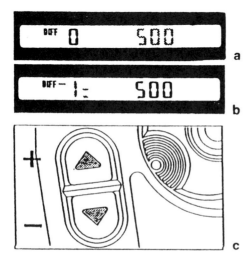

Figure 9-15 *Display in D mode* In the D mode, the display shows 0 and the calculated shutter speed (a). When you move the camera to brighter or darker areas, the shutter speed does not change. The 0 changes to a deviation figure, indicating how much brighter or darker the new area is; in this case, the difference is $-1\frac{1}{2}$ (on the 205 model). Exposure and shutter speed are changed by using the adjustment buttons (c), and the deviation figure changes accordingly (b).

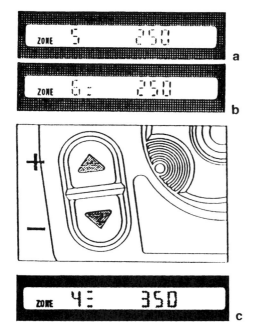

Figure 9-16 *Display in Z mode* In the Zone mode, the display shows zone 5 and the selected shutter speed (a). When the metering spot is moved to other areas, the shutter speed does not change, but the display shows the new zone: 6½ (b). You can change the shutter speed and zone at any time using the adjustment buttons (c).

This is an ideal setting for using the camera in the shutter priority mode, an approach that can work beautifully in flash location photography.

THE ZONE SYSTEM THEORY

The Zone mode, in combination with the precise spot meter in the 205 camera, is the ideal metering system for black and white photographers working with Ansel Adams's zone system. There is no need to make calculations nor to transfer exposure figures into zone values. The zone value for any measured area appears on the viewfinder display. You can change it at any time using the adjustment buttons.

An important aspect of Adams's zone system theory is the concept of adjusting exposure and film development so that all the resulting black and white negatives can be printed on standard-grade paper no matter what the contrast range of the scene might have been. In principle, low-contrast scenes are given less exposure but longer development time, whereas a subject that has a high contrast is exposed longer and developed for a shorter time. Adams referred to these adjustments as expansion (increasing contrast) and contraction (lowering contrast), and he defined the adjustments more accurately with the so-called N– (for contraction) and N+ (for expansion). For details, consult Adams's or other zone system books.

The Zone System Compensation Dial

The ECC (TCC) film magazines have a dial to program these compensations, from −4 to +3, directly into the camera. The exposure is changed automatically based on these adjustments. To eliminate mistakes the contrast dial functions only in the Zone mode. The adjustment does not show on the viewfinder display, so check the setting on the magazine.

Keeping Track of the Contrast Range

When working with the 205 in the D mode, you can program into the camera a desired maximum contrast range. The normal value programmed into the camera is −9 to +9 f stops, a range that is probably greater than anything you need in your photography. You can program a narrower range into the camera—for example, from −2 EV to +3 EV—by pressing the minus adjustment button until you see the desired minus value. To set the + value, do the same with the + adjustment button. If the programmed values are exceeded during subject evaluation, the DIFF display flickers.

The Reference Mode in the 203

With the 203 set to the Manual mode, it is possible to program a reference value into the camera that will warn you when the light or the subject brightness changes beyond a desirable level. To take advantage of the reference mode, you must turn on the meter using the front release, not the AE lock button.

ELECTRONIC FLASH

All 200 series cameras have a dedicated flash system that measures the light from a 40mm center area of the film plane. The dedicated flash is operated in the same way as with the other Hasselblad cameras. All cameras can also be used in the nondedicated fashion with any portable or studio flash units. With the camera's focal plane shutter, flash can be used at shutter speeds up to $\frac{1}{90}$ second. If the shutter is set at shorter speeds, the flash does not fire, the exposure is made automatically at $\frac{1}{90}$ second, or you receive a warning, depending on the camera model. With the shutter in a lens, all shutter speeds up to $\frac{1}{500}$ second can be used.

The Flash Connections

For dedicated flash with the focal plane shutter, the six-pin cable from the flash unit or dedicated flash accessory is connected to the six-pin socket on the side of the camera. No other connection is necessary. When you are using

nondedicated units with the focal plane shutter, the sync cable goes into the PC socket next to it. When dedicated or nondedicated units are used with the shutter in a lens, the sync cable goes into the PC socket on the lens. For dedicated use, the six-pin cable must also be connected to the camera body.

Flash and Exposure Modes

Any type of flash can be used in all the exposure modes (A, Ab, D, Z, and M). I do not suggest using the A or Ab mode for flash work in dark indoors because the camera will set itself for a undesirably long shutter speed. In the D, Z, and M modes you can photograph at any desired shutter speed, perhaps at $\frac{1}{30}$ second to pick up more of the existing light. You can also consider

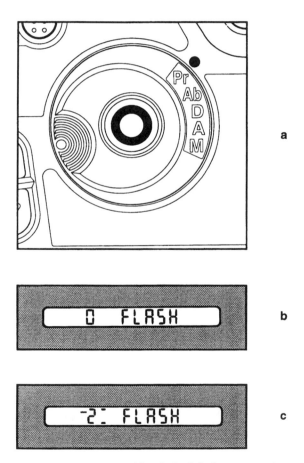

Figure 9-17 *Flash exposure adjustments* The desired flash exposure is programmed into the camera at the Pr setting (a) and indicated on the viewfinder display. A 0 means that the flash exposure is normal and equal to the existing light (b). The display in (c) indicates a flash exposure reduction of $2\frac{2}{3}$ f stops on the 202 or 203 camera.

using the M mode for location flash photography because it lets you preset the shutter speed at a specific value, $\frac{1}{90}$ second or longer.

Chapter 17, Flash Photography with Hasselblad Cameras, has more details on outdoor flash photography and the technique of combining flash and existing light.

Flash Exposure

On all 200 series cameras, the desired exposure for the flash is adjustable within a wide range and is completely independent of the lens settings (see Figure 9-17). On the 201 model, you make the adjustment using the ISO dial on the side of the camera, as on the 500 models. On cameras with built-in metering systems, the desired value for the flash exposure is electronically programmed into the camera. Press the AE lock repeatedly until FLASH appears on the display. The values + or − are then programmed with the adjustment buttons. Recommended adjustments are mentioned in Chapter 17.

Flash with the Original 205TCC Camera

On the 205FCC and the 202 and 203 cameras, the exposure is always made at the shutter speed indicated on the viewfinder display, even when dedicated flash is used, not so on the original 205TCC model. When this camera is used in dedicated flash fashion, the camera uses the shutter speed that is set physically on the shutter speed ring, not the speed set by the camera's microprocessor and shown on the viewfinder display. The simplest way to overcome this problem is to use the Manual Exposure mode and set the shutter speed manually at a figure not higher than $\frac{1}{90}$ second.

When the camera is set to C for use with the lens shutter, the shutter speed and the letters SET do not appear on the display.

10

Selection and Use of V System Film Magazines

V SYSTEM MAGAZINES

All Hasselblad rollfilm magazines in the V system are of the same design and are used in the same way. Each magazine consists of three parts: the shell, the darkslide, and the insert that holds the spools. Magazine shells have serial numbers on the plate that attaches to the camera; film inserts have a three-digit number engraved between the two film spools. These three numbers should correspond to the last three digits on the magazine shell. For example, if the magazine number is VC482232, the insert with the number 232 belongs to it.

This matching system ensures the best possible film flatness. Hasselblad V system film magazines have small rollers going across the top and bottom of the opening on the magazine shell and larger rollers on the insert. The interaction and alignment between these rollers in the magazine shell and insert are adjusted in the factory on every magazine (Figure 10-5). Matched numbers ensure the best possible performance. If inserts are switched, the magazine still works, but spacing between images may not be as even and the film may not be as flat. If you work with more than one magazine, check the numbers once in a while.

HASSELBLAD ROLLFILM MAGAZINES

Magazine Type

All the latest Hasselblad rollfilm magazines have a darkslide holder for storing the darkslide while pictures are taken (Figure 10-1). The magazines are otherwise identical to older types. The darkslide holder should not be added to older magazines.

Magazines come in three types: the E type, the ECC type, and the A type.

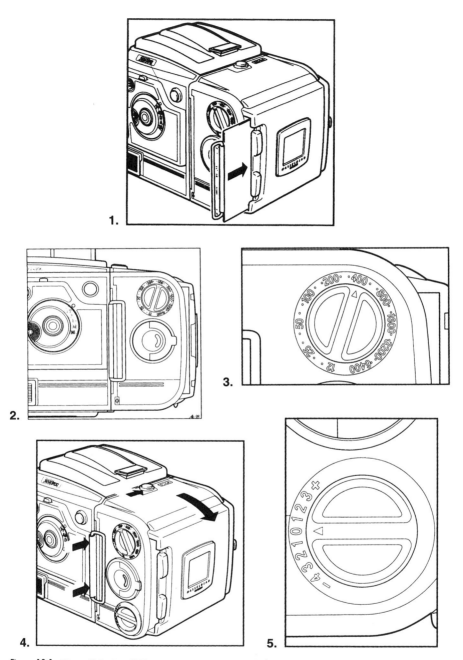

Figure 10-1 *Hasselblad rollfilm magazines* **1** and **4.** All newer magazines have a dark slide holder at the rear. **2.** E magazines have an ISO adjustment dial at the top. **3.** It can be set for ISO 12 to 6400. **4.** ECC magazines have the ISO dial on top and a contrast adjustment control at the bottom. **5.** The adjustments are from −4 to +3 based on Ansel Adams's recommendations.

E-Type Magazines The E types have an ISO dial and electronic contacts to transfer the ISO sensitivity to the 200 cameras that have a built-in exposure meter.

ECC Magazines The ECC magazines (formerly called TCC) are for use mainly in combination with the spot meter in the 205 camera and also have the ISO dial and electronic contacts. In addition, they have a dial for programming image contrast adjustments based on Ansel Adams's zone system theory.

E and ECC magazines are used like any other magazine on cameras that don't have a metering system.

A-Type Magazines A-type magazines do not have adjustment controls and are mainly for use with cameras that don't have a metering system. A-type

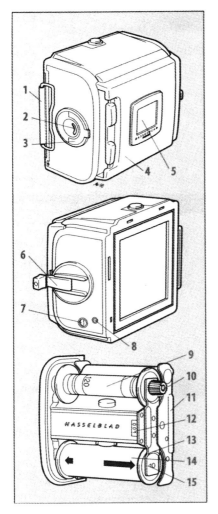

Figure 10-2 The rollfilm magazine components.
1. Darkslide
2. Film load indicator
3. Film holder key
4. Darkslide holder
5. Film tab holder
6. Film winding crank
7. Frame counter
8. Film advance indicator
9. Take-up spool
10. Take-up knob
11. Film clamp
12. Film insert number
13. Spool clamp bar
14. Supply spool
15. Film load index

magazines can also be used on cameras that have a metering system; in that case the ISO film sensitivity must be programmed into the camera.

Magazines for 120 Rollfilm

All magazine types are available as "12" versions—A12, E12, E12CC—made for 12 images in the $2\frac{1}{4}$-in. (6 × 6cm) size on 120 rollfilm. Some magazine types are also available in the "16" version—A16, E16—made for 16 images in the 6 × 4.5cm format on 120 rollfilm.

The 16 magazines are supplied with a transparent mask to show the rectangular area on the focusing screen. The checked screens can be used instead of these masks because the lines engraved on the screen also correspond to the 16 format.

Magazines That Are No Longer Available

The film magazine 16S, made for the Superslide format, is no longer made because 35mm projectors cause vignetting in projection.

The magazine A12V produced 12 images in the vertical format without the need for turning the camera. The same results can be obtained today with standard 12 or 24 magazines by placing a mask at the rear of some camera bodies.

For a short time, Hasselblad also made a magazine producing 24 × 56mm panoramic images on 35mm film. Today, the XPan camera provides a better solution for panoramic photography.

All rollfilm magazines made before 1969 were of the nonautomatic type. They can be distinguished by a chrome winding key on the side (possibly covered by a nonfoldable accessory crank) instead of the foldable crank and a round cover at the rear engraved with film speeds and types. The cover can be opened to let you see the paper backing of the 120 rollfilm. This is necessary because the beginning of the film must be moved through the magazine until #1 is visible through this window.

Magazines for 220 Rollfilm

Some film magazine types are also made for 220 rollfilm and are known as "24" because they produce 24 images in the $2\frac{1}{4}$-in. (6 × 6cm) format on 220 rollfilm, or as "32" when made for the 6 × 4.5cm format (now discontinued). The 220 rollfilm has the same dimensions as the 120, and both types are supplied on identical spools. Instead of paper backing along the entire roll of film, the 220 type has only short paper leaders and trailers at the beginning and end of the roll to protect the film when it is loaded and unloaded. Twice as much film can be put on the same size roll and into the same size magazine, giving twice as many images on one roll of film; that is the main advantage of 220 rollfilm. Using 220 film reduces the number of film or magazine

changes, but the choice of film is greatly reduced, and 220 film is available only in professional camera outlets.

The 220 rollfilm magazines differ from the 120 types in the gear mechanism, the springs on the pressure plate, and the roller adjustment. The 220 film is only about half as thick as the combined thickness of film and paper on the 120 type, and therefore the rollers and the pressure plates must be adjusted differently.

Using 120 Film in 220 Magazines Because the rollers and the pressure plates in 120 and 220 film magazines are adjusted to produce best image sharpness on the film only for which they are made, it is highly recommended that you use each magazine with the film only for which it is made. In an emergency, the following options exist:

- The 120 rollfilm can be used in a 24 magazine type. The spacing, however, becomes wide toward the end of the roll, so you end up with only about 11 images.
- The 220 film can be used in an old, nonautomatic magazine after the magazine is made light tight by closing the opening at the rear. Image spacing and the number of images, however, are questionable.
- The 220 film cannot be used in an automatic magazine.

USING MAGAZINES

Care of Magazines

Before you drop the loaded holder into the magazine, look inside the shell to ascertain that there are no leftover pieces of paper from a previous roll. Before you place the film on the holder, always completely remove the paper that is used to tape the beginning of a roll. Never leave any loose paper on a roll of film. It can easily come off and possibly lodge itself in the film gate.

Remove any dust and dirt particles in the magazine because they can easily scratch the film. Keep the openings of the connecting gear and pin free from any dust that may enter the magazine's winding mechanism.

Film Identification

When using different types of film, you want to know what type is in which magazine. As an easy way to keep track, simply place the top from the film box underneath the black cover disc. Earlier magazines had a dial that could be set for the film sensitivity, but current models do not.

Operating Signals

Whenever the insert, with or without film, is removed from the magazine shell, the frame counter jumps back, and the operating signal in the

magazine becomes black. The spring-loaded device that keeps the film tight on the loaded spool also activates the film consumption indicator on the roll holder lock. With a full roll, the indicator shows all white. As the film is used, more and more red shows in the circular window (Figure 10-3).

Film Inserts

The film inserts made since 1985 are somewhat different from the earlier types. They have a single, solid stainless steel spool-holder arm on a spring mechanism, instead of separate arms for feed and take-up spools. The magazines with new inserts start at number 3250869 for magazine A12 and at 3524656 for magazine A24. The latest inserts (made since 2001) also have a second starting index, which you use when loading the somewhat thicker Ilford films. Place the arrow opposite this new index before the insert with Ilford film goes into the magazine.

Figure 10-3 *The film holder—film insert* The new film inserts (1) have in the center portion a spring-loaded device (a) that keeps the film tight on both the feed and the take-up spools. The roller (b) on the feed side rests against the film to actuate the film consumption signal. Two chrome strips (c) served the same purpose on the older film inserts (2). A film consumption signal (3) that is partially red and chrome indicates that a partially exposed roll of film is in the magazine.

Loading the Magazine

All rollfilm magazines are loaded in identical fashion. The paper protects the film from daylight, but it is best to avoid exposing it to direct sunlight whenever possible.

The film magazines can be loaded while attached to the camera or off the camera; in the latter case the darkslide must be in the magazine. It is easiest to load the magazine when it is attached to the camera without the darkslide inserted.

Film loading is described step by step in the instruction manual. Let me repeat here the most important points to keep in mind, also illustrated in Figure 10-4.

1. The take-up side on the insert is easily distinguished by the knurled knob.
2. Make certain the film comes off the spool so that the black side is outermost; the emulsion faces the lens. The film needs to curl the opposite way from the way it is wound on the spool.
3. Make certain the film rides under the side guide, not over it. I find it easiest to press my thumb against the paper next to the guide to keep it under the guide. It eliminates the need for using the insert lock.
4. For proper spacing, the black arrow on the paper must be placed opposite the red triangle (the Ilford index for Ilford films on the latest magazines). Most films have only one arrow going across the paper backing. Some 220 films, however, have a black dotted line followed by an unbroken black arrow a few inches later. Advance the film to the line with an arrow.

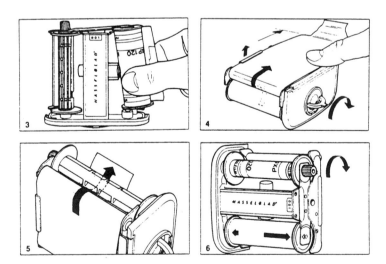

Figure 10-4 *Important film loading steps for the automatic magazines* **3.** The take-up spool is identified by the knurled knob. Place the film on the other side. **4.** Make certain the film unwinds the opposite way from the way it is wound on the spool, with the black side outermost, and that it is placed underneath the side guide. **5.** Attach it in the same way on the take-up spool. **6.** Use the knurled knob on the take-up spool to move the film until the black arrow on the film is opposite the triangular index.

Figure 10-5 *Film flatness* **A.** The Hasselblad film magazines have small rollers (b) in the shell, which are factory aligned to be at the exact distance and perfectly parallel to the large rollers (a) in the film insert. This interaction ensures maximum film flatness and is the reason every film insert must be matched to the shell. **B.** Magazines on other medium-format cameras do not have these rollers, possibly making the film buckle just ahead of the take-up roller.

5. Before placing the insert into the magazine, ascertain once more that the edge of the film is underneath the side guide.
6. Make certain to turn the magazine's winding crank until it stops before you start to take pictures; otherwise, you will lose the first two or three pictures and the spacing will be uneven. The film winding crank brings the number 1 automatically into the film counter window. At this point, the crank is locked and cannot be turned again until after the first exposure. Thereafter, the film winding crank is unlocked but should not be touched until the end of the film.

Unloading the Film

After the last picture on a roll has been taken, the camera's winding crank or knob can be turned as usual, so you really do not know that you have reached the end of the roll until you try to take the next picture. I have found that the turning of the crank feels a little different and the sound of the moving film is a little different when moving to the last frame (from 11 to 12 on a 120 magazine). You can become accustomed to the difference and recognize when the film is moved to the last frame without checking the frame counter.

At the end of a roll of film, turn the film winding crank again to pull the paper trailer through the magazine and around the exposed roll of film so that it can be removed in daylight. You know when the paper has gone through: It becomes easier to turn the crank.

It is advisable to wind the paper through immediately at the end of the film, even if the magazine is not to be reloaded immediately. You may forget that you did not advance the film to the end, and pulling out the insert at that point ruins at least the last two shots.

Spacing

With the film properly loaded, all Hasselblad magazines should space images pretty evenly from the first to the last picture so that the space between

Figure 10-6 *Film magazine 70* **1.** On the side of the magazine are the film transport key (A); the film counter setting button (B); the film counter (C); the signal indicating whether the magazine is loaded (white), not loaded, or at the end of film (red) (D); the operating signal (E); the film plane mark (F); and a panel for notes (G). **2.** Without a cassette holder, the inside of the magazine can be seen with the film winding shaft (A); the slotted pin (B), which locks the cassette holder to the magazine; the pin (C) connecting to the exposure counter; and the feeler lever (D), which connects to the film load indicator. The camera can operate only when the lever is pushed down by the film or manually.

images never exceeds about 6 mm and is always wide enough to make a cut. If spacing is not correct, consult the Hasselblad service center.

FILM MAGAZINE 70

Film magazine 70 (see Figure 10-6) is made for 70mm film loaded into cassettes, with one cassette providing about 70 images in the $2\frac{1}{4}$ square format. Magazine 70 has one operating signal near the film plane indicator, and this signal shows whether the film has been advanced. A second one near the exposure counter shows whether the magazine is loaded with film. A camera equipped with film magazine 70 operates only with film in the magazine or when the feeler lever is taped in the down position. (This should be done only for demonstration purposes.) If there is no film in the magazine, the release is locked.

You advance the film to 1 using a foldable winding key. The magazine has an exposure counter numbered from 1 to 73 and another—an engraved circle with a knurled center knob—above the counter window. This summarizing counter can easily be seen from a distance. Each engraved dot on the circle corresponds to 10 images.

Both counters return to the original position—to 0 or to the red line—when the cassette holder is removed. You can manually reset both counters by turning the center knurled disc with your thumb. The counters are helpful when you are removing a partially exposed film. For instance, if you want to remove and develop a film with 23 images, wind the exposed film completely inside the take-up cassette by turning the film winding crank three full turns. Remove the cassette holder and cut the film. Remove the exposed film from the cassette in a darkroom. Reload the magazine in the usual fashion, and wind the film to 1. Now reset the exposure counters manually to the number of images that have been removed, adding 4 for the probable amount of film

Figure 10-7 *Loading the 70mm magazine* The cassette holder is removed from the magazine shell in the same way as the rollfilm holders in other magazines. Open the cassette holding arms (1A). Place the feed cassette (2B) on the side of the magazine without the winding pin, making sure that it unwinds in the correct direction. Close the cassette holding arm. Guide the film around the sprocket wheel (2D), over the pressure plate, and under the film clamp (3A). Attach the take-up cassette (2A) to the other side of the magazine. If the film runs smoothly, close the holding arm. Place the cassette holder in the magazine. Turn the film winding key until it stops (the counter should show 1).

that has been lost in cutting. If 23 exposures have been made, set the counters to 27. Film loading is shown in Figure 10-7.

The 70mm Film

The 70mm film comes either unperforated or perforated in various ways. The Hasselblad magazine 70 requires the type 2 perforated type. Some film is available in daylight loading cassettes. Other emulsions are purchased in bulk for loading your own cassettes in a darkroom, a process that is like loading a 35mm cassette.

Although 70mm film offers the benefits of a large number of exposures per roll, 70mm film is available only in very few emulsions and frequently on special order only. Also, be sure to use a laboratory that is equipped to process the 15-foot lengths without cutting.

OTHER FILM MAGAZINES

Magazine 70/100–200

This magazine, which may be available by special order, has the same dimensions as magazine 70 but is designed for use of 70mm film on spools, not cassettes. Depending on the film thickness, this magazine provides up to 200 exposures but requires darkroom loading.

Magazine 70/500

This large film magazine, which could provide up to 500 exposures on 70mm film, was available for a number of years before 1980.

Sheet Film Holder and Adapter

The sheet film adapter has been discontinued, mainly because sheet film in the proper size is no longer available. It was necessary to use 4×5 sheet film cut to the proper size in a darkroom.

The Hasselblad Data-Recording System

The data-recording magazines that are in use in the American space program can record up to 32 characters directly on the edge of the film when used on a motor-driven camera model. Obtain further details from the Hasselblad distributor.

USE AND APPLICATION OF THE INSTANT FILM MAGAZINES

The instant film magazine allows you to see the image that will be recorded on the film before you shoot, thereby giving you the opportunity to make changes in the camera or lighting setup. The instant film magazines encourage experimentation, eliminate guesswork, save on film and laboratory costs, and serve as a great teaching tool.

Instant film can also show things you cannot see on the focusing screen, such as the result of camera-made double exposures, the lighting ratio between flash and ambient light, and the effect of multiple strobe use. It also lets you see the amount of blur when you zoom, when you move the camera, or when you photograph moving subjects at slow shutter speeds.

Checking Exposure

Checking exposure is especially valuable when you are working under unusual lighting situations or are combining different light sources. It is also useful in photomicrography or high-magnification photography.

The exposure latitude of instant film is not as wide as with regular negative or transparency films, and lens settings are more critical. This is actually an advantage because it means that a good instant film exposure is probably a perfect exposure on the other films.

Keep in mind that a good exposure on instant film means a correct exposure for transparencies that need to be exposed for the lighted areas. The results are correct for negative materials when the instant print shows some details in the shade.

Instant Film Magazines for Hasselblad Cameras

The current magazine is made for the professional films in the 100 and 600 series, which are the preferred emulsions in professional photography. The

magazine can be used on all current Hasselblad models and also in combination with the 45-degree prism finders, but not in combination with the PM 90 and PME 90 viewfinders.

The discontinued magazine 80 was made for the amateur films Polacolor 88 and black and white 87. This magazine cannot be used on focal plane shutter or Superwide camera models.

The Purpose of the Glass Plate

The Hasselblad instant film magazines have glass plates in front of the film to move the image to the exact film plane distance (see Figure 10-8). With the Hasselblad instant film magazines protruding at the top of the camera, the camera's magazine hooks prevent the film plane from being at the same position as on other film magazines. It is slightly farther back. The glass plate restores the image distance.

Because the glass plate is right in front of the film plane, dirt and dust particles will show up in the image. This is not a serious problem on test shots, but it will be if the magazine is used with negative/positive film. For this reason, keep it clean. Being glass, it can be cleaned like lens surfaces.

The Polaroid magazines attach to Hasselblad camera bodies like the other film magazines and are removed in the same way, with the darkslide inserted (see Figure 10-9).

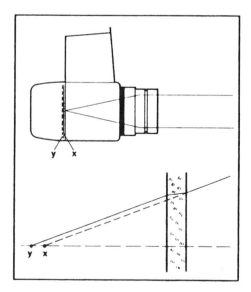

Figure 10-8 *The purpose of the glass plate* The design of the instant film pack makes it impossible to bring the film plane at the same distance as in other Hasselblad magazines. The image formed by the lens falls at x, slightly in front of the instant film plane (y). The glass plate lengthens the distance and moves the image from x to y so that it is formed exactly where the film is and where it produces the sharpest possible image.

Figure 10-9 *Using the instant film magazine* To attach and remove the instant magazine, press the catch (D). To load the magazine, open the lid by releasing the clamp (A). With the film toward the glass plate, push the file pack at an angle completely under the flange (B) on the hinged end of the magazine; push it down so that it snaps into place. Close the lid, making certain that all the white tabs are free. Pull the black safety cover all the way out of the camera. The film pack is ready for the first picture.

Figure 10-10 *Using the instant film pack* After exposure, grasp the center of the white tab (E), and pull it all the way out at a moderate and constant speed without stopping. Developing time starts now. The film magazine is ready for the next exposure. The darkslide can be stored in the holder (F). The developer spreader should be cleaned frequently with a moist cloth. To remove it, lift the two rear arms (H) diagonally upward at the same time. Press the arms down simultaneously when you replace the spreader.

Adjusting for the Different Film Sensitivities

In most cases, the negative or transparency film used for the final image will have a different exposure index than the instant film used for the test. You can match the two by changing either the aperture or the shutter speed or by using a neutral density filter.

If you use a neutral density filter, you can make the test shot and the final image at the same aperture and shutter speed, with both pictures having identical depth of field. Use the neutral density filter for the test shot if the instant film has a higher ISO value, and use it for the final picture when the negative or transparency film has a higher ISO value. If one of the films has twice the ISO of the other (50 versus 100 ISO, or a 3 DIN value difference), use a

filter with a 0.3 density. If one of the films has an ISO value three times as high (100 versus 800 ISO, or a 9 DIN value difference), use a filter with a 0.9 density for the faster film.

Using the Instant Film Magazine on Cameras with a Built-In Metering System

The Hasselblad instant film magazines do not have the electronic connections to transfer the ISO sensitivity into the camera body. You must program the film sensitivity of the instant film into the camera's microcomputer using the Pr setting on the mode selector.

When E-, ECC-, or TCC-type magazines are used for the final film, it is not necessary to make any adjustment in the ISO when you switch magazines. The metering system switches automatically from the ISO value programmed into the camera for the instant film to the ISO value set on the film magazine for the negative or transparency film. If the magazine for the final film is an A type without the electronic connections, the ISO value must be reprogrammed with every change of magazine.

Care of the Instant Film and Magazine

When you handle film packs, do not press against the center of the pack because this may damage the film. Hold the film pack by its edges.

The caustic jelly that may be in the film pack should be wiped off your skin immediately and washed off as soon as possible. Keep the discarded materials out of the reach of children and animals and out of contact with clothing and furniture. Clean the rollers of the developer spreader in the magazine, preferably after every film pack. Do not touch the face of the instant print immediately after separation. Let it dry and come to a hard gloss.

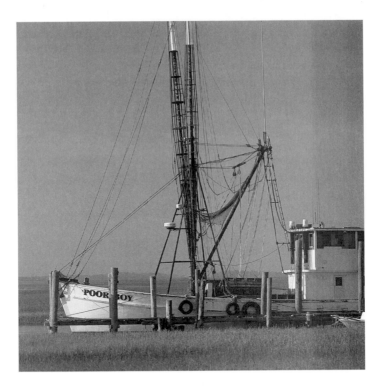

▲ The Hasselblad teleconverters increase the focal length of a lens without any objectionable loss of image sharpness. "Poor Boy" vessel photographed with 2× converter on 250mm lens. Side lit church photographed with 1.4× converter on 110mm lens. Ernst Wildi

▲ With a short focal length lens, the mountains in the background appear small and far away. A longer focal length lens used further away from the truck makes the mountains appear larger and closer and makes them a dominant part of the scene. Ernst Wildi

▲ A short focal length lens includes a large part of the background area including trees and a disturbing sky area. A longer focal length lens used from a longer distance maintains the size of the statue, but eliminates much of the distracting background details. Ernst Wildi

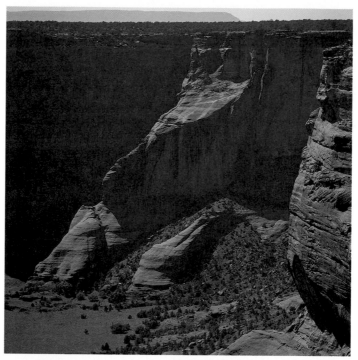

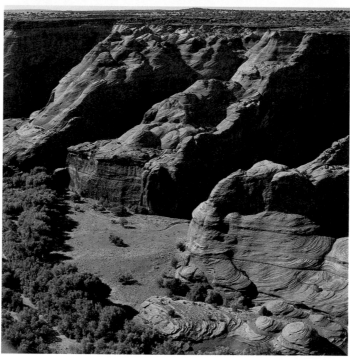

▲ The two images taken at the same day and time, in the Canyon de Chelly in Arizona with a 250mm lens, show the striking improvement in the color saturation with a polarizing filter that eliminates the reflections on the distant rock formations. Ernst Wildi

11

V System Viewfinders and Focusing Screens

Viewfinders are interchangeable on all the more recent V system Hasselblad camera models, and focusing screens are interchangeable on all models made since 1970. This versatility allows convenient image evaluation and focusing with all lenses and accessories and with the camera handheld or on a tripod.

FOCUSING SCREENS

The Acute Matte Focusing Screen

All Hasselblad cameras made since 1998 are supplied with an Acute Matte screen, and the very latest 500 models have a version with a split-image rangefinder and a microprism. The Acute Matte design consists of an acrylic focusing screen with a fine Fresnel pattern and microlenses (see Figure 11-1). Combined with a protective glass plate mounted in a metal frame, this design provides remarkably high brightness over the entire surface.

Although screen brightness is helpful for composing and evaluating the image, brightness alone does not help in achieving precise focusing. The latter needs a high resolution in the focusing image. The Acute Matte screen beautifully combines the two necessary characteristics, providing the photographer with a superb focusing screen for any type of photography in any lighting conditions. If your camera is equipped with the old groundglass screen, consider the Acute Matte very seriously, even if it means changing to a newer camera model.

The Acute Matte is also the only screen that ensures correct exposures with the latest meter prism viewfinders. Although the plain Acute Matte type seems to help most photographers in achieving accurate focusing, some prefer focusing with a split-image rangefinder or a microprism. This is a personal choice that you can make only after trying the different options.

The 200 camera models have Acute Matte screens with the metering area engraved: the 6mm spot meter area in the 205 or the 28mm center area in

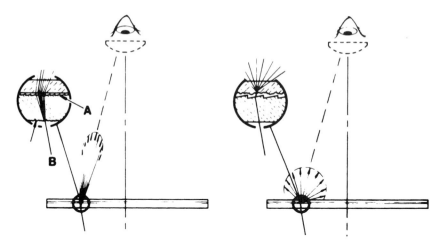

Figure 11-1 *The Acute Matte screen* The superb image brightness and contrast of the Acute Matte focusing screen (left) are achieved with a fine Fresnel pattern (A) and a focusing screen plate composed of microscopic lenses (B). The lenses direct much more light toward the eye than an ordinary focusing screen (right), which diffuses the light in all directions.

the 202 and 203 models (see Figure 11-2). There is also an Acute Matte screen that shows the 12mm spot metering area of the PME 90 and PME 45 meter prism viewfinders.

Focusing with Split-Image Rangefinder

The Acute Matte screens with split-image rangefinder can be inserted into the camera with the dividing line running horizontally or vertically. The image can be focused either in the clear rangefinder center circle or in the surrounding screen area. In the rangefinder area, the subject is in focus when a straight line crossing the rangefinder area appears unbroken across the dividing center line (see Figure 11-3). This is easy to see even by photographers who have a focusing problem.

Keep in mind that the image in the rangefinder area always looks sharp. You must focus on a straight line crossing the split area. Rangefinder focusing also requires that the rangefinder area be aimed at the main subject, a requirement that may be inconvenient when you must work fast.

Split-image rangefinder focusing has limitations with regard to lenses. When the aperture of the lens is smaller than $f/4$ or $f/5.6$, one side of the split-image rangefinder field blacks out. You can no longer use the rangefinder for focusing. This is not a serious limitation because the lens aperture is normally wide open and the limitations appear only when you focus with the aperture manually closed down or with small aperture lenses, perhaps telephotos.

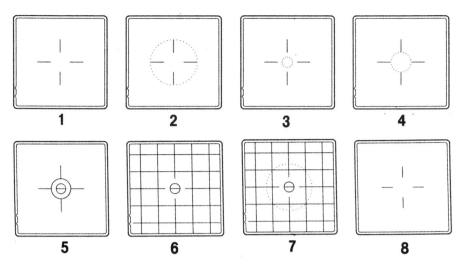

Figure 11-2 *Different focusing screens* In addition to the standard Acute Matte focusing screen (1) are the screens with the 202/203 center metering area (2), the 205 spot metering area (3), and a screen showing the metering area of the PME 90 and PME 45 meter prism finder (4). There is a screen with a microprism/split-image rangefinder area, which is the screen supplied in the latest 500 camera models (5), and two screens that combine a split-image rangefinder with grid lines (6) and that show the 202/203 metering area (7). The plain glass screen (8) has been discontinued.

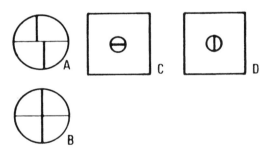

Figure 11-3 *Rangefinder focusing* Accurate focusing with the split-image rangefinder screen is obtained when a straight line of the subject crossing the split is not broken (A) but continuous (B). The screen can be placed in the camera so that the split is horizontal (C) or vertical (D).

Split-image rangefinder focusing with any lens requires that your eye be in the optical axis. If one field is blacked out, move your eye slightly up or down or sideways.

Focusing with Microprisms

The microprism center area consists of many tiny prisms that split lines if the lens is not focused at the proper distance. The image jumps readily and

rapidly into place. Screens with microprism areas had definite advantages with the old focusing screens. The value is somewhat reduced with the Acute Matte types, which offer a sharp image over the entire screen area.

Focusing Screens with Grid Lines

The focusing screens that have equally spaced horizontal and vertical grid lines are helpful when the lines of a subject must be perfectly horizontal or vertical within the image area. The most typical application is in photographing buildings, whether it involves professional architectural photography or souvenir pictures of the beautiful buildings that we encounter during our travels. Other applications come up in product photography and in any type of copying.

The engraved lines on these focusing screens are spaced so that the two vertical and the two horizontal outside lines correspond to the 6 × 4.5cm film format and the 8 × 10 paper ratio and can therefore also be used as cropping guides instead of masks (see Figure 11-4).

Other Focusing Screens

Over the years, other screens have been available for Hasselblad. These screens should not be used in combination with meter prism viewfinders. The exposures will not be correct.

The clear glass screen, now discontinued, is a plain glass screen with a Fresnel lens and a reference cross in the center. This screen is recommended only for focusing on very fine detail, as in photomicroscopy, and for use by people who know how to focus the image in a microscope.

The original groundglass screen should no longer be used because today you have the opportunity to enjoy the brightness and sharpness of the Acute Matte screen, which makes composing and focusing faster and more precise.

Figure 11-4 *Focusing screen masks* **3.** The film magazines and the camera masks for the 6 × 4.5cm and panoramic image format are supplied with a transparent mask that is placed over the focusing screen to show the rectangular image area covered on the film. Such a mask is also helpful when you photograph in the square but plan to change some or all of the images later into rectangles corresponding to the 8 × 10 paper proportions. **4.** Darkening the corners of the mask with black lacquer or any other method can further assist in composing in the rectangular format. The focusing screens with grid lines can also be used for this purpose because the outer lines correspond to the 8 × 10 image proportions.

The fine line focusing screen was the old groundglass screen, but with the Fresnel lines more closely spaced so that they were less obvious.

The Optofibre screen was made up of nearly 100 million light conductors, yielding a brighter image compared with the standard screen.

The Bright Matte screen provided a brighter image over the entire screen surface, with a microcutting that made the Fresnel circles invisible.

Cleaning Focusing Screens

Never use lens cleaning fluids, other chemicals, or water on any focusing screen. Instead, clean it with a soft cloth, if necessary by breathing on it. Never dry it with hot air. Handle the acrylic screens carefully, because they can easily become scratched.

VIEWFINDERS

The interchangeable Hasselblad viewfinders magnify the image on the screen for accurate focusing and shield the screen from extraneous light for convenient image evaluation even in bright sunlight. They are attached to the camera as shown in Figure 11-5.

Each viewfinder has its own advantage, so select the type that appears to be most satisfactory for your type of photography and for the way you operate the camera with the lenses and accessories that you usually use. All finders are beautifully suited for handheld photography.

When you are working from a tripod set at eye level, a prism finder is a necessity to eliminate the need for standing on a chair.

Viewfinders to Improve Camera Steadiness

The danger of camera motion is reduced when two forces work against each other. With a handheld camera, the two forces are the hands pressing the camera in one direction and the photographer's head, with the eye pressed against the viewfinder, pushing the opposite way. A firm contact between eye and viewfinder is necessary. The rubber eyepieces on the Hasselblad finders (except the standard hood) encourage this firm contact.

You can wear eyeglasses for viewing with the latest Hasselblad accessory finders (because of their high eyepoint), but the firm contact is somewhat lost because it is difficult to press a finder eyepiece as firmly toward eyeglasses as you can toward your eye and forehead. Eyeglasses also leave an open space on the sides where light can enter, creating a disturbing flare and making the image on the screen appear darker than it actually is. On older finders (without the high eyepoint), eyeglasses also prevent you from placing your eye close enough to the eyepiece to see the entire screen area.

Figure 11-5 *Attaching viewfinders* To mount any viewfinder on the camera, remove the film magazine, and then slide the finder into the grooves and completely forward as far as it goes.

Some finders that have the older eyepiece can be changed to the newer type. Check with the Hasselblad service center. The standard focusing hood on the camera cannot be used in any practical way with eyeglasses.

Whether to work with or without eyeglasses must be your decision. Because I do much handheld photography, my personal choice is to view without glasses. I keep my reading glasses—which I need for reading the numbers on the cameras and lenses, especially in low light—hanging on a chain around my neck so that I can simply drop them for viewing and focusing.

Viewfinders for Exposure Measurements

Equipping the camera with a meter prism viewfinder adds a built-in light-metering system to any V system Hasselblad camera. The light is measured through the lens (TTL) and through filters, extension tubes, and bellows, and you can recognize the measured area while composing the image on the focusing screen. For these reasons, the meter prism finders offer an excellent solution for light metering that is more accurate, more convenient, and faster than the regular handheld metering approach. Chapter 12, Achieving Perfect Exposures, discusses the use and operation of the metering system in these finders.

Viewfinders for Accurate Focusing

A viewfinder must provide you with an absolutely sharp image of the focusing screen. This happens only if your eyes are able to focus for the distance at which you see the focusing screen in the viewfinder, just as you can read a newspaper only if your eyes can focus at the reading distance.

Table 11-1 Viewfinders and Focusing Hoods and Their Diopter Values

Viewfinder type	Built-in diopter adjustment	Potential diopter range with correction lenses or eyepleces	Magnification
Standard focusing hood		−4 to +3	4.5×
PME 90	−2 to +0.5	−4 to +3	2×
PM 90		−4 to +3	2×
PM 45 and PME 45	−2 to +1	−4.5 to +3.5	2.5×
Magnifying hood (discontinued)	−2.5 to +3.5		3×
View magnifier	−3 to +4.5		2×
Magnifying hood 4 × 4 DPS	−2.5 to +0.5		5.5×
Magnifying hood 4 × 4 DPS	−1.5 to +1.5 with standard focusing screen adapter		5.5×
Some older prism finders		−4 to +3	
Magnifying Hood		Correction lens	
HMZ		mounting kit available	3.3×
Rmfx finder		Correction lens mounting kit available	3.3×

Note: The correction mounting kits do not include the correction lenses which must be obtained from an optical store.

Make a test with your camera and finder. Point the camera at a subject with fine detail, turn the focusing ring, and see whether you can easily see the details, whether you can really see when the lens is focused accurately. Focus a few times to see whether you always end up at exactly the same setting on the focusing ring. Make the test with different lenses if you have them, especially with wide angles, and also at lower light levels, where focusing always becomes a problem. If you plan to wear your glasses for viewing, make this test with the glasses on; otherwise, do not wear them. If your glasses are bifocals, make the test through the part of the glasses that you plan to use, which is likely the upper, long-distance part.

MATCHING THE VIEWFINDER TO YOUR EYESIGHT

If the focusing test does not provide the desired image sharpness for focusing, your eyes cannot adjust to the viewing distance of the finder. Except for the HM 2 and Rmfx finders, all newer Hasselblad viewfinders can be matched to your eyesight, as shown in Table 11-1.

The built-in correction ranges seem to be sufficient for most photographers. If not, consider changing the eyepiece or magnifying lens, if available. Unfortunately, there is no simple way of determining what diopter correction you need except to try the various correction pieces or lenses.

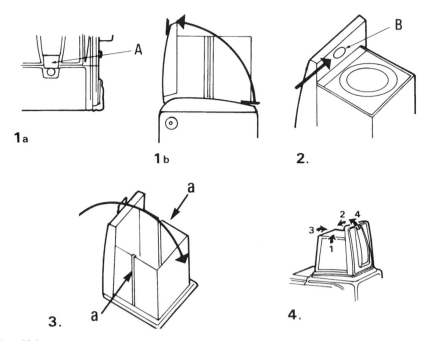

Figure 11-6 *Opening and closing the focusing hood* 1. You open the new focusing hood by placing your finger underneath the plastic tab (A) and lifting the hood upward (1a, 1b). 2. To bring the magnifying lens into viewing position, slide the tab (B) in the direction of the arrow. 3. To fold the new focusing hood, pinch the sides at the hinge (a) and press down the cover. 4. To close the older focusing hood, flip down the top plate and fold down the sides and rear panel. The front panel locks when folded down.

Adjusting the Built-In Diopter Correction

Because the eyepiece must provide a sharp image of the focusing screen and not necessarily of the subject, it is best to make the adjustment without a lens on the camera so that you see nothing but the focusing screen. Turn the diopter correction ring until the lines on the screen are absolutely sharp. After the first adjustment, remove your eye from the finder for a few seconds and look at a distant subject to relax your eye. Look at the focusing screen a second time to see whether the image is still sharp with the relaxed eye.

You can make this adjustment with the lens on the camera as long as you ascertain that you adjust the eyepiece for the screen, not for the image. (The image sharpness depends on the focus setting on the lens.)

Diopter Correction Lenses for the Standard Focusing Hood

The standard focusing hoods made for all SLR Hasselblad models since 1986 can be equipped with diopter correction lenses ranging from +3 to −4. These accessory lenses, mounted in a square frame like the one that is in the hood,

Figure 11-7 *Changing the magnifying lens on the standard focusing hood* To change the magnifying lens, remove the hood from the camera and open it. Hold the plate with the lens at an angle, pull it downward, and remove it through the bottom. To insert the new plate, reverse the process.

Figure 11-8 *Viewing with prism viewfinders* Prism viewfinders provide a magnified, upright, and laterally correct image. The rubber eyecup, which can be mounted for left or right eye viewing, provides additional shielding against extraneous light and is recommended when you are viewing without eyeglasses. For viewing with eyeglasses, either cut off the flap or use the rubber eyecup supplied with the finder.

are not added to the existing magnifier but instead are inserted in place of the present lens (see Figure 11-7). The standard viewfinders made up to 1985 offer no practical diopter correction method, so I can only suggest considering the new version or a prism finder.

Adjustment of Older Finders

On older Hasselblad prism viewfinders, the eyepiece adjustment was made by adding diopter correction lenses to the existing eyepiece or by changing the entire eyepiece. The correction lenses or eyepieces may or may not be available any longer. Check with the Hasselblad distributor.

VIEWFINDER MAGNIFICATION

The magnification of the various Hasselblad viewfinders varies and is indicated for most finders in Table 11-1.

Although the magnification varies, the image in all finders is sufficiently magnified for precise focusing on the Acute Matte screen. Your choice of finder is therefore best determined by the viewing convenience for your approach to photography. A higher magnification naturally enlarges the viewfinder display of a metering system, making the figures and symbols easier to read.

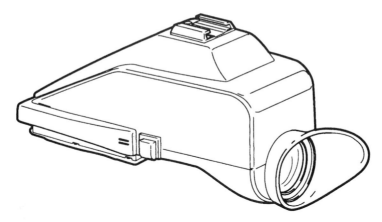

Figure 11-9 *The PM 90 viewfinder* The PM 90, like the PME 90, lies flat over the camera body and film magazine and therefore cannot be used with the Hasselblad instant film magazine or magazine 70. All other film magazines, including the E types, can be used.

The Hasselblad View Magnifier

In spite of the high magnification of the Hasselblad viewfinders, some photographers feel the need or desire for an even more precise approach, at least when working with a tripod. The view magnifier serves their needs. Attached over the regular viewfinder eyepiece (see Figure 11-12), the magnifier adds 2× to the magnification of the center portion of the focusing screen image. The center portion is thus magnified 5× with the PM 45 finders.

After focusing, you can move the magnifier's hinged eyepiece out of the way so that you can see the entire focusing screen to evaluate the composition. The needed switching between focusing and viewing makes the use of the magnifier practical only when you are working from a tripod. However, you can leave the view magnifier attached to the eyepiece, moving it into the magnified focusing position only when needed and when time permits.

The view magnifier comes in two versions: one for the PM 90 and some earlier 45-degree finders, and the other made for the PM 45, PME 45, and PME 90 finders and is attached as shown in fig 11-12.

AREA COVERAGE ON THE FOCUSING SCREEN

The focusing screen on Hasselblad V system cameras shows about 98% (horizontally and vertically) of the image recorded on the film. This reduction was originally done purposely to match more closely the area of a projected transparency (which is cut off by the slide mount). Some viewfinders cause an additional slight cut-off, and the 200 camera models have an additional 1mm cut-off at the bottom caused by the camera body. The differences need not

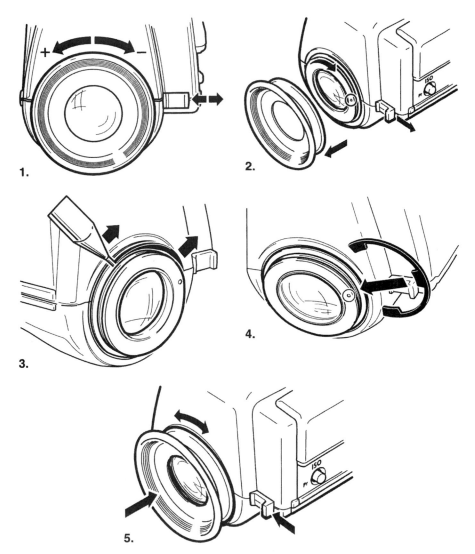

Figure 11-10 *Eyepiece correction in PM and PME finders* **1.** To set the diopter correction built into the PME finders, pull out the eyepiece lock. Then turn the eyepiece to the proper setting and push the lock lever back into the finder. **2.** To change the eyepiece in the finder, remove the eyecup, release the diopter lock, and rotate the diopter all the way to the right. **3.** With a pointed tool, remove the red "C" lock ring and remove the diopter. **4.** Insert the corrective diopter eyepiece and the red "C" lock ring. **5.** Reinstall the rubber eyecup, rotate the eyepiece to the correct setting, and lock it by inserting the locking lever into finder.

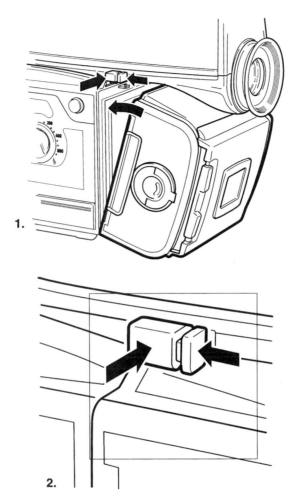

Figure 11-11 *Attaching and removing a film magazine with PM 90 or PME 90 on the camera* **1.** You attach or remove a film magazine by pressing the magazine catch slide. **2.** The catch slide can be pressed only if the locking lever is pushed forward simultaneously. This double lock arrangement prevents the magazine from falling off if the lever should be pressed accidentally.

be considered except by the photographer who plans to exhibit images complete with their actual frames.

Vignetting

When you use long focal length lenses, extension tubes, or bellows on older cameras without a gliding mirror system, you may note vignetting along the upper edge of the viewfinder image. The vignetting starts with focal lengths

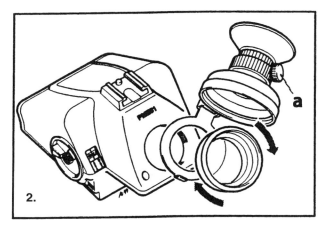

Figure 11-12 *Attaching the view magnifier* **1.** Remove the eyepiece and rubber eyecup by unscrewing them counterclockwise. Remove the original eyecup, and slide the supplied eyecup over the threaded end of the eyepiece as far as it will go. **2.** Fold out the hinged ring of the magnifier and place it over the opening of the finder. Screw the eyepiece back by turning it clockwise. You can rotate the magnifier to the most suitable position by loosening the eyepiece a little.

greater than 100 mm but becomes objectionable only with lenses 180 mm and longer and when you use longer extension tubes with any lens.

This image cut-off, caused by the mirror, happens only on the focusing screen, not on the film, and you must therefore allow for it. Move the camera slightly upward to see what is in the cut-off area to make certain that it does not include anything that should be in the image. If you work extensively with longer lenses or close-up accessories, consider switching to a newer camera model with the gliding mirror system. All Hasselblad cameras with a gliding mirror system show the entire image that is recorded on the film with any lens or accessory.

SELECTING A VIEWFINDER

Selecting a viewfinder is a personal choice based on your type of photography, but you may also want to consider a meter prism viewfinder simply because it adds a metering system to the camera.

The Standard Focusing Hood

The standard focusing hood (Figure 11-5) has definite and unique advantages compared with any other type of viewfinder. It provides the highest magnification and, because it is foldable, keeps the camera lightweight and compact. By not using the magnifying lens, you can also view the image from a distance and with both eyes open. With the standard hood, you can view the image on the focusing screen from many camera angles, from waist level, from low angles or ground level, and from high levels by holding the camera upside down above your head.

The standard hood is not suitable for viewing with eyeglasses, so you should change the magnifying lens to one that provides a sharp image of the focusing screen without eyeglasses. Also, the hood is not very comfortable when pressed against the eye, as it should be for handheld work. A magnifying hood with a rubber eyecup is a better choice because it allows you to view the image from above. With both the standard finder and the magnifying hood, the image is right side up but reversed sideways. You can get accustomed to this, at least with stationary subjects. You are likely to move the camera in the wrong direction when following moving subjects.

The standard viewfinder and the magnifying hood can be used with all film magazines, including those for instant film.

Magnifying Hoods

A magnifying hood adds almost no weight but makes the camera bulkier because it is not foldable. On the other hand, with its soft rubber eyecup the magnifying hood keeps out extraneous light and provides comfortable viewing when the camera is pressed against the eye.

In place of the magnifying hood with built-in diopter correction that has been available for many years, Hasselblad has the HM2 model, a simplified and less expensive version. HM2 does not have built-in diopter correction but has two settings: one when it is used on cameras, and the other when it is used in combination with a focusing screen adapter.

Magnifying Hood 4x4 DPS

The designation 4x4 refers to the 40mm area coverage. This magnifying hood is optimized for use with digital backs with CCD sizes smaller than 40mm. The magnifying hood enlarges this area 5.5×.

Viewing from the Top

Viewing from the top lets you photograph from almost any camera angle and holding the camera in many different ways, and it is especially helpful in low-angle photography (see Figure 11-13). When viewing without the magnifier, you can take pictures without anyone being aware of your photography because the camera need not be in front of your eyes. Viewing from the top is also convenient when the camera is mounted vertically on a copy stand or microscope.

On the other hand, a focusing or magnifying hood is not practical with a tripod-mounted camera at eye level.

90-degree Eye-Level Viewing

The 90-degree viewfinders in Figure 11-9 may have a special appeal to 35mm photographers who are accustomed to this type of viewing and focusing. Viewing and focusing are practical and convenient, whether the camera is held in the normal fashion or turned sideways for shooting verticals, and this is why such finders are on all 35mm cameras and on the Hasselblad H1. A 90-degree finder is necessary when you are photographing handheld verticals with magazine 16 on any Hasselblad V system camera. All prism finders show an image that is right side up and unreversed. These viewfinders also have a shoe on top for attaching a small flash unit or other accessory. The PM 90 finders cannot be used with the instant film or the 70mm film magazines.

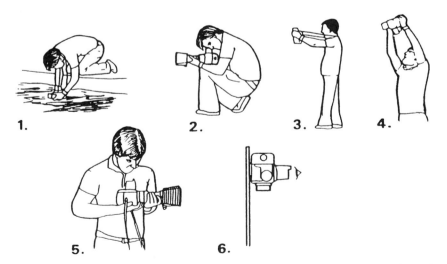

Figure 11-13 Viewing from the top has great advantages when you are photographing, for example, from low angles (1), from the knee (2), straight down (3), from over the head (4), sideways (5), or from a vertically mounted camera (6).

Reflex Viewfinder RMfx

The RMfx contains a mirror instead of a prism, and the viewing angle is 10 degrees from the vertical. This finder is designed for use with the focusing screen adapter on the Superwide cameras, the FlexBody, and the ArcBody, and it offers the wonderful advantage of providing a 3.3× magnified image that is right side up. With other viewfinders attached to the focusing screen adapter, the image is upside down.

45-degree Eye-Level Viewing

The prism viewfinders with 45-degree viewing are a good compromise between the standard hood and the 90-degree eye-level finders. You can hold the camera steadily, with your hands pressing the camera diagonally upward toward your slightly tilted head. Held in this fashion, the lens is only about two inches lower than with a 90-degree prism finder. Viewing can be considered eye-level whether you work handheld or from a tripod. These finders can be used with all film magazines, including the instant film types.

Discontinued Hasselblad Viewfinders

Reflex Viewfinder RM 2 The RM 2, originally called HC 3/70, is for 90-degree viewing from behind the camera. It has a viewing tube long enough to go to the rear of the 70mm film magazine. The eyepiece is adjustable from −5 to +5 diopters and can be locked in the set position. It can be used with instant film magazines.

HC-4 Viewfinder The HC-4 viewfinder for 90-degree eye-level viewing is designed like the RM 2 but with a shorter tube for use with rollfilm magazines only.

HC-1 Prism Viewfinder The HC-1 was the original 90-degree finder, going back to the 1960s. It has not been made for many years.

PME 5 and PM 51 These two 45-degree prism finders with built-in exposure meter are almost identical for use on all camera models.

PM 3 and PME 3 The PME 3 (with exposure meter) and the PM 3 (without) are identical to the PM 5 and PME 51 but do not have the cut-out front for use on cameras with a built-in metering system. The meter is adjusted for the Acute Matte screen.

PME/VFC 6 Prism Viewfinder This finder looks like the PM 3, but the meter was adjusted for the old groundglass screens. It needs an adjustment of about one stop when used with the Acute Matte screen. Test exposures are advised with

some lenses and teleconverters. Using one of the newer meter prism finders with the newer cameras is recommended.

NC-2 Prism Finder This original 45-degree prism finder was introduced in 1963 as NC-2. It could not be used in combination with an instant film magazine. The finder was modified in 1981 to the NC2-100 to be usable with the instant film magazine.

Meter Prism Finder This is the original meter prism finder, introduced in 1971 with a CDS cell. The meter indications are made with a movable needle. This finder has delicate moving parts and should be replaced with a newer, more modern meter finder.

Frame and Sports Viewfinders The frame and sports viewfinders made by Hasselblad were mounted either on the side or the top of a camera or on top of some lenses. They have been discontinued because they serve little purpose on a modern camera.

Cleaning Viewfinders

Clean the eyepiece lenses and the lens in the standard and magnifying hood in the same way you clean any lens. Be certain to blow or brush away all dust particles before wiping with lens tissue. Wipe the lens gently with the tissue, but only if necessary. The same approach can be used on the bottom prism surface, but do it carefully because it is a large glass surface that can be damaged easily.

The bottom surface of older prism finders was covered by a plastic sheet, which should never be cleaned with cleaning fluids or any other chemicals. Protect the bottom surface of the prism finder with the cover when it is off the camera.

12

Achieving Perfect Exposures

Correct exposure in any lighting situation is best determined with an exposure meter, which can be a separate handheld meter or one built into the camera system. All metering systems produce good results if used properly. It is therefore essential that you learn in detail how the different metering methods work, how the different meters measure the light, and how they must be used to provide the correct results with any subject in any lighting situation.

There are two methods of exposure metering. You can measure the light that falls on the subject, known as incident light metering, or you can measure the light that is reflected off the subject or scene, known as reflected light metering.

THE INCIDENT LIGHT-METERING APPROACH

An incident meter reading is taken by a measuring cell covered with a dome-like diffusion disc that measures the light falling on the subject from all directions. Such a diffusion disc is found on top of the Hasselblad PME 90 and PME 45 viewfinders, the only two items in the Hasselblad system made for incident meter readings (see Figure 12-1). To use handheld light meters for incident light readings, you usually slide or attach a diffusion disc over the measuring cell.

You take incident meter readings by holding the meter in front of the subject or in another location that receives the same amount of light as the subject, with the metering cell facing the camera lens. In this position all the light that falls on the subject also falls on the metering cell. In some cases, such as with a strong sidelight, you may want to compromise and have the cell face in a direction between the camera and the main light. Incident meter readings of backlit subjects are problematic, but for backlit landscapes where the ground covers a large part of the composition, try holding the meter flat over the ground with the meter cell pointing toward the sky.

Because incident meter readings usually have to be made where the subject is, the photographer must move away from the camera. Light

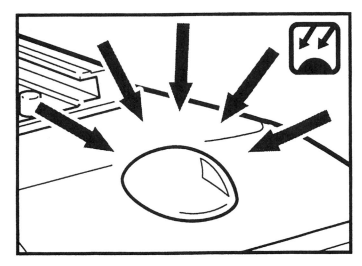

Figure 12-1 *The PME incident metering cell* The PME 90 and PME 45 meter prism view-finders have the incident metering cell covered by a domelike fixture on top of the view-finder. The cell measures the light falling on the subject from all directions.

metering can become a time-consuming, impractical process, especially in handheld photography.

Incident meter readings, however, have the wonderful advantage of being unaffected by the color and brightness of the subject. The incident meter measures only the light that falls on the subject, giving the same reading whether held in front of a white, gray, or black subject. The reading of an incident meter is correct regardless of the color or brightness of the subject.

Using the Incident Meter on the PME Prism Viewfinders

Incident meter readings with the PME 90 and PME 45 must be made in the same way as incident meter readings, with a handheld incident meter. The measuring cell, the dome, must be held in front of the subject being pho-tographed or in a place that receives the same amount of light as the subject. The dome must face toward the camera lens (see Figure 12-2). You can take the meter reading with the finder on the camera, an approach I have found most practical, or you can remove the finder for the reading, leaving the camera set up on the tripod.

Hold the meter prism finder (or the camera with the finder) so that the measuring dome is more or less parallel to the subject and is pointing toward the position from where the picture will be taken. Make certain that you do not shade the measuring dome. Press the metering button to set the meter reading which also locks it automatically. You can now take all the time you wish to read the metered value in the viewfinder and make the appropriate lens settings.

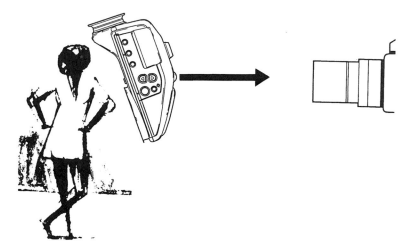

Figure 12-2 *Using the PME incident meter* An incident meter reading with the PME meter prism finders must be made in the same way as an incident reading with a handheld meter. The metering cell is pointed toward the camera from a position where it measures the light falling on the subject from all directions.

REFLECTED METER READINGS

Reflected meter readings are usually more practical, in location and handheld photography, because the meter reading can be made from the camera position. This is true whether the reading is taken with a handheld meter or a built-in metering system. With a metering system built into the camera, the reading can be more precise and definitely much faster.

In a reflected meter reading, we no longer measure the light falling on the subject; instead, we are measuring the light reflected off the subject. The meter reading, with the meter pointed at the subject, is now determined not only by the amount of light falling on the subject but also by the amount of light reflected from the subject. A bright subject gives a higher reading than a dark one even if the same amount of light falls on both. The difference between light and dark colors can amount to four or five EV values or *f* stops (see Figures 12-3 and 12-4). This fact applies to a handheld reflected meter as well as exposure meters built into a camera system, as in the Hasselblad H, XPan, and 200 model cameras, or when a meter prism finder is used on any V system camera.

Light Reflectance and Gray Tones

Although the reflected meter measures the actual brightness of the subject we are photographing, in many cases the reading on the reflected meter does not provide the correct exposure. The measuring cell in all reflected meters, handheld or built into the camera, is adjusted at the factory for an 18%

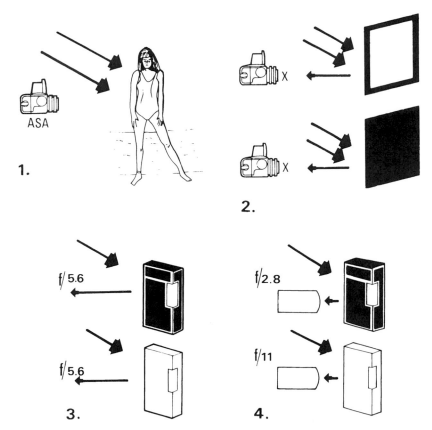

Figure 12-3 *Basics of incident and reflected metering* **1.** Correct lens settings for exposure are determined by the sensitivity of the film and the amount of light that falls on the subject. **2.** If an incident exposure meter reading indicates that the amount of light falling on the subject requires a lens setting of X, this same setting is correct whether the subject is light or dark. **3.** For example, the same aperture and shutter speed is used when you photograph a black or a white lighter, under the same lighting. **4.** Reflected light meters give higher readings (smaller apertures) for light subjects than for dark ones, even though the same amount of light falls on both.

reflectance value. The reading on the meter is perfect only if the meter is pointed at a subject area that reflects 18% of the light, such as a graycard or a green field. If the measured subject area reflects more light, the subject is brighter, and we need to increase exposure. Set the EV to a lower value (to EV 10 or 9 instead of 11), or open the lens aperture (to $f/5.6$ or $f/8$ instead of $f/11$). When pointing the measuring area at darker subjects, we must decrease exposure, close down the lens aperture, or set the EV to a higher value.

It seems to confuse many photographers that the aperture must be opened when reading bright subjects and closed for dark ones. To demonstrate this point, consider the following example: A reflected meter reading of a subject with an 18% reflectance is EV 14, requiring settings of $\frac{1}{125}$ second

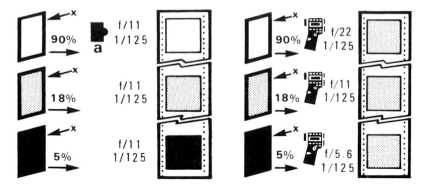

Figure 12-4 *Incident and reflected meter readings* An incident exposure meter gives the same aperture and shutter speeds for white, gray, and black subjects, and these settings record white as white, gray as gray, and black as black (left). Reflected meter readings differ when you point the meter at white, gray, or black, even though the same amount of light falls on all three. If you set the lens for the white reading (*f*/22, $\frac{1}{125}$ second), white is recorded as gray, not white. A lens set for the black reading (*f*/5.6, $\frac{1}{125}$ second) also records black as gray, not black, and so does a reading of gray at *f*/11 and $\frac{1}{125}$ second (right).

and *f*/11. A reading off a white subject (such as snow) would be EV 16, or $\frac{1}{125}$ second at *f*/22. To bring this snow reading to the correct 18% reflectance value, you must open the aperture from *f*/22 to *f*/11. The same applies when working in the zone system (see Figure 12-6).

Use of a Graycard

A graycard, available in camera stores, has a perfect 18% reflectance and can be used to obtain correct exposure with any reflected light meter and with a subject of any color and brightness. Hold the graycard in front of the subject more or less parallel to the image plane so that the same light that falls on the subject also falls on the card. The reading off the gray-card is correct, regardless of the color or brightness of the subject (see Figure 12-7). Although this method is not practical when you are working handheld or working with a metering system built into the camera, it can be an excellent approach in many fields, such as close-up photography and copying.

The Graycard as a Color Test

Bcause the graycard is a known color, you can also use it to check how a light source matches the film. Simply include the graycard in one of the images on the film. This can be especially helpful with color negative films. Without a subject of known color value on the negatives, the laboratory is somewhat at a loss to know what the colors in the print should be.

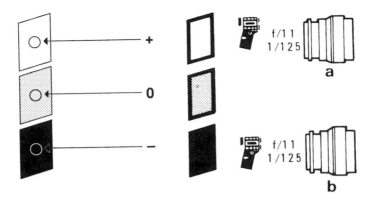

Figure 12-5 *Reflected meter readings* A reflected light meter reading is correct only when taken off a subject area of average brightness reflecting about 18% of the light. Exposure must be increased for brighter subjects, decreased for darker ones (left). An incident meter reading gives the same exposure ($f/11$ and $\frac{1}{125}$), whether held in front of a white, grey, or black subject (right).

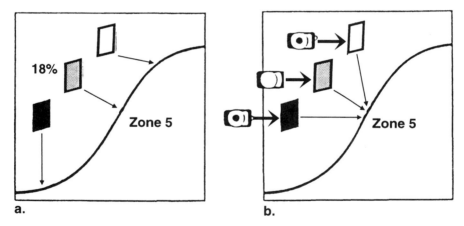

Figure 12-6 *The zone system exposure principle* Lens settings, based on a reflected meter reading of 18% gray, record this middle gray tone as zone 5. A reflected meter pointed at white records white also as a zone 5 middle gray and does the same for black (b). For correct exposure, only middle gray should be recorded as zone 5. To place white and black at the ends of the curve (for example, as zones 1 and 9), you must make adjustments in the reflected meter readings (a).

Reflectance Values of Different Colors

Most subjects that we photograph are not in different shades of gray tones, but in different shades of colors which reflect different amounts of light. The color chart in the color section of the Manual should help in determining what shades and colors need corrections and how much. A reflected meter reading of the colors in column 0 should be correct without any adjustment. A reading made of colors in column +1 need a one-stop exposure increase,

Figure 12-7 *Use of a graycard* Instead of measuring the light reflected off the subject, you can measure the light reflected off the graycard. The reading is then the same whether the card is held in front of the white or the black lighter (left). A graycard reading should provide the correct exposure in a portrait regardless of the color of the skin (right).

those in column +2 a 2-stop increase. A reading made of the darker colors in column −1 requires a 1-stop decrease.

SHADED AND LIGHTED AREAS

Many subjects that we photograph have areas that are brightly lit and other areas that are in the shade. Whether working with an incident, reflected, or built-in exposure meter, the photographer must decide whether to expose for the lighted areas or the shaded areas or somewhere in between. There is no metering system in the world that will do this for us automatically. The logical thought is perhaps to set the lens somewhere between the two readings, a solution that often works with negative but not with transparency films.

Exposing Negatives Versus Transparencies

Negative and transparency films need different exposures with subjects or scenes that have important details in shaded and lighted areas. To produce high-quality prints, black and white and color negatives must have adequate details in the primary shadow areas. Negative films (black and white or color) therefore must be exposed for good shadow density. You want to base the lens settings on the meter reading of the important shadow areas or set them to a value between the shadow and highlight readings.

Transparencies almost invariably must be exposed for the lighted areas; otherwise, the lighted areas look overexposed, become washed out, and lose color saturation. You really cannot worry about shadow details in transparencies except to try to avoid large shaded areas in the composition unless used for effect. Point the metering area at a lighted part of the scene or subject, or take an incident reading in the lighted part. Whether you take a shadow reading for negatives or a highlight reading for transparencies, you

Figure 12-8 *Exposing for negatives and transparencies* **1.** With transparency materials, the meter reading should be based on lighted areas marked P, for negative materials on shaded areas marked N. **2.** Reflected light meter readings must be based on the main subject without being affected by light (right) or dark backgrounds (left).

must point a reflected or built-in meter at an 18% reflectance area or else make the adjustments mentioned earlier (see Figure 12-8).

Another metering approach that can be recommended and saves time, especially if you take pictures of the same subject on transparency and negative film, is as follows. Take the meter reading of the lighted area as suggested for transparency film, and take the transparency. Decrease the EV value one number (assuming both films have the same ISO value), and take the picture on the negative material. The increase in exposure gives the additional needed shadow details.

If you plan to make color prints from a color transparency, you may want to take a special transparency at an aperture 1 stop larger for more shadow details.

Handheld spot meters, and metering systems in the camera, make it easy to see whether the metering cell measures a lighted or a shaded area. They have a definite advantage for this purpose.

USING VARIOUS METERING SYSTEMS

Reflected light readings can be taken with a regular handheld exposure meter, a handheld spot meter, or a metering system built into the camera or built into a viewfinder. Handheld exposure meters, the standard for many years, have become rather sophisticated, offering various metering modes and digital readouts. They still serve a good purpose for amateur and professional photographers. Handheld spot meters, showing the exact measuring area in a viewfinder, are great tools in the hands of photographers who have a thorough knowledge of exposure and metering.

Although separate handheld meters are good tools, a good metering system built into a modern camera can provide more accurate readings in a

much simpler and faster fashion and should therefore be seriously considered for serious amateur and professional photography.

Metering Systems Built into Cameras

Metering systems built into cameras have one thing in common: They all measure the light reflected off the subject or scene, so you must consider the points that have been said about reflected meter readings. Otherwise, built-in meters are of different designs, offering different metering modes, different ways of showing and transferring the metering information, and different degrees of automation. The requirement that is essential for me, and I feel essential for serious photography, is a system in which the measuring area is clearly indicated in the viewfinder. I do not use matrix metering, where the system measures different parts of a scene with individual metering cells; a computer in the camera then compares the various readings and selects an average. Such a meter produces good exposures in snapshooting and is therefore the system used in point-and-shoot cameras. I do not suggest it for serious work because the measuring area is unknown or difficult to determine. My suggested metering mode can be either center area metering or center-weighted metering or a spot meter; with both systems, I know what I am metering. With such a system your exposures with any subject in any lighting situation can be perfect, usually without bracketing.

Average Metering

Average metering means measuring the entire, or almost the entire, image area equally from side to side and top to bottom. It can be a good choice for fast shooting in compositions without large dark or bright areas such as a white sky. The H camera offers the averaging metering option, with the meter reading based on a 45×37mm center area, or about 70% of the total image area.

Center-Weighted Metering

The built-in meter measures more or less the entire area seen in the viewfinder but not equally. The meter reading is based mainly on the subject brightness in the center portion of the composition. Because the main subjects are usually in the center, such a metering system works well in most cases. Compared with average metering, it reduces the danger of measuring unimportant dark or light background areas. In the center-weighted mode in the H camera, most of the reading is based on a center area about 23×20mm in size, or approximately 20% of the total image area. The Hasselblad PME 51 meter prism (discontinued) has a center-weighted system, with approximately 50% of the exposure reading based on the light reflected from a center top area (see Figure 12-11).

Center Area Metering

Center area metering is very similar to center-weighted metering except that the meter measures only the center area. Center metering is the method used in the XPan camera. It is also one of the options on the PME meter prism finders, where most of the light is measured within a 40mm center area. Center area metering is also the measuring mode in the 202 and 203 camera models, with approximately 75% of the light measured in the indicated center area. Because a center area metering system measures the most important (center) area of the composition, the readings are in most cases accurate enough to allow use of the 200 cameras and the XPan cameras in the automatic mode, with excellent results even on transparency films.

Spot Meters

A spot meter measures a small center area outlined on the focusing screen. A well-designed spot meter measures only the light within the small outlined area and is virtually unaffected by any light from outside areas, no matter how bright it might be. A spot meter offers a very precise method for metering small, specific areas or various areas within the composition to determine the brightness difference, such as between shaded and lighted areas. The spot meter in the 205 camera measures about 1% of the total image area; about 2% is measured by the 7.5mm circle in the H camera. PME finders set for spot metering measure a 12mm center area.

The measuring angle of a built-in spot meter depends on the focal length of the lens on the camera. On the 205 camera, it is 4.5 degrees with the 80mm lens, and 3 degrees with the 110mm lens, and it becomes a 1-degree spot meter when the reading is made through a 350mm lens. The measuring angle of the PME spot meter is 12 degrees with the 80mm lens.

Exposure in Electronic Imaging

The evaluation of the tonal range and exposure in electronic imaging is discussed in Chapter 2, Digital Imaging with Hasselblad.

THE HASSELBLAD METERING SYSTEMS

The metering system in the H camera can be set for average, center-weighted, or spot metering, with many different light-measuring approaches and programmable functions that can match the metering approach to your photography. Details are in Chapter 4.

The 205 camera models have built into the camera body a spot meter that can be operated in various modes, including the Differential and Zone modes, which provide a wonderful way of locking an exposure value. They are used in Aperture Priority or Manual mode.

The 203 and 202 models have center metering that can be operated in the Aperture Priority or Manual mode and in various fashions, including Differential.

The PME viewfinders can be set for incident metering and for reflected metering either in center metering mode or as a spot meter (see Figures 12-9 and 12-10). The viewfinders can be attached to any 500, 200, or 2000 camera model as well as the focusing screen adapter on the Superwide cameras, the FlexBody, and the ArcBody, providing TTL metering in all cases. The readings in the finder must be transferred manually to the lenses.

The center area metering system in the XPan camera measures approximately one-third of the total image area and can be operated manually or automatically (see Figure 12-12).

The Advantages of a Built-In Metering System

A built-in metering system offers a number of advantages:

- A metering system in the camera or viewfinder eliminates the need to carry and worry about a separate meter.
- Determining and making the lens settings is much faster than pointing a hand-held meter at the subject, reading the figures on the meter, and transferring

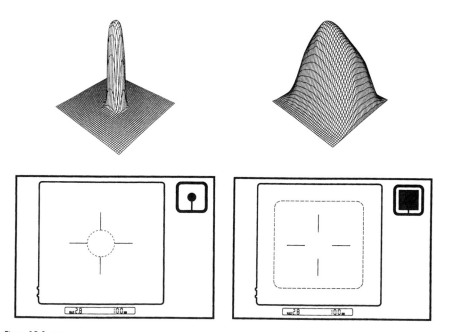

Figure 12-9 *Metering patterns in PME meter prism finders* In addition to incident metering, the PME 90 and PME 45 meter prism finders offer the option of a spot meter measuring a 12mm center area within the four black lines (left) or center area metering where most of the light is measured within a 40mm center area (right).

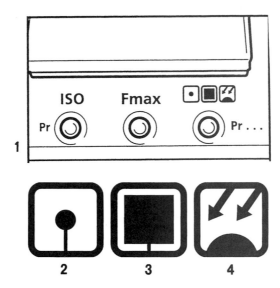

Figure 12-10 *Selecting the metering mode* On the PME 90 and PME 45 meter prism finders, you set the desired metering mode by pressing the metering mode button marked Pr (1) and then pressing the up or down adjustment button until the desired mode symbol appears on the viewfinder display. The metering mode symbols are spot meter (2), center area metering (3), and incident metering (4). The ISO button is for setting the film sensitivity. The Fmax button is for setting the maximum aperture of the lens on the camera.

Figure 12-11 *Metering area on PME 51 and earlier PME finders* In the PME 51 center-weighted meter prism finder, approximately 50% of the light is measured in a top center area with all focal length lenses. This measuring area for the PME 51 is indicated by a dotted line on both diagrams. On the old PME prism finder, the metering area depended on the focal length of the lens. The solid line on the left shows the metering area for lenses up to 110 mm, and the solid line on the right for lenses 110 mm to 350 mm. The small area indicated by the broken line on the right is for the 500mm Tele-Apotessar.

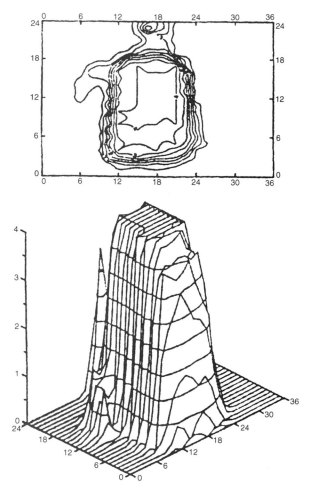

Figure 12-12 *Metering pattern of XPan camera* The classic center area metering pattern of the XPan camera is concentrated within about one-third of the total area, weighted slightly toward the top. It gives good meter readings whether the camera is held horizontally or vertically.

them to the camera or lens. With all Hasselblad built-in metering systems, you can take the meter reading while you compose. With the 200 cameras, you only need to set the aperture; the shutter speed sets itself automatically and changes automatically. With the H camera set to P or Pv, you need not make any lens settings manually. Just point and shoot, or for more control, you can preset either the aperture or the shutter speed. With the PME finders, you just read the EV value and set the figure on the lens.

- The possibility of making mistakes is reduced because few or no values have to be transferred and few or no manual settings have to be made.
- With the measured area known or visible on the focusing screen when you compose the image, you always know what area is measured by the meter, or you can easily select the area or areas that you want to measure.

- Because the light is measured through the lens (TTL metering), the focusing screen always shows the correct measuring area, no matter which lens is on the camera. When you change lenses, the measuring area adjusts automatically to the area coverage of the new lens. This is especially valuable when you are working with longer focal length lenses or photographing distant subjects that may not permit a close-up reading with a separate meter.
- All the information you need to know about exposure and lens settings is visible in the viewfinder while you are composing and evaluating the image. You need not remove your eye from the finder to make changes, and warning signals may appear if a problem exists.
- The light is measured through accessories placed in front of the lens, such as filters, or accessories that are between the lens and camera, such as extension tubes, bellows, and teleconverters. The reading in the viewfinder or settings on the camera are correct without the need for considering filter or exposure factors.
- In the 200 model cameras and the H camera, lenses and film magazines are or can be electronically coupled to the camera body, offering the ultimate solution for speed, convenience, and accuracy.

The Advantages of Spot Metering

In addition to all the advantages of built-in metering systems mentioned in the preceding paragraph, a spot meter in the camera offers a few other benefits:

- The small spot metering area can be aimed at very specific subject areas, where you know exactly the color and brightness and you know whether the indicated lens settings are correct or whether adjustments need to be made and, if so, how much, based on the color chart in this book. The reading is not affected by light coming from outside areas. Your lens settings can be extremely precise, usually eliminating the need for bracketing.
- The small spot metering area makes it easy to measure various areas within the subject or scene to see the differences between lighted and shaded areas and between the main subject and the background so that you know the contrast range. It also makes it easy to determine the difference between the area lit by a main light and the area lit by a fill light so that you know the lighting ratio, allowing you to make changes in the lighting before you take the pictures.
- The spot meter readings between light and dark areas can be used to determine the proper developing time that produces the desired contrast on black and white negatives.
- The 205 camera can give you the spot meter readings in zone values, and the camera can be used with a CC magazine that has a control for automatic contrast adjustment based on Ansel Adams's zone theory.

Metering Procedure with Built-In Meters

Whether the metering system is built into the camera or the viewfinder, the basic metering approach is the same. A good, fast approach for determining

aperture and shutter speed with a center-weighted or spot metering system is as follows:

1. Prepare the camera for the ISO rating of the film and the proper meter operation. For example, preset the lens aperture (on XPan and 200 cameras), set 200 camera models to either Differential or Zone metering, or set the H camera for aperture or shutter speed priority so that exposure is locked (as discussed in the H camera operations in Chapter 4). Set meter prism finders for the maximum aperture of the lens. Close the lens aperture manually if required (on shutter lenses without Databus connections used on 200 camera models).

2. Determine the camera position that provides the desired composition.

3. Evaluate the subject or scene to determine whether it includes areas of average brightness with about 18% reflectance and whether these areas are in sunlight (for transparency film) or in an important shaded area (for negative emulsions).

4. If such areas exist, point the center or spot meter area at that part of the composition, and then do the following:
 a. Read the EV value on the meter prism finder and set the value on the lens.
 b. Press the AE lock in the side of 200 cameras, thereby turning on the camera and also setting and locking the shutter speed.
 c. Make certain that the H camera settings lock the metered value.

5. Move the camera for the desired composition and take the picture.

This approach is easy and fast even with a spot meter because it eliminates the need for making exposure compensations.

A compensation must be made if there are no areas of average brightness. For example, in a snow-covered landscape I take a reading of the snow and then increase the exposure by two EV values.

I suggest that you always check the set aperture and shutter speed values before pressing the release.

THE 205 ZONE MODE IN COLOR PHOTOGRAPHY

Although the zone system applies only to black and white photography, the zone mode in the 205 camera can be helpful when you are working with color film. Instead of thinking about exposure adjustments in EV values, you can give a zone value to any color. Any color that reflects 18% of the light or 18% gray, such as a green field, is zone 5. Any shade or color that is one stop darker, such as most evergreen trees, becomes zone 4; a shade or color that is brighter goes into a higher zone value, with snow placed in zone 7. The zone values for various colors are indicated at the bottom of the color chart in the color section of this manual.

Zone values are easier to remember than compensations in EV values, especially because there is no need to remember whether exposure must be increased or decreased.

BRACKETING

By using any of the Hasseblad metering systems described earlier, you should have very satisfactory exposure of all your negatives or slides. Bracketing, which means taking images of the same subject or scene at two or more different exposure settings, should not be necessary. Bracketing, however, is still recommended whenever you have any doubts about the result, when you cannot find subject areas of a known reflectance value for metering, and when you photograph subjects that have a high contrast range. Sometimes you may also want to bracket for the purpose of producing the most effective image, not necessarily the best exposure. Sometimes the two are not the same. You may sometimes prefer a darker image because it is more dramatic and has more color saturation. An early morning picture or a picture taken in the fog may be more beautiful when colors are more on the pastel side, creating a high-key effect.

For critical work on transparency film, such as in beauty or product photography, you probably want to bracket in $\frac{1}{3}$ or $\frac{1}{2}$ f stop increments. For most other work, bracketing in full f stops makes more sense even with the modern transparency films. Manual bracketing is a good approach in most cases.

On the H and XPan cameras, and on most 200 models equipped with a motor winder, you can bracket automatically, a feature that is wonderful in situations when you must work fast. A sequence of three bracketed shots can be made in almost the same time as a single picture and without moving the camera from the eye.

EXPOSURE WITH FILTERS AND CLOSE-UP ACCESSORIES

When accessories are placed in front of the lens or between the lens and the film, such as the accessories for close-up photography, the light reaching the image plane is reduced. You must compensate for the loss if the meter reading is made with a handheld exposure meter. Check the required increase in the instructions for the accessory or, in other sections, of this manual for teleconverters and close-up accessories. The lens settings shown on built-in meters or meter prism finders are correct because the light is also measured through the accessory. When using teleconverters or extension tubes without Databus connections on 200 cameras, you must manually close down the aperture when taking the meter reading, just as you do with lenses without the electronic connection.

On meter prism finders, set MAX at the maximum aperture engraved on the lens, as you normally do. A meter reading with a meter prism finder attached to the focusing screen adapter on the FlexBody or ArcBody should be taken before shifting or tilting, and exposure tests are recommended.

EXPOSURE WITH VARIOUS FOCUSING SCREENS

The PME 90, the PME 45, and the earlier models PME 51, PME 5, and PME 3 are adjusted to provide the correct exposure with any type of Acute Matte screen, at least when used in center area metering. The spot meter reading is affected by the bright center area of the microprism and/or split-image rangefinder area. These screens should therefore be used only in the center area metering mode. If you plan on using the spot meter mode of the PME 90 or PME 45, use an Acute Matte screen without microprism or split-image rangefinder area.

The meter prism finders mentioned earlier do not give correct exposure in combination with the various types of earlier groundglass screens. Changing the screen is highly recommended.

Earlier meter prism viewfinders not mentioned here were made for the old focusing screens and need a one-stop increase in exposure when used with the Acute Matte types. Exposure tests should also be made when these viewfinders are used with special lenses and teleconverters.

THE PME 90 AND PME 45 METER PRISM VIEWFINDERS

The metering areas, the metering options, and the operation of the metering system are identical in both finders. The two finders (see Figures 12-13 and 12-14) differ in the following few points.

The metering system in the PME 90 is operated from a lithium CR123A, and the PME 45 from a lithium CR2 (see Figure 12-16). The PME 45 has a diopter correction from −2 to +1, with the possibility of using accessory eyepieces with corrections from −4.5 to +3.5. The PME 90 has a correction from −2 to +0.5. Accessory eyepieces from −4 to +3 diopters are available for the PME 90 finders.

The PME 90 has an illumination window for the viewfinder display, and the PME 45 does not. Whenever the PME 45 is turned on, the display is illuminated via LEDs powered by the battery. The magnification is 2× on the PME 90 and 2.5× on the PME 45. The PME 45 can be used with the instant film magazine attached to the camera, and the PME 90 cannot.

Basic Meter Prism Operation

As with any exposure meter, the ISO film sensitivity must be set on all meter prism finders. Because the meter reading is made with the lens aperture fully open, as it normally is, all meter prism viewfinders must also be set for the maximum aperture of the lens on the camera and must be changed when you switch to a lens having a larger or smaller maximum aperture. As a precaution, I might suggest that you make certain that the lens is not manually closed down when the meter reading is taken. If you want to take a meter

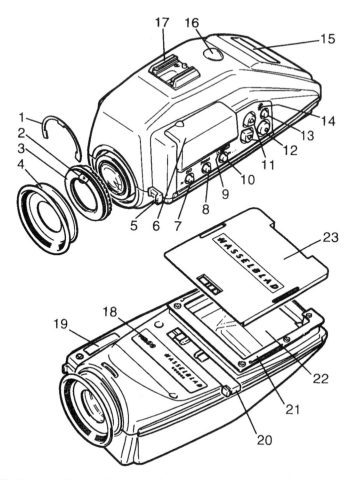

Figure 12-13 The PME 90 operating controls.

1. Locking clip
2. Indication mark
3. Eyepiece diopter adjustment
4. Removable rubber eyecup
5. Eyepiece diopter lock
6. Battery compartment cover
7. ISO setting button
8. MAX aperture setting button
9. Metering mode symbols
10. Metering mode selector
11. Upper and lower adjustment buttons
12. Metering button
13. Display illumination button
14. Display illumination symbol
15. Display illumination window
16. Incident metering dome
17. Accessory shoe
18. Viewfinder type emblem
19. Cover for service use
20. Magazine catch operating slide
21. Viewfinder retaining plate
22. Prism
23. Protective cover

reading with the lens manually closed down, you must set the maximum aperture value for the preset aperture.

On the PME 90 and PME 45, you set the ISO value by pressing the ISO button and then using the adjustment controls to set the ISO value. You use the same approach for setting the maximum aperture after pressing the Fmax button (see Figure 12-15). The aperture setting is not necessary for incident meter readings because the light is not measured through the lens.

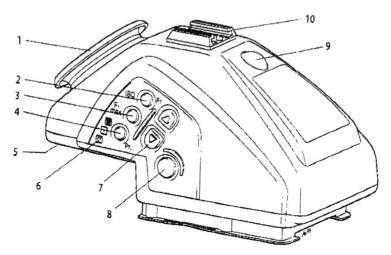

Figure 12-14 Operating controls on the PME 45.

1. Rubber eyecup
2. ISO selector knob
3. MAX aperture selector
4. Metering mode selector
5. Eyepiece diopter adjustment lock
6. Metering mode symbols
7. Up and down adjustment
 buttons
8. Metering button
9. Incident light dome
10. Accessory shoe

On the PME 90, the display is illuminated from a window on top of the viewfinder. Don't cover it up with your hand. You can illuminate it in low-light levels by pressing the illumination button. The PME 45 display is illuminated permanently from the inside.

Operating the PME 90 and PME 45 Meters

When the meter is turned on, the display shows the maximum aperture and the film sensitivity set on the finder. After 1.5 seconds, the display changes to show the meter reading, which can be in EV values or as aperture or shutter speed priority. In aperture priority, the display indicates the correct shutter speed for the set aperture; in shutter priority, it shows the necessary aperture for the preset shutter speed. Selecting EV values is usually the most practical, fastest, and least mistake-prone solution with Hasselblad shutter lenses.

The PME Programming Functions The programming functions work in all metering modes: spot meter, center metering, and incident metering. You obtain the programming mode by simultaneously pressing the ISO and meter mode selection buttons. These two buttons have a small Pr engraving next to them. You obtain the different programming possibilities (from Pr 1 to Pr 7) by pressing the metering mode button repeatedly.

With Pr 1 turned on, the meter display shows EV values. If you prefer either aperture or shutter speed priority, turn off Pr 1 and turn on Pr 2. You

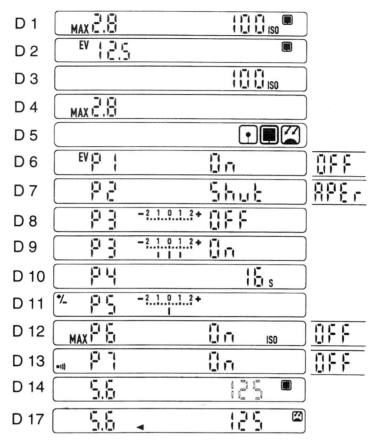

Figure 12-15 *Viewfinder display for various operating modes* The set ISO value and the MAX lens aperture (D 1) appear on the screen when the meter is turned on with the metering button. After 1.5 seconds, the display changes (D 2). The set ISO value is shown after the ISO button is pressed (D 3). The set maximum aperture can be seen after pressing the Fmax button (D 4). The metering mode symbols (D 5) are (left to right): spot meter, center metering, and incident metering mode. In the Pr 1 mode, the meter shows EV values (D 6). In Pr 2, the meter is set for either aperture priority or shutter speed priority instead of EV values (D 7). In Pr 3, a reference value can be programmed into the meter. It is turned off (D 8) and turned on with a +1 and −1 value programmed into the finder (D 9). The metering duration is programmed in Pr 4 and is set to 16 seconds in A permanently (D 10). An exposure correction from +2 to −2 can be programmed into the meter in Pr 5 (D 11).

With Pr 6 turned on, the set ISO and maximum aperture values appear on the display for 1.5 seconds before the meter reading comes on (D 12). A sound warning can be added to the reference mode in Pr 7 (D 13). Display with center area metering and aperture priority (aperture figure solid) is shown (D 14). A stored value is indicated by an arrowhead pointing toward the stored value, in this case the aperture (D 17). All values programmed into the PME finders remain memorized in the finder until they are changed. Removing or replacing the battery does not affect the settings.

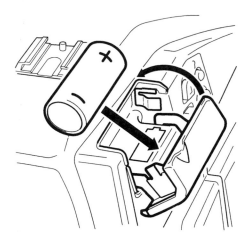

Figure 12-16 *Inserting the battery in PME 90 and PME 45* You insert the 3V lithium battery as shown, after opening the battery compartment cover. A battery symbol appears on the viewfinder display when the battery needs to be replaced.

change from aperture to shutter speed priority by pressing either adjustment button.

The length of time that the meter stays on can be programmed from 5 seconds to 60 seconds in programming function Pr 4. Pressing the adjustment buttons changes the time. For most photography, the standard 16 seconds is a good compromise.

Programming function Pr 5 allows programming an exposure correction from −2 to +2 f stops into the meter prism. Pressing the up adjustment button increases the correction value, and pressing the down control decreases it.

By pressing either adjustment button, you can have the Pr 6 programming function turned on or off. In the On position, the ISO and the maximum aperture set on the meter appear on the display for 1.5 seconds every time the meter is turned on. I feel that this is a good reminder for most photographers. In the Off setting, the metered value appears immediately.

The reference mode allows you to program specific limits into the meter so that a warning appears on the display when the reading exceeds the programmed limits, such as the brightness range. The reference mode is shown on the finder display by programming Pr 3, which is turned on or off with the down adjustment button. You set the reference value by pressing the up adjustment button. You can add an audible warning by turning on Pr 7.

The PME 51 Meter Prism Finder

The PME 51 meter prism viewfinder (now replaced by the PME 45) combines convenient 45-degree viewing with TTL (through the lens) metering.

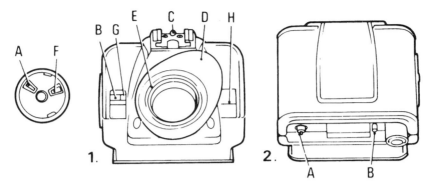

Figure 12-17 *The PME 51 meter prism finder* **1.** (A) Film sensitivity selector; (B) film sensitivity scale; (C) flash and accessory shoe; (D) removable, rotatable eyecup; (F) aperture setting lever; (G) aperture indication window; (H) green battery check signal. **2.** (A) Operating button; (B) battery cover. Earlier versions of the finder also had a retaining ring (F) for correction lenses. On the latest versions, the entire eyepiece is changed.

It has a center-weighted metering mode, with approximately 50% of the light measured in the top center area.

The exposure reading is shown in EV values below the image area. If two figures light up, the value is between the two; for example, it is EV 13.5 if values 13 and 14 are lit. The meter is powered by a 6V battery, PX28 or similar. A green signal in the right viewfinder window lights up when the meter is turned on, also indicating that the battery is in good condition. You set the meter to the film sensitivity and the MAX aperture by turning the two selector dials until the proper figure appears between the lines in the window. To obtain a meter reading, press the operating button for one second and the LEDs at the bottom of the finder will light up, showing the EV value (see Figure 12-17).

DISCONTINUED ITEMS FOR EXPOSURE METERING

Original Meter Prism Finder

Meter indications were via a moving needle. This finder cannot be recommended for today's photography.

PME/VFC-6 Prism Finder

This 45-degree finder was similar to the later PME versions but adjusted for the old focusing screens.

Exposure Meter Knob

The exposure meter knob can be attached to the original 500 camera models in place of the regular winding knob or crank. It has a built-in selenium meter

that does not require a battery but is limited in low-light measurement. The meter knob can be used as a reflected or an incident exposure meter on or off the camera.

Automatic Aperture Control Lenses

The Planar 80mm and 100mm and the Sonnar 150mm and 250mm lenses used to be available with an attached servomotor, which opened and closed the diaphragm automatically and therefore provided fully automatic exposure control. Because only a few are in use, instruction is not included here. If help is needed, call the Hasselblad agent.

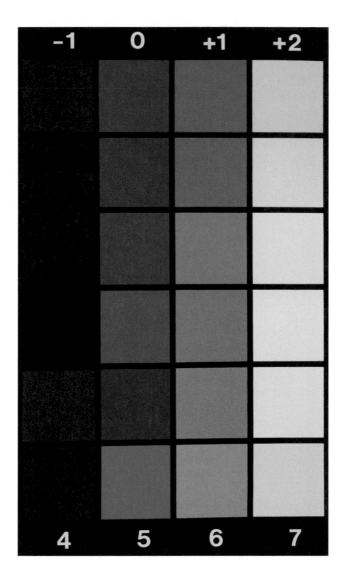

▲ Chart shows reflectance values of different shades of color.

The color shades in column 0 reflect 18% of the light and therefore need no adjustments of a reflected or built in meter reading. The color shades in column +1 need a one stop increase, those in column +2 a, 2 stop increase in a reflected meter reading. Decrease exposure one stop for the darker color shades in column −1. The figures 4 to 7 at the bottom indicate in which zone the different color shades should be placed in a reflected meter reading

▲ Examples of how the spot meter reading provided perfect exposures by pointing the metering area at a part of the subject, or scene, with average brightness and in a lighted area for transparency film. The spot meter reading is not affected by bright or dark outside areas, as they exist in the illustration of the lady standing in the doorway in Mexico. Fill flash, reduced to $-2\frac{1}{2}$ and a Softar #1 were used in the picture of the model by the newspaper boxes. Ernst Wildi

▲ The fastest and simplest approach that provides perfect
exposures is to point the measuring area of a center
area metering system at a subject area of average
brightness such as light green or grey. Make certain
that the metered area does not include large bright
areas like the white fog in the picture of the stream, or
the bright sky area outside the temple. Ernst Wildi

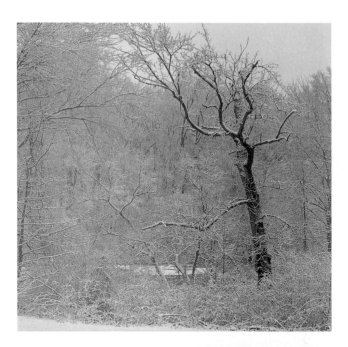

▲ In winter scenes, the built-in meter reading of the snow
increased by 2 f-stops provides correct exposure. A
built in spot meter is helpful in scenes with lighted and
shaded areas allowing to take a meter reading for the
transparency film of a small lighted area with 18
percent reflectance. Ernst Wildi

13

Controls for Exposure and Creating Images

EXPOSURE CONTROLS

The amount of light that reaches the film or digital sensor—and therefore the exposure—is determined by the aperture and the shutter speed. The maximum aperture of a lens is frequently referred to as the "speed" of the lens, and large aperture lenses are known as "fast" lenses. The aperture is determined by the size of the diaphragm opening, with a low number, such as f 2.8, indicating a larger opening. You reduce the amount of light reaching the image plane by setting the aperture to a higher number, such as $f/11$. A change in aperture from one setting to the next either doubles or halves the amount of light reaching the image plane.

Because aperture and shutter speed together determine the total amount of light that reaches the image plane, the same exposure can be obtained with many different combinations of aperture and shutter speed. Because aperture numbers double or halve the amount of light, it is easy to adjust the shutter speed to compensate for a change in aperture.

EXPOSURE AND DISTANCE SETTING

When the focusing ring on lenses without internal focusing is turned toward the closer distances, the amount of light reaching the image plane may be reduced. The amount is negligible for all practical purposes within the normal focusing range of a lens because it almost never exceeds $\frac{1}{2} f$ stop. The loss is compensated for when exposure is determined with a metering system in the camera. On many newer lenses, you focus optically by moving some of the lens components rather than physically moving the entire lens. This focusing arrangement, known as internal focusing, or rear or front focusing on the H camera lenses, does not require an increase in exposure.

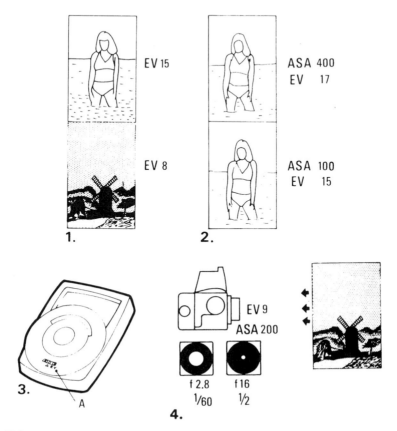

Figure 13-1 *Exposure values* **1.** A lower EV number indicates a smaller amount of light or a darker subject. **2.** If the EV is 17 with 400 ISO (27 DIN) film, it will be 15 for a film with ISO 100 (21 DIN). **3.** Most professional exposure meters have an EV scale. **4.** For every EV value you have a choice of various aperture and shutter speed combinations, such as *f*/2.8 and ¹⁄₆₀ second or *f*/16 and ½ second. Both give the same exposure because they have the same EV value.

Exposure Values

Exposure values (EVs) are easy-to-remember, single numbers that indicate how much light exists in a certain location or is reflected from a subject for a specific film sensitivity. A camera or lens set to a specific EV number produces the same exposure no matter what the aperture and shutter speed combination might be (see Figure 13-1).

On V system cameras that do not have a metering system, you can set the lens for the desired EV number and then interlock the aperture and shutter speed ring and set them interlocked to any one of the possible aperture/shutter speed combinations or take pictures at different combinations. They all produce the same exposure (see Figures 13-2, 13-3, and 13-4). If you change the aperture in the interlocked mode, the shutter speed changes auto-

Figure 13-2 *Aperture and shutter speed settings* Once the EV value is set on any V system lens (1), you can see all the possible aperture and shutter speed combinations as well as the depth of field on the lens (2).

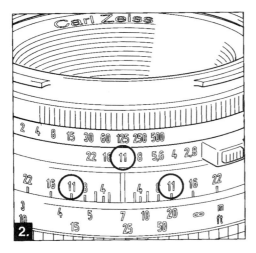

matically and vice versa. You can take two or more images with different depths of field, or at different shutter speeds, almost instantly and be assured that they all will be equally exposed.

CONTROLS FOR CREATING IMAGES

Aperture for Depth of Field

When a camera lens is focused at a specific distance, only the subject at the focused distance is recorded critically sharp in the image. Sharpness gradually falls off for subjects in front of and beyond the set distance. On the photographic print or transparency, however, some degree of blur is acceptable

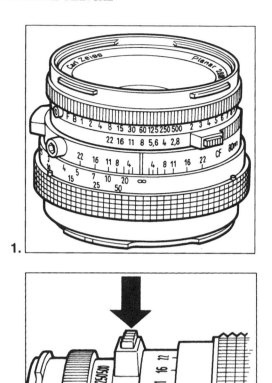

Figure 13-3 *Aperture/shutter speed lock* On CF, CFE, CB, and CFi lenses, you set shutter speed and EV values by turning the shutter speed ring. You set the aperture by turning the aperture ring (1). You interlock aperture and shutter speed rings by pressing the interlock button (2).

because it still appears sharp to our eyes. This range of acceptable sharpness is called depth of field (see Figure 13-6).

At normal distances, about one-third of the total depth of field is in front, and two-thirds is behind the set distance. At close distances, the range is more equally divided between the areas in front of and behind the set distance. The amount of depth of field is determined by the lens aperture. Depth of field increases as the aperture is closed down, as clearly shown by the depth-of-field scales on the lenses (see Figures 13-5 and 13-7).

Depth of Field and the Focal Length of the Lens

"Wide-angle lenses have more depth of field than telephotos" is a common statement in the photographic field. The statement is correct, but only if the different focal length lenses are used from the same distance. In such a case,

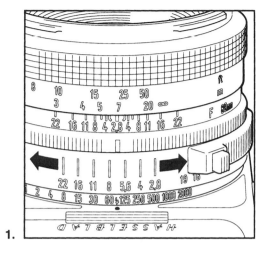

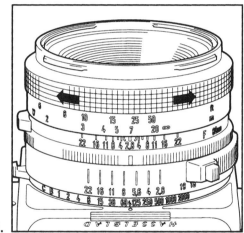

Figure 13-4 *Aperture/shutter speed lock on lenses without shutters* On FE, TCC, and F lenses, the shutter speed is set on the camera (except on 202FA). The aperture is set using the rear ring, which has grip sections (1). The focusing ring is at the front (2).

the wide-angle lens has more depth of field but also covers a much larger area than the standard or telephoto lens. The three lenses create three completely different images (see Figure 13-8). If you use different focal length lenses to cover the same size area by taking the pictures from different distances, the depth of field is exactly the same with every lens. It can be changed only by opening or closing the aperture (see Figures 13-9 and 13-11).

Medium-Format Depth of Field

If you move to the medium format from 35 mm, be aware that the depth of field in the medium format is shallower than in 35 mm. The explanation is

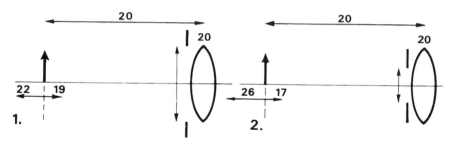

Figure 13-5 *Depth of field at different apertures* **1.** With the lens focused on the subject at 20 feet (or meters) and the aperture wide open, the depth of field may extend from 19 to 22 feet, with one-third in front and two-thirds behind the focused distance. **2.** With the lens closed down, the depth of field increases, for instance to a range from 17 to 26 feet, still with one-third in front and two-thirds behind the focused distance.

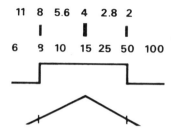

Figure 13-6 *Sharpness within the depth-of-field range* Depth of field is not a range of critical sharpness (in the example, from 8 to 50 feet) with an abrupt falloff to blur. Instead, it is a gradual decrease in sharpness on both sides of the set distance (15 feet in the example) even within the depth-of-field range.

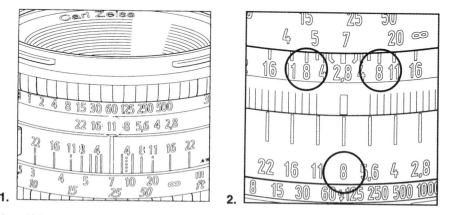

Figure 13-7 *Depth-of-field scales* **1.** The depth of field is the distance range (on the focusing ring between the aperture figures on the left and right) that corresponds to the aperture (here, *f*/11) on the lens. **2.** The same scales, here set for *f*/8, are on FE, TCC, and F lenses.

usually based on the longer focal length of the lens that is necessary in the medium format for equal area coverage—for example, 80 mm vs 50 mm for standard area coverage. The more correct explanation, however, is in the different magnification for the same area coverage. For example, covering an area 56mm wide with a Hasselblad camera means a 1× (life-size) magnification, whereas it is only 0.6× in 35 mm. A higher magnification has less depth of field at the same aperture.

Depth-of-Field Scales and Charts

The figures on depth-of-field scales and charts are calculated based on the acceptable blur known as the "circle of confusion." They are not in any way related to the lens design or the type or quality of a lens.

When you evaluate your negatives or transparencies under a magnifying glass with an 8× or 10× magnification, which I recommend for evaluating medium-format images, you will undoubtedly notice a considerable difference of sharpness even within the depth-of-field range. Although the subject at the focused distance is critically sharp, subjects toward the end of the depth-of-field range look outright blurred in such an image evaluation (see Figure 13-6). This may bring you to the conclusion that your lens does not produce enough depth of field.

Don't blame the lens. You can blame the incredibly sharp films that we have today that make these differences in sharpness more obvious, and you can also blame the age of the depth-of-field scales and tables. They were

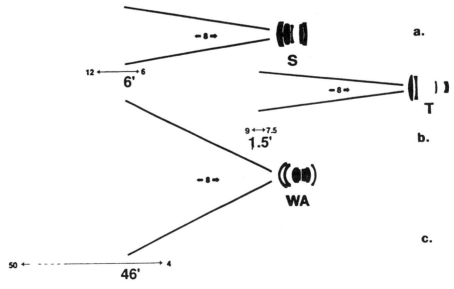

Figure 13-8 *Depth of field with different lenses* When different focal length lenses are used from the same distance (here, 8 feet), the wide-angle lens (c) has more depth of field (46 feet) than the standard lens (a), with 6 feet, or the telephoto lens (b), with 1.5 feet.

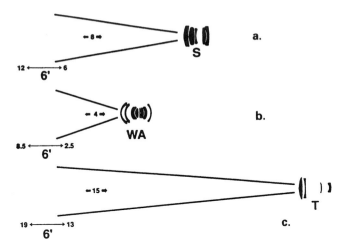

Figure 13-9 *Depth of field and area coverage* To cover the same size area, the wide-angle lens (b) must be used from a closer distance than the standard lens (a). With the telephoto lens (c), you must move farther away. In this situation, all three lenses have the same depth of field (6 feet) at the same aperture.

calculated years ago when films were not very sharp. Although the scales are still usable for general work, you may want to adjust for critical work, either by not using the entire range or by closing the aperture one or two stops more than necessary for the desired depth-of-field range. Whenever a specific subject is to be critically sharp, focus the lens on that subject. Don't rely on depth of field.

Seeing Depth of Field on the Focusing Screen

The focusing screen on a 35mm or medium-format camera is wonderful for evaluating the image and for critical focusing, but not for seeing depth of field. The focusing screen, even on a medium-format camera, is small compared with the size of the final photographic print or the projected transparency. There is no way you can determine from the screen image where the sharpness range starts to fall beyond the acceptable level. The problem is increased when you evaluate the image with the lens aperture closed down.

The Hasselblad focusing screens are ideal for focusing, for composing, and for showing what is really sharp and how much blur you have in background and foreground areas. For determining depth of field, use the scales on the lenses after determining the min and max distances (see Figure 13-13).

Hyperfocal Distance

Hyperfocal distance is often referred to as the distance setting that produces the maximum depth of field at a specific aperture. Although this is correct,

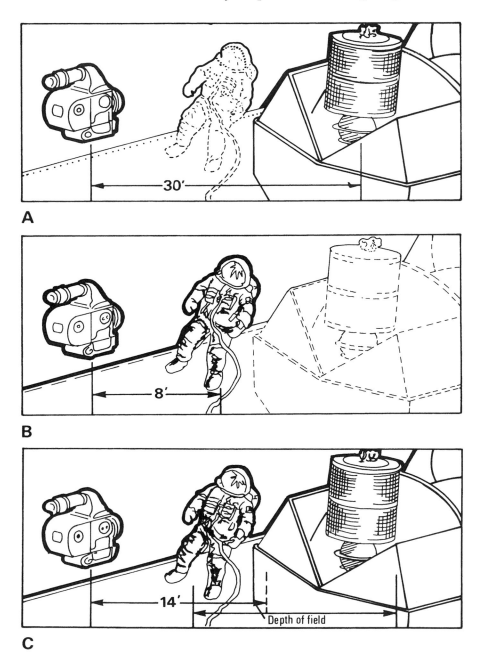

Figure 13-10 *Setting lens for depth of field* To set the lens for depth of field, focus the lens (manually or automatically on the H camera) at the farthest subject you want to be sharp. Read the distance on the focusing scale (here, 30 feet) (A), and then focus at the closest subject that you want to be sharp and read the distance (8 feet) (B). Set the lens so that the two distances are within the depth-of-field indicators (C), 14 feet in this case.

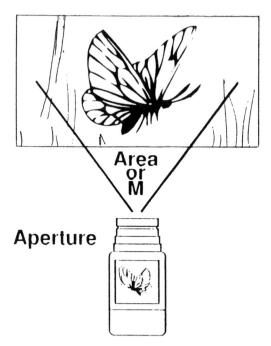

Figure 13-11 *Depth-of-field theory* When you are photographing an area of a specific size, depth of field is determined only by the aperture and the area coverage (magnification).

I suggest looking at it as the distance setting that produces depth of field to infinity at the set aperture. Because lenses have depth-of-field scales, there is no need for hyperfocal distance charts. Simply set the distance ring so that the infinity mark is opposite the corresponding aperture on the depth-of-field scale on the right. The hyperfocal distance, if you want to know it, is the distance opposite the index (see Figure 13-14). You will also find that the depth of field extends on the other side to half the hyperfocal distance—for example, to 8 feet (2.6 meters) if the hyperfocal distance is 16 feet (5.2 meters) .

Manual Diaphragm Stop Down

On single-lens reflex cameras, the diaphragm is normally wide open to provide the brightest view of the focusing screen. This setting also shows the image as it will be recorded by the lens at the maximum aperture. The manual diaphragm stop down on all Hasselblad lenses and on the H camera allows you to see how the image is recorded at different apertures (see Figures 13-12 and 13-13).

When you operate the stop down mechanism, the lens diaphragm closes to the preset aperture. The focusing screen becomes darker; you can now see

Figure 13-12 *Manual aperture stop down* **1.** You can close down the aperture on the latest V system lenses to any preset aperture by pushing the stop down lever downward (a). It remains in the stopped down position until you move the stop down lever back to the original position by pressing the bottom part of the lever (b). **2.** The stop down control on the CF lenses looks somewhat different but is operated in the same way. You manually close down the aperture on all H system lenses by clicking the stop down lever at the front of the camera.

Figure 13-13 *Hyperfocal distance* A lens is set to the hyperfocal distance when the infinity mark is placed opposite the set aperture on the depth-of-field scale, at *f*/11 (a), *f*/4.5 (b), and *f*/22 (c). The depth of field then extends from infinity down to half the distance that is opposite the index (to 10 feet at *f*/4.5, to 2 feet at *f*/22, and to 4 feet at *f*/11).

Figure 13-14 *Controls on C lenses* **1.** The manual stop down control is on the right side. The aperture returns to the wide open position when you recock the shutter or move the aperture ring to the maximum aperture. **2.** The depth of field is indicated by two red pointers that move when the aperture setting is changed.

the image as it will be recorded in the camera at the set aperture, or you can see how the image changes as you open or close the aperture. You can take the picture with the aperture manually closed down, or you can reopen the aperture before you take the picture.

Photographing Groups

There are different opinions on whether the people in a group picture should be arranged in a straight or a curved line so that they will all be sharp from side to side, especially when wide-angle lenses are used. The photographers who insist on a curved arrangement justify their explanation with the fact that in a straight arrangement, the people on the outside are farther away from the center of the lens than those in the center and will therefore be out of focus. If the group is arranged in a curved line, everybody from center to the edges can be at the same distance (see Figure 13-15).

This is not, however, the way lenses are designed nor how they record a subject. Every lens is designed to record a sharp image on the flat image plane from a flat subject in front of the lens, whether the subject is a building, a flat document, or a group of people. If this were not the case, the walls of a building and a document would also have to be curved to ensure sharpness from left to right. If you prefer a curved arrangement for artistic reasons or for better flash illumination, feel free to use it, but be aware that the lens aperture needs to be closed down more because you need more depth of field.

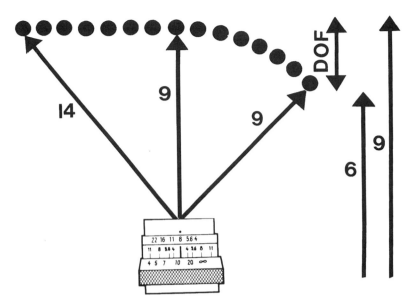

Figure 13-15 *Photographing groups* When people are arranged in a straight line, the people at the edges are farther away (here, 14 feet) than the people in the center (9 feet) when measured from the center of the lens. Arranged in a curve, they all can be at the same 9-foot distance. Lenses, however, are designed to produce a sharp image from a flat, not a curved, subject plane. If the group of people is arranged in a curved line for other reasons, the lens aperture must be closed down because you need more depth of field, from 6 feet to 9 feet in this example.

Background Sharpness

The lens aperture determines the degree of blur in subjects in front of and beyond the depth-of-field range—how sharp or how blurred backgrounds appear in the photograph. Because backgrounds are a dominant part of many pictures, you should set the aperture for depth of field and to evaluate the image at different apertures and to check the degree of sharpness or blur in the background. Blur in the background is enhanced not only at larger apertures but also with longer focal length lenses. If you want to keep backgrounds reasonably sharp, use a shorter focal length; if you want to blur backgrounds more, change to a telephoto.

CREATIVE USE OF THE LENS APERTURE

Before you press the release, you must decide whether everything from foreground to background should be sharp or whether one or both should be blurred, and if so how much.

With your eyes you see everything sharp because our eyes focus constantly and instantly. If you desire to present the scene or subject as seen

with your eyes, try to have sharpness from foreground to background. A maximum range of sharpness is usually called for with subjects that we are accustomed to see sharp, such as buildings, room interiors, product displays, and food illustrations. Generally, subjects with sharp, straight lines, such as fences and rock formations, look better sharp, especially when they are in the foreground.

On the other hand, limiting the range of sharpness lets us create images that look different from the way we see the world and create images as only the camera can do. By narrowing the plane of focus, you create a strong attention-getting element, forcing the audience to look at that part of your image. The lens aperture is a powerful tool for creating effective, different-looking images.

SELECTION OF SHUTTER SPEED

The shutter speed may be predetermined for exposure or for allowing hand-held camera operation. With moving subjects, the shutter speed must be chosen from the image-creating point of view because it determines how the subject is recorded in the camera. You must decide whether the motion is to be frozen, recorded with a slight blur, or completely blurred.

A moving subject recorded at a high shutter speed appears to be standing still, producing interesting and sometimes strange pictures. The shutter speed necessary to stop action depends on the speed of the moving subject, the size of the subject as recorded in the camera, and its direction of movement in relation to the image plane (see Figure 13-16). To stop continuous motions, such as skiing; diving; motorcycle, car, and horse races; or roller-coasters, $\frac{1}{800}$ or $\frac{1}{2000}$ second is frequently necessary, especially with longer focal length lenses.

You can also stop motion at slower shutter speeds by photographing at the peak of the action. It works beautifully with all sports or actions that are not continuous but have a beginning and an end or are repeated. There is a peak of action on many amusement park rides, in jumping on a trampoline, in ballet dancing, and in other stage and circus performances (see Figure 13-17).

Blurred Motion Effects

The photographic approach of blurring subjects with a slow shutter speed is not limited to sports actions. Interesting and fascinating images can be created with anything that moves: water in any form, reflections on water, clouds moving in the sky, smoke, rain, trees, flowers or grass blown by the wind, traffic at night, amusement park rides. Because we cannot see blurred motion with our eyes, slow shutter speeds allow us to create images that are different from our way of seeing—undoubtedly a main reason blurred motion effects are fascinating and attract attention.

Because the desired effect in the image is usually based on personal taste, it is difficult to give recommended shutter speeds. For moving trees, grass,

Figure 13-16 *Shooting direction* Using the same shutter speed, blur is greatest when the subject is moving at right angles to the camera view (1). A subject moving at the same speed straight (2) or at an angle (3) toward the camera view is less blurred. There will be less blur even at the same shutter speed when the subject is photographed from a greater distance (4).

Figure 13-17 *Photographing the peak of the action* Blur in moving subjects is reduced when the shutter is released when the subject is momentarily still, as at the end of a swing or at the top of the bounce from a trampoline. Another method is to follow the moving subject with the camera and make the exposure while the camera moves.

and reflections, shutter speeds around 1 second can be used as a starting point. For moving water and waves, ⅛ to 1 second can produce good results, but you can also go to speeds of several seconds for a different effect.

Following Moving Subjects

Another approach that works beautifully with moving subjects is to follow the subject with the camera and snap the shutter while the camera moves. If you move the camera at the same speed as the subject, only the background is blurred. You can also move the camera slower or faster than the subject, creating a blur in the background and in the subject. With many subjects, some elements are moving in different directions at different speeds—for instance, the spokes of a wheel, the legs of a bicycle rider or a horse, the wings of a bird, and the arms of a ballet dancer or ice skater—thereby creating different amounts of blur within the image. The feeling of motion is enhanced when you photograph the moving subject against a contrasting background that has dark and bright and different-colored areas that create noticeable streaks. Spectators and trees are good examples.

Many photographers find it best to follow a moving subject with a handheld camera, especially when the subject changes speed or direction, as birds or ice hockey players might. If the subject moves along a straight line, such as a racing car or an athlete in a 100-meter sprint, a tripod-mounted camera is more likely to produce successful results.

▲ The small lens aperture necessary for producing sharpness from fore to background required a relatively long shutter speed of 1/15 second and therefore the use of a tripod. Closing the diaphragm to its smallest aperture did not produce any noticeable loss of sharpness. Ernst Wildi

▲ "Burning Bed" photographed for Amore Caliente by
Karen Kuehn. Fishing boat in Louisiana photographed
by Ernst Wildi with 1.4× teleconverter on 110mm lens,
and polarizing filter.

14

Characteristics and Use of Lenses on All Camera Models

FOCAL LENGTH

Lenses are distinguished mainly by their focal length, which is measured from the rear nodal point (or principal plane H). Focal length is an optical characteristic built into the lens. You can change it only by adding or removing optical components, such as a teleconverter. Focal length is unchanged when you add extension tubes or bellows, switch a lens from one camera to another, or use a lens for different film formats. On zoom lenses, you can change focal length within a certain range by moving some of the optical components inside the lens.

To classify lenses into standard, wide angle, and telephoto, consider the focal length in relation to the format. A lens is considered standard when its focal length is about equal to the diagonal of the picture format for which it is used. On Hasselblad cameras, 80 mm is a normal focal length because the diagonal of the $2\frac{1}{4}$-inch (6×6cm) square is 78 mm (70 mm for the 6×4.5cm format). Lenses with longer focal lengths are classified as long focal length lenses, telephotos, or telelenses, and those with shorter focal lengths as wide angles.

ANGLE OF VIEW

The angle of view is the angle of the area that the lens covers on a specific image format (see Table 14-1). The angle of view can be related either to the diagonal or to the horizontal or vertical dimension of the picture. A lens that has a diagonal angle of approximately 50 degrees is considered standard on any format (see Figure 14-1).

Table 14-1 Equivalent Focal Lengths for Different Film Formats

Horizontal angle of view (degrees)	*Focal length of lenses (mm)*			
	4.5 × 6 cm and 2¼ × 2¼ inch (54 × 54 mm)	*35 mm (24 × 36 mm)*	*6 × 7 cm (54 × 68 mm)*	*4 × 5 inch (98 × 120 mm)*
84	31	20	38	67
72	38	25	48	83
69	40	26	50	87
65	43	28	54	93
62	46	30	58	101
58	50	33	63	109
54	54	35	68	117
49	60	39	75	130
40	76	50	96	167
38	80	52	100	175
36	84	55	105	183
32	100	65	125	218
30	105	69	131	229
26	120	78	150	261
24	130	85	163	283
23	135	88	169	295
21	150	100	190	330
15	206	135	259	450
13	250	163	314	545
10	306	200	383	667
9	350	229	439	763
7	458	300	575	1000
6½	500	327	627	1090

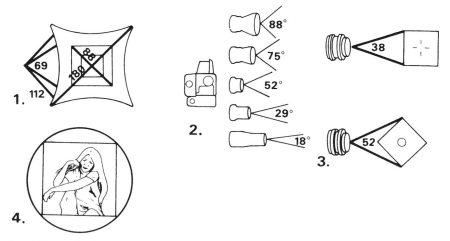

Figure 14-1 *Angle of view* **2.** The diagonal angle of view of different lenses on Hasselblad: 88 degrees for 40mm; 75 degrees for 50mm; 52 degrees for 80mm; 29 degrees for 150mm; and 18 degrees for 250mm focal length. **3.** The angle of view can be expressed in relation either to the picture diagonal or to the horizontal or vertical side. The two are different. **1.** On the 30mm full-frame fish-eye lens, the 180-degree diagonal angle of view is completely out of proportion to the 112-degree horizontal or vertical angle. **4.** The covering power of a lens is the diameter of the circle within which satisfactory image quality and illumination are obtained.

AREA COVERAGE

The angle of view of a lens determines the area coverage and the magnification. The area coverage for any lens is directly proportional to the subject distance. At twice the distance, a lens covers an area twice as wide. A lens with a larger angle of view covers a larger area, and this also means that the subjects are recorded smaller because the magnification is lower.

COVERING POWER

Lenses are optically designed to produce satisfactory image quality and illumination in a specific image format. The Hasselblad lenses are designed to produce this promised quality in the $2\frac{1}{4}$-inch (6×6cm) square format or the 6×4.5cm H camera format and not necessarily in anything larger. This design characteristic is called covering power. The covering power depends on the design of the lens, not the focal length. Lenses with a 100mm focal length, for instance, can be made to cover the 35mm format, the 55×55mm film area of the medium format, or the larger area of a 4×5-inch camera.

Because lenses produce a circular image, the covering power of a lens is indicated by the diameter of the circle within which definition and illumination are satisfactory (Figure 14-1). Beyond that circle, the illumination or the sharpness or both are unacceptable. Lenses designed for a larger format can be used for a smaller format.

RELATIVE ILLUMINANCE

The corners of the image recorded by any lens receive somewhat less light than the center. The loss of illumination can be caused by the lens design, such as limiting the lens diameter to keep lenses compact and lightweight. On wide-angle lenses the cause is often found in the lens barrel design. Light rays that enter the lens at steep angles are cut off by components in the lens barrel. Furthermore, the diaphragm opening is circular when seen from the front and allows a large amount of light to enter. Viewed from the side, this same opening takes on an elliptical shape of a much smaller size, letting less light through the opening.

Lens designers try to keep the difference within acceptable levels. If this is not possible, you can improve the results by reducing the illumination that goes to the center of the image using a neutral density center filter placed over the lens. Within the Hasselblad line, this is necessary or recommended only with the 30mm and 45mm lenses of the XPan camera and the Rodenstock lenses for the ArcBody. On all other Hasselblad lenses, the corner illumination is within acceptable levels so a darkening is never objectionable or even visible in the final image.

You always improve corner illumination by stopping down the lens (see Figure 14-5), and that explains why the center filter for the 45mm XPan lens is really necessary only when the lens is used at apertures $f/8$ or larger. The data for relative illuminance at two lens apertures are published for all Hasselblad V and H system lenses and are available from Hasselblad.

COLOR RENDITION

Color rendition in an image is determined mainly by the glass used in the lens. Individual multicoating of the different lens surfaces can also help to reduce variations between lenses.

Because sequences of images are frequently taken with different focal length lenses, accurately matched color rendition in all lenses is extremely important. All lenses in the Hasselblad system produce images with virtually identical color rendition. This applies even when we compare the V system and the H system lenses.

LENS QUALITY

A single lens element produces an image affected by all kinds of faults, called aberrations, that include spherical and chromatic aberration, coma, astigmatism, field curvature, and distortion. The aberrations can be reduced by combining various lens elements of different curvatures and thicknesses, made from different types of glass and arranged in different ways within the lens mount. It is the lens designer's job to find a combination that reduces all aberrations to a point where they are not visible or objectionable in the applications for which the lens is made.

Although large-aperture and extreme wide-angle lenses require more elements, the quality of the complete lens is not determined by the number of elements. Rather, it is governed by the skill of the designer in combining a number of elements to produce the maximum in quality, using the latest types of glass and design techniques.

Although lens design is important, the quality of the finished lens is determined even more by the accuracy with which each lens element is ground and polished, the accuracy and workmanship that goes into each mechanical component of the lens mount, the precision that is used in assembling the components, and the time and care taken in testing the finished lens.

Lens quality used to be expressed by the number of lines per millimeter a lens is capable of reproducing as separate lines. Lens and photo technicians have, however, found that the sharpness in a photograph is not determined so much by the resolution of fine detail as by the edge sharpness of lines within the image. This is known as acutance. Acutance values correlate very well with the observer's impression of sharpness.

The image-forming qualities are expressed today with modulation transfer function (MTF) diagrams, which are published in identical fashion for all

the lenses in the V and the H systems and are available from Hasselblad. These diagrams can be helpful for comparing the performance of the Hasselblad lenses or to see whether image sharpness improves when the aperture is closed down.

On the MTF diagrams, the center of the image is on the left. Each vertical line represents 10 mm, so the far right is 40 mm from the center. The corners of the 2¼-inch (6 × 6cm) square are at 38 mm, and at 34 mm for the 6 × 4.5 format. The performance is illustrated with three sets of lines for different resolution figures, with the top line (or the two top lines) being the most important to be considered for general photography. The higher the lines, the better the lens. The dotted curve is for tangential lines, and the solid curve for sagittal lines (see Figures 14-2, 14-3 and 14-4).

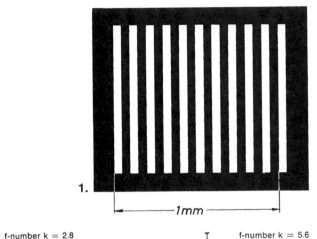

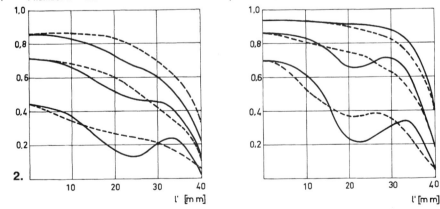

Figure 14-2 *MTF diagrams* **1.** The quality of a photographic image is not determined so much by the number of lines that are resolved as by the edge sharpness, which is called acutance. **2.** On the MTF diagrams, the image height is on the horizontal axis, with the center at the left. The diagrams are shown with the aperture wide open (left) and stopped down about two aperture values (right). Illustrated are the curves for the FE 50mm *f*/2.8.

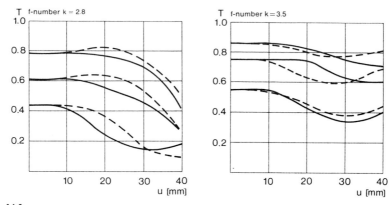

Figure 14-3 *MTF curves for different lenses* Although the Planar 80mm (left) is an excellent lens, the MTF diagrams clearly show the better quality of the Planar 100mm (right), especially at the corners of the image.

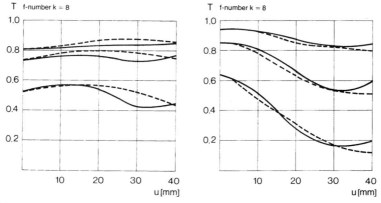

Figure 14-4 *Image quality at different distances* The MTF curves for the Makro-Planar lenses are shown at long and close distances, clearly illustrating the better performance in close-up work (left) at the same lens aperture.

The Hasselblad MTF diagrams cannot be used to compare the Hasselblad lenses to those made by other companies because there are no standards within the industry. Most companies publish these diagrams based solely on the computer printout, not taking into account the manufacturing precision. The charts for the Hasselblad lenses show the actual performance of the lens that you bought or that is waiting for you at the dealer.

Image Quality at Different Lens Apertures

The very best lenses in the V system—such as the Biogon 38mm, the Planar 100mm, the Sonnar 180mm, the Superachromats, and the Makro-Planars used

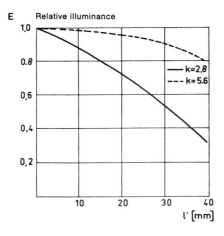

Figure 14-5 *Relative illuminance* The relative illuminance for Hasselblad lenses is also published with the aperture wide open (top line) and closed down two *f* stops (bottom line). The image height is again on the horizontal axis with the center at the left and the corner at the right.

in the close-up range—produce almost perfect corner sharpness with the aperture wide open. However, image sharpness improves on any lens as the aperture is stopped down, with excellent, or even maximum, corner-to-corner sharpness when the aperture is two *f* stops below the maximum.

Image Quality at Small Apertures

When lens apertures become very small, a loss of sharpness may be caused by the nature of light, not the lens or lens design. Light going through a small opening spreads slightly at the edges, an effect known as diffraction, possibly affecting image sharpness at small apertures. To reduce this problem, manufacturers of high-quality lenses limit the minimum aperture to a point where the quality loss is not objectionable or even noticeable. This explains why some of the lenses may stop down only to *f*/16 or *f*/22. As a result, you need not be concerned about closing the aperture too far. Stop it down completely if the depth of field requires it.

Your Own Quality Tests

There are probably occasions when you want to make your own film tests. You can use the readily available lens test charts for that purpose, but other objects with fine detail and sharp outlines, such as good-quality printed material, are even better. Brick walls are often suggested for outdoor tests, but they are not exceptionally good because they do not have sharp outlines or much contrast. An old building made from stone or weathered wood is a better choice.

Here are a few other points that you must consider:

- The test target must be absolutely flat so that you need not worry about depth of field.
- The image plane must be parallel to the test target.

- If you compare different focal length lenses, each lens must cover the same size area.
- Each negative or transparency must have the same exposure and must be developed identically.
- Eliminate any possibility of camera motion.
- Make the test with the aperture wide open and with it somewhat closed down.

When evaluating the results, look at the actual negative or transparency with an 8× or 10× magnifying glass. Never evaluate prints made from a negative or slides projected onto a screen because too many other factors can enter and distort the results.

Evaluate the center and the corners of the negative or transparency. Also keep in mind what the lenses are designed for. The Distagon retrofocus lenses were designed to give the best image quality at long distances. Make the test at longer distances. The Makro-Planars were designed for optimum quality at a 1:5 magnification. Make the test at closer distances.

Color Correction and Apochromatic Lenses

Most photographic lenses are corrected so that mainly the red and blue light rays form the image at the same point. Such achromatic lenses can produce images of superb sharpness, at least within the wide angle, standard, and short telephoto range, but they may produce images with color fringes in long telephotos. As a result, many long telephoto lenses are of the apochromatic design. They are corrected not only for red and blue but also the colors in between and may carry the letters "apo" or the word "apochromatic" as part of their name.

Apochromatic lenses may have elements made from special optical materials (not glass) that are sensitive to changes in temperature that affect the focus setting. As a result, the focusing ring goes beyond the infinity setting. Such a lens must always be focused visually on the focusing screen. Don't just set it at infinity if the subject is far away.

The 250mm Sonnar Superachromat, originally developed for the American space program, is further corrected into the infrared range of radiation from 700 nm to 1000 nm. It is an ideal lens for highest-quality infrared photography without the need of adjusting the distance setting.

Coating and Multicoating

Lens coating, invented by Zeiss in 1935, reduces light reflections off a glass surface from about 5% to 1%. In multicoating, invented later, each lens surface receives several layers of coating, each of a different thickness, to reduce reflections from the different wavelengths of light. This process reduces reflections down to about 0.3%.

All Hasselblad lenses in the V system are coated, and the newer ones, those with a T designation, are multicoated with six or seven layers on each

glass air surface (the surface when glass meets air). The 250mm Sonnar Super-achromat is not engraved T because it has a one-layer coating. Designed also for infrared photography, multicoating would absorb the infrared radiation that is necessary for creating these images.

Coating and multicoating reduce the light that otherwise would be reflected between lens surfaces and eventually reach the image plane, where it would cause flare and reduce the image contrast and color saturation. Disturbing light reflections can also be created by the interior of the camera body or the lens barrel. The interior of the H camera body is treated to reduce or eliminate reflections and the latest cameras in the V system have a Palpas coating. The rear of the lens barrel in the latest CFi and CFE lenses is also designed to reduce the risk of stray light reaching the film, a major difference between the CFi/CFE and earlier types.

Using Lens Shades

Multicoating of lenses has not reduced or eliminated the need for lens shades. Shades serve a different purpose than multicoating. Multicoating, and coating the interior camera body, reduces reflections from the light that actually goes through the lens to form the image in the camera. Lens shades must be used to eliminate all the light that falls on the lens from outside areas and is not needed for the image. Lens shades are especially important when you are photographing toward light sources and against white backgrounds or bright outside areas such as overcast skies, water, and snow. A lens shade is also a good protection for the lens when it rains or snows. I suggest keeping a lens shade on the lens at all times.

Regular square or round shades are compact and provide good shading in most cases. They are made in different lengths to provide maximum shading for different focal length lenses. Shades for zoom lenses must be a compromise because they can be only as long as possible for the shortest focal length. On the Proshade, the bellows can be extended to match the focal length of the lens. Therefore, it can be used with most of the lenses used for general photography and provides the best shading for all lenses. The Proshade made for the V system is highly recommended when you are photographing against white backgrounds. The Proshade can also be used for holding gelatin filters in the 100mm (4-inch square) size in front of various lenses.

Older Professional Lens Shade

Earlier versions of the Professional lens shade served basically the same purpose but did not have the convenience of a foldable front. The railing was at the bottom and was not foldable. Shades also came in two different sizes to accommodate lenses of different sizes.

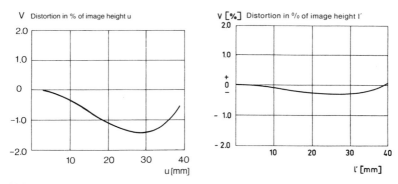

Figure 14-6 *Distortion diagram* Distortion is shown in terms of the percentage of the relevant image height. The two diagrams show the better distortion correction of the Biogon 38mm (right) compared with the Distagon 40mm (left).

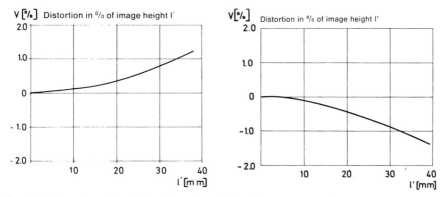

Figure 14-7 *Barrel or pincushion distortion* If the distortion curve has a positive value and goes upward (left), the lens has pincushion distortion. A curve with a negative value goes down (right), indicating barrel distortion.

Lens Distortion

Distortion refers to the lens's inability to record straight subject lines as straight lines over the entire image area. Straight lines near the edges appear curved, either inward (referred to as pincushion distortion) or outward (called barrel distortion). In some photography such as portraiture, the degree of distortion correction is less critical than in architectural, product, and scientific photography. The distortion corrections for the lenses made for Hasselblad are also published (see Figures 14-6 and 14-7).

The ability or inability to record straight lines properly over the entire image area is the only distortion caused by the lens design. Don't blame the lens for any other distortions that might appear in your images, especially with wide-angle lenses.

Other Image Distortions

When a subject or part of a subject close to the camera, such as the nose in a portrait, appears excessively large in relation to the rest of the subject or scene, we do not have lens distortion but instead have foreshortening caused by the lens being too close to the subject. To avoid excessively large noses with any lens and any camera, the camera must be at least three feet (one meter) away from the person.

Slanted vertical lines are frequently referred to as distortion but again are not created by the lens but by a tilted camera.

Another type of distortion occurs when three-dimensional subjects are photographed with wide-angle lenses. The objects near the edge of the picture appear wider than those in the center. A perfectly round chandelier, for example, appears egg-shaped in the corner of the picture. A person's face is elongated. This effect is called wide-angle distortion because it becomes obvious and objectionable only in pictures taken with wide-angle lenses. In fact, it is not caused by the lens. It happens in pictures taken with the best wide-angle lenses such as the Biogon.

The flat image plane is the major cause (see Figure 14-8). A second reason can be found in the fact that the lens sees objects on the sides from a different angle than those in the center. In a group of people the lens sees those in the center from the front, but looks at the side of the head of those at the sides. In group or product pictures, the distortion can be reduced by turning the people or products so that they all face toward the center of the lens (see Figure 14-8). In cases with immovable objects, try to make the composition so that objects that easily look distorted do not appear on the edges or corners of the frame.

LENS DESIGN

The names on Carl Zeiss lenses in the V system indicate a specific lens design. They do not mean that one design is better than another, but simply that a specific design was selected as the most suitable for that particular focal length (see Figure 14-9).

Planar lenses are of a symmetrical design, with five to seven elements grouped into similar front and rear sections. The name is based on their ability to produce an exceptionally flat field. Makro-Planars, originally called S-Planars, are corrected to produce the sharpest images at close distances, but they also produce good quality at longer distances.

Sonnar lenses, consisting of four or five elements, are of a compact design, with the main components in the front section.

The Tessar is a classic four-element lens design that produces lightweight lenses of a compact design.

Tele-Tessar lenses are optically true telephoto types, with a positive front section and a negative rear section separated by a large air space.

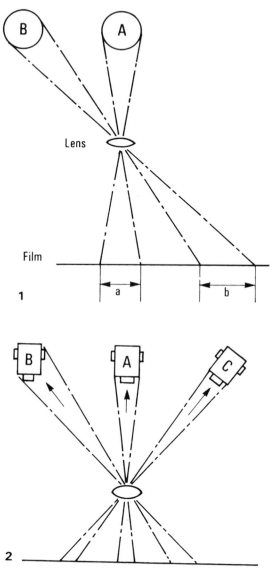

Figure 14-8 *Wide-angle distortion* **1.** A round subject at the edges (B) becomes elongated when traced onto the image plane. Distance (b) is greater than distance (a) for the round subject in the center. **2.** When you photograph groups of people or products, wide-angle distortion is further emphasized because the lens sees the subjects at the edges from the side (B), but it sees those in the center from the front (A). You can greatly reduce the distortion by turning the people or the products on the sides so that the lens also sees them from the front (C).

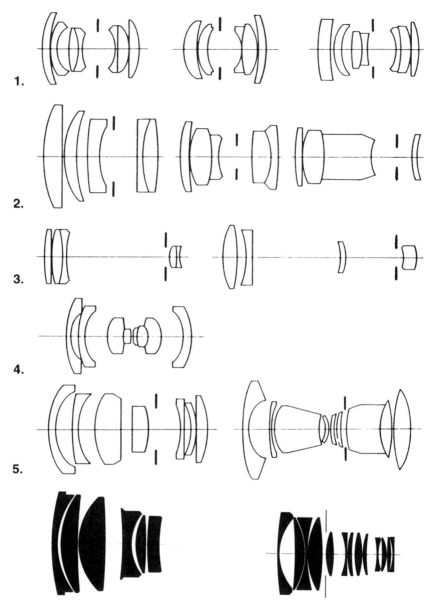

Figure 14-9 *Lens designs* **1.** Planar lenses are (left to right) 80 mm, 100 mm, and 135 mm. Makro Planar **2.** Sonnars are (left to right) 150mm *f*/2.8, 150mm *f*/4, and 250mm *f*/5.6. **3.** Tele-Tessars are (left) 500mm Tele-Apotessar and (right) 350mm *f*/5.6 Tele-Tessar. **4.** The Biogon 38mm is an optically true wide-angle lens. **5.** The Distagon is a retrofo- cus-type wide-angle lens: 60mm (left), 30mm fish-eye (right). An apochromatic design is shown at the bottom left; it is the 350mm Tele-Superachromat. The 60 to 120mm zoom design is shown at the bottom right.

Superachromatic types are apochromatic lenses of the highest quality, corrected for all colors in the spectrum.

Distagons are retrofocus-type wide-angle lenses with a long back focus for use on SLR cameras.

The Biogon (on the Superwide cameras) is an optically true wide-angle design.

Variogon is the trade name for the zoom lens made by Schneider. The 60mm to 120mm zoom lens is designed by Hasselblad and manufactured to Hasselblad's specifications and tolerances.

Lenses for the H Camera System

All lenses for the H camera system are made by Fuji in Japan in cooperation with Hasselblad in Sweden and do not have specific names for the different optical designs, unlike the typical practice with the Carl Zeiss and other German-made lenses. The lens designs and lens specifications are shown in Figure 14-10.

All lenses are manufactured to the highest standards specified by Hasselblad, with all the glass and air surfaces multicoated. All H system lenses are designed to produce the most satisfactory image quality not only on film but also in digital photography.

Wide-Angle Lens Designs

Biogon and Distagon are wide-angle lens designs of two completely different optical configurations. The Biogon is an optically true wide-angle lens, the classic design that is still used for wide-angle lenses on large-format cameras for the most critical architectural, commercial, and scientific work. Because the nodal point from which the focal length is measured is within the physical dimension of the lens, these wide-angle lenses must be close to the image plane, something that is possible on the Superwide cameras. For the very best in corner-to-corner sharpness, for architectural, product, scientific, or any other type of wide-angle photography that requires "view camera quality," the Superwide and the Biogon 38mm lenses should still be considered.

The Biogon focuses down to 12 inches (0.3 meters) and maintains the superb sharpness from infinity down to 12 inches, making the Superwide also a superb tool for copying and other critical close-up photography.

Distagons are retrofocus wide-angle designs, sometimes also called inverted telephotos. The nodal point is behind the physical dimension of the lens, bringing the rear element of the lens far away from the image plane. This is necessary on SLR cameras, where the mirror must have room to move up and down. Wide-angle lenses on SLR cameras must have the retrofocus design. It is more difficult to design a retrofocus lens for maximum sharpness over a wide range of distances. They are designed to provide best image quality at long distances, where they are normally used. Edge sharpness

3.5/35	1
3.5/50	2
2.8/80	3
4/120 Macro	4
3.2/150	5
4/210	6

Figure 14-10 *Lens designs of H system lenses* 1. The HC 3.5/35mm retrofocus wide-angle with 11 lens elements and rear focusing. 2. The HC 3.5/50mm retrofocus wide-angle with 10 lens elements and rear focusing. 3. The symmetrical design of the 6-element HC 2.8/80mm standard lens with full focusing. 4. The 9-element HC 4/120mm Makro lens with focusing from infinity to life-size magnification. 5. The HC 3.2/150mm telephoto with 9 elements and internal focusing. 6. The HC 4/210mm telephoto with 10 lens elements and rear focusing. The zoom lens and the teleconverter are illustrated later in this chapter.

suffers somewhat at closer distances but can be corrected by closing down the aperture.

Floating Lens Elements

The floating element (FLE) lens design improves image quality with retrofocus-type lenses at closer distances. In an FLE lens, some of the lens elements can be or are moved separately from the rest (see Figure 14-11). In the 40mm and 50mm shutter lenses, you manually move the floating elements using an adjustment ring at the front of the lens (see Figure 14-12). Do not forget to set it before you take a picture, and always set the front calibration ring first to one of the click stops based on the subject distance; then focus the image in the normal fashion by turning the regular focusing ring. Do not focus the image first and set the calibration ring afterward. The image will be out of focus.

If the calibration ring is set to the wrong click, the images most likely will still be usable but may not exhibit the very best image quality. If you want sharpness from foreground to background, set the calibration ring to the longest or second-longest distance setting. If all the wide-angle photography is done at longer distances, in wedding photography perhaps, you may want to tape the calibration ring at either one of these two settings so that it cannot move accidentally.

On the Distagon FE 50mm *f*/2.8 non-shutter lenses, the floating portion of the lens elements moves automatically to the proper position when you turn the regular focusing ring.

True Telephoto Lenses

An optically true telephoto lens is an optical design in which the principal plane, from which the focal length is measured, is not within the physical

Figure 14-11 *Floating lens element design* **1.** The focusing ring on a lens moves all the lens elements (a). In a floating lens element design, some elements—two elements on the Distagon 40mm—are or can be moved separately (b). **2.** On the 50mm Distagon *f*/2.8, the four floating elements are moved automatically when the focusing ring is turned.

Figure 14-12 *Operating the floating lens elements* On the 40mm and 50mm CFi (CF) lenses, the floating elements are moved with the front ring to three or four click stops, which are engraved in meters only. The four settings on the 50mm lens are infinity to 12 feet (4 meters); 12 feet (4 meters) to 4 feet (1.2 meters); 4 feet (1.2 meters) to 32 inches (0.8 meter); and 32 inches (0.8 meter) to 19 inches (0.5 meter).

dimension of the lens but is somewhere in front of it. This lens design allows the lenses to be made physically more compact—shorter than the focal length of the lens.

Telephoto Lenses for Close-Up Work

As the focal length of a lens increases, so usually does the minimum focusing distance, and this may give some photographers the impression that these lenses are meant for long-distance photography only. This is not so. The focusing distances are limited for mechanical design reasons. All telelenses can be used at closer distances in combination with close-up accessories. Extension tubes are perfect for this purpose.

Internal Focusing

Focusing a lens to closer distances usually means moving the entire lens farther from the image plane by making the lens physically longer. This is still

the case with many lenses of shorter focal length. On other lenses, especially telephotos, focusing is accomplished optically by moving some of the lens elements within the lens design. This method, usually known as internal focusing, can result in smoother, easier focusing than the mechanical type, especially in long telephotos. On some Hasselblad H system lenses, internal focusing is indicated as rear or front focusing, depending on whether the front or rear elements are used for this purpose.

CHARACTERISTICS AND USE OF ZOOM LENSES

The focal length on zoom lenses can be changed with the zoom control, which moves some of the lens elements (see Figure 14-13). The ratio between the shortest and the longest focal length is known as the zoom range and is 2:1 (or 2×) for the Hasselblad FE f/4.8 zoom lens (60mm to 120mm), and 2.2× for the 50mm to 110mm HC zoom for the H camera.

Zoom lenses can reduce the number of lenses that you must carry and can reduce or eliminate the need for changing lenses and focusing each lens after the change. You are always ready to shoot.

With manual focusing, it is recommended that you focus a zoom lens while it is set to the longest focal length, where the image on the focusing screen has the highest magnification and the minimum depth of field, regardless of the focal length setting used for the picture. This suggestion need not be considered with automatic focusing. The aperture remains the same over the entire zoom range; however, many zoom lenses have a somewhat smaller maximum aperture at the telephoto setting than at the shorter focal length. This is the case with the HC 50mm to 110mm zoom for the H camera, explaining why the aperture figure is f/3.5–4.5. The slightly smaller aperture is f/4.5 at 110mm.

Zoom Lenses for Close-Up Photography

When the distance from the lens seat to the image plane is changed with an extension tube, the subject does not stay in focus when the focal length of a zoom lens is changed. You can use the Hasselblad extension tube 16, however, with the Variogon and the Hasselblad zoom lens set at one specific focal length if you are willing to refocus whenever you change the focal length. Set the lens for the desired area coverage, and then focus.

The 140mm to 280mm Variogon (now discontinued) focuses down to a little more than 8 feet (2.5 meters) at any focal length. You can use the lens for photography at closer distances by pushing the button next to the zoom ring to Macro. The zoom ring can now be turned beyond the 140mm setting. This does not change the focal length, which stays at 140mm, but enables focusing from 8 feet (2.5 meters) down to 2.5 feet (76 cm), covering an area about 13 inches (33 cm) square.

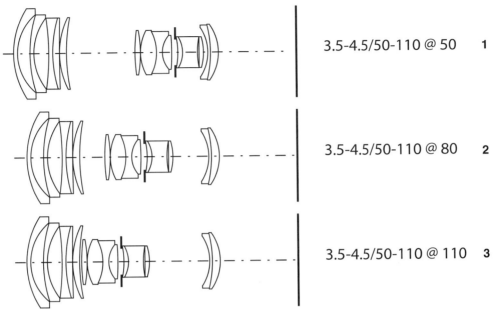

3.5-4.5/50-110 @ 50 **1**

3.5-4.5/50-110 @ 80 **2**

3.5-4.5/50-110 @ 110 **3**

Figure 14-13 *Zoom lens design* The 14-element HC 3.5/4.5 50mm–110mm zoom lens with front focusing in the 50mm position (1), set at 80mm (2), and set at 110mm (3). This zoom lens can be used with extension tubes. See Chapter 18, Close-up Photography, for more detail.

Using the Zoom Lens for Creative Purposes

Zoom lenses, used in combination with longer shutter speeds, offer unique possibilities for creating fascinating images by zooming while the shutter is open. Zooming changes the size of the subject and converts highlights into streaks radiating either from the center to the outside (when you zoom to longer focal lengths) or vice versa (when you zoom from the long to the shorter focal lengths). Shutter speed must be long enough to allow time for zooming. One second is usually a good choice.

If you zoom for the entire exposure time, the image consists of streaks only. Most zoom images are more effective when the subject can be recognized and is surrounded by streaks. For such results, keep the focal length at a fixed setting for about half the exposure time ($\frac{1}{2}$ second when the total time is 1 second), and zoom only during the second half. To produce bright streaks, effective zoom shots require subjects that have bright areas. The streaks produced by the highlights are also more visible if they cross darker image areas. You can make the streaks longer by zooming over the entire focal length range or shorter by using only part of the zoom range.

USING FISH-EYE LENSES

Fish-eye lenses produce a curvature in all straight lines that do not pass through the center of the image. The effect is one of greatly exaggerated barrel distortion, resulting in strangely beautiful images. Some fish-eye lenses produce a circular image that covers only the central area of the image. The effect can be striking, but it is largely the circular image that attracts attention. The effect wears off quickly as all pictures start to look alike. Such lenses therefore have limited application in serious photography.

Other fish-eye lenses, including the 30mm Distagon in the V system, cover the entire format without any visible light falloff in the corners and with excellent sharpness from corner to corner even with the lens wide open.

The 30mm Distagon Lens

The 180-degree diagonal angle of view of the 30mm Distagon does not allow placement of accessories, filters, or shades in front of the lens because they would cut into the field of view. The Distagon design and the multicoating have reduced flare to a degree that makes it possible to photograph directly into a light source, including the bright sun, without any noticeable loss of contrast.

The filter problem has been solved with a removable front section that allows you to attach small, 26mm filters inside the lens. The lens comes from the factory with a clear glass in place. This clear glass, or filter, must always be there because it is part of the lens design. Image quality suffers without the glass. Four of the most common filters are supplied with the lens.

Fish-Eye Images without the Fish-Eye Look

Fish-eye images are best recognized by the curved lines they produce. With the full-frame Distagon design, however, images need not have the typical fish-eye look. Straight horizontal, vertical, and diagonal lines that intersect the center of the field are recorded as straight lines.

You can avoid, or at least reduce, the fish-eye look in scenic pictures by composing the image so that the horizon crosses the center of the field. A tree trunk photographed with a tilted camera can be perfectly straight if composed to go from one corner to the other, crossing the center of the image. Circular subjects, such as the face of a clock, if perfectly centered in the square remain perfectly circular. Compared with a wide-angle picture, the fish-eye shot covers a 180-degree angle diagonally, including a much larger background area.

CHARACTERISTICS AND USE OF TELECONVERTERS

Teleconverters, also called tele extenders, are optical components that are mounted between camera and lens to increase the focal length of the lens used in front of them. A 2× converter doubles the focal length of the lens. Combined with a 250mm lens, we end up with a 500mm focal length. A 1.4× converter increases the focal length 1.4 times, so the focal length of a 100mm lens is increased to 140mm. The H1.7 X converter, for the H system, changes the 150mm focal length to 255mm. The XE designation in the V system converters means that the converter has the electronic Databus connection for the metering system in 200 cameras. The XE converters can also be used on the other V system camera models.

The teleconverters are attached to the cameras like other lenses are. When you remove a teleconverter from a V system camera, remove the lens first from the converter and then remove the converter from the camera. Never remove a lens from a converter that is not attached to the camera.

Compact size and low weight are the advantages of teleconverters. You can have a 360mm focal length with a 180mm Sonnar that is only 5 inches (128 mm) long and a 70mm long 2× converter. As a further advantage, a converter can usually be used with different lenses, thus giving you a choice of twice as many focal lengths. With three lenses and one converter, you can have six different focal lengths.

Teleconverters with Different Lenses

Some teleconverters can be used with all lenses in a camera system, and others are made for specific lenses only. The 1.7× teleconverter in the H system can be used with all H system lenses except the 35mm wide-angle and the 50–110mm zoom lens.

The Hasselblad 2 XE teleconverter can be used with all fixed focal length system lenses except the Makro-Planar 135mm. It should not be combined with zoom lenses.

The Apo 1.4 XE converter was designed and optically optimized for the Tele-Superachromat CFE 350mm but can also be used together with the Sonnar CFi 250mm, the 350mm Tele-Tessars, and the 500mm Tele-Apotessar. For physical reasons, the Hasselblad teleconverter 1.4 XE can be used only with lenses from 100 to 500mm focal length (except the 135mm Makro-Planar). The 1.4× converter can be used in combination with the Variogon 140–280mm at all focal lengths, and the Hasselblad 60–120mm zoom lens at longer focal lengths, with satisfactory results.

Focusing Range and Area Coverage

The focusing range of the prime lens is maintained when combined with a teleconverter. If the lens focuses down to 5 feet (1.55 meters) it still focuses

down to 5 feet when combined with a 2× or 1.4× converter. Combining with a 180mm lens, we have a 250mm (with 1.4×) or a 360mm (with 2×) lens that focuses as close as 5 feet—probably much closer than a telephoto lens of the same focal length. A converter might even serve as a close-up accessory instead of an extension tube. The 120mm Makro-Planar, which focuses down to somewhat less than 3 feet (0.8 meter) and covers an 8-inch-wide area, covers an area as small as 4 inches (100 mm) when combined with the 2 XE converter.

Image Quality with Teleconverters

Because teleconverters emphasize quality faults in the basic lens, they can produce good-quality images only if combined with a high-quality lens. Fortunately, this is no problem in the Hasselblad systems. The image quality of a converter also varies depending on the lens and lens design with which it is combined, but all teleconverters made for Hasselblad and used with the recommended lenses produce a sharpness that comes close, or even matches, that of an equivalent longer focal length lens (see Figures 14-14 and 14-15).

Exposure with Teleconverters

With any 2× converter, the light that reaches the film is reduced by two *f* stops. A 2× converter combined with the Planar 80mm *f*/2.8 results in a

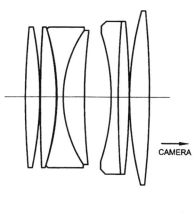

Figure 14-14 *Teleconverter design* To achieve good image quality, a teleconverter may need as many or more lens elements than basic lenses. Shown is the seven-element design of the Hasselblad 2 XE teleconverter.

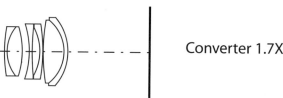

Converter 1.7X

Figure 14-15 *H system converter design* The 1.7× teleconverter in the H camera system is a six-element lens design.

160mm focal length with a maximum aperture of *f*/5.6. A 1.4× converter causes a loss of 1 *f* stop, a 1.7× converter, 1½ *f* stops. You must compensate for this loss of light when taking a meter reading with a separate exposure meter.

If the light is measured through the lens with a meter built into the camera or meter prism viewfinder, you need not worry. Whatever the built-in meter shows is correct. The aperture on a meter prism finder is set for the maximum aperture of the lens as usual.

The Mutar Teleconverters

Mutar is the name for teleconverters made by Zeiss. When the name is combined with "Apo," it indicates a Zeiss teleconverter with apochromatic correction. The PC Mutar is a 1.4× teleconverter with shift capability.

CREATIVE USE OF LENSES

Wide-angle lenses, with their larger angle of view, cover larger areas and record subjects smaller than the standard lenses. Telephoto lenses have a smaller angle of view, and they cover smaller areas and make subjects appear larger. Using various focal length lenses to cover areas of various sizes is a good application and good reason for selecting wide-angle, standard, or tele-lenses. Lenses, however, can also be major tools for creating effective, beautiful, unusual, and interesting images.

Changing Perspective

Lenses can be used to change the size relationship between foreground and background, known as perspective (see Figure 14-16). Visualize a scene with a birch tree in the foreground and a mountain range in the back. You have a choice of photographing the scene with a wide-angle lens, perhaps a 50mm, from a close distance of 10 feet (3 meters) or with a telephoto lens, perhaps of 250mm focal length, from a longer distance of 50 feet (15 meters). Although the size of the birch tree is identical in both images, that of the background is not. In the wide-angle scene, the mountains appear small, even smaller than we see them with our eyes. In the telephoto shot, the distant mountains are five times larger—more majestic and much larger than seen with our eyes. The same picture taken with an 80mm lens would show the scene as seen with our eyes. That's why it is called a normal or standard lens.

Although there are times when, for good reason, you want to see the image in the "standard" fashion, you frequently will create more fascinating images when changing the perspective with wide-angle lenses or long telephotos. The description of the birch tree and mountain scene might perhaps give the impression that the focal length of the lens determines perspective.

Figure 14-16 *Image perspective* With a telephoto lens (A), the pieces of fruit appear close to each other, with the banana as large as the apple. With the standard lens (B), the relative positions are as seen by our eyes. With the wide-angle lens (C), the banana is much smaller than the apple and appears to be much farther away.

Not so. Perspective is determined by the subject distance. The different focal length lenses are necessary only to let you cover the foreground subject in the same size from different distances. You need a wide-angle lens to cover a large-foreground subject from a close distance, and you need the telephoto to cover the same foreground subject in the same size from farther away.

Selective Backgrounds

Different focal length lenses can also be used to change the background area without changing the size of the foreground subject (see Figure 14-17). Long lenses permit us to cut down background areas, eliminate distracting background elements such as billboards, cars, people, or direct light sources. In the studio, a longer lens allows smaller backdrops to be used. In outdoor people pictures, longer lenses may be preferable because they produce a blurred, undisturbing background for the portrait.

In other pictures, such as candid shots of people, a large background may be desirable to identify a location.

If the backgrounds are beyond the depth of field and therefore are not sharp, the focal length of the lens determines the degree of blur. As longer lenses magnify backgrounds, they also magnify the blur. Such backgrounds

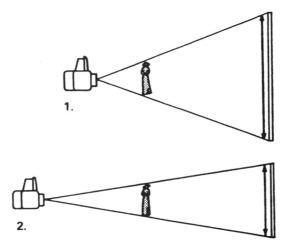

Figure 14-17 *Background area coverage* A short focal length lens (1) covers a large background area, whereas a longer focal length lens used from a longer distance (2) covers a smaller background area. The size of the main subject is the same with both lenses.

are therefore more diffused, less disturbing. With a short focal length lens, the backgrounds may be just slightly out of focus at the same diaphragm opening.

Effective Wide-Angle Photography

Consider wide-angle lenses not only for covering larger areas but also for enhancing the three-dimensional aspect of a scene, especially outdoors. They work beautifully for this purpose. All you need to do is to include effective foreground elements in the composition. The foreground subjects can be anything: a rock or rock formation, a flower bed, a field, an area of water, a tree stump, a fence, you name it. Such compositions can be especially effective when the foreground area covers a good part of the image and thereby adds depth and a three-dimensional feeling to the image. This approach is especially effective with wide-angle lenses because they emphasize the size relationship between foreground and background, making the background subjects appear to be farther away than they actually are. The wide range of depth of field also allows you to maintain sharpness from foreground to background, if desired.

Foreground Sharpness

Although blurred backgrounds work in many pictures, you must be more selective with blurred foregrounds. Such blurred foregrounds can work beautifully on color film, where blurred patches of flowers can add a touch of color or can be used to frame the main subject. Blurred foregrounds are

generally best when blurred completely so that the subjects are hardly recognizable. When the foreground is blurred just a little, the effect might look like a mistake. If the standard lens does not provide enough blur, go to a longer lens. Blurred foregrounds are seldom successful in black and white.

Correcting Verticals

The vertical lines of a building or other object appear in the finished picture vertical and parallel to each other only if the camera was level, with the image plane parallel to the building. When the camera is tilted upward or downward, the verticals slant toward each other, and the building seems to be falling over (see Figure 14-18).

Sometimes you can avoid this effect by photographing the building with a longer lens from a longer distance. The longer distance may eliminate or at least reduce the need for tilting the camera (see Figure 14-19). Other solutions exist, or at least existed, with the PC Mutar, the FlexBody, and the ArcBody. These items are no longer made.

1.

2.

Figure 14-18 *Slanted verticals* Tilting the camera to cover a building from bottom to top results in slanted verticals (1). To record straight verticals (2), the image plane must be parallel to the building.

Figure 14-19 *Photographing buildings from different distances* Photographing a building from a longer distance with a longer lens (a) may reduce the need for tilting the camera, which is necessary from a shorter distance with a shorter lens (b). The result is less slanting of the verticals.

THE PC MUTAR TELECONVERTER

The five-element PC Mutar is a 1.4× teleconverter that can be used with lenses from 40 to 80mm focal length. The PC Mutar also increases the covering power of Hasselblad lenses from an 80mm circle to one of 106mm diameter. This allows you to shift the lenses on V system cameras 16mm up or down, giving you perspective control without loss of image quality or darkening of the corners. The PC Mutar eliminates the need for tilting the camera in architectural and product photography. Image quality is excellent.

Camera Operation with the PC Mutar

There is no mechanical connection between the camera and the lens, so the camera and lens shutter must be operated with the supplied cable release. The two cable release ends can be adjusted so that camera and lens operate in the proper sequence as follows:

1. The shutter in the lens closes.
2. The mirror lifts up, and the auxiliary shutter opens while the shutter in the lens remains closed.
3. The shutter in the lens opens and closes to makes the exposure. After it is adjusted and locked, the sequence remains intact at least for that particular lens and camera. Do not use the prerelease because the lens shutter does not close down.

Although the operation with the double cable release works, you can simplify the operation by attaching the PC Mutar to a 200 model camera. Using the focal plane shutter for the exposure, you need not worry about synchronizing the camera and the lens. You can operate the camera in two ways:

1. Attach only one cable release to the camera release thread of the PC Mutar to release the camera. (The release button is covered by the PC Mutar.)
2. Make the exposure with the self-timer built into the camera set for a short two-second delay. You do not need a cable release, and this approach can be used with shutter and non-shutter lenses and does not require recocking the shutter in the lens after the exposure. You must remember, however, to close the lens aperture manually for metering and for the exposure (see Figure 14-20).

Exposure with the PC Mutar

Because the PC Muter is a 1.4× converter, exposure needs a one-stop increase. You will also notice a darkening on the focusing screen when the PC Mutar/lens combination is shifted away from the 0 position. This darkening is only on the screen and not in the image (as also described for the Flex-Body and ArcBody). But you must take a meter reading with a meter in the camera or prism viewfinder at the neutral 0 position (before shifting).

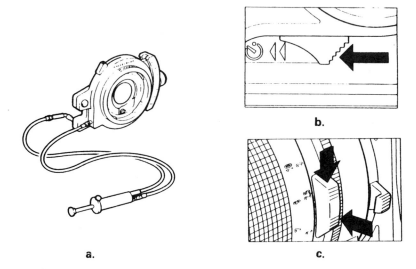

Figure 14-20 *PC Mutar on focal plane shutter cameras* The supplied cable release (a) need not be used with any lens used on 200V system cameras. Use the focal plane shutter for the exposure, and release the camera with the self-timer. The aperture (b) on all lenses must be manually closed down (c).

Photographing with the PC Mutar

When the camera is level, the vertical lines of a building or any other subject are recorded parallel to each other when the image plane is parallel to the subject. Start the photography by leveling the camera, perhaps using the spirit level built into the newer tripod couplings as an aid. Loosen the PC Mutar shift control lock and shift the PC Mutar up or down until you see the desired image area on the focusing screen. The PC Mutar provides an excellent solution for perspective control, especially when used on 200V system cameras with 40mm and 50mm lenses.

USING HASSELBLAD LENSES ON OTHER CAMERAS AND ON ENLARGERS

Although Hasselblad lenses can be used on other cameras that produce an equal or smaller image format, it is not a practical approach to be recommended even if a lens adapter is available.

A Hasselblad accessory called a lens flange used to be available for using Hasselblad V system lenses on an enlarger. It is no longer made because a camera lens is not convenient for this purpose and because photographers seem to be reluctant to take the camera lenses into the darkroom.

PROTECTING YOUR LENSES

Lenses are expensive components of all Hasselblad camera systems. It therefore makes good sense to keep them clean and in perfect operating condition. Protect them as much as possible, on and off the camera, by keeping them in cases. Protect them further and reduce the need for cleaning by attaching front and rear covers whenever they are not being used.

This applies especially to the rear of the lens, which is often more difficult to clean. The rear of Hasselblad V system lenses also needs protection to maintain the proper functioning of the connecting mechanism.

If cleaning the lens surfaces seems to be desirable, always start by blowing off any possible dust and dirt to prevent scratches on the lens surface. Do any further cleaning only if deemed necessary. To do so, wipe the surfaces gently with a clean chamois, eyeglass, or lens-cleaning tissue, breathing on the surface if necessary. Lens cleaning fluid can be used, but never put the fluid on the lens. Instead, put it on the cleaning cloth or tissue. Do not overclean lenses. A little dust does not affect image quality, but fingerprints do. Never touch lens surfaces with your fingers. Never touch the electronic contacts on Fe, CFE, and the HC lenses with your fingers.

▲ The writing on the building wall in Chengdu, China formed an appropriate background for the girl on her way to school early in the morning. *Ernst Wildi*

▲ Africa #16 from L'ATTITUDES fashion editorial by
Howard Schatz for *Zink* magazine.
Available as a fine art print Schatz/Orenstein 2002
www.howardschatz.com

▲ Nude Study #1142 by Howard Schatz from *NUDE*
BODY NUDE (Harper Collins)
Available as a fine art print Schatz/Orenstein 2000.
www.howardschatz.com

▲ The curved lines produced by the 30mm fish-eye lens
made a striking image of the otherwise ordinary
interior of a high voltage center. The cat, placed
perfectly in the center of the 30mm fish-eye
composition shows no signs of the typical fish-eye
effect. Both images by Chip Simons.

15

Operating the FlexBody and ArcBody

For years, the Hasselblad camera system was considered perfect for any type of photography except for applications that required swing and/or tilt control. To eliminate these limitations Hasselblad added the FlexBody, the ArcBody, and the PC Mutar to the V system line. The FlexBody and the ArcBody were not introduced as substitutes for studio cameras; instead, the aim was to give the Hasselblad location photographer the possibility of swing and tilt control on inexpensive rollfilm without the need to carry a large studio camera with an assortment of large-format lenses.

The FlexBody allowed creation of pictures with a sharpness range way beyond the depth-of-field capability of the lens. The ArcBody allowed architectural photography with view camera capability. Unfortunately, not very many photographers showed an interest in using Hasselblad cameras for these special applications, perhaps because the computer age had reduced the need for such controls. Slanted verticals, for example, can be corrected in the computer. The limited demand made it necessary for Hasselblad to discontinue the FlexBody and the ArcBody.

CAMERA DESIGN

The FlexBody and the ArcBody are camera bodies with a flexible bellows that allows the photographer to shift and tilt the image plane. In both cameras the image is recorded in Hasselblad V system film magazines or certain V system electronic backs. On the FlexBody the image is recorded with Hasselblad V system shutter lenses. The front of the ArcBody is designed for the use of Rodenstock lenses specially designed for the ArcBody.

On both cameras, the image is evaluated on the focusing screen adapter specifically made for these cameras and included in the camera package. Figure 15-1 shows the main FlexBody operating controls, and Figure 15-2 shows those of the ArcBody.

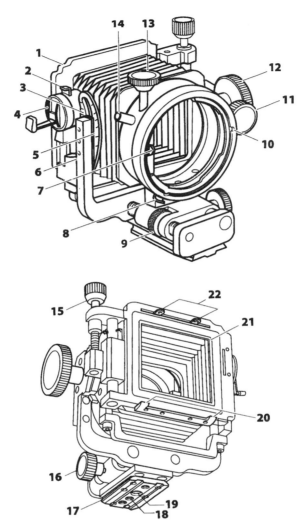

Figure 15-1 The important FlexBody operating controls.

1. Rear standard
2. Winding crank lock
3. Tilt scale
4. Winding crank
5. Tilt index
6. Front standard
7. Drive shaft
8. Lens release lever
9. Close-up extension wheel

10. Lens marking
11. Tilt control lock
12. Tilt control
13. Shutter cocking knob
14. Cable release socket
15. Shift control knob
16. Locking knob for close-up extension

17. Quick coupling plate with ¼-inch and ⅜-inch tripod thread (18, 19)
20. Magazine support
21. Rear frame
22. Magazine hooks

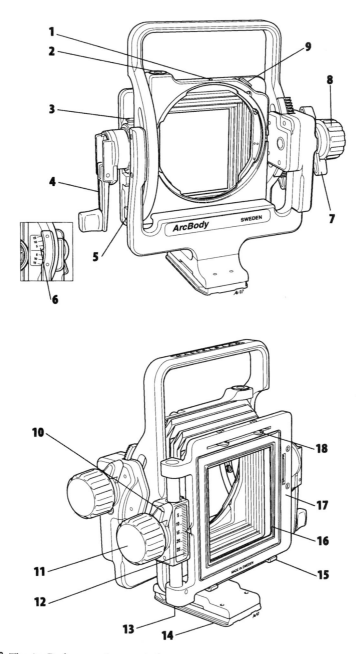

Figure 15-2 The ArcBody operating controls.

1. Lens alignment index	7. Lock for tilt control	13. Spirit level
2. Spirit level	8. Tilt control	14. Quick coupling plate
3. Lock for film winding crank	9. Lens release catch	15. Magazine supports
4. Film winding crank	10. Lock for shift control	16. Stray light mask
5. Spirit level	11. Shift control	17. Rear standard
6. Tilt scale	12. Shift scale	18. Magazine hooks

USING THE TILT CONTROL

On an "ordinary" camera, the sharpness range is determined completely by the depth of field of the lens at the set aperture. When you are photographing a flat plane from an oblique angle—as in a tabletop setting, a food illustration, or a landscape photograph of a flat area such as a water surface—or a flat field, you can control the sharpness range independently from the depth of field by tilting the image plane. You can have almost unlimited sharpness, even at large lens apertures that allow short shutter speeds (see Figure 15-3).

This tilt control principle, which applies to any camera, in any format, and with any lens, is known to large-format photographers under the name Scheimpflug (the name of the photographer who came up with the principle). It is based on the following:"When photographing a flat plane from an oblique angle, you have the maximum possible sharpness range when a line extended from the lens plane and a line extended from the image plane meet at a common point on a line extended from the subject plane"(see Figure 15-4).

Although the Scheimpflug principle could be applied to predetermine or calculate the amount of tilt, you will probably find that you can more easily determine the necessary degree of tilt and the correct focus setting on the FlexBody or ArcBody by evaluating the image on the focusing screen. Start perhaps by focusing the lens at a point approximately one third beyond the closest and two thirds in front of the farthest subject distance, at 14 feet

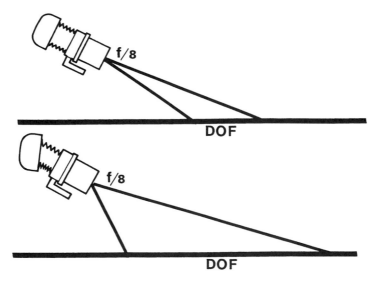

Figure 15-3 *Depth of field and sharpness range* The lens aperture produces a specific amount of depth of field at a certain aperture, *f*/8 in the example (top). You can extend the range of sharpness at the same aperture by tilting the image plane in relation to the lens plane (bottom).

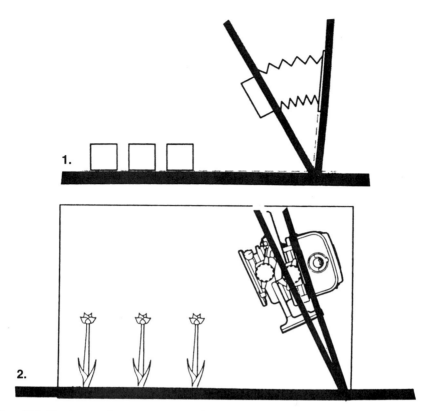

Figure 15-4 *Maximum sharpness range* The maximum sharpness range on the FlexBody (1) or ArcBody (2) is obtained when lines extended from the lens plane and image plane meet at a common point on a line extended from the subject plane.

(4.3m) when the closest subject is 6 feet (1.9m) and the farthest 30 feet (9.1m). Tilt the image plane in one direction, and check whether the sharpness range increases. If it does not, tilt the plane in the other direction. Check the sharpness at the top and bottom and see whether both become critically sharp at some point. If they do not, change the focus setting on the lens. You will quickly find a point where you have sharpness over the entire plane. Lock the tilt control.

Limitations of Sharpness Controls

With the tilt control you can accomplish sharpness over the entire area even with the lens aperture wide open, but only if you have a flat subject plane, such as the surface of a table or a flat field in the landscape. If there are any three-dimensional subjects on the table—a vase with flowers, a bottle of wine—or a building or tree in a landscape, the various subjects are no longer on a flat plane. We have at least two different image planes; one is the flat

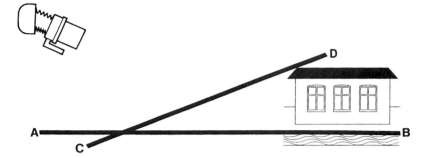

Figure 15-5 *Sharpness in different subject planes* The image plane can be tilted for sharpness in one subject plane only, either the plane A to B or the plane C to D. The depth-of-field control must be used to achieve sharpness in both planes.

surface, the other a plane going from the surface to the top of the subject (see Figure 15-5). You can adjust the tilt for either, but not for both. The difference must be corrected with the lens aperture and its resulting depth of field.

The tilt control also allows you to do the opposite—to limit the sharpness to one particular plane, one specific product, a specific person, or even part of the person. This flexibility is especially helpful when the different subjects are at the same distance and the depth-of-field control does not work. Be careful when using the tilt control for limiting the sharpness range because it is a special effect that can easily look artificial and attract unnecessary attention. When you tilt the image plane (not the lens plane), as done on the FlexBody and the ArcBody, the image plane remains in the center of the optical axis. You can tilt as much as necessary without the need for special lenses with a larger covering power. That explains why V system Hasselblad lenses can be used on the FlexBody without any limitations.

The tilt control in both cameras works only up and down. If you need to tilt along the horizontal plane, tilt the entire camera sideways.

THE SHIFT CONTROL

On the FlexBody and the ArcBody, the image plane can also be shifted—moved up or down while remaining parallel to the lens plane. The main applications are in product and architectural photography. Instead of tilting the camera upward to cover a building to the top, resulting in slanted verticals, you can shift the image plane downward (see Figure 15-7). By doing so you can keep the image plane parallel to the subject plane—the wall of the building—as you do on the PC Mutar by shifting the lens plane. By turning either camera sideways, you can accomplish the same results in the horizontal plane (see Figure 15-8).

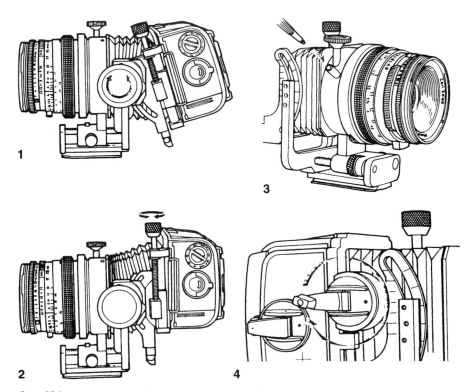

Figure 15-6 *Operating the FlexBody controls* **1.** You tilt the image plane by rotating the large tilt knob. **2.** You move the image plane up or down by turning the shift control knob on top. **3.** You extend the front for close-up photography by turning the knob below the lens. **4.** You advance the film by turning the winding crank. The ArcBody has the same controls, but they are in somewhat different locations and operate in a slightly different fashion.

Table 15-1 Maximum Shift in Millimeters on the FlexBody with Various Lenses

Focal length of lens	40mm	50mm	60mm	80mm	100mm	120mm	250mm
Maximum without mask	0	5	10	10	14	14	10
Maximum with mask	7	12	14	14	14	14	14

Limitations of the Shift Control

When using the shift control you are moving the image area out of the optical axis and out of the 78mm covering power circle of the Hasselblad V system lenses. Soon, two corners of the image darken, or even vignette, and lose image sharpness. Shifting with the Hasselblad lenses on the FlexBody is therefore limited, as indicated on the first line in Table 15-1 for various lenses. You can extend the shift capability to the values shown on the bottom line of the

Figure 15-7 *Use of the shift control* A tilted camera results in slanted lines (top). Instead of tilting the camera, you can shift the image plane downward until the top of the building is included in the composition, keeping the image plane parallel to the building (bottom).

table if you are satisfied in covering the subject in a horizontal 6 × 4.5 format. A mask for this format comes with the FlexBody.

Considering these limitations, the FlexBody with its tilt capability serves its purpose best for increasing the sharpness range. For architectural and similar work that requires shift control, consider the ArcBody (or the PC Mutar lens discussed in Chapter 14). This camera was introduced to eliminate the limitations of the covering power of Hasselblad lenses. The Rodenstock lenses that must be used on this camera have a much larger covering power, so you can shift 28 mm with all three lenses of 35 mm, 45 mm, and 75 mm focal length without losing image quality.

CLOSE-UP PHOTOGRAPHY WITH THE FLEXBODY

The front frame on the FlexBody with the lens can be moved forward as much as 22 mm for close-up photography. Moved to 22 mm, it produces the same results as a 22 mm extension tube would with the same lens on other

Figure 15-8 *Use of the shift control horizontally* Instead of turning the camera to record a subject that cannot be photographed from the center (top), you can shift the image plane (bottom) to include the desired subject area.

Hasselblad V system cameras. I suggest using this close-up extension only for close-up photography. For photography at normal distances, move the front frame all the way to the rear, and focus the lens with its focusing ring.

VIEWING, FOCUSING, AND EVALUATING THE IMAGE

On both cameras, the image is evaluated on the focusing screen adapter, in combination with either any Hasselblad V system camera viewfinder or the special RMfx Reflex finder, which shows the 3.3× magnified image right side up. The image on the Acute Matte focusing screen is bright to the corners, at least when the tilt and shift controls are in the 0 positions. When you tilt or shift, the image on the top or bottom of the screen darkens because your eye is no longer aligned in the optical axis. The darkening does not happen on the film.

The Fresnel slides supplied with both cameras solve this problem beautifully (see Figures 15-9 and 15-10). The FlexBody slide marked "10" is used for tilt angles from 5 degrees to about 15 degrees, and the slide marked "20"

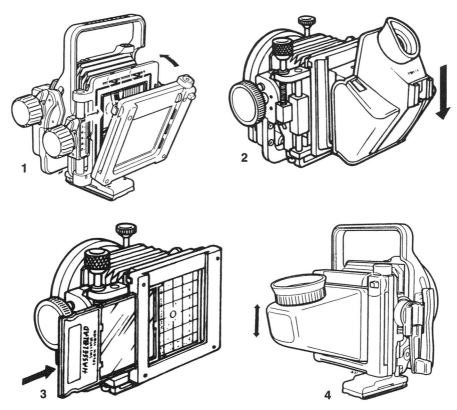

Figure 15-9 *The focusing screen adapter and correction slides* **1.** You attach the focusing screen adapter by placing it on the lower support hooks and then pushing it toward the top of the camera while pressing the release lock. Press the release lock to remove it. **2.** Viewfinders are inserted from the top. **3.** The correction slides are inserted either from the left or right but always with the text toward the rear. **4.** The RMfx viewfinder attached to the focusing screen adapter gives an upright image.

is used for greater angles. The three slides that come with the ArcBody are marked "Small" for corrections up to 5 mm, "Medium" for corrections 5 to 15 mm, and "Large" for corrections more than 15 mm, all with 35 mm and 45 mm lenses. The slides marked 10 and 20 are used with the 75 mm lens.

TAKING A PICTURE WITH THE FLEXBODY AND ARCBODY

After the image plane is adjusted, the lens focused, and the aperture and shutter speeds set on the lens, remove the focusing screen adapter, and attach the film magazine but do not remove the darkslide (see Figure 15-11). Proceed as follows:

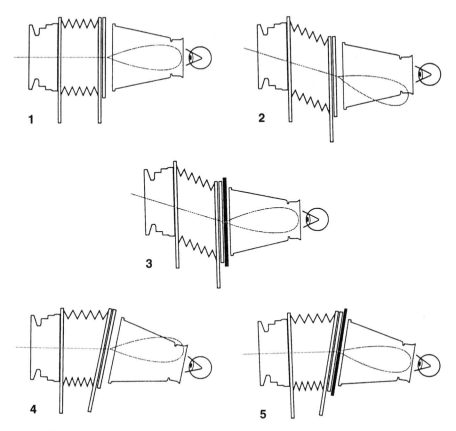

Figure 15-10 *Purpose of correction slides* **1.** When the image plane is parallel and centered with the lens plane, all the light goes toward the eye. **2.** When the image plane is shifted without a correction slide, the light rays are not in line with the viewing axis, darkening one side of the focusing screen. **3.** The correction slides redirect the light rays to the center of the eye for equal brightness over the entire screen area. **4, 5.** The same happens when the image plane is tilted.

1. Attach the supplied cable release, and press the release halfway. You will hear the lens shutter closing.
2. Remove the darkslide.
3. Press the release completely. The shutter opens and closes to make the exposure.
4. Insert the darkslide before you do anything else. Make certain you do not cock the shutter before the darkslide is in the magazine. That would expose the film to light.
5. Recock the shutter.
6. Advance the film using the film winding crank on the FlexBody.

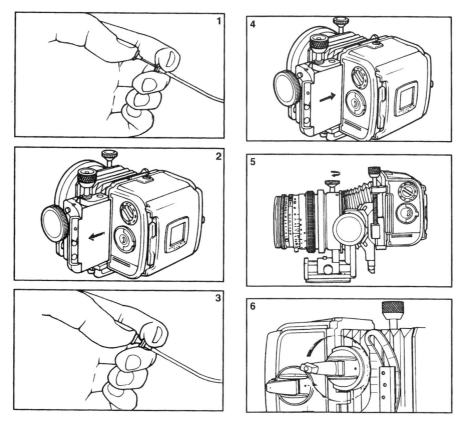

Figure 15-11 *Photographing with the FlexBody* After the lens settings are made and the film magazine is attached, press the cable release halfway (1) to close the lens shutter. Remove the darkslide (2), and press the release completely (3) to make the picture. Then insert the darkslide (4), recock the shutter (5), and advance the film (6).

The ArcBody operation is identical, but you must also operate the open/close lever for the shutter on the lens. You must also use the central neutral density filter with the 35mm and 45mm lenses to achieve even brightness over the entire image area (discussed in Chapter 14).

▲ A wide angle composition by Patrick Demarchelier with model Maya from the WOMAN model agency. Hair by Michele Aleman Bryan Bantry. Make up by Dee Dee Calliste.

▲ Model Maya from the WOMAN model agency
photographed with wide angle lens by Patrick
Demarchelier. Hair by Michele Aleman Bryan Bantry.
Make up by Dee Dee Calliste

▲ The straight and parallel vertical lines in the image of
the Victorian building were achieved by photographing
the building from a long distance with a 350mm
telphoto lens. Ernst Wildi

▲ Backlight brings water to life. Taken in British Columbia
with a 350mm Carl Zeiss Tele-Superachromat. Ernst
Wildi

16

Understanding Light and Filters

USING FILTERS

There are five basic reasons for using filters: to obtain correct color rendition in color photography or correct gray tones in black and white work, to enhance color images or change gray tones in black and white, to create special effects and moods, to reduce the amount of light reaching the film, and to protect the lens.

Filters as Lens Protection

Lenses are expensive components in any camera system, and they are easily damaged and usually expensive to repair. It is a good practice to protect the front element with an optically plain piece of glass such as an ultraviolet (UV) or haze filter. Filters protect the lens from dust, dirt, and possible damage without changing the colors or gray tones to any noticeable degree.

Because these filters are used all the time and therefore become a semi-permanent part of the lens, they must be of the very highest quality. Equip each lens with its own filter. It is too time-consuming to switch filters every time lenses are changed. For color photography, it is best to use identical filters made by the same company to avoid possible differences in color rendition. A lens shade offers further protection for the lens and also prevents snow or raindrops from falling on the lens element.

Haze and UV Filters

Haze and UV filters absorb UV rays without changing colors to a noticeable degree and can be helpful when you are photographing in places that have large amounts of UV light, such as at high altitudes. Most modern lenses, however, have some lens elements that are made from glass that absorbs UV rays to a greater extent than a UV filter. In a way, such lenses have a built-in UV filter. Consequently, haze and UV filters have little value for improving pictures, for reducing haze penetration, and for improving distant shots. Polarizing filters should be considered for this purpose.

Table 16-1 Polarizing Filters

Density	*Percentage of light transmission*	*Increase in exposure in f stops*
0.3	50	1
0.6	25	2
0.9	12	3
1.2	6	4
1.5	3	5
1.8	1.5	6

Neutral Density Filters

Neutral density filters, also called gray filters, are made from neutral gray colored glass and are used in black and white and color photography to reduce the amount of light reaching the image plane without changing the tonal rendition. You may want to use these filters outdoors so that you can photograph at a larger aperture to reduce depth of field or photograph at a long shutter speed to blur moving subjects such as water. You can also use these filters to compensate for different film sensitivities when using the instant film back for test shots.

Neutral density filters come in various densities, requiring the exposure increases shown in Table 16-1. The filters can be combined, with the exposure increases added up.

Filters for Black and White Photography

In black and white photography, the various colors are recorded in a range of gray tones from white to black. Filters can be used for purposely darkening or lightening certain colors to emphasize, suppress, separate, increase, or reduce the image contrast. You can lighten or darken any color. To lighten a color, use a filter of the same color or at least from the same side of the color wheel (see Figure 16-1). To darken a color, select the color directly across the wheel or at least from the opposite side. A yellow filter darkens colors from blue-green to violet. Green filters lighten green and darken purple and red; they can be used to lighten shaded green areas under trees.

In black and white photography, a yellow filter produces some improvement in distant shots, but orange and red filters and polarizing filters are more effective. Complete or almost complete haze penetration can be obtained with a red filter, combined with infrared film, but other colors are also changed—for instance, green appears as white.

THE COLOR QUALITY OF LIGHT

Color transparency films are manufactured for a specific color or light source, and correct color rendition can be obtained only if the color of the light

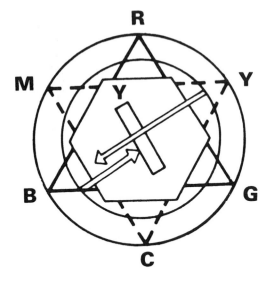

1.

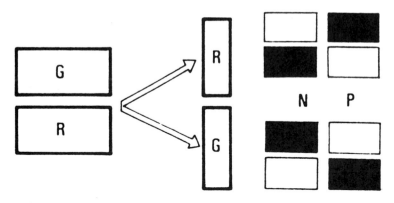

2.

Figure 16-1 *Filters in black and white photography* **1.** The color wheel with the colors red (R), yellow (Y), green (G), cyan (C), blue (B), and magenta (M) is a convenient tool for determining how various colors are reproduced in black and white through different filters. A yellow filter (Y) transmits yellow and absorbs blue. **2.** Photographed through a red filter (R), green gives a light image on the negative (N) and a dark image on the print (P); red is reproduced darker on the negative, lighter on the print. The situation is reversed when a green filter (G) is used.

Table 16-2 Color Temperatures of a Few Typical Light Sources

DM	Kelvin	Type of light
8	12500	Shade with clear blue sky
16	6250	Overcast day
18	5600	Sunlight at noon
31	3200	Tungsten lamps
34	2900	100–200W household lamps
54	1850	Candlelight

matches that for which the film is balanced. The color quality of light, known as color temperature, is usually expressed in Kelvin (K) and sometimes in decamired (DM) values. Kelvin and decamired values arc directly related by the following formula:

$$\text{DM value} = \frac{100,000}{\text{Kelvin value}}$$

Daylight color films used in medium-format photography are matched to a 5600K (18DM) value. Tungsten films are matched for a 3200K (31DM) color temperature. Table 16-2 shows color temperatures for certain light sources.

Light Balance and Conversion Filters

Light balance and conversion filters are used in color photography to match the color quality of the illumination to that of the film or purposely to obtain a warmer or cooler color rendition in the images.

The filters with a warming effect—the 81 series light balance and 85 conversion type or the decamired red (R, CR) types—are used when the light is too blue. The filters with a cooling effect—the 82 series light balance and 80 conversion filters or the decamired blue (B, CB) types—are used when the light is too red.

Years ago I used 81A or 81B (CR 1.5 or CR 3) light balance filters for outdoor pictures taken on overcast, foggy, or rainy days or in shaded areas to eliminate or reduce the bluish cast. I have not found this need with the color films that we have today. You may still want to consider these filters, perhaps for portraits in the shade. Fill flash, however, can produce better results. There are also cases when you don't want to match colors. Early morning and late afternoon scenics are usually exceptionally beautiful because of the warm color of the early morning or late afternoon sunlight. Don't destroy the effect with a cooling filter.

Table 16-3 shows filter values for various situations.

Color-Compensating Filters

Color-compensating (CC) filters—available in six colors (yellow, magenta, cyan, red, green, and blue) and in different densities from about 0.05 to

Table 16-3 Filter Values for Various Situations

Purpose	Decamired filter	Wratten filter
To get a warmer rendition with electronic flash	R1.5	81A
To use Tungsten color film in daylight	R13.5	85B
To use daylight film with 3200K light	B13.5	80A
To use Tungsten film with household lamps	B3	82C

0.50—are used for changes in the overall color balance or for fine color corrections. These filters are most readily available in gelatin form.

Fluorescent and Vapor Lights

Unlike sunlight or the light from incandescent sources, the light from a fluorescent tube is not evenly distributed through the spectrum, so the results with color film can be unpredictable (except with special color matching tubes). Film and fluorescent tube manufacturers publish charts showing which color-compensating filters produce the most satisfactory results. Special filters for fluorescent lights are also available for use with daylight and Tungsten-type color film.

The Decamired Filter System

In the Wratten filter system, there is no direct relationship between the color temperature of the light and the filter value. The necessary filter can therefore be determined only by a color temperature meter or from a chart. In the decamired system, the light and filter values are directly related to each other. The required filter must have a DM value equal to the difference in the decamired values of the film and the light source. For example, if a DM 31 film is used with DM 28 light, you need a 3DM value filter—CR 3 (red) in this case because the light is bluer. The filters within each color can be combined to obtain different correction values, such as CR 9, by combining a CR 6 and a CR 3. Hasselblad used to have available decamired filters in blue and red with values from DM 1.5 to DM 6 for the most-used V system lenses. Because most photographers are more familiar with the Wratten system, these filters are no longer made.

EXPOSURE INCREASE

A filter absorbs light. With UV, haze, and some light balance and color-compensating types, the light loss is small and need not be considered. With darker filters, lens settings must be adjusted when the meter reading is made with a handheld meter. When the meter reading is made through the lens, as in the Hasselblad H and 200 cameras, or with a meter prism viewfinder on any other camera model, the light is also measured through the filter, and the light loss is automatically adjusted in the meter reading.

The necessary exposure increases may be indicated either in filter factors or in actual aperture values. The two are not the same. When the increase is indicated in aperture values, you must increase exposure by the indicated value—for example, two *f* stops if the value is 2. If indicated in filter factors, you convert the factors into the aperture values shown in Table 16-4.

Table 16-4 Filter Factors and *f* Stops/EV Values

Filter factor	1.5	2	2.5	4	6	8	16	32	64
Increase in EV or *f* stops	½	1	1½	2	2½	3	4	5	6

HASSELBLAD FILTERS

All lenses in the Hasselblad H system take standard-size filters made by filter manufacturers. Hasselblad does not make filters for this camera system.

Because filters are also quite readily available for the various lenses in the V system, Hasselblad reduced its own line to the UV, (Haze), and polarizing types. Other types, especially for black and white photography, used to be available. These filters carried all the necessary information engraved on the rim. For example, a filter engraved 60 2 x YG—1 has a size of 60 mm, a color of yellow-green, and a filter factor of 2, requiring an exposure increase of 1 EV value. Filter colors are designated as follows: Y = yellow; YG = yellow-green; G = green; O = orange; and R = red. Some color-compensating filters also carried the equivalent Kodak filter designation.

POLARIZING FILTERS

Light that reaches our eyes or the camera lens directly is unpolarized, which means light waves vibrate in all directions perpendicular to the light path. If such light reaches glass, water, or many other reflecting surfaces at an angle, it becomes polarized, with the light waves vibrating in one direction only (see Figures 16-2 and 16-3).

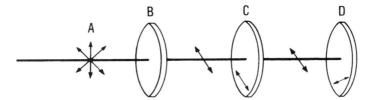

Figure 16-2 *Natural and polarized light* Natural, unpolarized light vibrates in all directions (A). As it passes through a polarizing filter (B), the light becomes polarized—vibrates in one direction only. If this polarized light meets another polarizing filter that has its axis of polarization in the same direction as the first (C), the light passes through. A polarizing filter with its axis of polarization at right angles to the first (D) absorbs the light, and we have what is known as cross-polarization.

Polarized light in nature is usually light reflected from water, leaves, rocks, trees, windows, or virtually any other shiny surface except bare metal (see Figure 16-3). Reducing reflections gives many surfaces a deeper, more saturated color. Reflections, of course, can also be natural, as on porcelain or silver, or they can make more beautiful pictures, as in the reflections on water surfaces; eliminating them can make the water dull and uninteresting. Watch the effect when you use polarizing filters.

Fortunately, the effect of the filter can easily be seen. Turn the filter on the lens while evaluating the image on the focusing screen, or turn the filter held in front of your eyes while looking at the subject or scene and see what happens. The difference may be dramatic. A polarizing filter need not be turned for maximum effect. You can use it at whatever setting produces the desired results.

Because the light coming from the sky has been polarized by passing through the thin layers of the atmosphere, a polarizing filter can make a sky dramatically darker, but only when you are photographing at a 90-degree angle to the direction of a line drawn from the sun to the camera—in other words, with sidelight (see Figure 16-4). Polarizing filters can drastically

Figure 16-3 *Reflected light* When natural, unpolarized light (A) is reflected, it may become polarized, vibrating in one direction only (B). In this state, it passes through a polarizing filter with its axis of polarization in line with the light (left) but not through one (D) at right angles (right).

Figure 16-4 *Angle for polarization* Reflected light is polarized only if it hits a surface at an angle of between 30 and 40 degrees, depending on the material of the reflecting surface (left). Skies are darkened by a polarizing filter only when the pictures are taken at right angles to the sun (right).

improve distant shots by eliminating the bluish haze, eliminating reflections, and improving color saturation on distant surfaces. This improvement again happens only with sidelight. Polarizing filters work with color and black and white films, and the improvements are alike.

Polarizing filters should be mounted on the camera so that they can be rotated easily. The lens shade may have to be removed for this purpose. Because the polarizing effect in the image depends on the angle of reflection, the effect may differ over the image area, especially in wide-angle pictures. Reflections on a window may be eliminated on one side of the window but not on the other; a blue sky may be darker on the left side than on the right. Such differences can be seen in the viewfinder, so evaluate the image carefully when you use polarizing filters.

Polarizing filters require an increase in exposure because the polarizing material has a grayish tint. The required increase is the same no matter how the filter is rotated to the position with either minimum or maximum polarization. Because a polarizing filter reduces or eliminates reflections, polarized images sometimes appear darker than expected but only because the reflections are no longer there.

Figure 16-2 illustrates the difference between natural and polarized light, and Figures 16-3 and 16-4 show the effects of reflection.

Polarizing Filter Types

The original polarizer, known today as the linear type, affects the light measuring or automatic focusing system (or both) in some cameras to the point of giving a wrong reading or distance setting. Whether this happens depends on the design of the metering and focusing system in the camera. The problem has been eliminated with a polarizer known as the circular type, which produces the same results in the picture but does not affect the metering or focusing and can therefore be used on any camera. The camera manufacturer should be able to tell you whether the circular type is necessary on your camera.

The circular type is needed on Hasselblad H cameras because the linear type affects the automatic focusing. Circular types are not needed on the 200 cameras with a metering system nor when you are metering with a meter prism finder. You can use the linear type on these cameras. The Hasselblad polarizers are the linear type.

Using Polarizing Filters over Light Sources

You can polarize light from tungsten lights or electronic flash by placing a polarizing filter over the light source. The polarizing filter on the camera lens then eliminates all reflections, at all angles, from all materials. This procedure is necessary to eliminate reflections on bare metal. It is also a superb approach for copying.

To be most effective, the polarized light must illuminate the picture or document from an angle of between 30 and 40 degrees. You then turn the polarizing filter on the camera by visually examining the image on the focusing screen. Copying with polarized light is described in more detail in Chapter 18.

PARTIAL FILTERING

It may sometimes be desirable to filter only part of a scene, such as darkening a bright sky to bring it closer to the brightness level of the landscape below. This is done with graduated filters, a neutral density type for darkening the sky. Such filters are available in square shapes so that they can be moved in front of the lens in a special filter holder. Graduated color filters can add color to part of a scene, perhaps adding a touch of blue to a white sky.

Be careful in using graduated filters because the effect often does not look real. You also must evaluate the image on the focusing screen at the aperture that will be used for the picture because the dividing line shifts and may become more or less visible when you open and close the diaphragm.

QUALITY OF FILTERS

Filters used with quality lenses for critical photography must be made to the same quality standards as the lenses. This is especially important when they are used extensively and when they are combined with long focal length lenses. Filters for long telelenses must be of the highest quality. A filter that is not perfectly optically flat may have the effect of a very weak lens element, decreasing the image quality and possibly making it impossible to focus the lens at infinity. The quality of filters becomes still more important when filters are combined.

Filters between the Lens

Because the 30mm Distagon fish-eye lens covers a 180-degree diagonal field of view, it is impossible to attach filters to the front without cutting into the diagonal field of view. Filters can be attached to the rear of the front section (see Figure 16-5) and are part of the optical design, meaning that the 30mm Distagon is designed to produce the best sharpness with a filter or clear glass in the lens. Never use the lens without a filter or clear glass. The rear ring of the lens is painted bright red to reduce the possibility of attaching the front section without a glass or filter. The Distagon is supplied with a clear glass and a yellow-orange conversion filter.

Figure 16-5 To attach or change a filter on the 30mm Distagon, press the release (A), and turn the knurled ring (B) counterclockwise until the two red dots (C) are opposite each other. Lift the front section, and screw the filter to the end of the cone. 2. Assemble the lens by placing the front section in the rear part, with the two red dots opposite each other, and turning the knurled ring clockwise.

Gelatin Filters

Gelatin filters can be used in combination with the Proshade. Older shades were made for the 3-inch size only. The 3-inch or 4-inch sizes can be used in the new shades made since 1991. The larger 4-inch sizes must be used with wide-angle lenses, long telephotos, and the 110mm Planar. The 3-inch size can be used for lenses from 60 to 250 mm. The filters should be placed into gelatin filter holders.

SOFT FOCUS EFFECTS

Some images, especially portraits and fashion illustrations, can be more effective with a soft touch, which also suppresses undesirable details and reduces the need for retouching afterward. Only a slight diffusion is necessary for this purpose. A soft focus effect can be produced with special soft focus lenses or with filters placed in front of the regular sharp camera lenses. Using filters makes more sense because they can be used on different lenses, and different filters can produce different degrees of softness.

Soft focus filters, sometimes called diffusion filters, are made by various manufacturers and produce similar, but not identical, results. Select a type in which the degree of softness is independent of the lens aperture—in other words, one that produces the same degree of softness at all apertures. This is important because you want to set the lens aperture for the desired depth of field, not for the degree of softness. Some filters, like soft focus lenses, produce a large degree of softness with the aperture wide open and an almost sharp image when closed down. In addition, make certain to select a filter that produces the softness not by blurring the image but by producing sharp images with diffused outlines created by the highlights bleeding into the

shaded areas. Good soft focus images must not give the impression of unsharpness. Our eyes are not accustomed to seeing blurred things. We always expect to see something sharp, whether we look at the actual subject or a photographic image.

The Softar Filters

The Softar filters, available in sizes for the lenses normally used for people photography in the Hasselblad V system, provide a wonderful solution for professional soft focus photography. The degree of softness is the same at all lens apertures, and they produce sharp images with a beautiful, professional softness. Softar #1 gives the minimum softness, Softar #3 the maximum, with #2 falling somewhere in between. For most pictures, especially portraits and fashion shots, the slight softness of #1 or #2 is sufficient.

Soft focus images can be beautiful in the flat lighting of an overcast or foggy day or with the lighting from a soft box in the studio. The effect can be very striking on backlighted subjects or scenes where the diffusion filter creates a sort of halo effect around every highlight in the scene or subject. Because the effect is produced by bleeding the highlights into shaded areas, the bright areas may produce a halo that can look disturbing against a dark background. Avoid or reduce this effect by photographing against a lighter background, photographing from a different angle, changing the lighting setup, or changing to a weaker soft focus filter.

The Softar filters are made from an acrylic material and should never be cleaned with lens cleaning fluids or other chemicals.

The Hasselblad Soft filters in square shapes for use in the Professional Lens Shade produce a very similar effect as the Softars, maintaining image sharpness and producing a softness unaffected by the lens aperture. The different degree of softness is created with different filters, from "light" to "medium" to "heavy," with the softness degrees similar to Softar #1, #2, and #3. Because most photographers found the Softars more practical, the Soft filters have been discontinued by Hasselblad.

VISIBLE AND INVISIBLE LIGHT

The light that is visible to the human eye has wavelengths from about 400 nm (violet) to about 700 nm (red). Beyond the red is infrared radiation, which is not visible to the eye but can be recorded photographically on special infrared emulsions. At the other end of the spectrum, beyond the violet, is ultraviolet radiation, which is also used in photography. The ultraviolet wavelengths are divided into three bands: long wave (320-400 nm), middle wave (280-320 nm), and short wave (ultraviolet 200-280 nm). Figure 16-6 illustrates the wavelength spectrum.

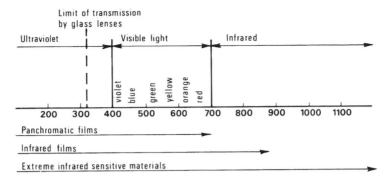

Figure 16-6 *The wavelength spectrum* Visible light extends from 400 nm to 700 nm; infrared radiation has wavelengths above this, and ultraviolet has wavelengths below it. Panchromatic emulsions record radiation up to about 730 nm, infrared films up to about 880 nm, and extreme infrared materials beyond 1000 nm. Ultraviolet light, at the other end of the spectrum, is recorded on regular emulsions. Glass transmits radiation down to about 320 mm.

Ultraviolet and Fluorescence Photography

In ultraviolet photography, the subject is illuminated with ultraviolet (UV) light and photographed through a filter, such as the Kodak 18A, that absorbs all the visible light. UV photography is used mainly in the scientific field for the examination of altered documents, engravings, tapestries, paintings, sculptures, and so on. Regular films and lenses can be used for photography in the longer wavelength ranges. Special lenses made from quartz elements are necessary when you work in the shorter ranges. Such a lens of 105mm focal length made by Carl Zeiss used to be available for Hasselblad V system SLR cameras.

Fluorescence photography means photographing objects and materials that fluoresce when subjected to UV light, such as a black light (BLB fluorescent tube). The radiation reflected from the subject is visible to the eye and can be photographed on regular films with regular camera lenses. A UV filter is recommended on the lens. The often brilliant and striking colors call for color film. On daylight film, yellows and reds will be more brilliant; tungsten film will accentuate the blues and greens. Although the difference is small, you should base your choice of film on the fluorescing color that is to be emphasized. Exposure can be determined with a handheld or built-in meter, but test exposures are suggested.

Electronic flash is another light source for fluorescence work. A filter that absorbs most of the visible light, such as a Kodak 18A, must be placed over the flash unit.

Infrared Photography

Infrared radiation has important applications in scientific photography and exciting possibilities for the experimenting photographer for producing

images with unusual tonal renditions on black and white film. For most photographic purposes, wavelengths from 700 nm to about 900 nm are used.

Almost all light sources used in photography, including daylight, can be used for infrared work. The photography must be done on special infrared films, which unfortunately are not easy to find or do not exist for medium-format cameras. Most infrared black and white photography is done with a red filter on the lens.

Figures 16-7 and 16-8 show how to focus for infrared photography.

Lenses and Focusing

All photographic lenses transmit infrared radiation and are therefore usable. With infrared color films, the lenses are focused normally because the image is created by a combination of infrared and visible light. With infrared black and white film, focus the lens, manually or automatically, as usual based on

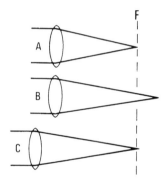

Figure 16-7 *Focusing in infrared photography* Infrared radiation (B) forms an image farther from the lens than the visible light (A). The image on the image plane (F) is therefore out of focus unless you compensate for this by moving the lens forward (C).

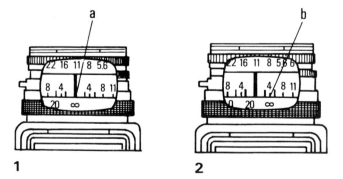

Figure 16-8 *Infrared focusing index* When you are using a lens with an infrared index, focus the subject visually and read the distance (a) opposite the white index (infinity in this case). Turn the focusing ring so that the distance (infinity) is opposite the red infrared index (b).

the image on the focusing screen. Before you take a picture, read the distance setting on the lens, and move this setting opposite the red infrared index, which is engraved on all H system lenses and on all newer lenses in the V system. This adjustment moves the infrared image on the image plane.

The 250mm Sonnar Superachromat is chromatically corrected for infrared radiation up to 1000nm so that the infrared image is formed at the same plane as normal wavelengths. A focus adjustment is not necessary. The image quality in infrared work and in ordinary black and white photography, especially with red filters, is also improved.

▲ The results with different Carl Zeiss Softar filters. Softar #1 in (1) Softar #2 in (2) Softar #3 in (3) No Softar used in (4). All pictures made with Carl Zeiss Makro Planar 120 mm with dedicated automatic fill flash. Ernst Wildi

▲ The drastic improvement with copying under polarized
light is clearly shown in the comparison made with
and without polarization, and in a 1920 wedding
photograph that was photographed in the same fashion
in polarized light. Ernst Wildi

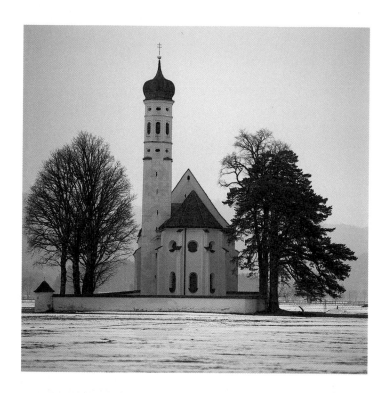

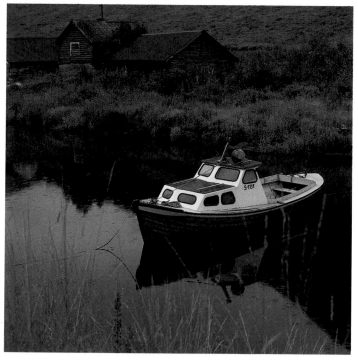

▲ The soft light of a rainy day in Norway produced a peaceful mood for the image of a boat taken with 1.4× teleconverter on 110mm lens while a foggy morning produced an image that is different from the postcard pictures published of this well-known church in Bavaria. Taken from a long distance with a 250mm lens which produced straight and parallel verticals. Both images Ernst Wildi

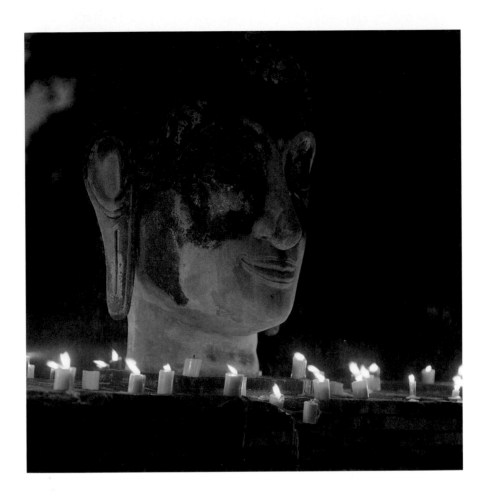

▲ Photographed with 180mm lens at dusk in Thailand with the main light coming from the candles. Ernst Wildi

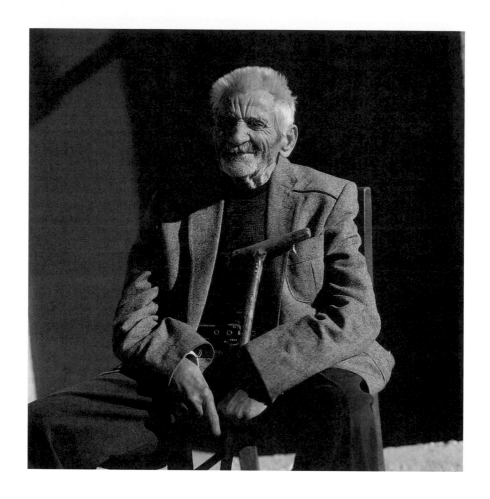

▲ Sidelight and a dark background enhance the portrait
of the old man in Cypress. Ernst Wildi

▲ The shadow pattern on the church wall in the
background enhance the effectiveness of this image
taken in Hungary. Ernst Wildi

17

Flash Photography with Hasselblad Cameras

ELECTRONIC FLASH PHOTOGRAPHY

Electronic flash units produce a large amount of light from a compact unit that can be attached to the camera or can be part of the camera itself, as on the Hasselblad H camera model. The duration of the flash is short, usually shorter than the shutter speed, and it therefore freezes action and helps to eliminate blurred images due to camera movement. The color temperature of electronic flash matches that of normal daylight, and the two can therefore be combined in color photography. The discussion in this book is limited to location flash photography.

ON-CAMERA FLASH

A flash unit built into the camera or mounted directly on the camera offers the greatest camera mobility in location work. The flat, front lighting is completely satisfactory for candid and news photography and for fill flash work outdoors. The best position for a camera flash is directly above the lens, preferably 6 to 12 inches above the camera lens at least for indoor work. This placement casts the shadows behind and below the people, where they might not be seen, and also eliminates red eye (see Figures 17-1 and 17-2). Red eye is caused when the flash is reflected from the retina at the back of the eye. With the flash well above the camera lens, the light enters the pupil at a slanted angle and does not illuminate the part of the retina that is directly behind the pupil.

Because the flash in outdoor work is usually used as a weak secondary light to fill the shaded areas, a unit right above the lens or built into the camera is completely satisfactory, and red eye is never a problem.

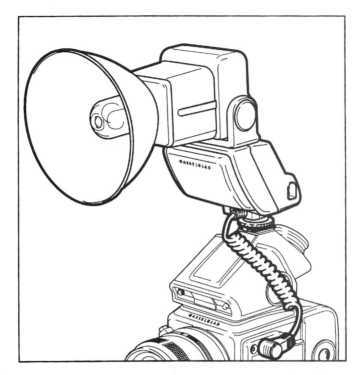

Figure 17-1 *Placement of the flash unit* A compact flash unit such as the Hasselblad D-Flash 40 is most conveniently mounted on the flash shoe on top of the prism viewfinder. The flash head is right above the camera lens and sufficiently far away to avoid red eye.

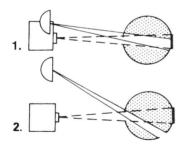

Figure 17-2 *Red eye* **1.** Red eye is caused by the flash light being reflected off the blood-filled retina. **2.** You can avoid this by placing the flash farther from the camera lens so that the retina is shaded.

Flash Units

The type and size of the required portable flash unit are determined by the amount of light that is needed in your photography and the number of flash pictures that need to be taken. A small, camera-mounted flash with built-in batteries or the unit built into the H camera produces more than sufficient light for fill flash pictures of people outdoors, which are usually made at larger apertures to blur the backgrounds. Such a compact unit is also sufficient for

indoor work within about a 15-foot (5-meter) range. Larger flash units are needed to photograph a banquet hall or a factory interior. A larger unit, perhaps with a separate battery pack, is also recommended when a large number of flash pictures need to be made.

The brightness of portable units is indicated in guide numbers, which are based on the film sensitivity. Most companies quote the guide number for 100 ISO (21 DIN) film.

The guide number tells you at what distances the flash must be used for the various lens apertures and therefore can also tell you what the maximum distance is. To obtain the maximum distance, divide the guide number by the maximum aperture of the lens. If the guide number is 42 and the maximum aperture is $f/2.8$, the distance is 15 feet. Guide numbers are given either in feet or in meters, so you must choose the same units for the conversion. At any distance, the flash exposure is determined by the lens aperture, see Figure 17-3.

FLASH OPERATION

Portable flash units can be made for manual mode, automatic mode, dedicated mode, or a combination of the three. In manual flash, lens apertures must be manually matched to the flash distance and must be changed when the flash is moved closer or farther away. This approach is time-consuming and should be considered only in special situations.

In automatic flash, a sensor built into the flash unit measures the light reflected off the subject and then determines the flash duration that provides correct exposure and turns off the flash at the proper time. Automatic flash eliminates the need for matching aperture to flash distance, but you must still match the aperture setting on the flash unit to the aperture actually set on the lens. After this is done, you can move closer or farther away without any

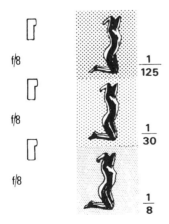

f/8

$\dfrac{1}{125}$

f/8

$\dfrac{1}{30}$

f/8

$\dfrac{1}{8}$

Figure 17-3 *Flash exposure* Because the flash duration is likely shorter than the shutter speed, exposure for flash is determined only by the aperture. Exposure for the flash is the same at any shutter speed within the shutter's synchronization capability.

additional adjustments. Automatic flash is a good choice when you are working with the Hasselblad XPan, the 501, and the Superwide camera models as well as all older models in the V system that do not have the dedicated flash option.

With all other Hasselblad camera models, dedicated flash is definitely the recommended approach today for all location flash photography, from family snapshots to serious professional candid, portrait, and wedding photography.

DEDICATED FLASH

Dedicated flash is the modern, convenient, reliable form of location flash photography. The flash exposure—the flash duration—is determined by a sensor built into the camera, which measures the light reflected off the image plane (OTF). The flash unit and the camera must be electronically interfaced, something that requires flash units or adapters that are made for a specific camera system.

The Hasselblad H camera is made for dedicated flash at shutter speeds up to $\frac{1}{800}$ second. The operation is described in Chapter 4. Hasselblad 503, ELX, and ELD models and all 200 camera models have dedicated flash capability and are used with flash in the same fashion in connection with a flash adapter.

The Hasselblad flash adapter SCA 390 works with flash units based on the SCA 300 system, which is common on European flash units. Some flash manufacturers, such as Quantum and Sunpack, make adapters for use with Hasselblad V system cameras. Consult the Hasselblad distributor for an up-to-date listing. The Hasselblad D-Flash 40 can be used in dedicated fashion on all dedicated flash V system cameras without an adapter.

The sensor in all Hasselblad cameras measures the light reflected off a 40mm center area of the image plane. You can easily visualize the measured area when composing the image on the focusing screen.

The Advantages of Dedicated Flash

Compared with manual or automatic flash, dedicated flash can provide better exposures and more flexibility and allow faster shooting while eliminating mistakes, for the following reasons:

- The sensor measures the light that actually reaches the image plane, which is unquestionably more precise than any other metering mode.
- The metering is done for the selected lens aperture, and you can change the aperture at any time without having to make any further adjustments.
- The metering works with direct or bounced flash, whether the flash is on or off the camera.
- You need not compensate when using filters, teleconverters, or extension tubes.

- With the light measured through the lens (TTL), the area measured by the sensor is matched to the lens that is used for the picture.
- No matter which lens is on the camera, you can visualize the area that is measured by the flash sensor when you compose the image on the focusing screen.
- The ready light is visible in the viewfinder, so you know when you can take a second picture without removing your eye from the finder.
- An exposure signal, also visible in the viewfinder, shows after the picture whether the film received a sufficient amount of light for correct exposure.
- The brightness of the flash can be adjusted independently from the aperture setting, so you can create any desired lighting ratio between the flash and existing light.

Setting the Film Sensitivity

When 503 and ELX or ELD models are used for dedicated flash, the ISO of the film must be set on the flash dial on the side of the camera body. This dial is operative only in dedicated flash operation (see Figure 17-5). This dial is engraved in ASA values only. If you are more familiar with DIN, the conversion chart in Table 17-1 may help. With manual or automatic flash, the film sensitivity must be set on the flash unit regardless of which camera is used.

Setting and Using Flash Units

The Hasselblad D-Flash 40 has all the necessary electronic interface components built into the unit. The D-Flash 40 does not have controls for use with other cameras or for use in other than dedicated fashion.

Other flash units that are used in combination with an adapter with the Hasselblad dedicated flash system in V and H system cameras are set to TTL (see Figure 17-6). The discontinued Hasselblad Pro Flash unit can also be used on Hasselblad V system cameras without an adapter.

Camera—Flash Connections

Connecting flash units to the Hasselblad H cameras is discussed in Chapter 4.

On V system cameras, the six-pin connector on the cable from the adapter is connected to the receptacle on the side of the camera. If the focal plane shutter in 200 cameras is used for the exposure, no other connection is necessary. The 200 cameras can be used for flash in all exposure modes, but the shutter speed must be $\frac{1}{90}$ second or longer.

Table 17-1 ISO/DIN Conversion Chart

ISO	15	25	50	100	200	400	800	1000
DIN	13	15	18	21	24	27	30	31

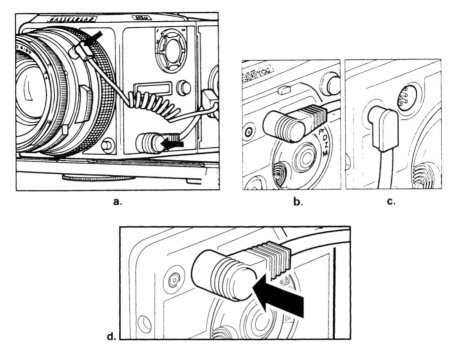

a. b. c.

d.

Figure 17-4 *Flash connections* For dedicated operation of V system cameras, the six-pin cable from the flash unit or adapter goes into the six-pin socket on the camera body (b). No other connection is necessary if the focal plane shutter is used for the exposure. When the lens shutter is used, the sync cable must also be connected to the PC socket on the lens (a). When nondedicated flash is used with the focal plane shutter, the sync cable is connected to the PC socket on the camera (c). To insert the dedicated flash cable, rotate the cable to match the grooved parts. Push the plugs straight into the socket, pushing at the flat top on the L-shaped type (d). Grip at the metallic sleeve to disconnect.

If the lens shutter is used on any camera, you must not only connect the six-pin cable to the six-pin socket in the camera but also have a sync cable going from the flash unit or the flash adapter to the sync contact on the lens to synchronize the flash with the shutter in the lens (see Figure 17-4).

If a portable or studio flash unit is used in the automatic or manual mode (nondedicated), you need only connect the sync cable to the sync contact on the camera, if the focal plane shutter is used, or to the sync contact on the lens when the lens shutter is used for the exposure. The old C lenses must be set to X when using electronic flash, see Figure 17-7.

CAMERA OPERATION WITH FLASH

Regardless of how you use the flash, you always set the desired aperture and shutter speed on the lens or camera, keeping in mind that the focal plane flash sync on 200 cameras is up to only $\frac{1}{90}$ second. If it is set to a shorter

Figure 17-5 *ISO setting* When dedicated flash is used, the film sensitivity on the 503, 553, and 555 cameras is set by turning the control (A) above the accessory rail until the desired rating is opposite the index. A six-pin connector (B) attaches to the dedicated flash socket on all Hasselblad camera models. The socket is in different locations on different camera models.

Figure 17-6 *Flash settings* With the ISO set on the camera (a), the flash dial is set to TTL (b). This is not necessary on the Hasselblad D-Flash 40. This unit simply needs to be turned on for either built-in or external battery use (c). The ready light/test button is near the on/off switch (d).

Figure 17-7 *Flash with older lenses and cameras* Older 500C and 500EL models made before 1976 were equipped with a sync socket (A) on the camera body next to the cable hook opening (B). The sync cable is connected there only when the camera is used without a lens, as in photomicrography. The flash fires when the auxiliary shutter is fully open. C lenses (C) must be set to X for use with electronic flash.

speed, the flash will not fire, a warning will appear in the viewfinder, or the picture will be made automatically at $\frac{1}{90}$ second, depending on the Hasselblad camera model.

Ready Light and Exposure Signal

In all Hasselblad V system cameras designed for dedicated flash, the flash ready light is visible in the camera's viewfinder as either a green flash symbol (in 200 cameras) or a red light on the left side of the focusing screen (on 500 models). The red light also becomes the exposure signal (see Figure 17-8). When it flickers for about two seconds after the flash fires, it indicates that the film received a sufficient amount of light. If it does not flicker, you must open the aperture, move the flash closer, or change to a faster film. On the 200 model cameras, a flickering signal, LO FLASH, appears on the display immediately after the picture is made, indicating that the flash illumination was insufficient. HI FLASH appears on the display if the light is too strong.

The H camera models can be programmed so that the camera can be released only if a dedicated flash mounted on the hot shoe is fully charged, and this serves the same purpose as a ready light. The H camera also gives a LO FLASH warning if the flash illumination from a dedicated unit is insufficient.

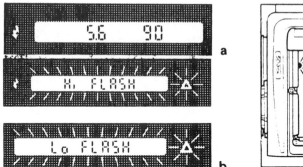
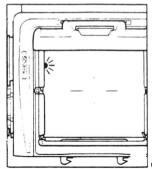

Figure 17-8 *Ready light* In the 200 camera models with built-in metering system, a green flash symbol on the viewfinder display indicates when the flash is ready to be fired (a). A HI FLASH or LO FLASH warning appears after the picture is made if the flash illumination was excessive or insufficient (b). On the other camera models, the ready light is visible at the edge of the focusing screen (c). It flickers after the exposure if the film received a sufficient amount of light.

USING ELECTRONIC FLASH FOR PHOTOGRAPHING PEOPLE OUTDOORS

Electronic flash is an ideal light source to combine with daylight. Portraits, fashion shots, publicity pictures, and family snapshots are very beautiful when sunlight is used as a backlight or sidelight, with the electronic flash added to lighten the shaded area and bring some light into the faces and eyes of the people being photographed. Such people pictures are very beautiful with the sun used as a backlight or a sidelight placing a highlight on the hair, the shoulders, and perhaps the forehead or cheek (not the nose). Fill flash can also bring some light into the eyes and improve the colors in people pictures taken in the shade or in the soft light of an overcast day. When you photograph in the warm early morning or late afternoon sunlight, place a warming filter over the flash to match the warm sunlight.

Selecting Aperture and Shutter Speed

Because exposure in flash photography is determined only by the lens aperture, any shutter speed within the sync range of the camera provides the same exposure for the flash but not for the surrounding area in the existing light. Location people pictures are a combination of flash and daylight, and they are most effective when the two light sources are combined in a natural-looking fashion with the flash being a secondary light source, not the main light.

Regardless of the type of flash you are using, always start by metering the daylit area that is behind or surrounding the people using the same meter and metering approach that you use for daylight pictures. Based on the meter reading, set the aperture and shutter speed that you feel produces the desired

results for the surrounding area. You can make it darker by reducing the shutter speed or make it lighter with a longer speed.

Determining and Changing the Flash Exposure

Regardless of the type and direction of the daylight, the flash exposure must be considered seriously. For a publicity picture, where the main purpose is to see what the people look like, you can use the flash as you do indoors without any reduction. For all other location people pictures, you want to make the flash a secondary light source only for the purpose of lightening the shaded areas or bringing a little light into the eyes. The best flash fill pictures are usually those in which you are not aware that flash was used.

Because you do not want to overflash and because most location pictures are done at larger apertures to blur the background, you do not need a large flash unit for this type of photography. A small portable unit, or the unit built into the Hasselblad H camera, is more than sufficient.

The reduction in the flash illumination that produces the best lighting ratio between the flash and existing light depends somewhat on the type and direction of the existing light. It is best determined by testing your camera and flash unit with the film that you normally use. I have found that a reduction between two and three f stops is most satisfactory. This reduction in the flash exposure can be done beautifully and without changing the exposure for the existing light on all Hasselblad dedicated flash systems. On the Hasselblad V system cameras, you reduce the flash by setting the ISO flash dial on the side of the camera body to a higher value. When this dial is set to ISO 400 with ISO 100 film, it reduces the flash exposure by two stops. Because we did not change the aperture or shutter speed, the exposure for the existing light is the same. Flash exposure is reduced in the same fashion with a flash unit used in the manual or automatic mode. Change the ISO setting on the flash unit.

On Hasselblad H cameras, the reduction up to three f stops is programmed into the camera, as discussed in Chapter 4. On the 200 camera models with built-in meter, the desired flash exposure value is also programmed into the camera body. Set the mode selector to Pr, and press the AE lock in the center of the dial repeatedly until the flash function shows up on the viewfinder display. You can now program into the camera flash exposure values from +1 to −3 by pressing the minus or plus adjustment buttons. The values are set in $\frac{1}{3}$ stop increments on the 202 and 203 models and in $\frac{1}{4}$ stop increments on the 205. Set it to the desired value. It remains programmed into the camera until you change it or the battery is removed.

Flash offers wonderful possibilities in nature photography on overcast days or in shaded areas. Flash adds life, gives the impression of sunlight, produces better colors, allows you to work at smaller apertures, and can reduce the likelihood of blurry pictures due to camera or subject movement. You can also make the flash a front light, a sidelight, or a backlight.

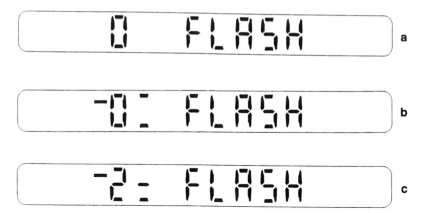

Figure 17-9 *Setting the flash exposure* On 200 cameras with built-in metering system, the flash exposure is set with the mode selector in the Pr setting. A 0 indicates no reduction in the flash (a). On the 202 and 203 cameras the values are set in $\frac{1}{3}$ stop increments, $-\frac{2}{3}$ in (b). The settings are in $\frac{1}{4}$ stops on the 205, $-2\frac{1}{2}$ in (c).

Determining the Lighting Ratio

The flash fill value, which determines the lighting ratio between the flash and existing light, must be your personal decision. It is best determined with a film test with your equipment, and with the type of film that you intend to use. The latter is very important because films have somewhat different reflectance values. You will probably find that flash values from $-1\frac{1}{3}$ or $-1\frac{1}{2}$ to -2 or $-2\frac{1}{2}$ provide natural results with sunlight from the side or back.

ELECTRONIC FLASH IN INDOOR WORK

The approach discussed in Chapter 16 for creating a desired lighting ratio between flash and existing light can also be used indoors if it is desired to make the room part of the picture. This would certainly be the case in a beautiful ballroom, a church, an office, a museum, in beautiful homes, in manufacturing areas. To make the room part of the image, take a meter reading of the part of the room that is behind the people or surrounding the people, as you do outdoors. Try to use the aperture and shutter speed combination based on the meter reading or a value close to it, perhaps one below the value.

Because the amount of existing light is limited in most locations, you may have to use a tripod. Before doing so, however, consider using a film with a higher sensitivity, and do not hesitate to use fairly slow shutter speeds, perhaps $\frac{1}{30}$ second. The flash duration is short, reducing the danger of blur due to camera motion, at least in the flashlit subjects, the people.

PRODUCING BETTER FLASH ILLUMINATION

The flash head on built-in and on some portable flash units is small, producing a directional light with sharply outlined shadow lines. You can make the results look more professional by softening the light. To produce a softer light, you must increase the size of the light source. For location work, you can add a small soft box, available in sizes up to about seven inches, to the portable flash unit. Adding such a box reduces the light somewhat, but this loss is more than compensated for by the beautiful results. The portraits no longer have the typical snapshot flash look. The Hasselblad D-40 flash has a larger flash reflector, reducing somewhat the need for a soft box.

Ghost Images

When flash is used with a moving subject in surroundings with sufficient ambient light, we can produce interesting images consisting of a sharp image of the moving subject surrounded by blurred streaks, conveying the feeling of motion. A dancer photographed at $\frac{1}{15}$ second, for example, can have just enough blur in the moving arms or legs to indicate the motion while at the same time showing sharp details in the dancer's body. A basketball player photographed at $\frac{1}{30}$ second can produce the same results. The shutter speed must be long enough to produce a blur, and the aperture must be set to produce the desired exposure of the existing light.

　　The Hasselblad H camera can be programmed so that the flash fires either the moment the shutter is fully open or just before it closes. This normal or rear sync option offers more creative possibilities for such images.

IMPROVING YOUR DEDICATED FLASH PICTURES

Although dedicated flash works beautifully and provides consistent exposures in the simplest possible way, there are a few facts you must know and understand to obtain the best possible results.

　　The sensor in all Hasselblad dedicated flash cameras measures the light reflected off a 40mm center area of the film. The subjects that need to be properly exposed by the flash—the people—must be in that center area, as is usually the case. This is seldom a problem because the measuring area is rather large.

　　The sensor in the camera, like the sensor in a reflected exposure meter, measures the light reflected from the subject and is adjusted for 18% reflectance. A dedicated (or automatic) flash system produces perfect exposures only when the subject reflects 18% of the light (see Figure 17-10). These variations may cause concern, especially for the wedding photographer, who works with brides dressed in white and grooms dressed in black. Wedding photographers who have been using Hasselblad's dedicated system will admit

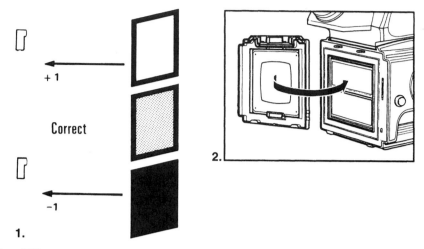

Figure 17-10 *Flash tests* **1.** The flash sensor in the camera is adjusted for 18% reflectance. Bright subjects turn the flash off earlier, creating underexposure; dark subject areas do the opposite. **2.** The new Hasselblad rear covers have a center area that reflects the same amount of light as the film does and can be used for checking whether flash illumination is sufficient.

that variations exist, but they are well within limits for negative films, probably because such pictures are usually a combination of many shades—flowers, flesh tones—rather than only white or black. If desired, you can adjust differences in the reflectance values by using a different ISO setting or programming a different value into the camera. Set the ISO to a lower value for brighter subjects, to a higher value for darker ones. A −2 setting turns the flash off earlier than −1 to compensate for the lower reflectance of darker subjects.

In an OTF dedicated flash system, flash exposures are determined by the amount of light reflected off the film emulsion. There are differences in films, but they are small among transparency films to which the Hasselblad system is optimized. Most negative films reflect somewhat more light, possibly creating a slight underexposure. Because film manufacturers constantly change films, I suggest that you make a test with your film and have it processed and evaluated in your laboratory. You can make compensations in the ISO setting, using a lower ISO, perhaps 80 for ISO 100 film. Set the flash value to +$\frac{1}{2}$ or +$\frac{1}{3}$ to accomplish the same thing with the 200 cameras. The reflectance values are quite different with special films such as instant films, and such films may not be very reliable for dedicated flash exposure tests.

Test Exposures

You may want to check whether there is sufficient light for a dedicated flash exposure before you take pictures and without using instant films. You can

do so, but only with film in the camera because it is the film that reflects the light to the sensor. If you do not want to waste a frame for this purpose, you can attach the rear cover that is now supplied with Hasselblad V system cameras (and with the D-Flash 40 unit) to the V system camera in place of the film magazine (see Figure 17-10). These rear covers have a center area with a reflectance value similar to or the same as the film. This rear cover multicontrol is available as an accessory.

Checking Flash Sync

After removing the film magazine from any Hasselblad camera and connecting the flash to the camera, you can look straight through the lens and the shutter to check the flash synchronization (see Figure 17-11). Set the diaphragm and the shutter speed at the values to be checked. Point the camera, with the flash ready signal lit, toward a light wall. Place your eye behind the rear of the camera, and trip the shutter. If you see the flash firing through the fully open shutter, the flash is synchronized. For a complete check, test all shutter speeds (up to $\frac{1}{90}$ second for focal plane shutters). This test also shows whether the diaphragm closes down as it should.

Flash Firing Failures

Probably the most annoying happening in photography occurs when flash pictures are made and the flash does not fire. If this happens, check the on/off

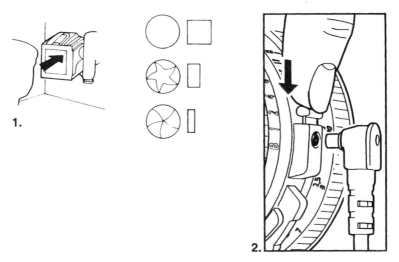

Figure 17-11　*Checking flash sync*　**1.** To check flash synchronization, look through the back of the camera while releasing the camera with the flash attached. You should see the flash firing. For a complete check, test at all shutter speeds.　**2.** The PC contacts on the latest V system lenses include a locking device.

switch. Check whether the ready light is on. Ensure that focal plane shutter cameras are set at $\frac{1}{90}$ second or longer. Check that sync cables are in good order and properly connected. Try another cable. If a contact feels loose, gently squeeze the contact with pliers into an oval shape, thereby making a firmer connection, at least on two sides. If the sync terminal on the lens appears to be loose, have the terminal replaced at a Hasselblad service center. The PC contact on the newer lenses has an improved friction lock to prevent the cable from becoming separated. The PC contacts on the latest lenses include a cable locking device that makes such separation almost impossible (see Figure 17-11).

Photographers often attach and remove flash cables from the sync contact by turning the cable back and forth. This is not a recommended procedure, especially on older lenses, because it may loosen the electrical connection. Attach and remove the cable by pushing or pulling it straight up or down. With C lenses, make certain that the flash lever is set to X.

Dedicated Flash with the 205TCC

The original 205TCC (not the FCC model) automatically changes to a "flash mode" when the ready light in dedicated flash appears. Instead of showing the shutter speed calculated by the meter, the display shows the shutter speed physically set on the shutter speed ring, and the exposure is made at the set speed. The automatic metering system no longer works, with the shutter speed changing to the speed set on the shutter speed ring. Use the camera in the Manual (M) mode with the shutter speed preset. This does not happen on the 205FCC or the other focal plane shutter models.

HASSELBLAD FLASH UNITS

The Hasselblad D-Flash 40

The Hasselblad D-Flash 40 flash unit (see Figure 17-12) is compact and light-weight (22 ounces, or 610 grams). This makes it easy to carry yet produces a sufficient amount of light even for most professional applications when you are working with ISO 400 film. It has a guide number of 137 (40 in meters) in the N reflector position, and 110 (33 in meters) in the W position. All electronic components necessary for the dedication to the Hasselblad V system cameras are built into the unit, eliminating the need for accessories. The necessary six-pin flash cable is fixed to the unit, and a separate flash sync cord for use with shutter lenses is supplied. It is not designed for use on the H cameras.

On Hasselblad V system cameras, the D-Flash 40 is most conveniently mounted on the flash shoe on top of a prism viewfinder. This placement brings the flash head high enough above the camera lens for a pleasing light without creating red eye. The power for the flash can come from five AA batteries, five rechargeable AA NiCads, or an external accessory power pack. The

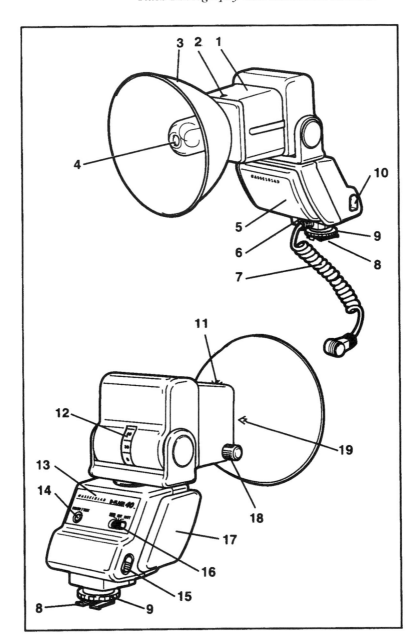

Figure 17-12 The D-Flash 40 operating controls.

1. Tilt and swivel head
2. Index mark
3. Adjustable reflector
4. Flash tube
5. Flash body
6. Sync cord jack
7. Sync cord
8. Flash mounting plate
9. Locking nut
10. External power connection
11. W indication
12. Tilt scale
13. Model designation
14. Ready light and discharge button
15. Battery cassette latch key
16. On/off switch and power selector
17. Battery cassette
18. Reflector locking knob
19. N position

choice may be determined from the number of exposures per charge, which is 120 to 1200 from regular AA batteries, 45 to 450 from rechargeable AA types, or 270 to 2250 from the external power pack. The number of flashes always depends on the distance between flash and subject.

Flash Reflector and Area Coverage

The flash reflector can be moved either to N with a 45-degree illumination angle for lenses 80 mm and longer or to W for use with shorter focal length lenses. The reflector can be left in the W position for longer lenses; the light is simply reduced somewhat. The reflector can also be removed completely for bare bulb use.

The Hasselblad Proflash 4505

The Hasselblad Proflash, the forerunner to the D-40 and now discontinued, also has all the necessary electronic components for dedicated use with Hasselblad V system cameras. The Proflash can also be used on Hasselblad or other cameras in the manual or automatic fashion.

Ringlights

Shadowless lighting is obtained when light of equal intensity reaches the subject from all directions. All shadows then cancel each other out. Such

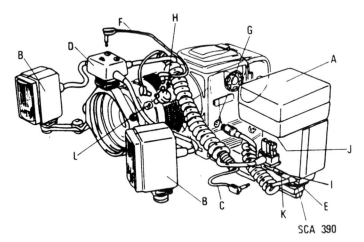

Figure 17-13 *Macro unit connected for dedicated operation* The power pack (A) with SCA390 adapter (E) at the bottom is connected to a six-pin socket (G) on the camera. The spiral cable (C) attached to the distributor (D) is connected to a socket (J) in the power pack. A straight sync cable (F) goes from the distributor (D) to a multiple coupling (L) attached to the PC contact on the lens. The sync cable (C) interwoven in the spiral cable goes from the multiple connector (L) to the power pack, with the PC end of the cable in the multiple connector. This coupling also works in manual setting, but a simpler connection serves the same purpose.

lighting can be produced by a ringlight. The Hasselblad ringlight is no longer available. Other companies still make ringlights, but they are seldom used and therefore are not discussed in further detail.

The Hasselblad Macro Flash

The macro flash unit (discontinued) consists of two small flash units with a guide number 28/92 (meter/feet). The units are connected to a distributor so that the two can fire simultaneously to produce flat front light (almost shadowless in close-up work) or one at a time for directional light from one side, top, or bottom (see Figure 17-13). A special bracket, which mounts in front of the lens with the lens mounting rings from the Proshade, allows mounting the flash heads in either of two ways: on the two arms or one on either arm and the other on top.

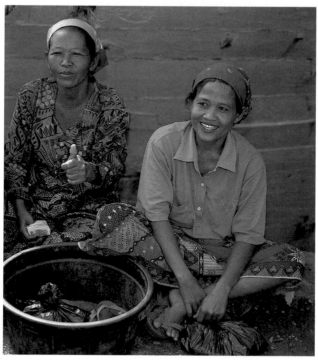

▲ Picture of a boy reading a magazine in Malaysia was made with 110 mm lens without flash. Dedicated flash, reduced to −3, was used in the candid picture of two ladies in Indonesia with 120 mm. Lens. Both pictures by Ernst Wildi.

▲ Comparison picture shows the difference between a
dedicated flash exposure without a reduction in the
flash exposure and with a reduction of −2 that
produces a more natural looking portrait. Flash was
also reduced to −2 in the other picture. The lens
settings were based on the built in meter reading of
the green foliage

▲ When photographing the model on the steps, flash was reduced to −3 producing a natural lighting ratio for a portrait. In the other picture, flash was reduced only to −1 which produced a good publicity-type picture— designed to make people easily recognizable. Both taken with Softar #1. Ernst Wildi

▲ The shutter speed of 1/60 second at f/4 was too short
to record the well-lit interior. A longer shutter speed of
1/15 second at the same aperture made the beautiful
room interior part of the picture. The third picture was
taken in the same location also at 1/15 second. Flash
exposure with the Hasselblad dedicated flash system
was automatic in all three cases. Ernst Wildi

18

Close-Up Photography

FOCUSING RANGE OF HASSELBLAD LENSES

Hasselblad lenses, like all lenses, can be focused down to a certain minimum distance, which depends mainly on the lens design and the focal length of the lens. All lenses can be used at closer distances in combination with close-up accessories. Used at closer distances with accessories, the lenses behave as they do at longer distances. The lens-to-subject distance determines the perspective. Different focal length lenses cover different background areas and blur the background more or less. You can cover the same area from different distances with different focal length lenses.

The distance between the lens and the subject in close-up photography is often called the working distance. Some applications—such as photographing surgery, dangerous activities such as welding, or timid insects—call for long working distances, so you want to use longer focal length lenses. When you are working on a copy stand or at high magnifications, a shorter focal length is preferable because it reduces the possibility of camera motion affecting the picture sharpness. You can also select a specific focal length lens, such as 120 mm, because the lens, the Makro-Planar, is designed optically to produce the best image quality in close-up work.

MAGNIFICATION

Magnification is the ratio in size between the actual subject and the size of its image recorded in the camera (see Figure 18-1). The most practical way to determine magnification is to relate the area coverage to the size of the image format, which is also the size of the focusing screen and which is 55 mm for both sides of the 2¼-inch square and for the long side of the 6 × 4.5cm rectangular format. If you cover an area 220 mm wide, the magnification is 55 divided by 220 = 0.25, or 1 : 4, or ¼. A ½ × magnification, also written 1 : 2, means that the image is half the size of the subject; 2×, or 2 : 1, means the image is twice the size.

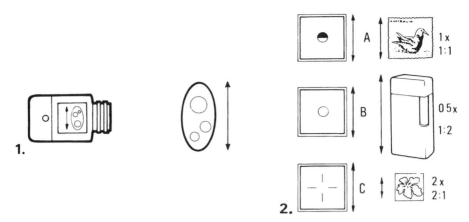

Figure 18-1 *Magnification* **1.** Magnification is the relationship between the size of an actual subject and the size of its image, as recorded in the camera or seen on the focusing screen of the camera. **2.** If the subject area is about the same size as the screen, we have 1 : 1 magnification (A); when the subject area is twice as large we have 0.5, or 1 : 2, magnification (B). When we fill the screen with a small subject half as large as the negative, we have 2×, or 2 : 1, magnification (C).

USING CLOSE-UP LENSES

Close-up lenses, sometimes called diopter lenses, are positive lens elements that are mounted in front of the camera lens like a filter. They allow photographing at close distances. They can be used on any type or focal length of lens, but adding such a lens element affects the image quality of the lens. Stopping down the lens aperture reduces the loss of sharpness to an acceptable level for many applications.

Close-up lenses can be considered for close-up work with the XPan camera, for which no other close-up accessories are available. Close-up lenses are not recommended for critical photography with Hasselblad V or H system cameras, and the Proxar close-up lenses that used to be available are no longer made. The focal lengths of the Proxar lenses, which are 2 meters (79 inches), 1 meter (39½ inches) and 0.5 meters (19¾ inches), are also the maximum distances at which these Proxar lenses can be used with any focal length lens set at infinity. You can photograph at somewhat closer distances by turning the focusing ring on the lens away from the infinity setting. The distances are measured from the subject to the Proxar lens, not the image plane. Proxar lenses do not require an increase in exposure.

EXTENSION TUBES AND BELLOWS

Consider extension tubes or a bellows for quality close-up photography with all Hasselblad SLR camera models (see Figure 18-2). The bellows is another good option in the V system.

$$E = M \times F$$

$$E = \cdot 5 \times 80 = 40$$

$$E = \cdot 5 \times 150 = 75$$

3.

4.

Figure 18-2 *Extension tubes and bellows* **3.** Extension tubes and bellows serve the same purpose: to move the lens farther away from the image plane. A bellows extended to the same length as a tube produces the same magnification and image with the same lens. **4.** Based on the formula $E = M \times F$, the necessary length of an extension tube or bellows for a 0.5 magnification is 40 mm for an 80mm lens, and 75 mm if the focal length of the lens is 150 mm.

Extension tubes and bellows serve the same purpose in close-up photography. Both accessories are mounted between the camera and the lens, for the purpose of moving the lens farther away from the image plane. They increase the image distance without any optical components.

A few basic facts are worth knowing:

- The longer the tube or bellows with a particular focal length lens, the closer the distance at which you can photograph, and consequently the smaller the area coverage and the higher the magnification.
- Shorter focal length lenses used with the same extension tube or extension on the bellows give a higher magnification and a smaller area coverage than longer lenses.
- You can cover the same area with a shorter focal length lens and a shorter tube or bellows extension, or with a lens of longer focal length combined with a longer tube or extension on the bellows. The two differ in the working distance.

You can determine the necessary length of extension with specific lenses from the following formula:

Length of extension = focal length of lens × magnification

For example, the extension necessary to obtain 0.5× magnification with an 80mm lens is $80 \times 0.5 = 40$ mm; and with a 120 mm lens, $120 \times 0.5 = 60$ mm. Knowing this relationship is valuable, because it eliminates time-consuming experimenting, moving of cameras, and adding and changing of lenses and accessories.

The above formula applies to most lenses where the focusing is achieved by moving the entire lens but does not apply with lens designs that have a

long distance between front and rear nodal points and feature optical focusing. That is the case with most HC lenses and lenses such as the CFE 350mm, the new CFE 40mm, the FE 60–120mm, or the FE 300 mm. Consult the close-up charts at the end of this chapter.

DEPTH OF FIELD

As mentioned in more detail in Chapter 13, when covering an area of a specific size, as is always the case in close-up photography, you determine depth of field only by the lens aperture and the magnification; depth of field is the same regardless of the focal length lens you use. You can increase depth of field only by closing the lens aperture or covering a larger area. Depth of field becomes about twice as large when you close the aperture two stops. Although the depth of field is the same with all focal length lenses, the blur beyond the depth of field falls off more rapidly with a longer lens. At close distances, the depth-of-field range is more evenly divided, with about one-half in front and one-half behind.

Because depth of field is determined only by the magnification and the lens aperture, we can make a simple depth-of-field chart that applies to all cameras and lenses. The chart shown in Table 18-1 is based on an $f/11$ lens aperture. Note the limited sharpness range in close-up photography.

Column A is for general close up work based on a circle of confusion of 0.06mm ($\frac{1}{400}$ inch) which is used for the calculations of the depth of field scales in the V system. Column B is for critical work based on a circle of confusion of 0.03mm ($\frac{1}{800}$ inch). Depth of field scales and charts in the H system are based on a circle of confusion of 0.045mm ($\frac{1}{600}$ inch).

Table 18-1 Depth of Field at Various Magnifications

	Total depth of field in mm at $f/11$	
Magnification	*A*	*B*
0.1×	100	50
0.2×	30	15
0.3×	15	7
0.5×	6	3
0.8×	3	1.5
1×	2	1
1.2×	1.5	0.7
1.5×	1	0.5
2×	0.8	0.4
3×	0.4	0.2

EXPOSURE

You obtain correct exposure in close-up photography in the same fashion as at longer distances, making certain that the meter reading is based on the small area being photographed. Holding a graycard over the subject and taking the reading of the graycard are often a good approach with reflected exposure meters. A metering system built into the camera or prism finder offers a definite advantage because you can see exactly the area that is measured by the meter.

A metering system built into a camera or prism viewfinder also eliminates the need for considering the necessary increase in exposure when you use extension tubes or bellows. Whatever the built-in meter says should be correct because the light is measured through the close-up accessory.

When the meter reading is made with a separate meter, the necessary exposure factor must be considered. Because extension tubes and bellows move the lens farther from the image plane, the light is spread over a larger area, and less light reaches the image area. The necessary increase in exposure is based on the ratio between the focal length of the lens and the length of the added extension, at least for the type of lenses normally used for close-up work. The required increases in exposure for the V system lenses and accessories are found in the close-up charts in this book. Such charts should not be necessary for determining exposure in the H camera system since the built-in meter is undoubtedly used for this purpose. Such charts are also included-in this book mainly to show the close-up capabilities with the HE extension tubes and the various HC lenses. If you want to know the increase or want to determine it for other cameras when you use a handheld meter, use the following formula:

$$\text{Aperture value to be set on lens} = \frac{\text{Aperture on meter} \times \text{focal length of lens}}{\text{Focal length of lens} + \text{length of extension}}$$

Here is an example for $f/16$ on the meter, a 120mm focal length, and a 56mm extension tube:

$$\frac{16 \times 120}{120 + 56} = \frac{1920}{176} = 10.9 = f/11$$

The above formula, like the one for life size magnification, applies to many lenses with mechanical focusing but is not strictly correct for lenses with optical focusing as found in most HC types. It also depends on whether the lens has front or rear focusing. The formulas also may not apply with lenses where front and rear nodal points are separated extensively as often is the case in retro focus and telephoto types or with lenses where the exit pupil is not located about one focal length in front of the image plane. Consult the charts at the end of the chapter for exact correction figures. Since exposures with H system cameras are undoubtedly always determined with the built-in

metering system, all of the above lens design information is included just for theoretical completeness. The information need not be considered and remembered while doing close-up photography. The same applies to 200 system cameras and all the other models equipped with a meter prism viewfinder.

LIFE-SIZE MAGNIFICATION

Life-size, or 1:1, magnification is achieved when the length of the extension tube or the bellows extension is equal to the image length of the lens. In life-size magnification, the subject distance is equal to the image distance, with the total distance between subject and image plane being 4× the focal length of the lens. The necessary exposure increase is 2*f* stops, and the total depth of field at *f*/11 is 2 mm (see Figure 18-3).

TELECONVERTERS FOR CLOSE-UP WORK

Because teleconverters increase the focal length of a lens while maintaining its minimum focusing distance, they can be used to cover smaller areas without the need to move closer to the subject. The Makro-Planar 120mm lens, which covers an area about 8 inches (200 mm) wide at the minimum focusing distance, can cover an area as small as 4 inches (100 mm) wide when combined with a 2× teleconverter. Combined with a 1.4 teleconverter, it can cover an area 6 inches (150 mm) wide without the use of any close-up accessory.

Combining Extension Tubes with Teleconverter/Lens Combinations

Extension tubes can also be used for close-up photography with a lens/teleconverter combination. The tube or tubes can then be mounted as usual

Figure 18-3 *Life-size magnification* Life-size (1:1) magnification is obtained when the length of the extension tube or bellows (L) is equal to the focal length (F) of the lens (L = F). The distance from the subject to the image plane (D) is equal to 4× the focal length (D = 4 × F). The exposure increase (E) is always 2 *f* stops, and the depth of field at *f*/11 is about 2 mm.

between the camera and the lens/teleconverter combination. The tube or tubes are attached to the camera, and the lens/teleconverter combination is attached to the front of the tube or tubes.

On the H camera and the HC lenses, image quality is slightly improved when the tube or tubes are mounted between teleconverter and lens. The teleconverter is now attached to the camera, the tube or tubes are attached to the converter, and the lens goes in front of the tubes. This arrangement also provides a somewhat higher magnification but may produce a somewhat higher light falloff at very high magnifications. The same mounting arrangement can be suggested when the 2× extender is used in combination with the CFE 120mm Makro-Planar.

THE HASSELBLAD CAMERAS IN CLOSE-UP WORK

The single-lens reflex concept of all Hasselblad cameras (except the Super-wide and XPan models) is ideal for close-up photography. The focusing screen on H cameras and all the newer V models with the gliding mirror concept show the full image covered with any lens and any close-up accessories.

Earlier V system cameras have a cut-off at the top when bellows or extension tubes are used. The cut-off is minor with shorter tubes but may extend to about $\frac{1}{4}$ inch with longer tubes or extensions on the bellows. This vignetting is caused by the mirror and appears only on the focusing screen, not in the image. Allow for it when you make the composition.

Motor-driven film advance has an advantage in close-up photography because it eliminates the possibility of moving a tripod-mounted camera while the film is advanced manually. With motor-driven film advance, you can take sequences of identical images without time-consuming recomposing and refocusing. Locking up the mirror in critical close-up work is recommended with any camera.

Although most close-up work is best done from a tripod or camera stand, handheld photography is possible and can certainly be considered, especially with the automatic focusing in the H camera. In handheld photography with a manual focusing camera, you'll find that focusing is frequently easier if you preset the focusing ring on the lens and then move the camera back and forth until the subject is sharp on the focusing screen. You can hold the camera with both hands in the most convenient fashion rather than hold the camera with one hand while using the other to operate the lens. This approach works well even with a bellows.

CLOSE-UP PHOTOGRAPHY WITH THE H CAMERA

The built-in light-metering system, the possibility of automatic focusing, the focus aids, the extremely smooth lens shutter operation, the mirror lock-up

capability, the availability of a Makro lens, and the many sophisticated features that can be programmed into the H camera make it a great tool for close-up photography. The HC4 120mm Macro lens must be the first choice for close-up photography. The focusing range of the lens goes from infinity down to a distance where it produces life-size 1 : 1 magnification covering an area as small as 55 × 41 mm. Exposure and focusing can be automatic down to this minimum distance.

The H camera system also includes three extension tubes—13 mm, 26 mm, and 52 mm in length—which maintain the electronic coupling to the HC lenses. The tubes can be combined if a longer extension is desired. Although the tubes can be used with all HC lenses, you want to consider the lenses 80 mm and longer for close-up work. They provide the best image quality.

The 50–110mm zoom lens can also be used with the tubes, but the image does not stay in focus when the focal length is changed. Set the lens first at the focal length that covers the desired area; then focus the image manually or preferably automatically if the distance is within the automatic focusing range. See charts at end of chapter.

If the automatic focusing system does not work with a specific combination of lens and extension tubes, you will get a message on the LCD screen, AF NOT POSSIBLE WITH THIS LENS. Manual focus may still work.

Complete close up charts for the HE tubes and HC lenses are at the end of this chapter.

THE V SYSTEM CLOSE-UP ACCESSORIES

In addition to the bellows, four extension tubes are available for Hasselblad V system SLR cameras. The numeral in the designations 8, 16E, 32E, and 56E refers to the length of the tube in millimeters; the E indicates that the tubes have the electronic connections for the metering system in 200 camera models and therefore transfer the data from a CFE, FE, or TCC lens to the camera. You can use the older tubes without the E on 200 cameras, but you must manually close down the lens aperture for the meter reading, whether you use the focal plane or the lens shutter for the exposure. The E tubes can be used on all V system SLR cameras. The 8 tube does not have the E because it cannot be mounted on the 200 cameras. The shutter speed ring prevents it. The four extension tubes mentioned here replace the 10mm, 21mm, and 55mm tubes available in earlier years. Also available until a few years ago was a tube with variable length from 64 to 85mm.

All extension tubes can be used alone or can be combined. However, it is not recommended that you combine more than three tubes because the coupling between camera and lens may not perform with utmost reliability. For longer extensions, it is better to consider the bellows, combined, if necessary, with one or two tubes.

Choosing a V System Lens

All extension tubes can be used with lenses 80 mm and longer, including the 350mm and 500mm focal lengths. The shorter extension tubes can be used with wide-angle lenses, but usually it is not a practical combination because the lens is too close to the subject, and the retrofocus wide-angle lenses do not produce the very best image quality. The Variogon 140–280mm and the Hasselblad 60–120mm zoom lenses can be used and do produce satisfactory image quality with the 16mm extension tube. The image, however, does not stay in focus when you are zooming.

The Makro-Planar 120mm (and the discontinued Makro-Planar 135mm) lens must be the first choice for close-up photography. These two lenses are optically designed to provide the best image quality at close distances and the very best at a 1:5 magnification, but they are also excellent lenses for use at longer distances. The 120mm Makro-Planar is in a standard mount with shutter and can be mounted on all V system SLR cameras directly or in combination with extension tubes or the bellows. The discontinued 135mm Makro-Planar has a special lens mount for use only with the bellows (or the discontinued variable extension tube). The Biogon 38mm is another lens that produces superb image quality at close distances, covering an area about 11 inches square at the 12-inch (0.3m) minimum focusing distance.

Attaching and Removing V System Extension Tubes and Bellows

The Hasselblad V system extension tubes and the bellows are equipped with coupling shafts that connect the camera and lens mechanism to maintain the automatic aperture close down and shutter cocking. Extension tubes and bellows mount on the camera exactly like lenses.

You remove extension tubes by pressing the locking button or lever on the tubes while the camera is in the cocked position. To remove tubes, it is of utmost importance to follow this procedure:

1. Remove the lens first from the tube, tubes, or bellows.
2. Remove the tube or bellows from the camera body.

If more than one tube is used, remove the tube farthest from the camera (the one that is closest to the lens). Then work toward the camera, removing each tube separately, removing the tube attached to the camera body last. Never remove a lens from a tube or bellows that is not attached to the camera. There is no tension to prevent the shaft from rotating, and it may uncock before the tubes and lenses are separated, jamming them together.

The same procedure should be followed with lenses attached to the bellows. Figure 18-4 shows the process of attaching and removing extension tubes. Extension tubes can be attached to the front of the bellows. The bellows cannot be attached to EL cameras equipped with the large square release. Replace it with a regular release button.

Figure 18-4 *Attaching and removing tubes* When you attach extension tubes (left), start at the camera by attaching the first tube to the camera. Then attach the second tube to the first, and finally attach the lens to the second tube. To remove extension tubes (right), reverse this sequence: First, remove the lens from the outermost tube, then the next outermost tube, and finally the tube attached directly to the camera.

Operating the Hasselblad Bellows

The V system Hasselblad bellows with a minimum extension of 63.5 mm (22 inches) and a maximum of 202 mm (8 inches) has a coupling shaft to maintain the mechanical camera and lens connection. It does not have the electronic coupling. The meter reading in 200 cameras therefore must always be made with the lens aperture closed down.

When you are working with a tripod, it is recommended that you use the tripod socket on the mounting plate of the bellows rather than the tripod socket on the camera. Mounting the bellows, rather than the camera, to the tripod head allows full use of the two adjusting controls, and that is a main benefit of using the bellows in close-up work.

The adjusting controls simplify and speed up close-up photography. With the bellows mounted on a tripod or stand, you change and adjust the lens-to-image plane distance by turning the lower knurled adjusting knob. The entire camera/lens/bellows combination moves back and forth without changing the distance between the lens and the image plane. It is basically the focusing control. You change and adjust the lens-to-image-plane distance (and thus the magnification) by turning the upper knob (see Figure 18-5). You may also want to use this knob for fine focusing because the image sharpness on the focusing screen changes more rapidly, thus making focusing more accurate. In actual photography, you will probably use both knobs more or less simultaneously, turning the lower knob until you cover the desired area and then using the upper knob to bring the subject into focus.

The 135mm Makro-Planar, now discontinued, was designed for use on the bellows with only a special rear mount to bring the rear element closer to the image plane. This design allowed using this lens/bellows combination not only for close-up photography but also for photography at all distances from infinity down to a close distance for life-size, 1 : 1 magnification. The lens is focused for infinity at the shortest bellows extension of 63.5 mm. At the longest extension of 202 mm, the 135 mm Makro-Planar covers a $2\frac{1}{4}$-inch area for life-size magnification.

An older, nonautomatic Hasselblad bellows interferes with the motor compartment of EL models. It can be used after you rotate the rear section 90 degrees so that the rail falls on the side. This older, nonautomatic bellows

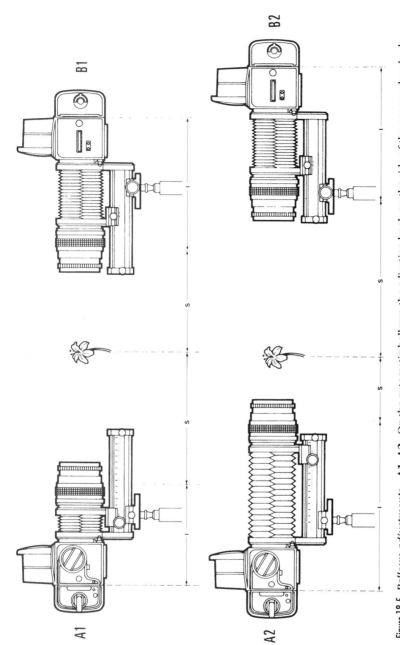

Figure 18-5 *Bellows adjustments* **A1, A2.** On the automatic bellows, the adjusting knob on the side of the engraved scale changes the extension of the bellows. It moves the lens, leaving the image plane stationary and thus changing lens-to-image plane distance, I, which determines the magnification. **B1, B2.** Turning the knob on the other side moves the entire camera setup (camera, bellows, lens) closer to or farther from the subject. It changes the subject distance, S, while maintaining the lens-to-film distance, I, and thus the magnification. This bellows operation is obtained only if the tripod or camera stand is attached to the bellows, not to the camera.

did not have the mechanical camera-to-lens coupling. Camera and lens functions had to be operated separately with the use of a double cable release. You must adjust the double cable release so that the various camera and lens functions follow this sequence:

1. Lens shutter closes, and diaphragm stops down to preset aperture.
2. Mirror moves up, and rear curtain opens.
3. Shutter opens and closes at the set shutter speed.

HOW TO USE THE V SYSTEM CLOSE-UP CHARTS

In the accompanying charts (Figures 18-6 and 18-7), the close-up accessories are indicated as follows: P for Proxar lenses 2.0, 1.0, and 0.5; B 64-202 for bellows. The extension tubes are indicated by their length (8, 16, 32, and 56), including combinations of tubes, such as 56 + 8. The left end of each line indicates the values with the lens set at infinity; the right end is set at its minimum focusing distance.

To read the chart, follow horizontally in the space marked "Area coverage, size of subject" until you reach the number in inches or millimeters of the area (the size of the subject) that you need to photograph. Then go straight down vertically to see which close-up accessories cross the line, and then go farther down to find the depth of field at $f/11$, the necessary increase in exposure, and the magnification. The line may cross various close-up accessories, indicating all the available choices. For example, you can cover a 100mm (4-inch) area with a 120mm Makro-Planar with either an extension tube 56 or the bellows. Depth of field at $f/11$ is about 7 mm, and exposure must be increased one f stop. Note that the indicated exposure increase applies only to extension tubes and bellows, not to the Proxar lenses.

HOW TO USE THE H SYSTEM CLOSE-UP CHARTS

All the necessary information for using the H system extension tubes successfully with different lenses on the H camera are shown in Charts A and B in the metric system with the dimensions in millimeters and in Charts C and D where the dimensions are in inches. Charts A and C apply when using just one of the three extension tubes with the different lenses, Charts B and D when combining two or three tubes. In all charts the information for the 50–100mm zoom lens is shown with the lens set at the 50mm and the 110mm focal length.

Planar CF 80mm *f*/2.8, Planar F 80mm *f*/2.8

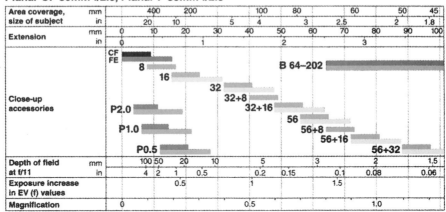

Planar F 110mm *f*/2

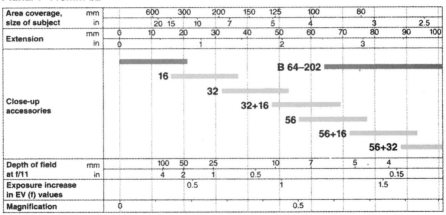

Makro-Planar CF 120mm *f*/4

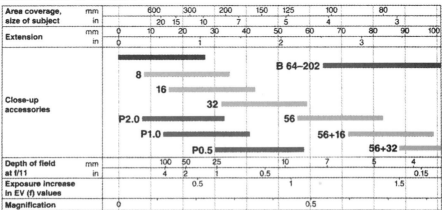

Figure 18-6 Close-up charts for 80mm to 250mm Hasselblad lenses.

Sonnar CF 150mm *f*4, Sonnar F 150mm *f*2.8

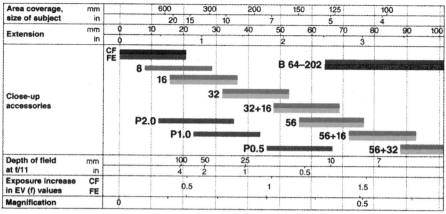

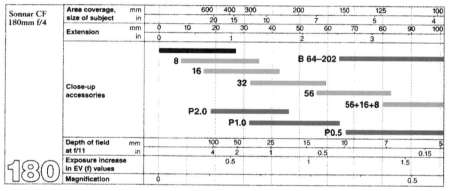

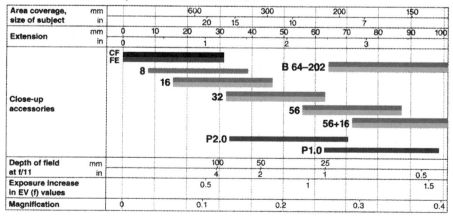

Sonnar CF 250mm *f*5.6, Tele-Tessar F 250mm *f*4

Figure 18-6 Close-up chart for Sonar CF 180mm.

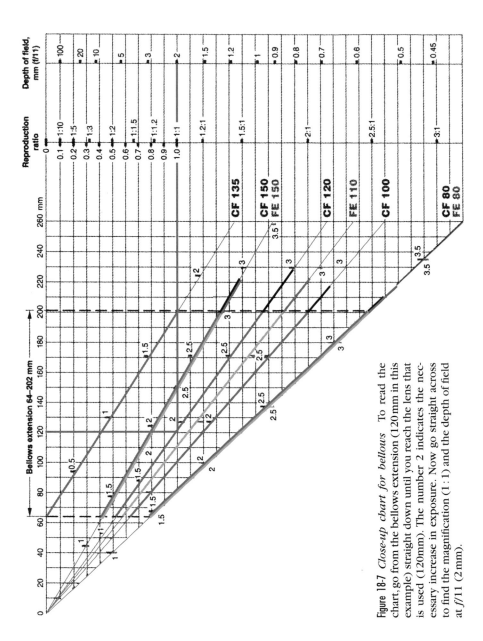

Figure 18-7 *Close-up chart for bellows* To read the chart, go from the bellows extension (120 mm in this example) straight down until you reach the lens that is used (120 mm). The number 2 indicates the necessary increase in exposure. Now go straight across to find the magnification (1 : 1) and the depth of field at *f*/11 (2 mm).

300

Both Charts show the following details:

W means the size area included along the long side (the 55mm side) of the image with the lens set to infinity and the minimum focusing distance. If you like to know the area size along the short (the 42mm) side, multiply the listed figure by 0.76. For example if W is $7\frac{1}{4}$ inches, the area coverage is $7\frac{1}{4} \times 5\frac{1}{2}$ inches.

O is the distance from the subject to the front of the lens, which is the working distance.

M is the magnification range with each lens/tube combination.

R the required increase in exposure in EV values which, of course, needs to be considered only if the meter reading is made with a separate meter rather than the metering system in the camera. Using the built-in metering system in the spot, center-weighted, or averaging metering mode is obviously the recommended choice especially in close-up photography.

In all charts, the first figure in a column applies when the lens is focused at infinity, the second figure with the lens focused at its minimum focusing distance. For example a figure for W of $13\frac{3}{4}$–$7\frac{1}{8}$ means that the lens covers an area $13\frac{3}{4}$ inches wide at infinity and $7\frac{1}{8}$ inches at its minimum focusing distance. A figure for M of 0.5–0.8 means that the magnification at infinity is 0.5 × and 0.8 × when the lens is set at the minimum focusing distance. The figures thus show the close-up photography range with that particular lens and tube or tube combination.

Figures that are in red indicate that the camera, lens, and extension tubes can be used for photographing at that distance but that the automatic focusing system in the H camera cannot be used; you must focus the lens manually.

Chart A

Lens		Ext, tube 13	Ext. tube 26	Ext. tube 52
35mm				
	W	151–119	77–67	39–36
	O	78–55	29–23	5–3
	M	0.4–0.5	0.7–0.8	1.4–1.6
	R	1/3–1/3	2/3–2/3	1.0–1.0
80mm				
	W	350–181	175–119	89–72
	O	552–298	294–210	165–140
	M	0.2–0.3	0.3–0.5	0.6–0.8
	R	1/3–2/3	2/3–1.0	$1\frac{1}{3}$–$1\frac{2}{3}$
80mm + 1.7×				
	W	207–108	106–71	53–42
	O	551–298	294–210	165–140
	M	0.3–0.5	0.5–0.8	1.1–1.3
	R	1/3–2/3	2/3–1.0	$1\frac{1}{3}$–$1\frac{2}{3}$
150mm				
	W	622–243	329–175	160–114
	O	1786–731	925–557	495–392
	M	0.1–0.2	0.2–0.3	0.3–0.5
	R	1/3–1/3	2/3–2/3	1.0–1.0
150mm + 1.7×				
	W	373–143	193–104	97–67
	O	1785–731	925–557	495–392
	M	0.2–0.4	0.3–0.5	0.6–0.8
	R	1/3–1/3	2/3–2/3	1.0–1.0
50–110mm zoom				
At 50mm	W	224–147	110–85	56–46
	O	182–96	80–43	30–11
	M	0.2–0.4	0.5–0.7	1.0–1.2
	R	1/3–1/3	2/3–2/3	$1\frac{1}{3}$–$1\frac{1}{3}$
At 110mm	W	467–164	233–114	117–72
	O	935–277	486–198	261–129
	M	0.1–0.3	0.2–0.5	0.5–0.8
	R	1/3–1/3	1/3–1/3	1.0–1.0

Chart B

Lens		Ext. 13 + 26	Ext. 13 + 52	Ext. 26 + 52	Ext. 13 + 26 + 52
35mm					
	W	51–47			
	O	13–10			
	M	1.1–1.2			
	R	1–1			
80mm					
	W	117–89	71–60	59–51	51–45
	O	208–166	139–122	122–110	109–100
	M	0.5–0.6	0.8–0.9	0.9–1.1	1.1–1.2
	R	1–1⅓	1⅔–1⅔	1⅔–2.0	2.0–2⅓
80mm + 1.7×					
	W	70–53	42–36	35–30	30–27
	O	208–166	139–122	122–110	109–100
	M	0.8–1.0	1.3–1.6	1.6–1.8	1.8–2.1
	R	1.0–1⅓	1⅔–1⅔	1⅔–2.0	2.0–2⅓
150mm					
	W	215–137	130–97	108–84	92–75
	O	638–457	409–346	351–312	310–287
	M	0.3–0.4	0.4–0.6	0.5–0.7	0.6–0.7
	R	2/3–2/3	1⅓–1⅓	1⅓–1⅓	1⅔–1⅔
150mm + 1.7×					
	W	127–82	77–57	64–50	55–44
	O	638–457	408–346	351–312	310–286
	M	0.4–0.7	0.7–1.0	0.9–1.1	1.0–1.3
	R	2/3–2/3	1⅓–1⅓	1⅓–1⅓	1⅔–1⅔
50–110mm zoom					
At 50mm	W	74–60	44–38		
	O	47–22	20–4		
	M	0.8–0.9	1.3–1.5		
	R	1.0–1.0	1⅔–1⅔		
At 110mm	W	156–89	93–61	78–52	67–46
	O	336–156	216–111	186–98	164–68
	M	0.4–0.6	0.6–0.9	0.7–1.1	0.8–1.2
	R	2/3–2/3	1.0–1.0	1⅓–1⅓	1⅓–1⅓

Chart C

Lens		Ext. tube 13	Ext. tube 26	Ext. tube 52
35mm				
	W	6.0-4¾	3.0-2⅝	1½-1⅜
	O	3⅛-2¼	1⅛-7/8	1/4-1/8
	M	0.4-0.5	0.7-0.8	1.4-1.6
	R	1/3-1/3	2/3-2/3	1.0-1.0
80mm				
	W	13¾-7⅛	6⅞-4¾	3½-2¾
	O	21¾-11¾	11⅝-8¼	6½-5½
	M	0.2-0.3	0.3-0.5	0.6-0.8
	R	1/3-2/3	2/3-1.0	1⅓-1⅔
80mm + 1.7×				
	W	8¼-4¼	4¼-2¾	2⅛-1¾
	O	21¾-11¾	11⅝-8¼	6½-5½
	M	0.3-0.5	0.5-0.8	1.1-1.3
	R	1/3-2/3	2/3-1.0	1⅓-1⅔
150mm				
	W	24½-9⅝	13.0-6⅞	6¼-4½
	O	70¼-28¾	36⅜-21⅞	19½-15⅜
	M	0.1-0.2	0.2-0.3	0.3-0.5
	R	1/3-1/3	2/3-2/3	1.0-1.0
150mm + 1.7×				
	W	14¾-5¾	7⅝-4⅛	3¾-2¾
	O	70¼-28¾	36⅜-21⅞	19½-15¾
	M	0.2-0.4	0.3-0.5	0.6-0.8
	R	1/3-1/3	2/3-2/3	1.0-1.0
50-110mm zoom				
At 50mm	W	8¾-5¾	4¼-3¼	2¼-1¾
	O	7¼-3¾	3⅛-1¾	1¼-3/8
	M	0.2-0.4	0.5-0.7	1.0-1.2
	R	1/3-1/3	2/3-2/3	1⅓-1⅓
At 110mm	W	18½-6½	9¼-4½	4⅝-2¾
	O	36¾-10⅞	19⅛-7¾	10¼-5⅛
	M	0.1-0.3	0.2-0.5	0.5-0.8
	R	1/3-1/3	1/3-1/3	1.0-1.0

Chart D

Lens		*Ext. 13 + 26*	*Ext. 13 + 52*	*Ext. 26 + 52*	*Ext. 13 + 26 + 52*
35mm					
	W	$2.0\text{-}1\frac{3}{4}$			
	O	$1/2\text{-}3/8$			
	M	$1.1\text{-}1.2$			
	R	$1\text{-}1$			
80mm					
	W	$4\frac{5}{8}\text{-}3\frac{1}{2}$	$2\frac{3}{4}\text{-}2\frac{3}{8}$	$2\frac{1}{4}\text{-}2.0$	$2.0\text{-}1\frac{3}{4}$
	O	$8\frac{1}{4}\text{-}6\frac{1}{2}$	$5\frac{1}{2}\text{-}4\frac{3}{4}$	$4\frac{3}{4}\text{-}4\frac{1}{4}$	$4\frac{1}{4}\text{-}3\frac{7}{8}$
	M	$0.5\text{-}0.6$	$0.8\text{-}0.9$	$0.9\text{-}1.1$	$1.1\text{-}1.2$
	R	$1\text{-}1\frac{1}{3}$	$1\frac{2}{3}\text{-}1\frac{2}{3}$	$1\frac{2}{3}\text{-}2.0$	$2.0\text{-}2\frac{1}{3}$
80mm + 1.7×					
	W	$2\frac{3}{4}\text{-}2\frac{1}{8}$	$1\frac{3}{4}\text{-}1\frac{3}{8}$	$1\frac{3}{8}\text{-}1\frac{1}{4}$	$1\frac{1}{4}\text{-}1\frac{1}{8}$
	O	$8\frac{1}{4}\text{-}6\frac{1}{2}$	$5\frac{1}{2}\text{-}4\frac{3}{4}$	$4\frac{3}{4}\text{-}4\frac{1}{4}$	$4\frac{1}{4}\text{-}3\frac{7}{8}$
	M	$0.8\text{-}1.0$	$1.3\text{-}1.6$	$1.6\text{-}1.8$	$1.8\text{-}2.1$
	R	$1.0\text{-}1\frac{1}{3}$	$1\frac{2}{3}\text{-}1\frac{2}{3}$	$1\frac{2}{3}\text{-}2.0$	$2.0\text{-}2\frac{1}{3}$
150mm					
	W	$8\frac{1}{2}\text{-}5\frac{3}{8}$	$5\frac{1}{8}\text{-}3\frac{3}{4}$	$4\frac{1}{4}\text{-}3\frac{1}{4}$	$3\frac{5}{8}\text{-}3.0$
	O	$25\frac{1}{8}\text{-}18.0$	$16\frac{1}{8}\text{-}13\frac{5}{8}$	$13\frac{3}{4}\text{-}12\frac{1}{4}$	$12\frac{1}{8}\text{-}11\frac{1}{4}$
	M	$0.3\text{-}0.4$	$0.4\text{-}0.6$	$0.5\text{-}0.7$	$0.6\text{-}0.7$
	R	$2/3\text{-}2/3$	$1\frac{1}{3}\text{-}1\frac{1}{3}$	$1\frac{1}{3}\text{-}1\frac{1}{3}$	$1\frac{2}{3}\text{-}1\frac{2}{3}$
150mm + 1.7×					
	W	$5.0\text{-}3\frac{1}{4}$	$3.0\text{-}2\frac{1}{4}$	$2\frac{1}{2}\text{-}2.0$	$2\frac{1}{4}\text{-}1\frac{3}{4}$
	O	$25\frac{1}{8}\text{-}18.0$	$16\frac{1}{8}\text{-}13\frac{5}{8}$	$13\frac{3}{4}\text{-}12\frac{1}{4}$	$12\frac{1}{4}\text{-}11\frac{1}{4}$
	M	$0.4\text{-}0.7$	$0.7\text{-}1.0$	$0.9\text{-}1.1$	$1.0\text{-}1.3$
	R	$2/3\text{-}2/3$	$1\frac{1}{3}\text{-}1\frac{1}{3}$	$1\frac{1}{3}\text{-}1\frac{1}{3}$	$1\frac{2}{3}\text{-}1\frac{2}{3}$
50-110mm zoom					
At 50mm	W	$2\frac{7}{8}\text{-}2\frac{3}{8}$	$1\frac{3}{4}\text{-}1\frac{1}{2}$		
	O	$1\frac{7}{8}\text{-}7/8$	$3/4\text{-}1/4$		
	M	$0.8\text{-}0.9$	$1.3\text{-}1.5$		
	R	$1.0\text{-}1.0$	$1\frac{2}{3}\text{-}1\frac{2}{3}$		
At 110mm	W	$6\frac{1}{8}\text{-}3\frac{1}{2}$	$3\frac{3}{4}\text{-}2\frac{3}{8}$	$3\frac{1}{8}\text{-}2\frac{1}{8}$	$2\frac{7}{8}\text{-}1\frac{3}{4}$
	O	$13\frac{1}{4}\text{-}6\frac{1}{8}$	$8\frac{1}{2}\text{-}4\frac{3}{8}$	$7\frac{1}{4}\text{-}3\frac{7}{8}$	$6\frac{1}{2}\text{-}3\frac{1}{2}$
	M	$0.4\text{-}0.6$	$0.6\text{-}0.9$	$0.7\text{-}1.1$	$0.8\text{-}1.2$
	R	$2/3\text{-}2/3$	$1.0\text{-}1.0$	$1\frac{1}{3}\text{-}1\frac{1}{3}$	$1\frac{1}{3}\text{-}1\frac{1}{3}$

SPECIAL CLOSE-UP APPLICATIONS

Slide Duplicating

Slide duplicates can be produced in professional laboratories, and it is often done digitally, which provides unlimited possibilities for changes and manipulations.

A simple way to produce your own dupes is to photograph the original transparency placed on a glass table using a camera mounted on a tripod and photographing straight down (see Figure 18-8). I use a tripod with the camera mounted on the tripod's reversed center post for this purpose. Align the camera so that the image plane is parallel to the glass surface.

The transparency is placed on an opal glass placed on top of the glass table. The opal glass, which diffuses the light to produce even light over the entire transparency surface, need be only somewhat larger than the transparency. The transparency is mounted on a black mask with a cut-out the size of the transparency. The mask holds the transparency flat and prevents unwanted light from shining directly into the lens. An 80mm, 120mm, or 135mm lens, in combination with the bellows, is most suitable for the V

Figure 18-8 *A slide duplicating setup* A usable slide duplicating setup consists of a glass table (A) about 26 inches above the ground and an electronic flash unit (B) on the floor. An opal glass (C) on the table diffuses the light. The transparency (D) is on the opal glass. The camera is mounted on the tripod's reversed center post.

system. Extension tubes can also be used on V system and H system cameras. Their total length must more or less be equal to the focal length of the lens as discussed in Life-Size Magnification, earlier in this Chapter.

Electronic flash from a portable or studio unit shining directly on the opal glass is the recommended light source. A studio flash unit has the advantage of having a modeling light that can be used to align the transparency and to focus the lens. The power of the light source and its distance from the slide determine the exposure.

The dedicated flash system of the Hasselblad V and H system cameras should provide excellent exposures automatically, but test exposures are recommended.

Slide duplicating films are the best choices for duplicating slides. Unfortunately, they are not readily available, so you have to use the regular color slide films. Use the daylight type for use with flash.

Copying Documents

Photographs of documents must have edge-to-edge sharpness, good contrast, even exposure over the entire image area, and true colors if done in color. These results can be obtained beautifully and easily with Hasselblad cameras.

A quality copy requires that the plane of the document and the image plane be perfectly parallel to each other. If the object to be photographed has definite parallel lines, such as a picture, align the camera as carefully as possible so that the horizontal and vertical lines are perfectly parallel to the edges of the focusing screen. The focusing screens with engraved vertical and horizontal lines (checked screens) simplify this alignment.

Hasselblad used to make a linear mirror unit consisting of two optical plane mirrors, which allowed accurate alignment in a simple way. A large flat mirror went over the copy, and a circular mirror with bayonet mount was mounted on the V system camera. It has been discontinued because of limited demand.

For quality copying with the 500 V system cameras, consider using the Makro-Planar 120mm or 135mm lens or the Superwide cameras. The 110mm lens with the aperture somewhat closed down is a good choice on 200 V system cameras. The HC 4/120mm should be the first choice on the H system. Another good choice is the HC 2.8/80mm, if necessary, in combination with extension tubes.

The Copying Setup For copying large originals, you might find that a horizontal camera with the original mounted on a wall is best. For extensive copying of smaller documents, a special copying stand is recommended. Another sturdy setup for vertical copying results, if the center column of the tripod can be reversed so that the camera sits between the tripod legs, is suggested for slide duplicating.

Prereleasing the camera—locking up the mirror—is another good suggestion.

The automatic focusing of the H camera should be extremely precise with any type of copy subject. For manual focusing with V system cameras, place a substitute focusing target—something with small, very fine printing—over a copy subject that lacks fine detail.

Film, Filters, and Lighting For maximum sharpness, use a film with low sensitivity. When photographing colored originals on black and white film, you can use color filters to make certain colors lighter or darker, to increase or reduce the contrast, or to suppress or emphasize certain sections of the originals, as discussed in Chapter 16. A yellow filter, for example, can be of value when you photograph old, yellowed originals. The filter will lighten the yellow background and thereby increase the contrast.

Tungsten lights or electronic flash, especially studio units with modeling lights, are good choices.

Lighting must be even from corner to corner and must have no disturbing reflection. For small documents, one light may be sufficient, but two lights provide better possibilities for larger documents. Place the lights at equal distances on two sides, far enough away to cover the entire area and each at an angle of approximately 35 to 40 degrees. Check the evenness of the lighting by using an exposure meter, either an incident meter or a reflected type, in combination with a graycard. When you are working in color, the surrounding areas, walls, and ceilings may reflect light onto the original and change its color. It may be best to turn off all or most of the room lights and close curtains or shades to keep out daylight. Check carefully that nothing from the room, the chrome parts of the camera, the copy stand or tripod, or the photographer's white shirtsleeve is reflected on the copy, especially when you are photographing glossy surfaces.

Exposure can be determined with an incident meter placed over the copy with the cell pointing toward the lens. A reflected meter reading made with a handheld or built-in meter is best done and most accurate if you place a graycard over the copy and take the meter reading off the graycard. The exposure should be perfect regardless of what you are copying.

If polarized light is used as discussed in the next paragraph, the measurement is made with the polarizing filter over the lights. In addition, it is necessary to compensate for the polarizing filter on the lens if measurement is made with a separate meter.

Use of Polarized Light Copying results can be improved, often dramatically, with polarized light. It eliminates or reduces reflection and produces images that have higher contrast and better color saturation. Polarized light is recommended for all copying but especially for photographing colored copy, shiny surfaces such as glossy photographs or pictures under glass, and charts on

black backgrounds. Polarization can make the background really black and make pencil lines and other marks disappear.

Because the subjects to be copied are at a right angle to the camera axis, a polarizing filter over the camera lens alone does not improve the results. You must also polarize the light that reaches the copy by using filters over the light source or light sources. For tungsten lights, sheets of polarizing material about 16 inches square work, but keep them at least a foot from the hot lights. I mounted mine in wooden picture frames. Such sheets can also be used for studio flash units (the recommended light source without heat problems) and with modeling lights that allow you to check the evenness of the lighting, something that is essential. When you are using a small portable flash unit, the polarizing filter need not be larger than the flash head. If two or more lights are used, each light must have its own filter, and the filters must be attached so that they polarize in the same direction.

The filters are usually marked, but if not, you can hold two sheets or two filters on top of each other and look through them while turning one. The sheets are polarized in the same direction when the most light goes through. Maximum polarization is obtained when the angle of the polarizing filter on the camera is 90 degrees to the angle of the filters on the light sources. This is known as cross-polarization. Turn the polarizing filter on the camera lens while visually checking the results on the focusing screen. A circular polarizing filter must be used on lenses in the H camera system.

Figure 18-9 shows a setup for polarized light copying.

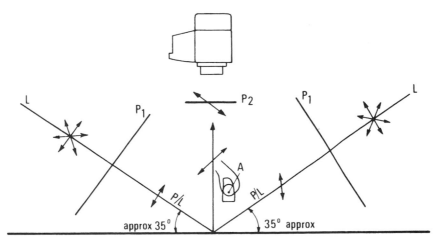

Figure 18-9 *Copying setup* A simple setup for copying in polarized light consists of two lights (L), on the left and right, illuminating the copy from the same angle of about 35 degrees. The light from both lamps goes through the polarizing material (P_1) so that the light falling on the copy is polarized. A polarizing filter (P_2) on the camera lens is turned to produce maximum contrast. Exposure is based on a reflected or built-in meter reading off a graycard (A) placed on top of the copy or the reading from an incident meter.

HIGH-MAGNIFICATION PHOTOGRAPHY

With the Hasselblad close-up accessories and lenses, magnifications up to approximately 2× can be obtained. A simple solution for higher magnifications is to use special objectives that look like objectives for a microscope and have a standard microscope thread (see Figure 18-10). They can provide magnifications up to about 20×. Carl Zeiss used to make Luminar lenses for this purpose, but they are no longer available. Objectives for the same purpose should still be available from other companies, especially camera manufacturers that also manufacture microscopes—for example, Leitz or Nikon. The lenses can be screwed directly into the Hasselblad lens mount adapter, which is a simple aluminum block with a Hasselblad bayonet mount at one side and a center opening with a microscope thread. This accessory has been discontinued but can probably be found on the used-camera shelf. Mounting the lens mount adapter with the lens in front of the bellows is the best solution. To focus and change the magnification, you extend or shorten the bellows.

My high-magnification setup is identical to the one described for slide duplicating, with a tripod-mounted camera over a glass table. For transparent subjects, such as photographing and enlarging a small segment of a transparency, I use a studio flash unit on the floor as for slide duplicating. For opaque subjects, such as photographing a small area of a postage stamp, I use a studio flash unit shining on the subject from a 45-degree angle.

Electronic flash is the most logical light source because high-magnification photography requires a lot of light. Furthermore, with electronic flash, a camera or lens shutter is not really necessary as long as you work in a fairly dark room. Use the open flash method. Set the lens or camera shutter on B, press the release to open the shutter, and fire the flash manually. This approach eliminates all vibration problems. Exposure is best determined with an instant film test.

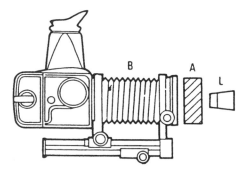

Figure 18-10 *High-magnification photography* The special lens (L) with microscope thread is screwed into the lens mount adapter (A), which is attached to the front of the bellows (B).

Figure 18-11 *Photomicrography* In photomicrography, the eyepiece forms the image on the film, so no camera lens is used. The microscope adapter holds the eyepiece and shields the camera from extraneous light. The eyepiece is dropped into the microscope adapter, and the adapter is then attached to the camera like a lens. The microscope adapter is no longer made. If you cannot find it on the used-camera shelf, you can undoubtedly construct a lighttight connection yourself.

PHOTOGRAPHY THROUGH THE MICROSCOPE

All Hasselblad SLR models can be used to record the image produced by a microscope (see Figure 18-11). A motor-driven model is recommended. Photography can be done with or without a lens on the camera, with the latter being the preferred method. If a camera lens is not used, a focal plane shutter camera can provide a variety of shutter speeds. An instant film magazine is valuable for checking exposure, lighting, contrast, and the reproduction of the various colors.

The quality of photographs is determined extensively by the microscope, its objectives, and its eyepieces but even more so by knowing which lighting and which optical system and arrangement produce the best results in a given situation.

I strongly recommend that you study special books, or even better, attend a special workshop to learn more about photomicrography.

19

The Hasselblad XPan Cameras

CAMERA MODELS

The original XPan camera, introduced in 1998, was superseded in 2003 by the XPan II camera model, with the following major changes and improvements: LCD viewfinder display that includes the shutter speed and exposure information, multi-exposure capability, self-timer delay of 2 seconds or 10 seconds, normal or rear flash sync possibility, improved infrared performance without film fogging, and electrical remote release capability. The new model, shown in Figure 19-1, can also be programmed to spool the film completely into the cassette after the last exposure, as on the original camera, or to leave a film tip outside the cassette.

The XPan II has a Mode button and up/down controls next to the camera LCD. The original model had only the AEB button (see Figure 19-8).

The operating instructions and suggestions here apply to both models, unless otherwise mentioned.

IMAGE FORMAT

The Hasselblad XPan is a completely different Hasselblad camera, with no component interchangeability with the other models. It is made for 35mm film and takes the standard 35mm cassettes with 12, 24, or 36 exposures. The images on the film, however, can be produced either in the standard 24mm × 36mm format or in a panoramic format of 24mm × 65mm, in which case you obtain 6, 13, or 21 panoramic exposures on a cassette.

On one and the same roll of film, you can produce all images either in the standard 35mm or in the panoramic format, or you can mix the two in any desired fashion. You make the switch from one format to the other by moving a single control. When you switch, the viewfinder adjusts automatically so that you always see the proper area coverage, and the frame counter adjusts automatically so that all images are always properly spaced on the film.

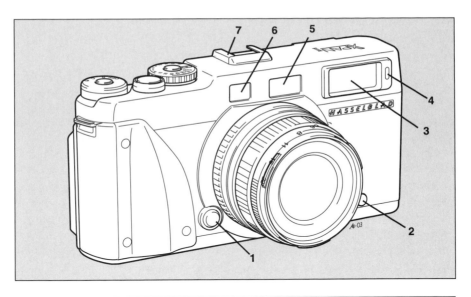

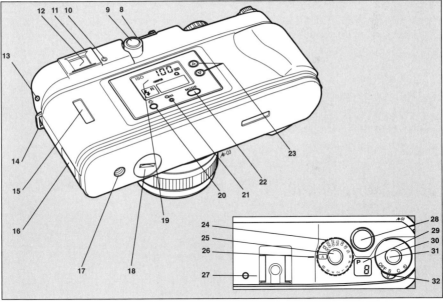

Figure 19-1 The XPan II camera and operating controls.

1. Lens release button
2. PC flash terminal
3. Viewfinder window
4. Self-timer lamp
5. Illumination window
6. Rangefinder window
7. Hot shoe
8. Format selector knob
9. Format selector release
10. Viewfinder eyepiece
11. Viewfinder eyepiece release button

12. Viewfinder LCD
13. Cable release socket
14. Strap lug
15. Film type window
16. Camera back release catch
17. Tripod socket
18. Battery compartment cover
19. Camera LCD display panel
20. LCD illumination button
21. Mid-roll rewind button
22. Program Mode button
23. Up/down controls

24. Shutter speed selector dial
25. Shutter speed selector lock
26. Shutter speed index
27. Film plane mark
28. Shutter release
29. Exposure counter LCD
30. Shooting mode selector
31. Shooting mode selector lock
32. Shooting mode selector lever

FILM PROCESSING AND PRINTING

If all the images on a roll of film are in the standard 35mm format, the film can be processed and printed anywhere, like any 35mm film. If all or some of the images are in the panoramic format, the film can also be developed in the normal fashion but only in a lab that can return the film to you without cutting it. Request that the film be returned in a strip and, in the case of transparencies, unmounted. In most automated laboratories, the machines not only process and print the film automatically but also cut it automatically and most likely will cut your panoramic images.

Prints from standard 35mm frames can be made in the normal fashion. Prints from panoramic images probably must be made in a custom laboratory because few one-hour labs are equipped to make them. You can find the name and address of XPan laboratories on the Hasselblad Web site, www.hasselblad.com, where you select OUR COMPANY/ADDRESSES/XPAN LABORATORIES. In the future, you will undoubtedly find more labs that can make prints from panoramic negatives.

You can make your own prints in the conventional darkroom process if your enlarger is made for negatives up to the 6×7cm format. The long side of the panoramic image is almost as long as the long side of the 6×7cm format. You must mask the negative carrier to the 24×65mm image area so that no light spills beyond the XPan image, reducing the contrast in the print. You can also scan your XPan negatives or transparencies and then make your own digital prints or send the scans to a digital laboratory. The scanner must be made for scanning the larger image area. A 35mm scanner is usable only for negatives or transparencies in the standard 24×36mm format.

The projection of panoramic transparencies is discussed in Chapter 22.

LENSES FOR XPAN CAMERAS

Three lenses are available: a 45mm $f/4$ standard, a 90mm $f/4$ telephoto, and a 30mm $f/5.6$ wide-angle (see Figure 19-2). On the standard 35mm format, these lenses perform in the same way as 30mm, 45mm, and 90mm lenses perform on any other 35mm camera. In the panoramic format, the 45mm lens covers along the long panoramic side an area that is equal to a 25mm focal length on the 35mm format; the 90mm is equal to a standard 50mm, and the 30mm covers a panoramic area equal to a 17mm lens on the 35mm format.

You attach the lens to the camera by aligning the index on the camera and lens and then turning the lens clockwise until you hear a click. The viewfinder automatically adjusts to the focal length of the lens on the camera, except with the 30mm wide-angle lens, which is supplied with a special viewfinder that is attached to the flash shoe on the camera. The composition is made through this special finder, and the lens is focused with the split-image rangefinder in the camera viewfinder. You remove the lens by

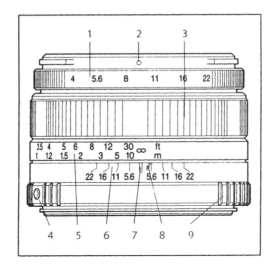

Figure 19-2 The lens controls.

1. Aperture scale
2. Aperture index
3. Focusing ring

4. Attachment index
5. Distance scale
6. Depth-of-field scale

7. Central index
8. Infrared index
9. Attachment ring

pressing the lens release button and turning the lens counterclockwise. Always attach and remove lenses by holding the lens on the rear lens attachment ring, not on the aperture or focusing ring.

All three lenses close down to *f*/22 in ½ stop settings. The 30mm and 45mm lenses focus down to 27 inches (0.7 meter), and the 90mm down to 39 inches (1 meter). The 45mm and 90mm lenses take standard M 49 screw-type filters. Two filters (including one of the polarizing type) can be used on the lenses without vignetting.

Image Illumination

All XPan lenses are optically designed to cover the wide panoramic format. However, as discussed in the section Relative Illuminance in Chapter 14, when light rays enter a lens at steep angles—as is the case when 45mm and 30mm lenses are used for the panoramic format—the light reaching the image area is reduced, causing a slight darkening at the edges and corners of the image. This may be noticeable on transparencies taken with the 30mm lens at any aperture and with the 45mm lens at apertures *f*/8 or larger.

You can eliminate the darkening by attaching a center gray filter. Such a filter is supplied with the 30mm lens and should always be on the lens when you take panoramic pictures. Such a filter is available as an accessory for the 45mm lens, and it is recommended that you use it when taking panoramic pictures at apertures *f*/8 or larger, especially if the pictures include sky or other areas of even brightness where the darkening is most noticeable.

The filters can be left on both lenses for all pictures, panoramic or 35mm, and the only negative aspect is that they create a loss of light equivalent to

one *f* stop. Exposure must be increased by one *f* stop with these filters, but only if the meter reading is made with a separate exposure meter. The XPan's built-in metering system automatically compensates for the loss of light.

The gray filters are optimized for use at larger lens apertures. It is therefore recommended that you photograph at apertures *f*/11 or larger when a gray filter is on the 30 or 45mm lens, whether you are photographing in the panoramic or the 35mm format. Avoid working at *f*/16 or *f*/22.

POWER SUPPLY

The XPan camera's built-in motor, which advances the film automatically after each exposure, and all the other operating controls are powered from two 3V lithium batteries type CR2 (see Figure 19-3). Two fresh batteries will provide power for about 3000 exposures. The camera does not operate without batteries, so you may want to carry spares.

You turn on the power to the camera by moving the mode selector to either S (for single pictures) or C (for sequences) or to the self-timer symbol (see Figure 19-4). To save power, the camera switches automatically to a standby mode after three minutes. You can reactivate the camera by setting the mode selector to C or S or to the self-timer symbol; by pressing the back illumination, the Mode button, or the shutter release halfway; or by operating the remote release.

Set the mode selector to OFF whenever the camera is stored or not used for longer periods of time.

FILM LOADING

Before loading a film, set the ISO dial to DX for DX-coded films or to the desired ISO value for noncoded films or if you want to use a different ISO

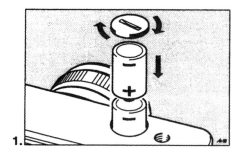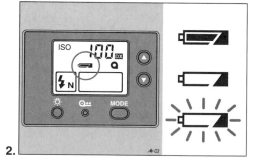

Figure 19-3 *Batteries and battery checking* **1.** The CR2-3V batteries are inserted as shown after the cover is removed using a small coin. The battery condition is shown in (2) after the mode selector is set to S: The batteries are in good condition (top); the batteries are low (center); the batteries are exhausted (bottom).

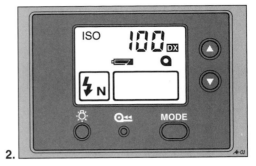

Figure 19-4 *The mode selector* **1.** The mode selector with the three operating settings: S for single pictures, C for sequences, and self-timer. **2.** The film sensitivity is shown on the display. This display also shows that the flash is set for N (normal), in which the flash fires as soon as the shutter is fully open.

value for a coded film. You must do this before loading the film because the camera will not transport a noncoded film if the dial is set to DX.

On the XPan II, you can also program the camera so that the film rewinds completely into the cassette at the end of the roll or rewinds to leave the film tip out of the cassette. You do this by switching the camera from OFF to S while holding down the Mode button on the camera's LCD panel. When the cassette symbol shows up, select OUT, if you want the tip of the film out of the cassette, or IN, if the film should rewind completely into the cassette. Confirm the choice by pressing the release halfway.

You insert the film cassette after opening the back cover and with the mode selector in the OFF position (see Figure 19-5). Pull enough film out of the cassette so that the beginning of the film, with the film lying flat over the guide rails, reaches the film tip mark on the other side of the camera body. Close the camera back until you hear a click. The camera now winds the film automatically out of the cassette and onto the take-up spool.

The XPan film transport is different from that of most 35mm cameras, in which the film moves from the cassette to the take-up spool while the pictures are made and is rewound into the cassette after the last picture. In the XPan cameras, the entire roll of film winds to the take-up spool when the camera is closed. The film then moves from the take-up back into the cassette while the pictures are made. This method eliminates the need for rewinding the film at the end of a roll. Because all the exposed XPan pictures are in the lighttight cassette, it also prevents exposed images from being ruined in case the back cover is opened accidentally.

The film counter shows the number of unexposed frames remaining on the roll of film. The counter changes automatically when you switch from one format to the other (see Figure 19-6). For example, the counter shows 36 when a 36-exposure cassette is loaded with the camera set for the standard 35mm format, but it shows 20 when it is set to the panoramic format. When fully exposed, the remainder of the film is automatically rewound into the cassette.

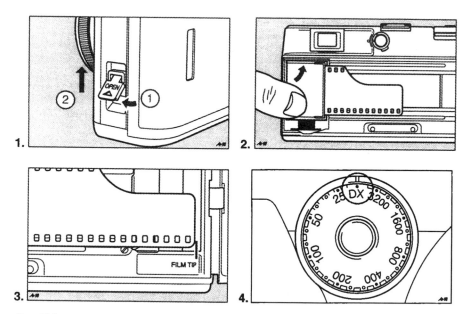

Figure 19-5 *Loading the film* **1.** Open the camera back with the lock on the side of the camera. **2.** The film cassette is properly placed. **3.** The beginning of the film is placed against the film tip indicator with the film lying flat in the camera. Close the camera back. **4.** The ISO dial is set to DX for coded films or to the film's sensitivity for other films.

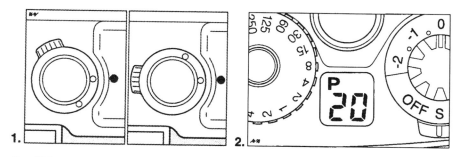

Figure 19-6 *Changing the image format* You change the image format by setting the selector knob to either of the two positions. The panoramic position is indicated by the letter P on the top of the dial and on the LCD display. A flashing P indicates that you have changed to the panoramic format when only one frame of the standard size remains on the film.

 When evaluating the exposed rolls of film, you want to remember that the last picture you took is frame 1 on the film and so on.

 A cassette of film can be removed after being exposed only partially. To do this, you must press the mid-roll rewind button located below the LCD panel. The control is recessed to prevent accidental use. It can be pressed with the tip of a ballpoint pen or similar object (see Figure 19-16).

OPERATING THE CAMERA

You put the camera into the operating mode by setting the operating dial either to S for single pictures, to C for sequences, or to the self-timer setting, where the exposure is made 10 seconds after the release is pressed on the original XPan model. On the XPan II you can program the delay time for either 2 or 10 seconds. The change is made with the up/down buttons on the camera LCD panel, where you can also see the self-timer setting. After the release is pressed with a 10-second delay, the self-timer light at the front of the camera lights up for 7 seconds and then flashes for 3 additional seconds (see Figure 19-7). Set to a 2-second delay, the self-timer light starts flashing immediately. Self-timer operation can be stopped even after it is in operation by changing the operating control dial to S, C, or OFF.

The exposure is made with the shutter release on the camera or with a cable release attached to the cable release socket. Pressing the cable release, however, does not turn on the metering system. You must press the release on the camera if you want to see the exposure information.

Multiple Exposures on the XPan II

On the XPan model II, you can produce multiple exposures, making as many as nine exposures on the same film frame. To program the camera for multiple exposures, press the Mode button on the camera LCD panel for one second and then press it again repeatedly until a flashing double frame symbol appears on the display. Use the up/down buttons to select a non-flashing double frame symbol. Confirm your selection by pressing the release halfway, which brings up the double frame symbol on the display.

You can now select up to nine exposures by pressing the Up button, with the numbers shown on the small exposure counter LCD. Keep in mind that most multiple exposures need adjustments in the exposure value; otherwise, the final image will be overexposed.

Figure 19-7 *The self-timer* A light at the front of the camera next to the camera's viewfinder window indicates when the self-timer is in operation.

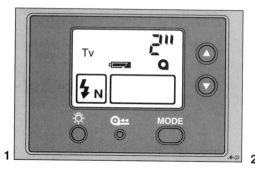

Figure 19-8 *The camera LCD display on XPan II* **1.** When the release is pressed halfway, the ISO number disappears and is replaced by the set shutter speed. **2.** A flickering shutter speed number indicates that the light is beyond the metering range.

Remote Releasing

All XPan cameras have a cable release socket for operating the camera with a standard cable release. The XPan II model can also be released with an accessory electrical release cord, which activates the camera (including the metering system) and fires the camera immediately. In Auto mode, you can see the selected shutter speed on the viewfinder display. In Manual mode, pressing the release halfway activates the meter and makes the settings.

Viewing and Focusing

Viewing and focusing are done through an optical viewfinder with a coupled rangefinder. The image in the finder is always sharp, so do not forget to focus the lens before taking the picture. You do this by looking into the bright center field and turning the focusing ring on the lens until the ghosted image coincides with the sharp image of the subject. Focusing is most successful and fastest when you view a subject area that has high contrast and sharp vertical lines. If the subject has dominant horizontal lines, you may want to turn the camera to the vertical position for focusing. The viewfinder is parallax corrected, so the outlined image area is correct at all distances.

The rangefinder in the camera is also used for focusing the 30mm lens. The viewing is done with the special 30mm viewfinder that comes with the lens and is attached to the flash shoe.

The eyepiece in the camera's viewfinder has a –1 diopter correction. This standard eyepiece can easily be exchanged for accessory eyepieces available in diopter powers from +2 to –4. You change the eyepiece by sliding it in and out of the viewfinder frame (see Figure 19-9). On the XPan II, the selected eyepiece is secured by a locking device.

This wide selection should allow any photographer to have a sharp view through the finder, with or without eyeglasses.

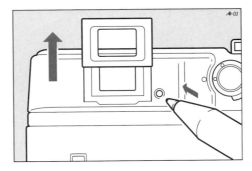

Figure 19-9 *Changing the viewfinder eyepiece* You change an eyepiece by sliding it in and out of the viewfinder frame. On the XPan II, the eyepiece is locked in position. To remove it, press the lock button while simultaneously sliding the eyepiece out of the frame.

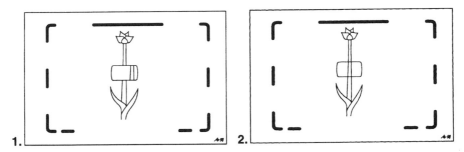

Figure 19-10 *Focusing* You focus the lens by watching the bright center area and turning the focusing ring until the ghost image (1) is lined up with the real image (2). Straight vertical lines are best for doing this.

COMPOSITION IN THE PANORAMIC FORMAT

A panoramic image must include important elements that enhance the image all the way from the left to the right or from the top to the bottom. There must never be an empty area that is considered unnecessary on either side or on the top or bottom of the image. Such areas make the viewer question why the image was made in the panoramic format. When evaluating the image in the viewfinder, look all the way from left to right or from top to bottom, and assure yourself that the image format is covered effectively.

Also be careful in aligning horizontals, such as the horizon, or verticals, such as the lines of buildings, so that they are perfectly parallel to the outside frame. The long side of the panoramic format makes slanted lines more obvious.

A spirit level accessory is available for the XPan camera and can help in the alignment of horizontals and verticals especially when you are working from a tripod (see Figure 19-11).

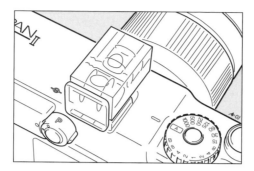

Figure 19-11 *Spirit level* The accessory spirit level must be pushed into the camera hot shoe as far as it goes. It is designed for leveling the camera in the horizontal or vertical position.

EXPOSURE CONTROL

The XPan camera has a built-in exposure metering system that measures the center area of the image (see Figure 12-12 in Chapter 12). Exposure information is shown in the viewfinder. The viewfinder display on the XPan II also shows the set shutter speed, which is helpful in making you aware of shutter speeds that might be too long for handheld photography.

Exposures can be made in either the Automatic or the Manual mode. The decision to select automatic or manual must be based on subject brightness and color, as discussed in Chapter 12. If the center field includes areas of more or less average brightness, as is the case with most outdoor subjects, Automatic is the logical approach. Avoid bright areas, such as white skies, within the metering area.

If the subjects within the measuring area are brighter or darker than the 18% reflectance, you have two options. You can still use the Automatic mode, but set the exposure compensation dial to a plus or minus setting. Set it to plus when subjects are brighter—for example, to +2 for snow. Set it to minus for darker subjects, such as −1 for dark green trees (see Figure 19-12). Do not forget to reset the dial to 0 after the exposure. You can also photograph such subjects in the Manual Exposure mode, making the necessary compensation.

For automatic exposure, set the shutter speed dial to A, set the aperture to the desired value, and make the exposure. For manual exposure, set the aperture or shutter speed to the desired value, and then set the other until the indications in the viewfinder show the correct setting.

The exposure information is shown in Figure 19-13 for the original XPan and in Figure 19-14 for the XPan 11.

Automatic Exposure Bracketing

The automatic metering system in the XPan camera produces beautiful results with most subjects and lighting conditions, even on transparency film.

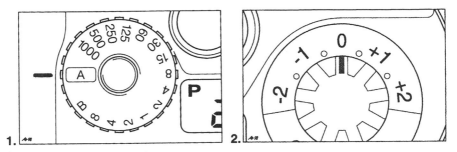

Figure 19-12 *Shutter speed and compensation dial* **1.** The shutter speed dial is set to A for automatic exposures for the desired shutter speed in the manual. **2.** You can increase or decrease exposures by using the exposure compensation dial.

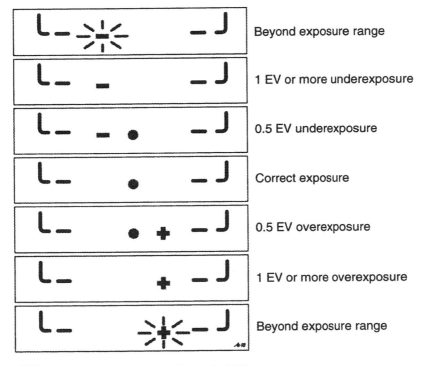

Figure 19-13 Exposure information on the original XPan camera.

If you have any doubt about the exposure being correct and feel better if you bracket exposure, use the Automatic Bracketing mode, which changes the shutter speed automatically (see Figure 19-15). To make the three exposures immediately after each other, simply keep the shutter release pressed; you need not remove your eye from the viewfinder. You can bracket in ½ *f* stops or full *f* stops by pressing the AEB button on the original camera once for ½ stop or twice for 1 stop bracketing, which is my recommendation. You set

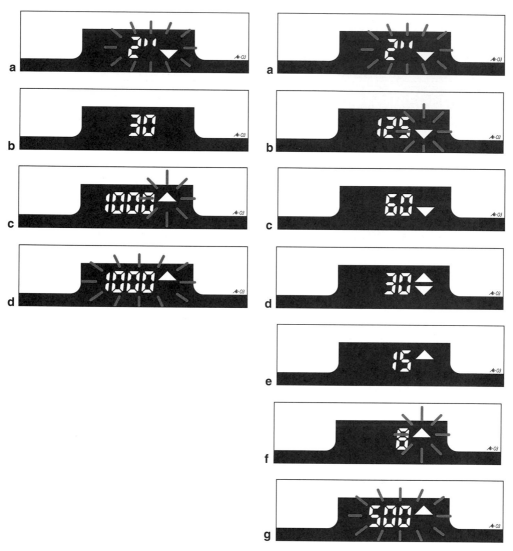

Figure 19-14 *Exposure information on the XPan II camera model* The indications when the camera is set to automatic exposure are shown on the left: a. Setting beyond metering range (too dark). b. Correct exposure. c. Calculated exposure time less than $\frac{1}{1000}$ second. d. Setting beyond metering range (too bright). The indications in manual exposure are shown on the right: a. Setting beyond metering range (too dark). b. More than 1 EV value underexposure. c. 0.5 EV value underexposure. d. Correct exposure. e. 0.5 EV value overexposure. f. More than 1 EV value overexposure. g. Setting beyond metering range (too bright).

Figure 19-15 *Automatic bracketing* **1.** On the original XPan camera, the Automatic Bracketing mode is actuated by pressing the AEB button once for ½ stop bracketing and twice for 1 stop bracketing. On the XPan II, bracketing is set with the mode and the up/down controls. **2.** On both cameras, the bracketing value (1 stop in the illustration) is indicated on the LCD display. The display shows that the camera is also set for the flash to fire at the end of the exposure.

the XPan II for automatic bracketing by repeatedly pressing the Mode button on the LCD display until AEB and +/− appear on the display. Select the bracketing value with the up/down controls, and then press the Mode button or press the release halfway again. A programmed exposure compensation is taken into account in the Automatic Bracketing mode.

You turn off the automatic bracketing by again pressing the AEB button (in the original XPan) or the Mode button (on the XPan II), or it automatically goes off when the camera is turned off.

When working with automatic bracketing, you should finish the sequence of three images; otherwise, the exposure adjustments for the remaining image or images will still be programmed into the camera. The camera will not operate if it is set to the Automatic Bracketing mode with only one or two images left on the film.

FLASH PHOTOGRAPHY

Electronic flash can be used at shutter speeds from B to $\frac{1}{125}$ second. The flash unit can be connected to the camera through either the hot shoe on top of the camera or the PC contact at the front of the camera.

When you are photographing in the standard 35mm format, any flash unit should cover the entire subject area with the 45mm and 90mm lenses. When you are photographing in the standard format with the 30mm lens, the flash unit must cover the 30mm area that is the area of a 17nm lens on a 35mm camera. When the 45mm lens is used in the panoramic format, the flash unit must cover the area of a 25mm focal length lens. Check the specifications of the flash unit. Some flash units have a wide-angle setting. If the flash does not cover the area, consider bare bulb or bounced flash use.

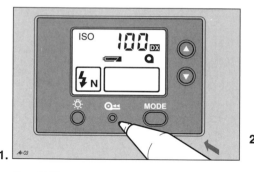

1.

2.

Figure 19-16 *Other XPan controls* **1.** The display on the LCD panel can be illuminated by pressing the LCD backlight button, which is in the center on the original camera and on the left on the new model. A partially exposed film is rewound by pressing the rewind button, which is in the center on the new camera, on the right on the original model. **2.** The self-timer is actuated at the self-timer setting.

Figure 19-17 For infrared photography, focus the lens as usual, read the distance on the focusing scale (here, 3 meters), and then set the distance (3 meters) opposite the infrared index (R).

On the XPan II model, the flash can be programmed to fire at either the beginning or the end of the exposure. To do so, press the Mode button on the camera LCD panel repeatedly until the flash symbol and the letter N or R appears on the display. By pressing the up/down controls, set the mode to N, if the flash is to fire at the beginning, or to R, if it is to fire at the end. Press the Mode button again to confirm the selection.

Infrared Photography

Because the image created by infrared light is formed farther from the lens than it is with visible light, a focus adjustment on the lens is necessary, as discussed in Chapter 16.

For infrared photography, focus the lens as usual (see Figure 19-17). Then move the focusing ring until the distance that is opposite the regular index is opposite the red infrared dot (R).

The XPan II has a film transport system that does not fog high-speed black and white infrared film and therefore is an excellent camera for infrared photography.

▲ The overall view of the colorful boat in Portugal is the "tourist view" that everybody sees. The close-up of the beautiful lines, shapes and colors on a small part of the boat shows details that most people overlook.
Ernst Wildi

▲ Three XPan pictures with the farm in Norway taken with the 45mm lens, the autumn tress with the 30mm wide angle and the pumpkins with the 90mm telephoto.

▲ Three unusual but effective compositions in the
panoramic format taken with XPan camera by
Francisco Gomez.

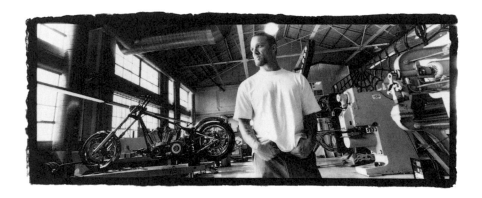

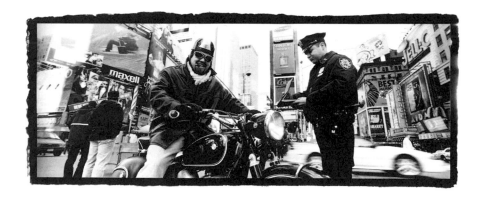

▲ Three examples of Karen Kuehn's approach to panoramic photography with the XPan camera. Kevin Thomasson on bike (bottom) Jesse James West Coast Choppers (center) Skater Hunter Barnes (top)

20

Keeping Camera Equipment in Working Condition

Keeping your camera equipment clean is better than cleaning it. Keep all equipment away from dust and dirt whenever possible. Store each item in a case, with the covers on lenses and viewfinders, and front and rear covers on camera bodies if stored without a lens or magazine attached. Take great care when dusting the mirror, the viewing screen, or the bottom of the meter prism finder. Never touch the titanium focal plane shutter of the 2000/2003 cameras. Never use canned air for cleaning.

More detailed instructions for maintaining specific items in good working order are found in the chapters on lenses (Chapter 14), viewfinders (Chapter 11), and film magazines (Chapter 10).

MINIMIZING FUNGUS

In tropical climates, glass surfaces, lenses, prisms, and filters often become cloudy, a condition caused by fungi attacking the polished surfaces. Because the relative humidity decreases as the air temperature increases, you can reduce fungus development by keeping the camera equipment in the sun, in circulating air. Do not keep it in closed bags, drawers, or boxes. Grease and dust can also help fungi to develop and should be removed from the equipment.

Humidity in small areas can be reduced with desiccants. Silica gel, usually in the form of small crystals in a dustproof bag, is best for this purpose. Place the bag inside camera cases or airtight containers. Choose indicator gel, which changes color from blue to pink when it reaches a saturation point and needs regeneration. To regenerate it, heat it at 120–150°C (250–300°F) for about 12 hours.

Optical surfaces covered with a slight film of fungus should not be cleaned with alcohol but rather with a special fungus cleaner, if available. If fungus remains visible on the glass, return the equipment to the Hasselblad agent. Lens elements may have to be replaced.

When you are working in areas with high humidity, take the cameras and all the lenses out of air conditioned areas, including an air conditioned car, at least 30 minutes before you plan to photograph. All the glass surfaces on the lenses, the viewfinder, and the mirror in the camera will fog up when the camera comes out of the air conditioned area, and it may very well take 20 minutes before the fog disappears. Trying to remove the fog with cleaning tissue does not help. It comes right back until the surfaces have adjusted to the outside temperature.

COLD WEATHER PHOTOGRAPHY

The viscosity of lubricants increases (i.e., lubricants thicken) as the temperature declines, and consequently, in very cold weather, the camera mechanism may operate more sluggishly. Lens shutters may be affected, with shutter speeds becoming longer, especially if the lubricant in the lens and shutter is old. Hasselblad cameras and lenses are lubricated to work at very low temperatures, and special "winterizing" is no longer necessary or recommended. Reliable cold weather operation, however, can be expected only if the lubricants are fairly new. Have the lenses cleaned and relubricated before you work in very cold climates. Before you photograph, operate all the shutter speeds a few times with the magazine removed. This may get the lubricant working.

For cold weather photography, simplify camera operation as much as possible. Remove unnecessary accessories that cannot be operated with gloves, and add others that may help the operation. Reduce equipment changes as much as possible. Preload film magazines before you go into the cold, if possible.

When you are out in the cold, avoid touching the unpainted metal surfaces of your equipment with ungloved hands, your face, or your lips. The skin will stick to the metal. Some photographers cover the metal parts with tape to prevent this possibility. Don't breathe on the lenses. The condensation will freeze, perhaps instantly, and is then very difficult to remove. Condensation also occurs when cold equipment is brought into a warm room. This means that a chilled camera cannot be used until its temperature equals that of its surroundings. A camera with condensation also should not be taken out into the cold until the condensation has evaporated. If you do, the condensation will freeze. This can be serious, because condensation may also cover the camera and lens mechanism inside and may freeze up the camera and lens operation.

You can avoid condensation by placing the camera in an airtight plastic bag, squeezing out the air beforehand. In this way, the camera is not exposed to the warmer temperature. Condensation forms on the outside of the bag instead of on the lens and camera body.

TAKING CARE OF BATTERIES

All batteries have a tendency to drain quickly in low temperatures. Always carry a spare set, and keep them warm until they have to be used. Lithium batteries are better in cold temperatures than alkaline or silver oxide types.

Try to keep the camera in a warm place as long as possible, or remove the battery or batteries (the battery grip from the H camera) until needed. Don't forget the battery in the meter prism viewfinder.

21

Older Hasselblad Cameras

OPERATING THE 1000F AND 1600F CAMERAS

Interchangeability of Components

The 1000F and 1600F models (see Figure 21-1) take the same rollfilm magazines as the newer models. The very early types of film magazine did not lock the release at the end of the roll, so you could take pictures after the film had gone through the magazine.

The 1000F and 1600F may have one of the older viewing hoods, where the magnifier is on a foldable arm rather than on a panel that covers the top completely. You can update such a camera by equipping it with any one of the current viewfinders.

The bayonet lens mount on 1000F and 1600F models differs from that of the newer models, and therefore lenses are not interchangeable. There is no coupling shaft between the camera and the lens, so lenses can be removed or attached at any time, with the film advanced or not.

Two extension tubes—20 and 40 mm—and a bellows with sunshade have been available and are attached between the camera and lens in the normal fashion. Because the lenses have no shutters, a double cable release is not necessary.

Releasing and Shutter Operation

The 1000F and 1600F models are equipped with stainless steel focal plane shutters with speeds up to $\frac{1}{1600}$ second on the 1600F model and $\frac{1}{1000}$ second on the 1000F. The stainless steel shutter is only $\frac{6}{10,000}$ inch thick and can easily be damaged. Be careful, especially when you attach magazines, that the corner of the magazine does not hit the shutter curtain.

You set the shutter speed by pulling out the winding knob and turning it clockwise until the desired shutter speed is opposite the red triangular index mark on the camera body. A cable release can be attached to a separate socket on the right side of the camera, next to the release. The shutter is recocked, and the mirror is lowered with the full turn on the winding knob.

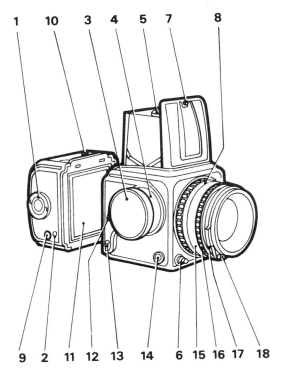

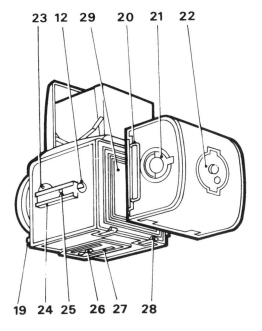

Figure 21-1 The 1000F and 1600F camera.

1. Magazine loading key
2. Film transport signal on magazine
3. Shutter cocking and film transport knob
4. Shutter speed scale
5. Focusing magnifier
6. Shutter release button
7. Release catch of finder hood
8. Depth-of-field scale
9. Film counter of magazine
10. Magazine catch
11. Magazine slide
12. Lug for carrying strap
13. Transport signal on camera
14. Cable release socket
15. Distance scale
16. Focusing ring
17. Aperture preselector ring
18. Rapid stop-down aperture lever
19. Lens changing catch
20. Handle of magazine slide
21. Film holder lock
22. Film indicator (and window in magazine back)
23. Synchronizing lever
24. Accessory shoe
25. Flash contacts
26. Tripod sockets
27. Base plate
28. Hooks for film magazine
29. Focal plane shutter

With older magazines, the shutter could be released if the darkslide was pulled out a mere $\frac{1}{4}$ inch (5 mm), not halfway as on the newer types. You may not be aware that the darkslide is still in the magazine, so it is a good idea to check visually and make certain that the darkslide has actually been removed.

Lenses and Lens Operation

The standard lens was originally a Kodak Ektar *f*/2.8 and later an 80mm Tessar *f*/2.8. Accessory lenses consisted of the 60mm *f*/5.6 Distagon, the 135mm Sonnar *f*/5.6, the 250mm Sonnar *f*/5.6, and the considerably larger 250mm Sonnar *f*/4. All lenses offer aperture preselection.

Set the desired aperture by turning the preselection ring until the aperture is opposite the index mark. The aperture is then preset. For focusing at the maximum aperture, turn the aperture ring with the trigger (a milled front ring on the 135mm lens) all the way to the right (when you look down). This opens the diaphragm. After focusing, turn the ring to the left as far as it goes, thereby resetting the diaphragm at the selected aperture.

Flash Operation

The 1000F and 1600F cameras have an accessory rail on the side that contains the flash contacts. To connect the sync cable to the camera, you need a sports viewfinder or flash shoe accessory, both of which were available with a standard 3mm contact and a type A contact. Both accessories have two contacts: one marked "flash" (for FP flashbulbs), and the other "strobe" (for electronic flash or M flash bulbs), both at shutter speeds up to $\frac{1}{25}$ second. Above the accessory rail is a curved synchronizer disc with a pin, which can be set opposite numbers 1 to 5 depending on the type of flash bulb being used. For electronic flash, no adjustment is required.

OPERATING THE ORIGINAL SUPERWIDE CAMERA

On the original Superwide, the Biogon was more like a view camera wide-angle lens, with two separate rings for aperture and shutter speed, and so was its operation (see Figure 21-2). The camera's winding knob does nothing more than advance the film in the magazine. The Compur shutter in the lens must be recocked separately with a lever. The shutter cocking lever is coupled to the self-timer control. For a self-timer exposure, you pull the self-timer button (between the 250 and the 500 engravings on the shutter speed scale) toward the camera while tensioning the shutter. Pulling the cocking lever fully to the left, past the self-timer button, sets the self-timer delay and also cocks the shutter.

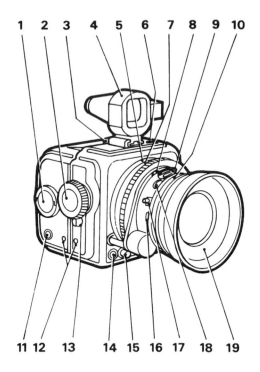

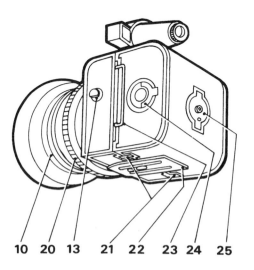

Figure 21-2 The original Superwide camera.

1. Magazine loading key
2. Film transport knob
3. Magazine catch
4. Wide-angle finder
5. Depth-of-field scale
6. Spirit level
7. Distance scale on focusing mount
8. Aperture lever
9. Self-timer control
10. Shutter speed ring
11. Film counter of magazine
12. Transport signals
13. Fitting for neck strap
14. Cable release socket
15. Release button
16. Synchronizing lever
17. Flash socket
18. Shutter tensioning lever
19. Biogon lens
20. Focusing ring
21. Magazine hooks
22. Base plate with tripod socket
23. Handle of magazine slide
24. Locking key of rollfilm holder
25. Film indicator and window in magazine back

A PC flash contact is part of the lens, and flash pictures can be made at all shutter speeds from 1 to $\frac{1}{500}$ second plus B. The synchronizing lever, with M and X positions on the lens, must be set to X for electronic flash or to M for flash bulbs.

The release button at the front of the camera cannot be pressed until the film has been advanced. Double exposures are made by removing the film magazine. Most of the original Superwide cameras were delivered with an optical viewfinder like the one on future models. Some early models came with a waist-level finder.

22

Projecting Medium-Format and XPan Transparencies

PROJECTING XPAN TRANSPARENCIES

Transparencies in the standard 35mm format, either cardboard- or glass-mounted, can be projected in standard 35mm projectors. The 24×65mm panoramic transparencies require a 6×7cm slide projector and 6×7cm slide mount, with the panoramic image area masked off with silver tape.

The $2\frac{1}{4}$-inch projectors, such as the Hasselblad PCP 80, can be used only for slide sizes up to 55mm, which is 9mm too short for the long side of the XPan panoramic images. To project these images in a $2\frac{1}{4}$-inch (6×6cm) slide projector like the PCP 80, you can consider two solutions. You can cut the long side of the panoramic image down to 55mm; this is not a great solution because well-composed panoramic images lose the effectiveness of the panoramic shape. The other solution is to have a duplicate transparency made in a reduced format of 56mm \times 21mm.

THE $2\frac{1}{4}$-INCH SQUARE AND 6×4.5CM TRANSPARENCIES

The $2\frac{1}{4}$-inch (6×6cm) square and the rectangular 6×4.5cm formats are excellent for projection. Projectors and slide trays are readily available. Because laboratories return 120 or 220 transparency films unmounted, you must mount your own slides. This is actually an advantage because the large transparencies should be glass-mounted to maintain corner-to-corner image sharpness in projection. Medium-format slides are large, and the heat from the projector would cause excessive popping of a cardboard-mounted slide.

Glass mounts protect slides physically but do not prolong their life or prevent color fading. For longest slide life, keep them in a cool, dry, dark place as much as possible. To minimize fading, do not expose slides to the bright projection light longer than necessary; keep them away from direct sunlight and fluorescent lights such as those found in a light box.

Slide Mounts

Glass slide mounts for $2\frac{1}{4}$-inch square and for 6×4.5cm transparencies are available. Both have the same outside dimensions and can therefore be used in the same slide trays and can be intermixed within a presentation. Plastic frames with rounded corners that slide or snap together are the preferred choice for the precise standards of the film gate in the Hasselblad PCP 80 projector.

If a slide does not drop, check the slide mount first, and make certain that the mounts are firmly pressed together. Do not attach paper or tape to the slide mount to identify slides. Instead, write the identification directly on the mount using a pen that writes on glass and plastic. To avoid having slides appear on the screen upside down or sideways reversed, you may want to indicate the proper positioning with a dot in one corner made with a pen directly on the mount. Proper positioning of all slides is ensured when all dots are visible in the same corner when you glance from the back of the tray.

Slide sequences in a professional presentation may require perfect registration from one slide to the one before and the one after. Such slide registration is achieved with pin registration slide mounts. The Hasselblad mounts are no longer made, but other makes should still be available, as should be the necessary tool to punch the registration marks into the film. These slide mounts are not made for the perforations in 70mm films used in the Hasselblad 70 film magazine. Professional multiple-image presentations usually use duplicate transparencies made in a pin-registered rostrum camera.

New glasses are factory cleaned and need nothing more than brushing off possible dust. For cleaning used glasses, use either a glass cleaner or warm water.

Store glass-mounted slides in areas with low humidity because otherwise the film base soaks up the moisture from the air. The heat from the projection lamp causes the moisture to evaporate, and the moisture may become visible on the screen and will cloud the glass. Moisture that has settled between slide and glass should be removed as soon as possible because it will deform the slide and may result in the growth of fungus. Take the slide apart and let it dry out before remounting.

OPERATING THE HASSELBLAD PCP 80 PROJECTOR

The Hasselblad PCP 80 projector (see Figure 22-1) is the most professional medium-format slide projector. It can be used in applications ranging from simple one-projector shows to the most sophisticated multiple-image presentations, using the same dissolve and control equipment used for 35mm projectors. In spite of the superb performance of the PCP 80, the market for slide projectors has been reduced to a point where Hasselblad was forced to

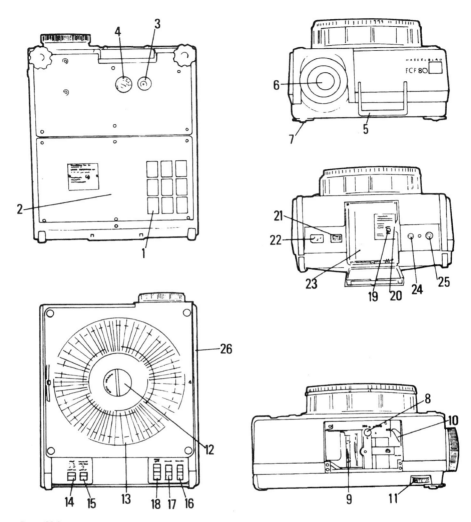

Figure 22-1 Operating controls on the PCP 80.

1. Air filter
2. Baseplate (can be removed to clean the projector)
3. Automatic circuit breaker
4. Voltage selector (does not exist on the U.S. version)
5. Carrying handle
6. Lens holder with projection lens
7. Adjustable feet for leveling
8. Adjustment for matching perspective control to lens
9. Removable condenser lens
10. Perspective control indicator
11. Perspective control adjusting knob
12. Magazine lock
13. Tray
14. Lamp ON switch
15. Lamp OFF switch
16. Forward and reverse slide changing
17. Lens focus control
18. Edit and reset control
19. Transport lock screw
20. AV socket for programmers
21. Power on/off switch
22. Power cable connection
23. Lamp housing door
24. Eight-pin connector for some programmers
25. Six-pin connector for Hasselblad remote control
26. Side cover

discontinue the product. Part of the reason is undoubtedly the much wider use of newer digital presentation methods.

Perspective Control

The designation PCP 80 comes from the built-in perspective control and the 80-slide tray capacity. With the built-in perspective control, you can move the image on the screen up and down by simply turning the perspective control knob, which moves the entire optical system from lens to lamp housing.

The weight of the PCP 80, combined with the floating optical system, requires special care in transporting. The PCP 80 has a transport lock for this purpose, which must be removed before you use the machine or operate any controls (see Figure 22-2). The transport locking screw is then inserted into the opening on the knurled knob on the right front foot. After it is inserted, turning the knob operates the perspective control. To ship the projector, reverse the procedure.

Voltage Selection, Projection Lamps, and Illumination System

The PCP 80 projectors sold on the American market are made for 110 volts only and need no adjustment. Other projectors have a voltage selector at the bottom, which must be set to the proper value. The PCP 80 works on 50 or 60 cycles.

The PCP 80 is supplied with two 250W 24V halogen projection lamps held in a common lamp holder. Should lamp 1, which is normally lit, burn out, a microswitch automatically and instantly flips lamp 2 into the projection position. LED lights next to the lamp switch show which lamp is on. If only the green LED is lit, lamp 1 is on. If the yellow LED next to it is also lit, lamp 2 is on, which means that lamp 1 has burned out. In that case, replace lamp 1 as soon as possible. The lamp is an EHJ type (DIN 49820 base 6,35–15)

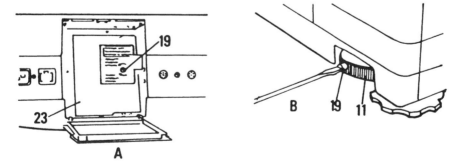

Figure 22-2 *The transport lock* **A.** To unlock the perspective control, remove the locking screw (19) completely. Close the lamp housing door (23) completely before using the projector. **B.** The locking screw (19) must be inserted into the perspective adjusting control wheel (11) before the perspective control can be moved.

that provides a screen brightness that is completely satisfactory for screen sizes up to 10 × 10 or even 12 × 12 feet (3 × 3 meters or 4 × 4 meters).

Projection lamps can be replaced easily because the entire lamp holder is removable through the rear of the PCP 80. When changing lamps do not touch the new lamp with your fingers. Insert the pins of the lamp into the socket while holding the lamp in the plastic envelope in which it is supplied.

For maximum screen brightness, you must center the lamp in front of the mirror by watching the filament and its reflection while moving the lamp in any one or all three of the possible directions (see Figures 22-4 and 22-5).

After reinserting the lamp holder, close the inside cover completely. If lamp 2 goes on without lamp 1 being burned out, push lamp holder ("d" in Figure 24-4) upward until it clicks into position.

To produce perfectly even corner-to-corner illumination, each projection lens comes with its own matched condenser lens, which can be changed after you set the perspective control at or near the 0 position (see Figure 22-3). Push the condenser completely into the projector until it snaps into place. The control lever must also be set to the proper position, which is 150 for the 150 and 75mm lenses, and 250 for the longer lens.

The projector and the slides are kept cool with filtered air drawn into the projector from the bottom. The air filter underneath the projector can easily be removed for cleaning, something that should be done occasionally. Clean it by washing it like air filters in other equipment. Make certain that the filter is dry before it is used again. Make sure that the opening for the filter underneath the projector is open. Don't project on a tablecloth or other flexible material that may block the opening.

A resettable fuse at the bottom of the projector pushes out if the projector overheats. After the projector has cooled off, press the fuse to reset it. However, you should always investigate the cause of overheating before resetting the fuse.

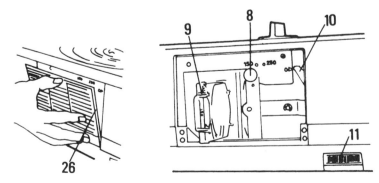

Figure 22-3 *Condenser lenses* You insert or remove the condenser lenses (9) after lifting off the side cover (26). The condenser can be pulled out or inserted only if the perspective control adjustment (10) is at or near 0. The perspective matching control lever (8) must also be set based on the focal length of the lens.

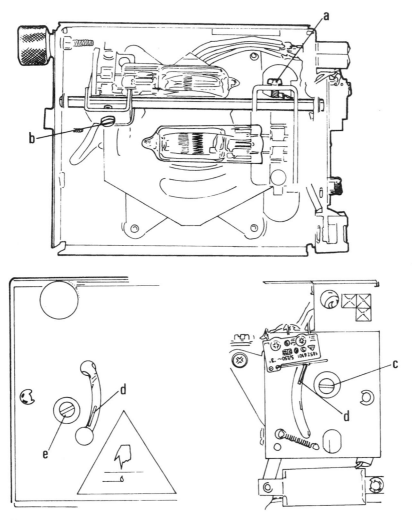

Figure 22-4 *Lamp holder adjustments* You remove the lamp holder by opening the rear door, unscrewing the large knurled knob on the upper left, and pulling out the lamp holder. You can align and center the two projection lamps after loosening the screws (a, b, c). If the lamp holder has switched to lamp 2 without lamp 1 being burned out, slide the metal tongue (d) to the upper position.

Attaching and Removing the Slide Trays

The slide tray can be attached in any position, but you must push the guide pin to the side if it is not in position 1. To attach a slide tray, be sure that the tray lock is in the unlocked position. The control can be turned from Lock to Unlock only when the projector is connected and the main switch is on. In the unlocked position, a red LED above the lamp's OFF switch is lit up, and none of the projector's operating switches works. You can project only

Right filament image

Adjusting the lamps

	Filament image	Adjust as follows
	The lamp filament and its reflected image are laterally displaced.	For lamp 1: Loosen *screw a* and slide the lamp fixture until the correct filament image is visible. Tighten screw (*a*). For lamp 2: Proceed in a similar manner.
	The reflected image is smaller than the filament.	For lamp 1: Loosen *screw a* and turn the lamp fixture until the correct filament image is visible. Tighten screw (*a*). For lamp 2: Proceed in a similar manner.
	The filament and its reflected image are vertically displaced.	For lamp 1: Loosen *screw c* and move the metal tongue vertically until the correct filament image is visible. Tighten screw (*c*). For lamp 2: Proceed in a similar manner.

Figure 22-5 Aligning the projection lamps.

Table 22-1 Projection Distances and Screen Sizes

Projection distance		Distagon 75mm f/3.5		P-Planar 150mm f/3.5		P-Sonnar 250mm f/4.2	
Meters	*Feet*	*Meters*	*Feet*	*Meters*	*Feet*	*Meters*	*Feet*
2	6.5	1.4	4.5	0.7	2.5		
3	10	2.1	7	1.1	3.5	0.6	2
5	16.5	3.5	11.5	1.8	6	1.1	3.5
10	33			3.5	11.5	2.1	7
15	50			5.2	17.5	3.2	10.5
20	66					4.2	14

if the tray is locked properly. Turn the tray lock knob until the red light disappears.

The slide tray can be removed only when all slides are in the tray. If a slide is left in the gate, press the Edit button. This moves the slide from the projection gate back into the tray.

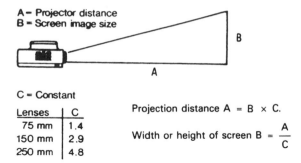

A = Projector distance
B = Screen image size

B

A

C = Constant

Lenses	C
75 mm	1.4
150 mm	2.9
250 mm	4.8

Projection distance A = B × C.

Width or height of screen B = $\dfrac{A}{C}$

Figure 22-6 Calculating projection distances and screen sizes.

The PCP 80 Operating Controls

The PCP 80 projector is equipped with three electric motors. The main switch turns on the motor for the centrifugal fan. Should the fan fail to operate, a thermal circuit breaker cuts off the power to the lamp. Such a failure would light up the HIGH TEMP LED. The 12V DC motor that operates the slide-changing mechanism is operated by the slide-changing, edit, and reset controls. The other 12V DC motor is operated by the focusing controls and moves the lens forward and back. The total power consumption is about 350W. All slide-changing functions are controlled electronically, making slide jamming almost impossible regardless of how you operate the controls.

Slide changing, forward and reverse, and lens focusing can also be operated with the Hasselblad remote control, which as a 13-foot cable that is connected to a six-pin DIN socket 25. The forward and reverse projection functions can also be operated with a standard Kodak remote control connected to the five-pin socket in the AV door at the rear of the projector. This door is found on all PCP 80 projectors sold in the United States. Dissolve and programming units made for U.S. Kodak projectors are connected to the same outlet.

Figure 22-7 shows how to start the PCP 80 projector, and Figure 22-8 shows the machine's operating controls.

Figure 22-7 *Starting the projection* **A.** The power cable is connected to the socket (22). The fan is turned on with the power switch (23). **B.** Slide trays can be attached only when the tray lock (12) is in the unlocked position, with the red control lamp burning. The slide-changing arm (a) is then in the up position. If the lock cannot be moved to Unlock, press the Edit button to bring the arm up. **D.** Attach the slide tray so that its groove (c) engages in the sensor (b) for the 0 position. **C.** To attach the tray in any position other than 0, move the sensor outward.

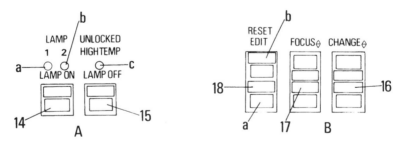

Figure 22-8 *Operating controls* **A.** The left side control panel has the lamp ON (14) and OFF (15) switches. When lamp 1 is on, the green light (a) is lit. If the yellow lamp (b) is also lit, projection lamp 2 is on, meaning that lamp 1 is burned out. If only the yellow indicating lamp (b) is lit, the projection lamps have been interchanged, but lamp 2 is not lit, or both lamps are burned out. The red lamp (c) is lit either when the magazine lock is not securely locked or when the projector has overheated. **B.** On the right control panel, you have the forward and reverse slide-changing switches (16). You move the lens forward or backward for focusing by pressing the front or rear position of the switch (17). Pressing the rear (a) of the switch (18) moves the slide back into the tray without advancing the tray. Pressing the top portion (b) turns off the projection lamp and moves the tray to the first position, where it stops.

Index